Advance Praise for *Overrun*

"A riveting 'can't put it down' book about fish? You bet! Andrew Reeves takes us on a dizzying journey along the waterways of North America with a rich cast of fish farmers, environmentalists, hustlers, scientists and befuddled politicians as we follow the murderous and seemingly unstoppable advance of Asian carp that now threaten the Great Lakes themselves. This is a very important book to heed if we want to save this watershed."

— Maude Barlow, author of *Boiling Point*

"In shining a light on the many facets of one of the most wicked problems besetting the planet — the spread of invasive species — Andrew Reeves shows us how to see with compassion and intelligence and how to voice a range of perspectives while holding in tension the need to embrace complexity and the urgency of choosing worthy solutions. This book is important not merely for its topic but for its nuanced and thoughtful approach."

— Trevor Herriot, naturalist and author of *Islands of Grass* and *River in a Dry Land*

"The definitive narrative of carp in America. Reeves chronicles the complex web of good intentions, imperfect science and different agencies and entities working at cross purposes that led to the carpification of U.S. waterways. His tour through the quest to regain control is compelling and comprehensive. In the end, Reeves takes a broad and holistic view of the issue, pointing out that fighting a few enemy fish species in the absence of meaningfully addressing the pollution, land management, water management and climate change that create the conditions for carp to thrive is like dueling with our own shadow. The carp is the symptom, not

the disease. A must-read for those who love the Mississippi River watershed and the Great Lakes, for those interested in 'invasive' species, for sportfishers and environmental historians."

— Emma Marris, author of *Rambunctious Garden*

"This detailed account of the invasion of Asian carp into North American waterways reads like a Kurt Vonnegut novel or science fiction. Yet the carp's unbelievable progress splashes another clear warning about how so-called solutions have become the chief cause of our problems."

— Andrew Nikiforuk, author of *Empire of the Beetle*

"*Overrun* is a whip-smart romp through the dystopian history of Asian carp, that wrecking ball of aquatic ecosystems in North America. But in telling it, Reeves charts a sustainable future for the waterways that connect all of us on the continent. An environmental writer as good as Reeves gives me hope."

— Harry Thurston, winner of the Lane Anderson Award for Excellence in Canadian Science Writing and the Sigurd F. Olson Nature Writing Award

"*Overrun* is more than an engaging story about nuisance fish. This eye-opening book demonstrates the interrelationship of species, the climate and the environment."

— starred review in *Foreword Reviews*

OVERRUN

OVERRUN

Dispatches *from* *the* Asian Carp Crisis

ANDREW REEVES

Published by ECW Press
665 Gerrard Street East
Toronto, Ontario, Canada M4M 1Y2
416-694-3348 / info@ecwpress.com

Purchase the print edition
and receive the eBook free.
For details, go to ecwpress.com/eBook.

LIBRARY AND ARCHIVES CANADA
CATALOGUING IN PUBLICATION

Reeves, Andrew, 1984-, author
 Overrun : dispatches from the Asian carp
crisis / Andrew Reeves.

Issued in print and electronic formats.
ISBN 978-1-77041-476-1 (softcover)
ISBN 978-1-77305-336-3 (PDF)
ISBN 978-1-77305-335-6 (ePub)

 1. Carp—United States. 2. Introduced
fishes—United States. I. Title.

QL638.C94R44 2019 597'.4820973
C2018-905337-2 C2018-905338-0

Editor for the Press: Susan Renouf
Cover design: Michel Vrana
Cover illustrations (also used in the interior):
© Joseph R. Tomelleri
Author photo: © Courtney Walker
Map illustrations: © Jackie Saik

The publication of *Overrun* has been generously supported by the Canada Council for the Arts
which last year invested $153 million to bring the arts to Canadians throughout the country and
is funded in part by the Government of Canada. *Nous remercions le Conseil des arts du Canada de
son soutien. L'an dernier, le Conseil a investi 153 millions de dollars pour mettre de l'art dans la vie
des Canadiennes et des Canadiens de tout le pays. Ce livre est financé en partie par le gouvernement
du Canada.* We acknowledge the support of the Ontario Arts Council (OAC), an agency of the
Government of Ontario, which last year funded 1,737 individual artists and 1,095 organizations in
223 communities across Ontario for a total of $52.1 million. We also acknowledge the contribution
of the Government of Ontario through the Ontario Book Publishing Tax Credit, and through
Ontario Creates for the marketing of this book.

ONTARIO
CREATES

ONTARIO ARTS COUNCIL
CONSEIL DES ARTS DE L'ONTARIO
an Ontario government agency
un organisme du gouvernement de l'Ontario

Canada Council Conseil des Arts
for the Arts du Canada

Canadä

PRINTED AND BOUND IN CANADA

PRINTING: NORECOB 5 4 3 2 1

MIX
Paper from
responsible sources
FSC
www.fsc.org FSC® C103560

*For Courtney, who has always been there
And Frances, who came along the way.*

CONTENTS

INTRODUCTION

WE FIRST CROSSED paths in 2012. Through the haze of research, travel, interviewing and reporting that has marked my time since, I can't recall how I first heard about Asian carp. It feels as though they've always been in the ether. In early 2012, I was reporting for the *Toronto Star*, one of Canada's largest newspapers, covering energy and the environment at Ontario's legislature. I read somewhere of a grand, $18 billion plan from the U.S. Army Corps of Engineers to hydrologically separate the Great Lakes from the Mississippi River watershed by severing the aquatic links in Chicago. No simple redrawing of continental maps, the Corps' scheme aimed to reset nature to how it once was.

I was baffled. Why was America's largest civil engineering firm being charged by Congress to investigate ways of tinkering with a Midwest waterway? The short answer (because of a fish) left me with even *more* questions. And what, I subsequently wondered, had transpired over five decades so that this nuisance fish, introduced to the United States in the 1960s to eat aquatic weeds and clean aquaculture ponds, was now threatening the Great Lakes with ruin after disrupting freshwater ecosystems as far south as the Gulf of Mexico? Big projects fascinate me — like a child's curiosity with fire trucks or dinosaurs — and this project felt *big*.

My first feature for a print publication appeared in *This Magazine* in the summer of 2012, for which I had frantically studied the Asian carp catastrophe, interviewing biologists, government officials and the heads of binational agencies. After the story was published, I watched the situation continue to deteriorate. The Great Lakes and Mississippi River Interbasin Study (GLMRIS), for which that $18 billion plan was conceived, had been delayed; bills before Congress and the Senate to tighten rules regulating the import of invasive species had stalled; and in 2013, Chicago sanitation officials dumped stormwater the city's sewers couldn't handle directly into Lake Michigan to mitigate flood risks, water that may have contained Asian carp. After these missteps, miscues and years of inaction, the Corps finally released their study in January 2014 to much fanfare.

Yet the shortcomings of news coverage accompanying the Corps' report soon became obvious. Beyond notable exceptions from the *Milwaukee Journal Sentinel*'s Dan Egan (whose wonderful book *The Death and Life of the Great Lakes* includes a chapter on the carp menace) and John Flesher from the Associated Press, most media accounts of Asian carp's American odyssey were content to chalk their origin up to carelessness on the part of Southern aquaculturists, or, if charitable, to Mother Nature in the form of flooding in the early 1990s that let loose this scourge. But from what I had gleaned in researching my article for *This*, so much of Asian carp's American history appeared uncomfortably reductive. The Army Corps, after all, doesn't propose spending $18 billion in taxpayer money for nothing. What was being omitted from these oversimplified narratives?

I aimed to find out.

• • •

Their takeover was dramatic. In the first years of the twenty-first century, researchers estimated that bighead carp, one of four Asian

carp species now in American waters, comprised 97 percent of the Mississippi River's biomass. Havana, a hardscrabble town of 3,000 people in central Illinois, gained minor fame as ground zero for silver carp when their stretch of the Illinois River was found to contain more of the invasive fish per square mile than anywhere else on the planet. In rivers they occupy, Asian carp are often the only fish longer than 16 inches, suggesting many competing native fish fail to reach adulthood.

Within a decade of their introduction in 1963, grass carp spread to 32 states with the enthusiastic support of government agencies, private interests and academia. Silvers and bigheads, introduced in 1972 and sometimes lumped together under the moniker "bigheaded carp," have moved effortlessly through the Mississippi watershed, following the Big Muddy and its tributary rivers like an interstate highway through the South and Midwest. By 1978, grass carp had spread 2,800 miles from their port of call in Arkansas, becoming what some believe to be the fastest spreading exotic species in North American history. "Their population exploded," says Matt O'Hara from the Illinois Department of Natural Resources (IDNR). "We saw our first fish in the early 1990s. Within a few years, there were fish everywhere." Steve Butler, a biologist with the Illinois Natural History Survey, tells me he's witnessed "billions of little, tiny silver carp everywhere" on the Illinois. "As far as the eye can see, it was solid spawning carp." Researchers believe one spawning season can increase the silver carp population by a billion fish. Or more.

Bigheads strike a prehistoric pose, as though forgotten by evolution. Large, wide-set eyes sit low on bulbous heads, their mouths hanging in a perpetual frown. In rare cases, bigheads reach 140 pounds and 7 feet in length, though 40 pounds and a length of 28 inches is standard — still big by American freshwater fish standards. Silver carp also sport frowning mouths and scaly heads, heads that are, comparatively speaking, less bulging than the aptly-named bighead. They shade from silver and caramel-colored

to olive green and can grow to 100 pounds, though 30 pounds is routine. Both silvers and bigheads share many physiological traits with the common carp found in waterways across the continent. Common carp aren't native to North America, yet they predate anyone currently living and are thought of by many as naturalized. This European cousin of Asian carp was first introduced to North America from Europe in the mid-nineteenth century and spread by human hands with unthinkably reckless abandon (imagine tossing live fish from trains into rivers and streams that early transcontinental railways passed by).

There is a fourth member of the Asian carp family — the black carp. They are equal to grass, silver and bighead carp in their voracious eating habits, though they eat snails and molluscs, including numerous endangered North American mussels. An average black carp weighs in at 35 pounds, though they too are capable of reaching tremendous sizes. As best we know, they arrived in America accidentally in a shipment of grass carp in the early 1970s before fish farmers began importing them specifically in the 1980s for grub control. But unlike other members of the Asian carp family, black carp have been found in the wild in small but growing numbers only since the mid-1990s and have been subjected to significantly fewer studies on everything from reproduction and feeding habits to geographic spread. Subsequently, researchers can largely speculate on what destructive power they may wield, but preliminary research shows reason to worry. Currently, there is little I can add to their still-unfolding story.

The more I scrutinized bigheaded carps the more remarkable I found the functioning of their bodies to be. Both species are filter feeders that consume throughout the water column, from the surface of the water to the riverbed. They eat while breathing, a common trait for filter feeders, though in the plankton-rich waters of the Mississippi, it's proven an especially successful physiological trait. Gill rakers, a crescent of spongelike cartilage just inside their

mouths, usher even the smallest phytoplankton and other organic matter into their gaping maws.

Duane Chapman — one of the U.S. Geological Survey's (USGS) leading Asian carp experts — suggests that what sets Asian carp apart from other specialized feeders is their adaptability. "This is an unusual thing," he says. Specially trained eaters tend to be the best at performing one task especially well. Think of the sword-billed hummingbird. With its thin beak, longer than its entire body, this South American bird can access nectar stored in a passion flower's narrow petals that other birds cannot reach. Grass carp have the unique ability to take waterlogged aquatic plants, a low-value food source that few fish eat well, and obtain all their nutrients from it. The specialized traits of bighead and silver carp are far more dangerous to the health of the Mississippi's and Great Lakes' watersheds. Microscopic organisms are their primary food source, the same phytoplankton that also serve as the predominant source of nourishment for most of North America's juvenile (and many of its mature) native fish. Yet when phytoplankton are scarce, native fish will starve while bigheads pivot to target zooplankton and detritus to survive. Silver carp can even live on algae and bacteria. And because Asian carp consume upwards of 20 percent of their weight each day, both species have fundamentally altered the structure of phyto- and zooplankton communities throughout the continent. This may have enormous consequences for species dependent on the resources these invasive fish insatiably consume. Aquatic North American ecosystems may never be the same as native fishes, and the complex web of predators and prey they interact with, struggle to adapt to life in rivers stolen by Asian carp.

Breeding populations of both species now swim approximately 76 miles from Lake Michigan, while solitary bigheads have been captured in Chicago's Lake Calumet, a stone's throw from the Great Lakes. Grass carp, meanwhile, are turning up in commercial

fishing nets in Lake Erie and Lake Huron with increasingly regularity.

•••

In October 2003, 35-year-old Marcy Poplett was on her jet ski when she was struck in the face by a jumping silver carp with such force that it knocked her unconscious. She fell into the Illinois River near Peoria and awoke facedown moments later. Her eyes pooled with blood; her lungs coughed up murky river water. Moving in and out of consciousness, her life jacket keeping her afloat, she heard five blasts from a nearby barge, a warning to get out of the way. But unable to move and watching her Sea-Doo drift slowly away, Poplett passed out. Mercifully, a family of nearby boaters spotted her listless watercraft and rescued her. But the interaction left Poplett with a broken nose and foot, cracked vertebrae, a concussion and a black eye.

Poplett's run-in wasn't an isolated incident. As silver carp have proliferated throughout the Mississippi watershed, stories of their violent interactions with boaters have grown more frequent. In Pleasant Hill, Missouri, 19-year-old Jordan Fiedler had his nose fractured by a leaping silver carp in August 2015. It also shattered his brow and both eye sockets. "I knew something was wrong when I felt my nose and it was way over here," Fiedler told FOX 2 News St. Louis, pointing to a spot on his face his nose shouldn't have been. On a canoe trip outside Thibodaux, Louisiana, a local man paddling his kayak beside my canoe recalled how his teenage daughter had been hospitalized the previous summer after a silver carp struck her. They were waterskiing on a lake near the family cabin. "We knew the risk, but we went out anyway," he told me. "We don't go as much anymore."

This visibility has put Asian carp center stage in almost any discussion about invasive species in Canada and the United States. *The New Yorker* and *The Atlantic*, among other national

publications, have joined countless local newspapers and TV and radio station affiliates of national broadcasters in covering the evolving carp crisis. The latest news on controlling, eating, fishing or the spread of Asian carp remains breathlessly reported on throughout the Midwest and Great Lake states (and into Canada). Amateur videos of jumping carp, meanwhile, have gone viral, spreading macabre images of projectile fish that would be funny were they not so frightening.

One video from Indiana Outdoor Adventures has been viewed over 5.9 million times since its posting in October 2010. "There's some good hang!" shouts host Troy McCormick, squealing in delight as he ducks to avoid slimy missiles on the Wabash River. Over four minutes of footage, McCormick's and co-host Mac Spainhour's happy go lucky demeanors fade as the threat of injury grows. "Ow! They smashed my finger," McCormick yells, lifting his knees to his chest and shaking his hand to cast away the pain. "Nailed me right in the back," Spainhour moans off-camera. "You're afraid to turn around," McCormick says darkly. All the while, fish thump like thunder. Nineteen silver carp died in the video, a sliver of the total silver carp in the Wabash, suffocating on the gunmetal bottom of the YouTube host's boat.

The effects of aquatic invaders are often difficult to discern, especially when we cannot see firsthand the devastation they cause below the surface. But silver carp's propensity to jump has viscerally demonstrated how out of control the carp problem has become. Throughout the course of researching this book, many I spoke to claimed the fish's jumping habit is the primary reason society continues to pay such close attention to Asian carp. Unlike many other aquatic invasives, we can see them.

Fighting invasive species is expensive. In 2006, researchers from the Great Lakes Institute for Environmental Research at the University of Windsor found the cost of just 21 nonindigenous species to Canada to be between $13.3 billion and $34.5 billion. Two years before, Cornell University evolutionary biologist David

Pimentel updated a previous estimate of what nuisance species cost the United States. No easy task, given that over 50,000 non-native species (including relatively benign additions like corn, wheat and poultry) have arrived in America and its territorial possessions since 1776. Still, Pimentel figured that invasives cost the U.S. roughly $120 billion annually, a figure he calls conservative since no monetary value was assigned to intangibles like species extinction, aesthetics or biodiversity loss. While Pimentel's figure is contested, with so many invasive species already in the country, he noted, not all have to be harmful "to inflict significant damage to natural and managed ecosystems."

After decades of relative inaction, tens of millions of U.S. and Canadian federal dollars began pouring into resource agencies and research institutions, aiming to fund science and technology that would curb the carp problem. This research wave got rolling in December 2009 when a controversial study from Indiana's University of Notre Dame catapulted Asian carp to the front page of newspapers by suggesting the fish had somehow spread past the electric barriers erected in the Chicago Area Waterway System in the early 2000s. Google searches for "Asian carp" spiked in Chicago, Michigan and Wisconsin within days of the report going public. Anxious Midwesterners went online for guidance to understand what, exactly, Asian carp were. What they found was reason to worry. Some latched onto the finding as proof that America was running out of time to protect the Great Lakes. Soon after its release, the Notre Dame study became the focal point of lawsuits between the states of Michigan and Illinois, in which Michigan sought to force Chicago to close its locks separating the Great Lakes and Mississippi basins. This set in motion a chain of events that led circuitously to the Asian carp frenzy that's overtaken North America — and, ultimately, to this book.

• • •

I conceived of *Overrun* as an environmental travelogue, a journey along Asian carp's invasion pathway. As I followed their trajectory, the story would move ahead in time, beginning with their introduction to the United States. I largely stuck to that format but fragmented the project into separate research trips: Illinois and Indiana, Arkansas and Louisiana, Wisconsin and Minnesota. Much of the field reporting for this book was done in clusters with follow-up interviews conducted via telephone, though the timing of events has been structured to ensure the story unfolds largely as the crisis did.

My focus broadened as I attempted to capture something of the vast geographic sprawl of Asian carp's story. Some eight dozen interviews I conducted in diners, libraries, canoes, powerboats, laboratories, fish farms, wetland preserves, city halls, taco bars, fine restaurants, processing plants and the banks of bubbling creeks occurred in 10 states and provinces stretching from the Gulf Coast up the Mississippi River to the Great Lakes. But the scale I hope to convey isn't just about physical space as observed on a map. Asian carp have manufactured a crisis that is as much social, economic and political as it is environmental, having roped in biologists, chefs, fishmongers, lawyers, fishers, shippers, economists, resource officers, bureaucrats, aquaculturists, politicians, engineers, authors, presidents and a czar.

They argue in these pages whether we can eat Asian carp to solve the crisis, whether aquaculturists are to blame for their escape, if hydrologic separation in Chicago can stop them and whether the Great Lakes deserve the attention and money they have received. We talked, not always graciously, while swatting mosquitoes, chucking dead fish, trying not to vomit, balancing on canoes, running from the rain, driving through ancient river valleys cut by glaciers, walking trails atop North America's newest subcontinental divide and (of course) eating silver carp. The people in this book — those I had the pleasure to meet and those I encountered only in books — represent a wide array of

Americans and Canadians mobilized in the Asian carp contest currently underway.

This book chronicles my dispatches from the Asian carp crisis and often captures the surprise I felt at the connections between today's events and those of the past. Uncovering how the glaciers that formed our continent's topography dictate where bigheaded carps pose the greatest threat to the Great Lakes, say, or learning the role of Reaganomics in scuttling a program to find uses for silver and bighead carp, has brought unexpected joy. Because if you scratch even lightly beneath the surface of this five-decade-long struggle, I discovered, you'll find a story as complex as any environmental issue in North America today.

We haven't been short on ideas in response to this calamity. One contest sponsored by the State of Michigan in 2018 awarded $200,000 to an atomic physicist for his proposal to stop Asian carp from advancing through the Chicago waterway system by employing underwater propellers and stinging bubbles. More than 350 entries from 27 nations answered the call when Michigan governor Rick Snyder announced the contest to solicit ideas for halting the carp in 2017. Meanwhile, we have poisoned them, eaten them, shot them with arrows, fenced them in with electric and wire fencing, caught them, deprived them of oxygen, shipped them to China and scared them with acoustic *booms*. We have invested in state-of-the-art technology while others argue antiquated methods are more effective. We have proposed pilot projects allowing licensed Illinois hunters to blast at jumping silvers with shotguns firing federally approved ammunition. And in Fort Wayne, Indiana, we have reshaped the earth into a massive berm to protect Lake Erie from fish lurking in the Wabash River 24 miles away.

Still the results of our labor remain inconclusive. Asian carp inch closer to the Great Lakes, albeit slowly, no matter what we seem to do. Is this the low point in the narrative? Are we debating who should conduct CPR while the Illinois River chokes to death,

hesitant to implement the big and costly projects needed to stop bigheaded carp? Or should we think nimbly and work to approve flexible and cost-effective alternatives?

These nagging questions and anxieties are one side of this story, but the Asian carp narrative contains soft victories we shouldn't ignore. We have looked at new tourism, resource extraction and food-processing business opportunities; we used Asian carp to inject cash into economically depressed parts of America; we fed them to those in need and to those in need of $140 prix fixe dinners; we learned to laugh at them and ourselves as they hurtled into "redneck" boaters wearing football helmets and wielding baseball bats and we developed environmental DNA testing to monitor them, technology that promises to revolutionize how we track the survival of the world's most endangered species, as well as those on ecological Most Wanted lists.

North America's collaborative approach to managing the Asian carp crisis has become the largest cooperative ecological endeavor undertaken on the continent. State, provincial and federal agencies have made common cause with environmental nonprofits, academia, industry organizations and community groups to tackle a problem falling under no single agency's (or country's) jurisdiction. America's Asian carp czar, John Goss, cannot recall another instance in his decades of work on multijurisdictional environmental matters in North America where both countries have collaborated so completely. Most organizations typically stay in their own lane, says Kevin Irons from the Illinois Department of Natural Resources, rarely deviating to observe how other agencies handle comparable problems. All that changed when Asian carp ballooned from a Midwest oddity to an international priority. "We're in the field together — that's the jewel in all of this," Irons says. "We're growing expertise throughout the region. We're building beyond carp."

• • •

Overrun will explore how exactly we got into this mess. Because only when overtaken by a highly visible nuisance species did we rediscover the worth of the waterways snatched from us. Only when faced with the threat of losing our degraded rivers forever did we rouse to save them. More than that, Asian carp have given us a unique opportunity to better learn how to manage invasive species in a holistic way, crucial in a warming, increasingly global future in which humans will continue to wrestle with the lingering effects of contaminated ballast water, poorly considered biological control plans, urban sprawl and agricultural pollution. These old worries interact with invasives in unpredictable new ways.

Moreover, we've learned to jointly manage the Great Lakes and appreciate them as one of the greatest treasures the United States and Canada share. And that when programs aiming to safeguard the ecological health of the Great Lakes come under attack, as they have in recent years, there is now overwhelming bipartisan resolve to say, "No!" and fight back.

Our prolonged struggle against Asian carp hammers home (as if we needed more reminding) that our collective behavior and individual actions have unimaginable consequences for the natural world. Perhaps equally worrisome is that our best and brightest cannot engineer a solution to our shared catastrophe and keep more than 180 nuisance aquatic species already present in the Great Lakes from going the *other way* and entering the Mississippi River system. Few know the names of these species, though they may soon. Aside from charismatic outliers like pythons in the Everglades, walk-on-water snakehead fish in New England or Japanese kudzu "eating the South," few have retained our attention over extended periods of time. Yet Asian carp have captured our collective imagination over successive generations. Why? We'll explore some of these reasons together throughout the book.

The televised, larger-than-life manner in which silver, bighead and grass carp have always been portrayed by American media

reveals something profound about our complex relationship with all invasive species. Our fascination stems, in some part, I think, from a desire to expunge the guilt we feel for having let the natural places we love, and purport to treasure, go to shit. We see our ruinous handiwork in the spread of invasives and sense the shame in our hubris, ignorance and failed best intentions. And so it's here, at the intersection of science, politics, economics and the ecology of Asian carp in North America, that we can discover how a single unwelcome fish has changed how we think about invasive species, binational and bipartisan cooperation on the environment and the fate of our rivers and Great Lakes.

There is no alternate timeline in which Asian carp are removed from North American waterways. Far from giving up, now is the time to seize the day (this is as close as I get to a *carpe diem* pun, I promise). But before we do anything, we must ask ourselves: Do we have the stomach for a protracted and expensive battle against Asian carp, one where success will be measured in poundage removed and not eradication?

There can be victory over Asian carp in some distant tomorrow, I believe; though victory may not look like what we imagine today.

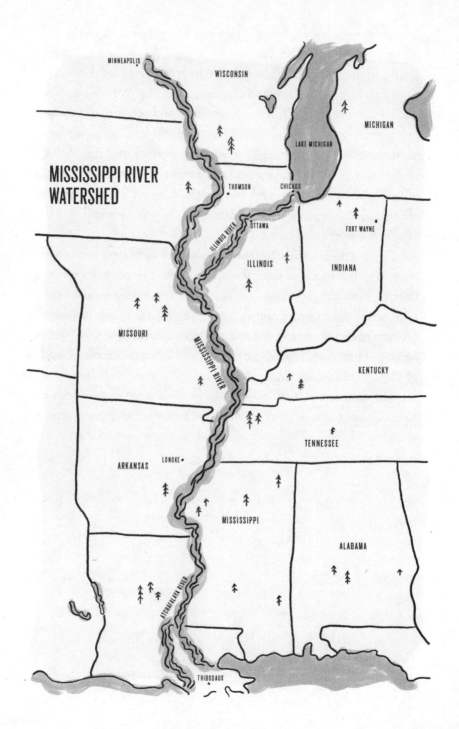

MISSISSIPPI RIVER
WATERSHED

MINNEAPOLIS

WISCONSIN

MICHIGAN

LAKE MICHIGAN

THOMSON

CHICAGO

ILLINOIS RIVER

OTTAWA

FORT WAYNE

ILLINOIS

INDIANA

MISSOURI

MISSISSIPPI RIVER

KENTUCKY

TENNESSEE

ARKANSAS

LONOKE

MISSISSIPPI

ALABAMA

ATCHAFALAYA RIVER

THIBODAUX

CHAPTER I

In the Beginning

LITTLE ROCK, AR — The man is grainy in the black-and-white photograph, standing on a clapboard dock, his back hardwood straight. There's a pile of debris where squat, wooden paddles form a makeshift step to a wobbly pier where a rickety wooden chair rests. Discarded boards are laid in the swamp beside an ancient dinghy, a boat launch of sorts. He stands in white shirt-sleeves and loose trousers, in contrast with his dark tie and hat, hands on hips angled towards the camera. Another man, his face blurred in motion, looks out over the trees half rotted from rooting in standing water. It is 1955. It is the beginning.

James Miller Malone Sr., a judge in Lonoke County in the northeast corner of Arkansas, had bought this $200 parcel of land two years before. Using equipment he acquired in a side business buying and selling heavy machinery, Malone Sr.'s ambition, when he wasn't running for governor of Arkansas, as he did in 1946, was to build a lake where people paid to fish. Responsibility for the project would ultimately fall to James Miller Malone Jr., the judge's boy, born in a Little Rock hospital on September 30, 1926, to Adele Willson Malone. In photographs, the younger Malone is identifiable by his wide, genuine smile half-concealed by an imposing dark mustache that grayed as he aged. An intensely curious man,

Jim Malone, as he was called, had driving passions for politics and writing. After finishing high school in 1944, he joined the navy and served two years on an auxiliary repair ship before being set loose in Millington, Tennessee, with the war's end. Like millions of other young men home from war, Malone Jr. used the GI Bill to attend the University of Arkansas in 1947, graduating two years later with a Bachelor of Science. Following his father's interests, he drifted into politics, stumping for Governor Sidney McMath in 1950 before speechwriting for Arkansas governor Orval Faubus from 1954 to 1956.

After constructing his father's fee fishing lake in the years after 1955, the younger Malone turned to rice production, borrowing money to sink two wells that helped him forge 160 acres of rice beds on his land. When a Washington decree on rice acreage shrunk his fields from 160 acres to 51, Malone protected his investment by raising golden shiner minnows on 25 acres as bait fish for Arkansas's fledgling fish-farming industry. It was that or risk losing everything.

He didn't know it then, but Malone's desperate shift from rice production to fish rearing reshaped the direction of both his life and North America's ecological landscape.

Entrepreneur, savior, environmentalist, despoiler, short-sighted capitalist: Malone's attempts to exploit the potential he saw in Asian carp, grass carp especially, would see him labeled with all these monikers and more. He foresaw a time when grass carp would keep unimaginable quantities of chemical herbicides out of the environment while taxpayers saved millions of dollars on pesticides bought to control aquatic weeds. By 1974, Malone himself was spending $18,000 each year (over $92,000 today) to control unwanted aquatic vegetation on his farm alone; his neighbor, fellow commercial fish producer Leon Hill, spent $20,000 annually on chemical controls. Malone became grass carp's staunchest defender when public opinion turned against them, a protective role he dutifully maintained despite the eventual opposition of

biologists, the federal government, sport fishers and the media. His involvement with all Asian carps took Malone before Congress to testify on the importance of maintaining a sterile grass carp certification program, while his research on fish genetics ushered him to the forefront of that growing movement, all of which elevated his stature in an expanding aquaculture world.

I witnessed the global extent of his influence in the pages of his office guest book. Hundreds of entries from dozens of countries were recorded in the ledger between 1975 and 2001, names written in reds, blacks and blues, from perfect mid-century cursive to choppy block letters printed in an unsteady hand that reminded me of my late grandfather's penmanship. For decades, Malone worked on grass carp spawning with a veritable fisheries League of Nations, and his guest book reflects this: Nigeria, Colombia, New Zealand, Japan, Saudi Arabia, Holland, Egypt, Bangladesh, West Germany, Pakistan. Visitors from around the world came to Arkansas to meet the man who spoke grass carp.

But naysayers in his own backyard saw those same fish as an ecological menace worthy of science fiction. Relentlessly harangued for his work, Malone waged a near-constant battle, spending decades rebutting critics, combating those who feared the effects grass carp and their larger cousins, the silvers and the bigheads, were having on aquatic ecosystems. Despite the opposition, he built a family business around grass carp and its weed-eating abilities regardless of the potential for ecological destruction many biologists believed the fish posed. In the early days of their importation and breeding, Malone convinced states to employ grass carp in place of chemical poisons to remove aquatic weeds while establishing the "World's Largest Hatchery of Chinese Fish." In doing so, he unwittingly facilitated their spread throughout America, in addition to playing a leading role in transporting silver and bighead carp to Arkansas, the two species currently tearing across vast swaths of America. Intently focused on the potential of sterile grass carp to rid America of pesky weeds, Malone never accepted the blame.

At the behest of his longtime friend Jim Johnson, a segregationist Arkansas Supreme Court justice, Malone donated a lifetime's worth of papers, correspondence, transactions and press clippings to the University of Central Arkansas (UCA) near the turn of the century. His collection spans more than a dozen boxes of material, the daily bric-a-brac of a man who, unexpectedly, found himself at the center of an ongoing controversy he didn't live to see the end of. One spring day I called UCA archival director Jimmy Bryant to ask about Malone's papers. "I knew what collection you was after the moment I heard where you're from," Bryant told me; there wasn't much else a Toronto writer would want from his stockpile. I booked a flight.

• • •

August 1963. Shao-Wen Ling, a Malaysian fisheries biologist with the United Nations' Food and Agriculture Organization, was received as a special guest of the U.S. Fish and Wildlife Service (USFWS) at their Fish Farming Experimental Station in Stuttgart, a small town in Arkansas's Mississippi River delta. The state was overrun with aquatic vegetation, consuming waterways that counties, municipal governments and private industry needed clear. Four years earlier, Ling had suggested grass carp could eat up America's nuisance aquatic weeds. Now, surrounded by officials from USFWS, Auburn University and the Arkansas Game and Fish Commission (AGFC), Ling counseled his American colleagues to strike a deal with Malaysia to ship grass carp fry to Arkansas. The U.S. officials in attendance had heard of grass carp's insatiable appetite, but few beyond Auburn University's Homer Swingle, who had been singing grass carp's biological control praise since 1957, had any notable firsthand experience with the fish.

The August meeting concluded with a promise to import grass carp fry for an in-lab study, leaving the USFWS to work out the logistics with Malaysian authorities. Despite the fact that it

was his recommendation, Ling added a cautionary note. "The unforeseen danger of careless introduction of exotic species could be tremendous," he warned. Grass carp "should be able to adapt to American waters well. But the possibility of having it become another major problem fish like the common carp is so great that unless the fish can become acceptable . . . its introduction should not be done hastily."

The Americans didn't deliberate long. On November 16, 1963, less than a week before President John F. Kennedy was shot in Dallas, 70 fingerling grass carp weighing less than a nickel each arrived in Stuttgart, bound for four lab aquaria and a tenth acre pond. Less than six months later, Auburn University's Agricultural Experiment Station received a dozen grass carp from Taiwan. Initially, Auburn researchers kept the fish in plastic lined pools topped with netting to prevent the carp from leaping out and suffocating on the laboratory floor. It was at Auburn that the first recorded instance of an American being struck by a leaping Asian carp occurred when a grass carp jumped a seine net and knocked the son of Homer Swingle, future head of Auburn's Department of Fisheries and Allied Aquacultures, to the ground.

Learning to spawn grass carp in-hatchery was the first challenge American researchers faced. Yet the artificial reproduction moved at breakneck speed. The first grass carp produced in America were bred on May 19, 1966, when Fish and Wildlife Service agents spawned 8,000 fry shared 50/50 between the Stuttgart facility and the nearby Joe Hogan State Fish Hatchery, run by the Arkansas Game and Fish Commission. Not to be outdone, Auburn spawned 1,400 fry weeks later and a whopping 100,300 fish by 1968. Astonishingly, so lax were the rules regulating exotic species that two-thirds of the one hundred thousand-plus Auburn fry were given to "various persons" operating beyond university control. The interstate brinksmanship continued when the AGFC teamed up with Fish and Wildlife staff to produce 3.1 million grass carp at Stuttgart in 1972.

There was now no question that U.S. biologists had mastered the art of spawning grass carp. In fact, by the late 1960s, Swingle ordered one of his Auburn graduate students, James Avault, to fry up all the grass carp the university had received in their 1964 shipment as a sort of taste test. "Go ahead and cook them," Swingle told Avault. "I've got more coming." Research continued into their effectiveness at eating invasive weeds as word spread of the grass carp's inextinguishable appetite. Scientists found themselves unable to temper expectations among state and private-sector resource managers or to resist the pressure from government bodies desperate for solutions to their aquatic weed problems. By the time Arkansas reared over three million fry, grass carp had been legally couriered from private hatcheries to 16 states, doubling to 32 by 1977. Fertile grass carp swam freely from California to New Hampshire, Oregon to Florida. Twelve years after the first spawn in 1966, Americans transported grass carp 1,100 miles south, 2,000 miles west and 2,800 miles northeast from Stuttgart, making grass carp one of the fastest spreading exotic species in U.S. history.

The United States wasn't alone in falling for Asian carp. Once commodified, the fish was traded among Eastern and Western nations for culturing as food and weed control. China, the world's single largest producer, spearheaded the global trade of Asian carp beginning in the 1960s. The origin of almost all carp species at the time could be traced to China in less than six degrees of separation, from all corners of the world. Follow the lineage: Peruvian officials received their grass carp from Israel, who were introduced to them from the West Germans, who got theirs from the Hungarians, who — along with the Brazilians, Soviets, Japanese and others — got their fish from China. Trading took place without Chinese involvement too: Mexico got carp from Cuba, Indonesia from Japan, England from Austria. After 1962, most nations were culturing Asian carp.

• • •

For a brief moment in the 1960s and early 1970s, America fell in love with grass carp. Their potential to rid irrigation canals, golf courses, public lakes and streams of choking aquatic weeds appeared boundless. They were an ecological solution as perfectly tailored to the decade's environmentalist fashion as bell-bottoms and silk cravats.

Optimism for grass carp's success became deeply rooted in reputable science once the first U.S. study emerged from Auburn University in October 1965. There was "little or no information about it in the United States since its recent introduction," said Auburn fisheries biologist James Avault. Gathering a dozen aquatic weeds known to choke Southern waterways, Avault spent 12 weeks watching how quickly grass carp consumed vegetation and what varieties they preferred. Filamentous algae were always the first to go, he reported, and while it would take longer, the more undesirable alligator weed and water hyacinth were eventually gobbled up too. "The grass carp appears to be one of the most promising fish species for biological control of aquatic weeds." He was particularly enthralled by their hardiness and cold-water tolerance.

Academic journals were swimming in papers from America, West Germany, Sweden, the Soviet Union and Romania suggesting native fishes grew faster and survived longer in water stocked with grass carp. Whole ecosystems benefited. "Freed from weed infestation, pond waters are better aerated, sunlit and warmed," wrote Barry Pierce, a biologist with the Sea Grant College Program at the University of Hawaii. With less space consumed by underwater weeds, habitable niches for surface-dwelling fishes increased, decluttering lake and river bottoms. Grass carp feces were also cited as food for bottom-feeders. Swedish researchers found that water stocked with grass carp often had more oxygen in it, resulting in heightened zooplankton and microfauna levels in Swedish lakes. And since their teeth evolved to eat only plant matter, grass carp didn't compete with native and game fish for

food. So perfectly did grass carp squeeze into a vacant place in America's riverine ecology that their import felt miraculous.

Miraculous indeed. "No bird or plane, it's a white amur!" noted the *National Observer*, which ran a feature with cover art depicting a crudely drawn, human-sized grass carp donning Superman's crest and cape. "It's tastier than red snapper!" the *Observer* claimed. "It's trickier to catch than trout! And can hurl itself through the air farther than a tarpon!" These superfish, the article claimed, could clean up Lake Erie's algae problem, and, in time, become so prodigious at eating aquatic weeds that an elaborate "Rent-a-Fish" industry could spring up to ferry them around the nation, sewing clean water seeds like a Piscean Johnny Appleseed.

The *Observer* wasn't alone in praising grass carp, which many, including Malone, often called "white amur." "Amur are so big and they eat so much so fast, a person needing a pond cleaned out may have to rent himself a fish for a few days," said Charles Walker, an executive in Washington's sports fisheries bureau. The trade magazine *American Farmer* called grass carp "ecology's helper," claiming the fish "slurps in weeds like a hay baler takes in alfalfa." They may even surpass beef as a protein source in American diets, *Mechanix Illustrated* claimed.

The craze accelerated rapidly. Grass carp had been shipped to private companies in Louisiana, Oklahoma, Maryland and Texas by 1972; soon after, the fish were turning up in waters throughout the South and Gulf Coast. Tax dollars flowed by the barrel towards Asian carp research throughout America in the years between 1972 and 1985. The Department of Agriculture's Fish Farming Experimental Station in Stuttgart and the U.S. Fish and Wildlife Service led the charge. In a sign of things to come, by the mid-1970s the U.S. Army Corps of Engineers began holding meetings on the effectiveness of grass carp at weed control. The Corps shelled out $1.3 million in 1976 to study what influence five thousand-plus grass carp would have on aquatic vegetation in Florida's Lake Conway.

Before that change of heart began, universities and state agencies got in on the action. Memphis State in Tennessee (now the University of Memphis) investigated chromosomal mutations in grass carp, while Clemson in South Carolina experimented with carp control of phytoplankton. They joined Louisiana State University in Baton Rouge, Oregon State in the Pacific northwest and the University of Florida in Gainesville in studying the hot new thing in fisheries science. Shipments of grass (and later silver and bighead) carp headed to the Texas Parks and Wildlife Department (TPWD), the Tennessee Valley Authority (TVA), California irrigation districts and the South Carolina government. As late as 1983, Senators were applauding the TVA for its use of white amur for hydrilla control. One Senator even read a poem on the Senate floor: "Don't go near the water, friend / The grassy-carp is loose / Yesterday, it ate my dog / Today, it ate my goose." Silver carp would arrive in commercial ponds at the University of Hawaii on Oahu's north shore for algae control. And on the recommendation of the National Academy of Sciences, the Arkansas Game and Fish Commission gifted 100,000 grass carp fry to Egypt in 1976 to clean coontail-infested irrigation canals; an AGFC research contingent was also deployed to Sudan to troubleshoot the African nation's faltering grass carp program.

The Bureau of Reclamation, meanwhile, funded silver carp stocking in Colorado into the Clinton administration.

• • •

In the late 1960s, the future looked bleak for Jim Malone. After a Washington decree forced Malone into raising minnows, an errant crop duster flying over a neighboring field doused his land with pesticides, destroying his entire stock of fish. When the federal restrictions were later lifted, few would have held it against Malone if he had given up on fish culturing and returned to harvesting rice. He did cover 800 acres with the crop. But something

about the potential of the white amur nagged at him. As his rice took root, Malone dedicated 20 acres at the center of his property to maintaining a broodstock of grass carp. As the rice gradually sucked the contaminants from his land, Malone succumbed to his foreign-fish fascination and ditched the low-paying rice crop to raise grass carp full-time.

Not just grass carp. Word spread like floodwater throughout the American aquaculture community that grass carp was routinely cultivated alongside two closely related species to great effect in China. While grass carp ate troublesome aquatic vegetation, silver and bighead carps filtered excess algae from the water column. "We came to recognize the polyculture of carps as miracle fish," wrote Illinois Natural History Survey biologist Homer Buck, an acquaintance of Malone's. The fish were "completely compatible," Buck wrote to his fisheries colleagues, "complementing each other in their feeding habits." While grass carp had proven itself effective at eliminating duckweed, eelgrass, needlerush and a host of other aquatic weeds in multiple studies conducted at Auburn, silver carp gobbled up phytoplankton and bacteria while bigheads ate untold volumes of zooplankton. Raise them all together and the result was a "great synergistic complex," Buck wrote. His own research at the Sam Parr Biological Station in central Illinois found silvers and bigheads raised together and fed nothing but hog manure and sunshine yielded over 3,000 pounds of fish protein per acre in six months. Catfish, in comparison, yielded just 1,000 pounds per acre over the same period on an expensive high-protein diet.

Malone was intrigued. After consulting the academic literature and researchers like Buck in both America and China, he placed a $3,500 order for ten thousand silver and bighead carp fingerlings from the Yuan Hu Chang Fishery in Taipei, Taiwan. It was the first private purchase of Asian carp in American history. On August 22, 1972, silver and bighead carp, along with fifty thousand grass carp fingerlings, arrived in one hundred cartons at the Little Rock airport on Flying Tiger Line.

The new fish wouldn't remain in Malone's possession long. Within months of their arrival, the Arkansas Game and Fish Commission suggested Malone turn over his stock of silver and bigheads for a period of three years. The commission's superior facilities and knowledgeable staff offered Malone the prospect of advancing the fish's value far faster than he could have managed independently. After months spent considering the offer and haggling over fine print, Malone agreed to the transfer in January 1974. By March of that year, roughly 2,500 adult and juvenile silver carp and 1,200 bighead carp were relocated to the Hogan hatchery. The contract included a proviso that Malone would have final say on all sales of silver and bighead carp from his stock to academic or government researchers. And under no circumstances could any recipient of Malone's fish sell them for personal profit.

He had reason to worry about containing his investment. Rumors hung like summer haze around Lonoke that grass carp held at state hatcheries and enclosed lakes and ponds had escaped into open rivers connected to the Mississippi. Ecologists and fisheries managers quietly grumbled about the impact the fish could have on aquatic ecosystems unaccustomed to the presence of an enormous, fast-breeding, voracious herbivore. But escape wasn't the only avenue into public waters for grass carp. American researchers, overcome by the enormous potential of these "miracle fish," put them to work as quickly as possible. Any risks, they felt, were minimal — and any damages manageable.

● ● ●

Drew Mitchell and I met at a coffee shop near his home in Little Rock, Arkansas. For more than 34 years, Mitchell worked as a fisheries biologist with the U.S. Fish and Wildlife Service in and around the Fish Farming Experimental Station at Stuttgart. Much of his early career centered on spawning grass carp. Mitchell recalled how, just before his retirement in 2011, the Asian carp saga

had played out before his eyes, but he wasn't sure the version of it he heard on the evening news was entirely accurate. Working with aquaculture expert Anita Kelly from the University of Arkansas at Pine Bluff, Mitchell and Kelly decided to challenge the well-worn myths about Asian carp's arrival and spread throughout America.

"Commercial fish producers were getting the brunt of the blame for the presence and release of Asian carps into the wild," Mitchell told me, settling deep into a plush red booth. His salt-and-pepper hair spilled onto his forehead, narrowly missing the rims of his trifocal glasses. He gestured widely with his hands while speaking, clanging a coffee mug or salt shaker against the table to convey gravitas. Grass carp's expedition into the wild didn't begin at private hatcheries, Mitchell believes, but at Stuttgart, the federally operated fish-farming station that employed him for decades. The facility, now called the Harry K. Dupree Stuttgart National Aquaculture Research Center, once dispatched its wastewater into ditches draining into La Grue Bayou, three miles away. From there, the La Grue wanders southeast for 30 miles before emptying into the White River in the White River National Wildlife Refuge. Fifteen curling, circuitous miles south of the refuge, the White's unhurried flow chances upon the mighty Mississippi. From here, Asian carp hacked into the Mississippi's 1.2 million square mile drainage basin, North America's largest watershed, fourth largest in the world.

Eastern Arkansas's physical geography played an important role in the journey that's taken Asian carp to Chicago and beyond. Lonoke is tailor-made to flood, anchored, as it is, by clay-heavy soils. When it dries, aggregate orbs manifest near the surface, forming spheres resembling shotgun rounds. Hence the soil's nickname — "buckshot." Water infiltrates the low, flat soil slowly, retaining its moisture. Arkansas's Mississippi delta is crisscrossed with bayous continuously feeding water into nearby streams. It's the basic hydrologic connection that, on a basin scale, sends 593,000 cubic feet of water into the Gulf of Mexico every second.

Feral grass carp were first caught by commercial fishers in 1970, Mitchell and Kelly report. After careful study, the captured fish were found to have spawned four years earlier, the first year Fish and Wildlife officials at Stuttgart successfully cultured grass carp. Is this proof the escaped fish are Stuttgart originals? Is it purely coincidental? Mitchell doesn't believe the 1970 finding exonerates fish producers from their role in releasing Asian carp, but "there is just a lot of corroborating information" that suggests the true culprit is the U.S. Fish and Wildlife Service, he told me. When I asked if Asian carp had escaped from Stuttgart during his tenure, Mitchell was unequivocal. "There was not only a release of fry," he said, but the clear release of grass carp between 7 and 11 inches long, "fully capable of survival," into La Grue Bayou or the nearby Little La Grue stream below the Stuttgart station.

In their muckraking article, Mitchell and Kelly argue that it's "highly likely" newly hatched carp fry escaped through holes in a wire mesh screen (called a "saran") that should have prevented their passage into drainage ditches. In person, Mitchell claimed the faulty screen escapes weren't the half of it. He said that Mayo Martin, a Stuttgart employee at that time and a key player in orchestrating the first Malaysian shipment, told him years later the government's spawning efforts were so successful that grass carp fry quickly filled tanks to the brim, spilling fish onto the floor and into overflow pipes. These pipes led to drainage ditches that flowed to La Grue Bayou and the Mississippi River beyond. "Frankly, the saran screens are not even important," Mitchell told me. So lax were Stuttgart's control measures that fish farmers in the region were told they could collect free grass carp from ditches and bayous adjacent to the porous Fish and Wildlife station. "One of those farmers I talked to said in '73 or '74 he collected 20 or so grass carp below the Stuttgart station," said Mitchell. He was also told that USFWS staff significantly underreported the number of grass carp they spawned.

Feral grass carp were detected in the Illinois portion of the Mississippi River by 1971, fish born in the first class spawned at

Stuttgart. These carp were part of an influx of white amur found wild that year; until that point, any free-swimmers caught by fishers were considered escapees, one-offs bred in captivity. Yet their presence in the wild, however they got there, struck some as fortuitous. If grass carp escaped from state and university hatcheries already swam freely in open waters, eating nuisance aquatic weeds, why shouldn't the state stock them intentionally? If a biological control for troublesome aquatic weeds actually existed, some mused, it was grass carp. Full stop.

The Arkansas Game and Fish Commission was getting antsy. Having worked with grass carp for almost a decade, it was clear to commission staff that the species excelled at eating underwater plants. Studies at Stuttgart, Auburn and the U.S. Bureau of Sport Fisheries in Warm Springs, Georgia, attested to this, as did extensive foreign studies from Asia, Europe and the Middle East. Global research was overwhelmingly supportive of deploying grass carp to control aquatic weeds. In Czechoslovakia, the fish eliminated over 80 percent of aquatic vegetation; grass carp performed admirably clearing weeds near water intake pipes around a hydroelectric plant in the Waikato lakes region of New Zealand; and in the Soviet Union, they cleared both hard and soft plants in the cooling water reservoir of Moscow's Klasson Power Station. Grass carp could eat every last root of targeted aquatic weeds with no ill effects on the environment, commission studies suggested. Some reports even argued that grass carp stocked in shared lakes helped sport fish like bass, sunfish and crappie grow faster and stronger.

Arkansas had heard enough. Convinced of grass carp's many virtues (and few vices), on March 20, 1972, the AGFC's official policy on grass carp stocking and distribution was modified to reflect their get-'er-done attitude, a move that ultimately paved the way for grass carp's spread throughout the Mississippi basin. Public waters, large community lakes and private ponds became fair game. Anyone possessing a fish farmer's permit, in fact, was now entitled to stock grass carp, hundreds of thousands of which were

cultured at the Joe Hogan State Fish Hatchery in Lonoke, a few miles from Jim Malone's farm. It was open season on open waters.

Updating their stocking policy was not a decision the AGFC made lightly. Both Arkansas bureaucrats and the commission reached their decision after careful scrutiny of the available scientific literature. Reports from U.S. Fish and Wildlife, the Bureau of Sport Fisheries, the Department of Agriculture, Auburn University and other state governments, not to mention foreign research from a dozen countries, all influenced Arkansas's decision to permit grass carp stocking. This doesn't mean the policy was correct. While made hastily, the decision was backed by timely (though, in hindsight, questionable) science.

Arkansas Game and Fish Commission biologist William Bailey was unapologetic about the decision. In a 1972 speech to the American Fisheries Society, he readily acknowledged that the commission's stocking policy became "more aggressive" once grass carp were caught swimming freely throughout Arkansas. "We must make the most of the situation as it is," he told conference goers. Bailey knew that grass carp could spread beyond the state but saw the risk as one worth taking. "Since 1970," he told the Fisheries Society, "we, in Arkansas, have known without a doubt that the white amur was already introduced, for better or worse, in the Mississippi River system, which gives it access to practically every stream between the Appalachian and Rocky Mountains." There's much we don't know about how they behave in open waters, he added, but "we will never know what effects the white amur will have in the wild until we place it there."

I asked Drew Mitchell if he or other fisheries employees with Fish and Wildlife or the Arkansas Game and Fish Commission had realized they were playing with fire. He hesitated. "I'm not sure how to answer that," he said after a long pause. He tapped his empty coffee mug on the tabletop. "Were they aware of the consequences? Fish and Wildlife employees, I don't think, reasoned out the full gravity of the potential of those consequences." He

looked at the mug grasped in his fist, all knuckles and taut pink skin. "That's about all I have to say on that."

• • •

Arkansas came out guns blazing. The state had been stocking grass carp in Lake Greenlee, a 300-acre topographically isolated watering hole near Brinkley, as far back as June 1969, almost three years before the March 1972 policy was officially adopted. Within nine months of the state's aggressive policy taking effect, the AGFC had introduced 290,992 grass carp into 54 lakes and ponds across Arkansas, ranging from small ponds a few acres in size to the 6,700-acre Lake Conway north of Little Rock. All had open access to the Mississippi watershed. The number of fertile fish placed in each waterway was highly variable, ranging from 1.5 to 182 fish per acre. This stocking rate ultimately determined whether the fish scattered throughout Arkansas lived or died. Early reports indicated that, in some instances, overstocking led to grass carp lunging towards riverbank greenery or picking wetlands clean in search of food. By 1978, grass carp were intentionally stocked in 115 lakes in Arkansas, waterways covering an area the size of Cincinnati, and, with the Natural State's love affair with grass carp in full swing, the fish had traveled (with government acquiescence) some 1,100 miles throughout the lower 48 states, all from their home base in Lonoke County, Arkansas.

Scott Henderson, a career fisheries biologist with the AGFC, later told an Asian carp conference in Florida that public and resource agency approval for stocking grass carp in open systems throughout America was growing. "Almost without fail," he told the crowd, "those who have had experience with the fish in actual field trials have opinions ranging from 'advocate' to a 'proceed with caution' approach. But none that I am aware of are among those still adamantly opposed to their use."

Yet opposition to grass carp grew in near perfect unison with

public and private demands for the fish. Henderson wasn't alone in believing the increasingly loud voices calling for a halt to grass carp stocking based their fears on "sensationalism . . . very loosely tied to factual information." But as the 1970s concluded, these contrarian voices grew impossible to ignore.

• • •

Jimmy Bryant from the University of Central Arkansas archives suggested I call J.M. Malone & Son since the family farm was still in operation. With his sister Beverly, James B. Malone (who I'll call Jim B. to differentiate him from his father) has run the business for almost 30 years. When Jim called me back, his voice was guarded and thick with an Arkansas drawl. I was welcome to stop by the farm tomorrow to talk about his father, he said gravely — but if I started pointing fingers he would end the interview quick. "We're not to blame for Asian carp escaping into the wild, that much I can tell you."

The following day I awoke with the sun. Heading south, I drove rural roads hugged by cotton fields and bottomlands. These low-lying marshes, littered with bald cypress, their bulbous bottoms jutting skyward, are ubiquitous in the South, like Spanish moss. Swamp encroached on the road, the land so flat the rumor of rain could have flooded the highway. The air sagged.

Jim B. greeted me outside his office with the shy yet enthusiastic help of a copper-colored Boykin spaniel named Ben who snaked figure eights through my legs. He led me into his office that was outfitted with lush leather couches surrounded by dark-stained walls. A pair of stag heads was mounted behind his desk, their glassy eyes staring out. Trim at 57 years old with a thick mop of silvery hair, Jim B. seemed to sense that my days in the archives pouring over his father's papers suggested I wasn't assigning blame so much as making sense of why Malone staked his career and reputation on grass carp. Jim had turned down media interviews

before. Too often he felt their intent was to scapegoat his father for all environmental ills that followed Asian carp's arrival. He wasn't having it. "Farmers didn't pull their screens off their pipes and drain the fish into the bayou," Jim B. told me, since "that's profit going down the drain." In a competitive market where every fish reared is sold, why would producers let grass carp fingerlings slip past? It's throwing money away. Common practice, he said, was to net every fish from a pond and reset it for the next batch. Jim B. conceded that some fish did escape from aquaculture farms. But, he quickly pointed out, much like Mitchell did, "I know of places where it came from that had nothing to do with farmers."

By the time the elder Malone received bighead and silver carp at his Lonoke property in 1972, the outcry against the pioneering grass carp had spilled over from the isolated preserve of university biology departments to the broader public sphere. Headlines that had recently trumpeted its almost unnatural ability to consume aquatic vegetation began asking if grass carp were less a superfish and more a scourge. "Vicious Tales Bedevil White Amur, a Fish Once Thought to Be Savior," noted the *Wall Street Journal*, while Florida's *St. Petersburg Times* contended "Asian carp seen as possible threat to freshwater fish." The *Sarasota Journal* called the white amur "Florida's Imported Pain in the Grass" while Connecticut's *The Day* reported that the Nutmeg State had issued a "death sentence on Asian carp."

Popular media coverage throughout the 1970s grew increasingly hysterical. Louisiana's *Shreveport Times* wrote that "grass carp may very well constitute the most alarming situation in the history of fisheries research." The United Press International wire, meanwhile, wrote that "grass carp could decimate the coastal rice industry." Orlando's *Sentinel Star* reported the fish "prefers animal rather than vegetable food," despite grass carp lacking the necessary teeth for mashing animal flesh. Alabama's *Anniston Star* observed that "those handling [grass carp] always wear a baseball catcher's mask for protection. One death has been attributed to

the fish." This fable was furthered by the *Cleveland Plain Dealer*'s Sunday edition, which claimed fencing masks worked well if no catcher's mask was available. On the other side of the fence, *Farm Pond Harvest*, an aquaculture industry trade magazine, featured a piece from Richard B. Thomas in 1978 on the potential of Asian carp to clean hog manure lagoons that reached new levels of absurdity. Thomas claimed grass carp could live for an astonishing 150 years on a diet of grass clippings. He also argued that grass carp were the predominant species in Lake Erie (they weren't), where they had begun breeding with escaped goldfish (they hadn't).

It's tempting to dismiss the public's concern over grass carp as misguided, as many in the aquaculture industry did. But among the questionable reporters were those like Mel Ellis. Writing for the Associated Press in February 1973, Ellis noted it would be years before anyone could sort through the grass carp controversy to determine if the imported fish was angel or devil. But one thing was clear even then: "It is obvious, of course, that no plant or animal should be intentionally introduced until it has been thoroughly investigated by a board of responsible scientists." And with the purposeful spread of grass carp inaugurated with Arkansas's policy shift, the public didn't sense any such investigation had been done. Ellis expected that Americans may live to rue that late winter day in 1972 when grass carp were sanctioned by mid-level Arkansas bureaucrats.

The righteousness of the public's reaction took many in the Arkansas aquaculture community by surprise. They saw in grass carp an astonishing tool for controlling nuisance aquatic weeds, this troublesome collection of plants that was universally despised by fishers, boaters, farmers, irrigation managers, municipal water workers — essentially everyone. From speeches, internal memos and insider trade magazine articles, it's clear the pro-grass carp congregation felt theirs was the one true religion. Members of the aquaculture community, many armed with degrees in biology and fisheries research from American institutions, had bibles of *facts* at

their disposal. And their opposition came from the public, often misinformed by newspaper reporters, who relied on hearsay and rumor, or so aquaculturists believed, to inform their outrage.

Ignoring the media was easy. It was far harder to ignore the mounting anxieties of state agents that aquaculturists were actively courting to buy their fish. The Texas Parks and Wildlife Department called the biological risk of stocking fertile grass carp "too great," while Alabama's Department of Conservation and Natural Resources refused to recommend the public use of white amur — or even tell interested consumers where they could purchase them. The department stated, "We do not recommend the use of white amur by members of the public under any circumstances." In the Sunshine State, Dr. E.O. Frye from Florida's Game and Fresh Water Fish Commission criticized grass carp for failing to eat invasive weeds and impairing largemouth bass and bluegill spawning. Frye stated, "The grass carp is just not living up to the glowing words of its proponents."

The elder Malone had his own theories as to why state biologists fretted over wild grass carp. He felt they had an ax to grind with aquaculturists, opposing anything fish producers supported. Malone maintained a sometimes-unhealthy suspicion of the U.S. Fish and Wildlife Service throughout his career, convinced the federal agency formed a "cadre of opposition" to grass carp existing "beyond the bounds of rationality," perhaps, even, beyond the "American standards of freedom, justice and fair play." The Stuttgart station, the backbone of America's grass carp program, was a "stepchild" of USFWS, he wrote, "permanently ignored and underfunded" to stymie white amur's chances of success. Malone also alleged that international petrochemical companies, whom he refused to name in his correspondence, were pressuring the Department of the Interior and the USFWS to suppress research and cease all public and private studies on applying grass carp for weed control. "Restriction of the white amur obviously is essential to the production and sale of squatic [sic] chemicals," Malone published

in *Farm Pond Harvest*, linking grass carp's treatment to the U.S. Department of the Interior's historically "unhealthy relationship" with the petroleum industry dating back to the Teapot Dome scandal of the 1920s. Later in his career, Malone confided to a friend that at a zebra mussel conference in Wisconsin, a "federal employee" from the Fish and Wildlife Service had approached his booth and stated coldly, "We're going to put you out of business."

As Malone tried desperately to convince the American public that grass carp were biologically and reproductively safe to distribute throughout the country, state agency support waffled as they pinned down their fears. It was a laundry list of known-unknowns and unknown-unknowns, since academic studies at the time had failed to track their ecological impacts in open waterways. But reasonable hypotheses suggested that lakes and streams denuded of vegetation by poorly stocked and hungry grass carp would invariably stress existing fishes, since reduced vegetation would compromise the spawning abilities of native and game fish, jeopardizing future generations. Juveniles and forage fish would lose habitat and protective cover from predators, and the effects would be felt throughout the aquatic food web. Invertebrates, mammals and waterfowl would face stiff competition for phyto- and zooplankton, staples of underwater diets. Weeds necessary for wetland waterfowl as food and nesting material could be eliminated if too many grass carp were stocked. Meanwhile, researchers also feared that parasites from the fish's native range in China may have immigrated to America with the earliest fingerlings.

The anxiety resource officials felt towards grass carp rose as they gleaned more about the species's physiology and behavior. Some speculated whether the ineffectiveness of grass carp's short intestinal tract would encourage hazardous algal blooms. Grass carp, similar to other herbivores, from giant pandas to Canada geese, must eat huge volumes of plants to get the nutrients they require. In much the same way parks are blanketed with half-digested green droppings after Canada geese pass through,

biologists suspected that waterbodies with too many grass carp could witness an explosion in blue-green algae that would not only stymie the growth of phytoplankton but could carry potent cyanobacteria-produced liver toxins. When phyto- and zooplankton populations crash, food becomes scarce for many fish species. "The danger of this type of destruction is what bothers ecologists most," wrote Jon L. Hawker in the *Missouri Conservationist* in the early 1970s. "Before committing themselves to any kind of releasing program, they must be certain that there is not the slightest chance of harmful effects, otherwise an already overtaxed environment might suffer a blow which could alter it forever."

Based on fears that stocking fertile grass carp would induce population explosions countrywide, many states began banning the stocking and importation of grass carp. Between 1972 and 1974, governments served notice to Malone and other grass carp producers that laws had changed, with new rules in place making it illegal to ship fertile grass carp. He was blacklisted, prohibited from advertising his services in national publications distributed in states where white amur were suddenly taboo. But tut-tutting naysayers weren't simply scaremongering. By the early 1980s, irrefutable evidence of what could go wrong when grass carp ran wild began to emerge. More than 270,000 of the fish stocked in Lake Conroe north of Houston moved into Texas's Trinity River basin, destroying wetlands all the way to Galveston Bay. Things got so dire that conservation scientists erected fencing to keep grass carp from cordgrass they had planted to curb erosion and protect against floods.

Yet as the controversy surrounding grass carp grew, the elder Malone never wavered. He used a feature in *Farm Pond Harvest*, ostensibly to discuss his recent escapade shipping grass carp to clean the Panama Canal, to lash out at critics. Malone had flown in a military grade C-130 cargo plane and bounced down jungle highways in Panamanian military jeeps to off-load 230,000 fingerling grass carp into Laguna Bay, the fish released from a

wooden crate dangling hazardously below the belly of a Huey helicopter. It was a hell of a story. His teenage son, meanwhile, was almost kidnapped during the excursion. Sleep-deprived after 72 hours transporting the fish from Arkansas to Central America, young Jim B. accepted an arranged ride from a driver sent to take him from his hotel to an elementary school where the grass carp fingerlings were being housed. "I get in the car and I just immediately go back to sleep. And when I wake up I see the lights of Panama are getting dimmer," he told me, lowering his voice. "And I say to the driver, 'Paradisio Elementary School.' And he didn't say anything. I asked him three times before I knew I was in trouble." Leaning forward in his leather desk chair, Jim mimed reaching up and grabbing his long-ago would-be assailant by the ears. "I yanked his head back and said, 'I will break your damn neck.' And he said, 'I'll take you Paradisio Elementary School.' And he turned the car around and drove me back. I have no idea where he was taking me," Jim B. said, the braggadocio emptying from his voice. "But I was scared to death."

"Adventure in Panama," as the older Malone titled the piece, was not an inappropriate epithet. And yet the article is pure Jekyll and Hyde. Beyond the action movie caper are words hurled in a kind of rearguard action against the "knee-jerk emotionalism" of the anti–grass carp crowd, characterized by "exaggerations, half-truths, downright lies, misrepresentations and appeals to selfishness and fear," Malone wrote. He accused the U.S. Fish and Wildlife Service of suppressing research favorable to grass carp, promoting studies that purposefully confused the issue for the public and threatening to withhold funds to scientists advocating for grass carp. I was sad reading "Adventure in Panama." It's clear that Malone took immense pride in the role he played in ridding the Panama Canal of hydrilla while spreading the gospel of grass carp. Yet his sharp digressions and inability to turn down an opportunity to prove his denigrators wrong revealed the exasperation of a man seemingly tired of continuously justifying his life's work.

• • •

State bans on grass carp increased, though the decision to restrict the fish wasn't always unanimous. After initial stocking of grass carp began in 1970, Florida's Game and Fresh Water Fish Commission reversed course and moved to eradicate them from public lakes in 1974. Meanwhile, Florida's Department of Natural Resources, anxious to keep the state's lucrative rivers and lakes free of tourism-killing weeds, simultaneously replenished the grass carp population being reduced by the Fish Commission. Both sides claimed the law and Florida's constitution gave them jurisdiction. The inter-agency quarrel escalated and ultimately landed before the courts, culminating in a bizarre and bitter feud. In March 1978, 80 grass carp worth $30,000 were intentionally poisoned at DNR's Orange County Pollution Control complex. The department blamed Game and Fresh Water Fish Commission staff for sabotaging their weed-control study but couldn't prove it. A subsequent report was unable to pin the blame on any one individual. But in a line worthy of Shakespeare, the report called for a plague on both their houses, concluding the fish died from "long standing animosity" between the agencies. This strife continued until the Florida Fish Commission won the turf war in 1980, wresting control of the state's grass carp program from DNR and promptly banning any stocking of fertile grass carp.

The Arkansas Game and Fish Commission was stunned at the backlash coming from an angry public and their fisheries colleagues in other states. They needed facts to bolster their pro-carp claims, leading commission biologist William Bailey to spend years monitoring fish populations in 31 Arkansas lakes before and after the intentional stocking of grass carp. His studies, published by the American Fisheries Society, argued that white amur had caused no negative influence on shad, largemouth bass, crappie or young-of-the-year sunfish. In fact, removal of excess plant material had helped boost largemouth bass, bluegill and redear sunfish

populations, he claimed. Bailey detected no instance where grass carp ate fish larvae when weeds ran low.

Yet Bailey's reassurances in academic journals and trade publications were falling on deaf ears. Despite grass carp's early glowing reviews, public fears over rivers clogged with unseemly invasive fish led many state resource agencies to the conclusion that introducing an alien species to a new ecosystem was never a neutral proposition, let alone a good idea. Recreational anglers, those deep-pocketed weekend warriors, decried the buildup of aquatic weeds near piers that made launching their boats a chore, yet lampooned the AGFC for stocking grass carp. They reasonably worried the fish wouldn't stop eating once they started. And if they turned their appetite towards desirable plants along the water's edge, white amur would destroy vital fish habitat, sinking sportfishing industries. The anglers' fears showed up in *Sports Illustrated* within a year of Arkansas's open stocking policy coming into effect. "The introduction of a foreign animal into a new setting usually has disastrous results for native wildlife," stated a magazine editorial. Grass carp had caused an "uproar" among biologists and sport fishers, they wrote, branding their importation "an incredible and frightening example of 'Big Brotherism.'" Then they twisted the knife. "A few relatively obscure employees of a minor federal agency undertook in virtual secrecy [a plan] to make a major ecological decision, probably irreversible, that will effect [sic] all Americans directly or indirectly for many decades." Arkansas was arrogant enough to assume they knew what was best for aquatic ecosystems reaching, as Bailey himself noted, from the Appalachian to the Rocky Mountains.

It stretched into a multidecade debate. When Texas Parks and Wildlife proposed making sterile grass carp available for stocking in private ponds in 1992, fishing clubs howled in opposition. "You cannot stock a million bodies of water and not have them escape," said former American Fisheries Society president Mac McCune in the inaugural edition of *Pond Boss Magazine.* "They will increase

density of carp in public waters," he wrote, and "bingo. They'll be in the rivers and streams of Texas. It will happen."

A noose was tightening around grass carp's neck. When a feature Malone wrote for *Farm Pond Harvest* in spring 1982 drew the ire of a Southern Illinois University (SIU) biologist, his reply was an exposed nerve. "It is disturbing when bits of scientific information are incorporated with chunks of speculative misinformation to create a format suitable for the sensationalism of the great plethora of trashy newspapers found today at the supermarket checkout counter," Malone wrote, running out of breath on the page. No one "uttered a cheep" when 30 inland states stocked striped bass into rivers and lakes "without a single investigation of its potential effects on an ecosystem," he typed in block letters. Striped bass were stocked "willy-nilly" while the scientific community sat cross-legged, picking "lint out of its collective navel for fear of losing some grant money for sport fishery research." Why the double standard?

His accuser, Professor J.E. Thomerson, was equally fierce. There was no reason to believe Malone was correct in stating grass carp wouldn't reproduce naturally or become an ecological disaster, he wrote in *Farm Pond Harvest*. Thomerson claimed his students at SIU had already found grass carp in the Mississippi system they believed had spawned without human involvement, a major blow to Malone's long-held but difficult to prove theory that grass carp were incapable of breeding in American rivers. It was only a matter of time, Thomerson said, before the Mississippi River, assaulted by wave after wave of grass carp larvae, would produce a breeding population. Then he let fly. "If I had a button I could push and murder every grass carp in the New World, I would push it without hesitation. I bitterly resent the arrogant ignorance and incompetence of the people who decided that we would use the Mississippi basin as a test area to see how the grass carp would fit into the new ecosystem." Ever prescient, Thomerson foresaw a day when the same pomposity that led to grass carp's intentional stocking would lead to uncontrollable populations of silver and

bighead carp throughout the United States. "Do you think we will go through this same argument in a few years on the bighead and silver carps?" he asked. "I expect we will unless tremendous efforts are made to prevent their escape from [aqua]culture." Most introduced species are disasters, and if America's Asian carp fiasco ends well for the nation's waterways, it will be due to "sheer good luck," Thomerson concluded, and "not informed foresight."

By the end of the 1970s, fertile grass carp were allowed in just four states: Arkansas, Alabama, Mississippi and Kansas. Florida, Iowa and Missouri allowed their use by restrictive permit only, while all other states banned their sale and importation. The downswing hit private producers like Malone hard. As a result of state bans and increased competition from rookie producers, grass carp breeding in Arkansas tanked between 1975 and 1979, dropping from 375,000 pounds to under 42,000. Acres devoted to culturing the white amur fell from 290 to 69. Washington also took action, making amendments to the Lacey Act, federal legislation governing the transportation of suspect species. Its application was broadened in 1981 to cover all "wild" animals, including any "bred, hatched or born in captivity." Aquaculturists took the change personally, believing Fish and Wildlife had needlessly added further regulation to domestic fish. Markets for Malone's product grew smaller by the month. The battle lines between grass carp's proponents and its detractors had been drawn.

• • •

Jim B. and I talked the time away. His spaniel Ben had proven too great a distraction and was banished from the room. Without his father running the show, Jim had modernized the business. And after the terrorist attacks of September 11, 2001, J.M. Malone & Son did away with international shipping. The drain on staff resources to prepare and package fish destined for overseas markets had been leading the company away from international shipments

for some time, but changes in air regulation after 9/11 were the final straw. Now, all J.M. Malone & Son shipments are trucked within the lower 48. North and South Carolina are major buyers, along with Louisiana's and Florida's water districts. They also won a contract with the Army Corps of Engineers to supply grass carp for use in Georgia.

Jim B. is actively reducing the percentage of his overall sales attributable to grass carp, but he still spawns 50,000 grass carp per acre on upwards of 27 acres annually, some 1.35 million of the fish. Grass carp accounts for about a third of his gross revenue, "which to me is a good thing. I don't want any one species of fish any more than I want one customer to be over 50 percent." He paused. "I'd really like to get that number down to 25 percent or less." Thirty years ago, grass carp accounted for 85 percent of his father's annual sales.

Jim walked me through the bustling operation Malone set in motion. From spawning barns to acre-after-acre of outdoor ponds filled with murky brown water buzzing with life below the surface. The farm had withstood a devastating 100-year flood in the late 1980s that wiped out 99 percent of their fish — 794 of 800 acres gone just days before Christmas. It was especially difficult because the stock lost to the flood represented the first full-profit fish J.M. Malone & Son had ever raised. Yet the farm remained, and the business has thrived

But this permanence was far from assured in the elder Malone's early years. In the latter half of the 1970s, he had ample reason to worry that increasing opposition would scuttle his grass carp gamble. Less than a month after Malone's first shipment of bighead and silver carp arrived in Little Rock in August 1972, and just six months removed from the Arkansas Game and Fish Commission greenlighting the introduction of grass carp to the state's interconnected waterways, the American Fisheries Society (AFS) met in the Arkansas tourist town of Hot Springs. In a position statement that emerged from the meeting, the AFS wrote that the introduction of

"exotic" species often carried "unfortunate" results. After urging fish farmers and importers to refrain from spreading unknown fish, the esteemed body of national fish researchers took aim at their hosts. No city, county, state or federal agency, they wrote, should be allowed to introduce exotic fish species into any local waterway with unimpeded access to river systems outside its political jurisdiction (exactly as the Arkansas Game and Fish Commission had done months prior) without every exposed state agreeing to the release. "Because animals do not respect political boundaries," the society wrote, "it would seem that an international, national and regional agency should either be involved at the start or have the power to veto at the end." Sure, this new system would result in fewer aquatic introductions, the AFS acknowledged, but the goal with releasing exotic species into a new ecosystem was quality not quantity. And "many mistakes may be avoided."

Malone got to thinking. If the primary objection to stocking grass carp for weed control was their potential to breed in the wild, could he alleviate those objections (and reverse state bans) by engineering a commercial-scale fish incapable of reproduction?

To save his business, Malone dove deeply into the genetic life of grass carp as part of a growing scientific hunt for a manufactured sterile fish. The result would make grass carp a permanent fixture of American rivers at a time when, despite pushback against fertile grass carp, Americans were willing to consider deploying a controversial fish in their pursuit of controlling nature rather than the nightmarish alternative of chemical saturation. Sparked in part by Rachel Carson's book *Silent Spring*, public outcry against pesticides raged in the 1960s, making a pesticide-free environment controlled by barren grass carp an attractive option for controlling unwanted aquatic plants.

Perhaps, Malone reckoned, they could be "ecology's helper" after all.

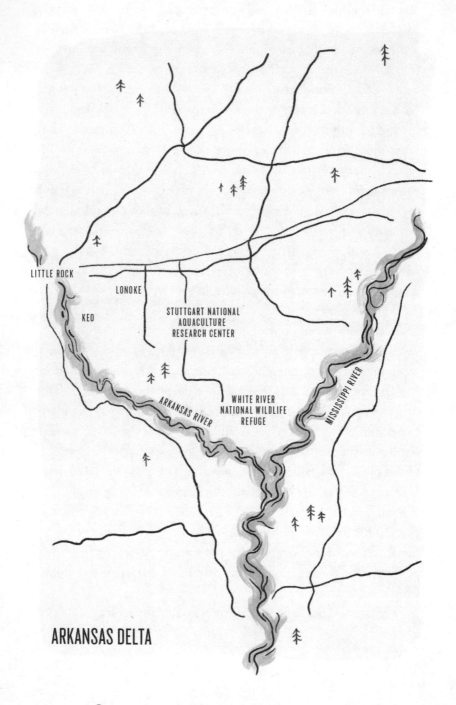

LITTLE ROCK

LONOKE

KEO

STUTTGART NATIONAL
AQUACULTURE
RESEARCH CENTER

ARKANSAS RIVER

WHITE RIVER
NATIONAL WILDLIFE
REFUGE

MISSISSIPPI RIVER

ARKANSAS DELTA

CHAPTER 2

"Ecology's Helper"

KEO, AR — Hunting rifles leaned against two corners of Mike Freeze's blustery office. It smelled of men outdoors and the sweet, musty odor of old fish. I shifted aside a crossbow resting on a padded chair and sat down across from Freeze, a cluttered desk piled high with papers between us. The walls reflected his deep commitment to hunting and fishing — framed photographs, awards and certificates jostled for room between not one, not three, but five taxidermied stag heads. Freeze only got into the fish business because he loved hunting so much that he didn't want to ruin a passion by maligning it with work. The lifeless stags suggest he finds plenty of hours for his favorite pastime.

Freeze worked for the Arkansas Game and Fish Commission before starting his own business in 1983; he has seen the Asian carp debate from both sides. His many years in public service spent in and out of "the Game and Fish," as he calls it, earned Freeze the commission's lifetime achievement award in 2014. He's tall, capped with thinning blond hair he tucks under a faded hat. When we met, he wore blue jeans and an oversized blue golf shirt. When Freeze speaks his mouth tries valiantly to keep up with his brain. His train of thought skips station stops, forcing him to pause, and, in heavy Arkansas tones, offer me a chance to direct our conversation.

Strangely, or so it felt in that moment, our conversation about Asian carp soon drifted to one of America's greatest environmental campaigners. "Rachel Carson wrote *Silent Spring* about all of the chemical compounds being sprayed on the environment," Freeze said, and in so doing, sparked a seismic shift in how, or even if, Americans thought about coating their land in herbicides. The Environmental Protection Agency (EPA) was "trying to do away with the use of chemicals," he told me. "They were saying there has to be a better way."

Grass carp, in many minds, was that better way.

From an environmental perspective, the '60s began with Carson, already a *New York Times* bestselling author with 1951's *The Sea Around Us*. In *Silent Spring*, she decried the pervasive spraying of pesticides that left a scarred landscape in their lethal wake. Birds in the sky, fish in the streams, people in the streets, insects in the soil — the soil itself: in the ethos of Cold War America, living beings throughout the animal kingdom could be sacrificed — laced with manufactured toxicants — to rid society of troublesome pests. "It was a spring without voices," Carson wrote. "Mornings that had once throbbed with the dawn chorus of robins, catbirds, doves, jays, wrens and scores of other bird voices there was now no sound; only silence lay over the fields."

From its hopeful beginnings, the decade would end in flames. 1969 saw rivers in Ohio and Michigan literally ablaze. Oil slicks on the Cuyahoga River burned for the second time in less than 20 years as cities prolonged the ageless tradition of confusing urban rivers with cheap sewer systems. Burning rivers were a disturbingly regular occurrence in heavily industrialized Rust Belt cities like Cleveland, Detroit and Chicago. But in the year that 400,000 people flocked to White Lake, New York, for three days of peace and music at Woodstock, and as U.S. military personnel in Vietnam peaked at over half a million Americans, the image of oil-slicked rivers engulfed in flames, choked with rafts of human shit, made plain how desperate America's environmental plight

had become. An unknown but oft-quoted environmental activist stated bluntly at the time that "when rivers are on fire, you know things are bad."

Soon after Carson's treatise was published, resource agents from across America cast about for a new approach to fisheries management, a regimen that would lessen their dependence on industrial chemicals. But how convincing, I wondered, was the connection Freeze was crafting between grass carp's introduction and an environmental legend whose writings on the evils of unchecked pesticide use birthed the modern environmental movement? Was this simply a convenient cover for an aquaculture man who once led Asian carp spawning for the Arkansas Game and Fish Commission?

To explore these questions, let's return to *Silent Spring*. Actually — let's go further back.

• • •

Don't underestimate postwar America's struggle with aquatic weeds. Far from a dockside annoyance at the boat ramp or cottage pier, underwater weeds constituted a clear and present danger to the United States' ability to do everything from grow food to generate electricity. Aquatic plants can, if left unchecked, destroy fisheries by choking out space, nutrients and light or clog intake pipes for hydroelectric and nuclear plants. Irrigation canals, whose free flow is essential for agriculture, can fill with invasive weeds in weeks. Enough aquatic vegetation will obstruct water flow, halt navigation, increase transpiration and prevent land from properly draining. What's more, a surfeit of aquatic weeds can increase flood risk, transmit disease, decrease property values and curtail recreational boating and fishing.

The speed of aquatic weed infestations accelerated rapidly in the postwar years. The Second World War had decimated trans-oceanic shipping capacity, with America alone losing 1,700 vessels;

entire fleets called to action during the conflict were nonexistent by 1945. Yet what was liquidated during war was quickly rebuilt as America's industrial might catapulted the country to the forefront of international shipbuilding. Liberty class vessels, a simple, low-cost cargo boat built at 18 shipyards throughout America during the war, were, in the conflict's final weeks, pumped out at a rate of one every 40 days. Some were completed in a week. All of the 2,700-plus Liberty ships built (and not destroyed) during wartime were decommissioned after 1945. These formed the backbone of the global merchant shipping fleet well into the 1960s. And in the late 1950s, one U.S. seafaring operation introduced containerized shipping from the east coast of America. The move sent ripples through the industry, setting in motion the international supply chains used today while revolutionizing the availability and price of consumer goods.

The global village opened its doors to commerce, but also, unwittingly, to an unwanted cache of invasive flora and fauna. Largely contained aquatic ecosystems like the Great Lakes, home to extensive import/export markets, were hit especially hard, as we'll see in chapter 11. Exotic aquatic plants hitched rides on transoceanic vessels and proliferated in their new homes. "The rapid growth of weed infestations has been both spectacular and frightening," wrote University of Wisconsin horticulturist L.G. Holm in a 1969 issue of *Science*. "The publicity devoted to several of these problems in the past decade has made us aware that something is wrong." Suddenly the complex infrastructures of modern life looked immensely vulnerable to a hearty collection of fast-reproducing plants.

Water hyacinth, a South American free-floating plant favored by horticulturalists for its pale lilac flowers, was an early offender. Predating the shipping freeloaders, it arrived in the United States during a horticultural exhibit in 1884 and spread soon after. Hyacinth's fine roots transported easily and took hold almost anywhere, especially sluggish, channelized canals. Once vital to

nineteenth-century transportation, America's canals were soon congested with dead and dying hyacinth. It added a foot of debris to waterway bottoms every year, decreasing flow rates by 90 percent. Irrigation ditches clogged entirely, and at $600 per mile to dredge, few farmers could afford the maintenance needed to keep waterways free of hyacinth. Little wonder that just 13 years after the plant's arrival in America, an investigation was called to figure out ways of terminating hyacinth with extreme prejudice. Fast forward to 1956. Shortly before grass carp arrived in Arkansas, hyacinth removal cost Florida, Mississippi, Alabama and Louisiana alone $43 million, some $390 million these days.

Hyacinth wasn't the only *herbage terrible* to fret over. *Salvinia*, hydrilla, water lettuce, Eurasian watermilfoil — all were serious barriers to prosperity. Watermilfoil spread in one Florida district from 200 to 3,000 acres in 24 months. That same plant invaded 197,000 acres of Chesapeake Bay, 64,000 acres of Currituck Sound in North Carolina and 5,000 acres of Tennessee Valley Authority reservoirs in the 1960s. There, watermilfoil was sprayed with 2,4-Dichlorophenoxyacetic acid (known as 2,4-D), an herbicide later used to manufacture Agent Orange, the defoliant that gained notoriety in the jungles of Vietnam. Some five million gallons would eventually rain from C-123 transport planes onto southeast Asian jungles, seeping into the tissues of, among other living beings, countless American war personnel and North and South Vietnamese soldiers and civilians. In *Silent Spring*, 2,4-D was called out on 10 separate occasions for the "tumorlike swelling" it caused. "Chromosomes become short, thick, clumped together," Carson wrote. "Cell division is seriously retarded." Up to 239 pounds of 2,4-D per acre was applied in TVA ponds, 12,000 times the EPA's current recommended 2,4-D concentration.

Holm's 1969 *Science* article was chockablock with descriptions of herbicides with space-age supervillain names — diquat, acrolein, xylene, dalapon — all used to great effect. For a while. Hydrilla could be controlled by acrolein for four to eight weeks

before additional applications were required. Amitrole-T constrained cattails for a few weeks. Apply enough dalapon and aquatic grasses and rushes were killed, but two or more treatments were required each growing season. Repeat as needed. Ad infinitum. Holm was ultimately a reluctant supporter of chemical spraying. "Until we become wise enough to appreciate our water," he wrote, "and until we have come to respect it as one of the most precious of all the gifts of nature, aquatic herbicides will be needed — for they will be one of the few tools that we can afford in the selective management of the vegetation in our waterways." It's a thin argument, given that most affluent societies can afford what they choose to prioritize. Still. "Because the cost is generally only 10 to 20 percent of other control methods" like mechanical dredging, he wrote, "there is frequently no other practical way to manage the vegetation."

Chemicals were less expensive than alternatives like dredging, though their near-constant reapplication kept chemical makers perpetually in the black. Between 1960 and 1968, the total volume of all pesticides (including herbicides, insecticides and fungicides) produced in America grew from 648 million pounds to 1.19 billion pounds. The value of those chemicals, meanwhile, ballooned. From $453 million in the early 1960s, the value of American-made pesticides rose, by 1970, to $1.13 billion, some $7.3 billion today.

• • •

By 1960, companies like Dow and Monsanto were cresting a wave that saw their industry become a multibillion dollar entity by decade's end. In the three years before grass carp were imported to Arkansas, American pesticide application jumped from 648 million to 764 million pounds; by 1970, landscapes the country over were drowning under a billion pounds of synthetic pesticides. The agency men who approved grass carp's introduction would have been very familiar with both the impact of relentless aquatic weeds

and the huge volumes of chemicals needed to control them; both certainties would have influenced their decision-making.

As always, William Bailey, the Arkansas Game and Fish Commission's fierce advocate of wide-open grass carp stocking, was indelicate in addressing grass carp's potential ecological impacts. Even the worst effects, he wrote in September 1972, "are far better than the possible effects of some of the chemicals which are now being used in its stead." Given what *Silent Spring* had revealed about pesticide's devastating impacts throughout the food web, Bailey was not entirely wrong. He seemed annoyed with the "emotionalism" keeping white amur from greatness. "While the carp controversy rages, and thousands of tons of unnecessary chemicals are dumped into our waters," Bailey wrote, "the white amur is slowly doing its job in the public waters of Arkansas. Nature has provided another valuable 'tool' to solve another problem if only 'technical man' is able to recognize it."

It took spunk to suggest that alternatives to chemicals be found, let alone implemented, when confidence in scientific problem-solving was unquestionable. The cost of chemical spraying wasn't purely economic; it was also a real-life manifestation of the faith that postwar Americans had in the verity of science and technology. Gypsy moths, Japanese beetles, fire ants, *Anopheles* mosquitoes and cockroaches all posed risks to society that chemical companies and economic entomologists consistently discussed in amplified language. Words like "horde" and "menace" instilled fear in an already jittery public. One branch of the Entomological Society of America noted with unsmiling hyperbole in 1962 that "insects, if left to their own devices, are a bigger threat to our way of life than . . . communism." The chronic anxieties of the Cold War exerted their own kind of influence. These alien agents were a vanguard of the Red Menace, threatening progress the postwar West and its fetishization of science were built on, wrote State University of New York historian David Kinkela. Questioning chemical poisons used to eradicate undesirable pests, he argued

in his book *DDT and the American Century*, was seen as undermining the country's vitality and international stature.

But scientists were beginning to worry that unrestricted herbicide use might possess far-reaching implications for human and ecosystem health. Beneath the glossy exterior of American postwar prosperity lurked a multitude of suspicious chemical interactions, Kinkela wrote, endangering "the environment, people and, by extension, the future of the nation." During this decade of conformity, these voices, far from the mainstream, lacked the argumentative prowess to take their unease public. That is, until a former Fish and Wildlife Service biologist became their voice.

But before pesticide spraying defined the Eisenhower era's approach to ecological problem-solving, and long before a startled public awoke to the dangers it posed, Americans were introduced to a miracle concoction that kept disease from killing more U.S. fighting men in the Second World War than enemy bombs and bullets combined.

• • •

Naples, Italy. 1943. Months after the Allied armies waded ashore in Sicily that July, typhus infections developed within the city 140 miles south of Rome. Typhus, caused by the parasitic bacterium *Rickettsia*, is typically transported to humans through bacteria-carrying lice. Fever, chills and flu-like symptoms can begin several weeks after infection. It quickly progresses into a rash, spreading to the body's extremities within days. If left untreated, those infected can exhibit bouts of delirium. Some become comatose. Many die. As the Allies advanced north against the crumbling Italian army that December, a full-fledged typhus outbreak was underway in Naples. Controlling the bacteria and its host became a significant military matter, as Allied servicemen increasingly encountered infected Italians fleeing the conflict.

Rotenone, a naturally occurring chemical capable of killing

insects and other skin parasites, was the U.S. Army's lice-killer of choice. Yet the rotenoid extract was derived from plants found in South America, Australia and southern Asia, all parts of the world Allied governments had limited access to during wartime. With organic supplies cut off by the German and Japanese navies, American scientists were forced to look elsewhere for rotenone substitutes to protect their GIS. Dichlorodiphenyltrichloroethane, better known as DDT, was one powerful option. DDT is an organochlorine insecticide. First synthesized in 1874, the chemical didn't gain widespread use as a pesticide until 1939. Early analysis suggested DDT was less toxic to humans than other arsenic-based insecticides, but its true value was in eliminating lice and other disease-carrying pests. Even better, it treated people for longer stretches of time than other pesticides with seemingly no adverse human health effects. Simply put, DDT looked to be magic.

Large-scale manufacturing of the chemical began in the United States as the Italian campaign commenced. Once the epidemic began in Naples, U.S. Army officials approved the widespread dusting of Neapolitans to contain the outbreak. By January 1944, 50,000 civilians had come to American military facilities seeking treatment, and, in total, more than two million Italians voluntarily reported for spraying. It worked. Within weeks, typhus reports dropped dramatically. The outbreak was largely controlled by February 1944.

Dichlorodiphenyltrichloroethane's dramatic success caught the gaze of American media. Between May 1944 and October 1945, nearly 21,000 enthusiastic reports were penned about its triumphs. The chemical's success in Europe ensured that DDT was deployed to the Pacific. Avenger torpedo bombers outfitted with nose nozzles sprayed a cocktail of DDT and diesel oil onto islands, eliminating malaria-carrying mosquitoes in advance of amphibious assaults by U.S. Marines. Even the nuclear devastation of Hiroshima and Nagasaki in Japan couldn't dampen America's

enthusiasm for DDT, as the chemical was hailed the "atomic bomb of the insect world."

Manufacturers couldn't make enough. Farmers bought DDT in bulk after the war to ward off unwanted insects on crops; towns began marching spray trucks down leafy Main Streets to kill gypsy moths, beetles and mosquitoes, with kids on bikes never far behind, hiding in the haze. School districts sprayed children with DDT to combat polio. Housewives detonated bug bombs to rid pantries of pests. America rejoiced. "Never in the history of entomology has a chemical been discovered that offers such promise to mankind for relief from his insect problems as DDT," proclaimed 1,600 members of the American Association of Economic Entomologists in 1945, while one brigadier general wrote in the *Saturday Evening Post* that DDT was "the war's greatest contribution to the future health of the world."

By the time Shao-Wen Ling suggested resource agents in Arkansas import grass carp from Malaysia, America was producing 188 million pounds of the insecticide annually, five times more than was manufactured at war's end.

But rumblings of its detrimental effects on humans and wildlife were growing louder. Ecologists, postwar purveyors of what was seen as a "soft" science, harbored concerns over how DDT had seeped into our food, our rivers, our animal and insect neighbors — and ourselves.

Rachel Carson, with her Fish and Wildlife Service experience and a master's degree in marine biology from Johns Hopkins University, shared this anxiety. *Silent Spring* was conceived as a story about the relationship between life and the physical environment beyond human interference. Yet Carson was shaken to her core by the use of atomic weapons during the Second World War. Before Hiroshima, she wrote, "it was pleasant for me to believe . . . that [humans] might level the forests and dam the streams, but the clouds and the rain and wind were God's." Believing life could withstand human assault after Hiroshima

became increasingly impossible. Postwar America was a troubled place for Carson, noted biographer Linda Lear: it was "a land laid siege to." In time, Carson's suspicion of pesticides blossomed into a larger skepticism of America's unflinching faith in science. When a friend suggested she investigate DDT spraying, Carson was intrigued. In 1945, she pitched *Reader's Digest* a feature story on the health and ecological effects of aerial DDT spraying, but the piece was rejected. The public wasn't ready then to learn about DDT and other potentially harmful synthetic chemicals in their midst, but they soon would be.

American faith in the unerring righteousness of science had served the country faithfully, offering a belief that the physical world could be comprehended, conquered and controlled. Steam engines, railroads, telegraphs, electric lights — all exemplified the new and awesome powers that innovation made possible. Chemical pesticides were simply the latest in a string of ventures furthering the Western world's "civilizing" mission. Arguments against this faith were antiprogress, antiscience and, ultimately, anti-American.

The first major blow against the infallibility of pesticides came in Long Island, New York. Public anger crystallized in 1957 when a crop duster, attempting to eradicate gypsy moths, flew low over farms, ponds, vegetable gardens, children in school playgrounds and commuters waiting for New York City–bound trains. All were drenched with poison. Travelers complained that the pilot soaked the station platform three times. Long Island was just the beginning. As pesticide-coated passengers scrubbed themselves of DDT-laced dust, radioactive material from atomic bomb testing began turning up around the globe in cow and breast milk.

Then came Thanksgiving 1959, when the "Cranberry Scare" heightened Americans' concerns about pesticides. That November, U.S. secretary of health Arthur Flemming claimed cranberries from the western United States were contaminated with amino-triazole. Also known as 3-AT, aminotriazole was thought to induce thyroid cancer in lab rats. Three million pounds of cranberries

were seized by federal officers in the ensuing panic, costing farmers $40 million in lost sales and American families their annual opportunity to eat cranberries. While it was later revealed that the American cranberries were free of 3-AT, the idea that chemicals sprayed on our food could make us sick took root in the public consciousness.

As New York straphangers were bathed in DDT (and Americans enjoyed a cranberry sauce–less Thanksgiving), Rachel Carson took note. The more intelligence she gathered "the more appalled I became," she later wrote. What began as serialized excerpts in *The New Yorker* were, by September 1962, published together as *Silent Spring*. This compact work of nonfiction bears a simple message: the way society indiscriminately applies chemical pesticides, DDT chief among them, is devastating the plant and animal world. More than 50 percent of chemicals sprayed at the time were capable of sticking to exposed soil for up to 15 years. Once ingested by any living organism, DDT remains locked in fatty tissue and passes through the food web. As birds eat contaminated insects or foxes eat polluted mice, they take on the chemicals stored in their prey. DDT magnifies its impacts, bioaccumulating in higher concentrations as it moves from predator to predator. Bird eggs thin, killing future generations before they're born. Fish lose the ability to tell up from down. Tumors develop in rodents and other mammals.

Carson recorded the trauma. It wouldn't be long, she wrote, if it wasn't already too late, before the ailments befalling birds and animals across America would befall people. And unlike her previous dismissal by *Reader's Digest*, this time, people were listening.

• • •

DDT, heptachlor, dieldrin, chlordane, 2,4-D. Efforts to eradicate plants and bugs ensured that these poisons and others leached into soils, leaves, rivers and mammal, bird and insect tissue. Between

1954 and 1961, a Chicago-sized area in Sheldon, Illinois, had been sprayed with dieldrin by the Department of Agriculture. Local populations of *Turdus migratorius*, better known as the American robin, were practically extirpated. Those that survived were infertile, and those eggs that had been laid before the spraying were now too thin to support the fledgling chicks inside. Pesticides also took a dramatic toll on mammalian life in Sheldon. "Among the mammals, ground squirrels were virtually annihilated; their bodies were found in attitudes characteristic of violent death by poisoning," Carson wrote. "Dead muskrats were found . . . dead rabbits in the fields. The fox squirrel had been a relatively common animal in the town; after the spraying it was gone."

Such reckless attitudes towards plant, animal and human life raised questions both scientific and moral, Carson wrote. "The question is whether any civilization can wage relentless war on life without destroying itself," she posited, "and without losing the right to be called civilized." Further, the very idea of relying on pesticides to eradicate species deemed "troublesome" to humans was "antithetical to Carson's ecological worldview," SUNY historian David Kinkela writes, and perhaps represented a logic more disturbing than the pervasive use of toxic chemicals. Using the stylized military language of her adversaries, Carson tied the laissez-faire spraying of toxins to the bottomless pit of corporate greed. It wasn't the chemicals themselves that were the problem, she wrote, so much as the prevailing attitudes of those employing them. Wresting control of these biologically potent agents from economic entomologists and chemical manufacturers, who saw nature as a soiled canvas in need of cleansing, was essential. Society would eventually see the danger in overusing pesticides and, she fervently hoped, demand new approaches to pest control.

But in that age of DuPont's "Better Living through Chemistry" ads, chemical companies, farmers, economic entomologists, politicians and many in media saw their way of life under attack. The response was swift and merciless, attacking Carson's pedigree,

theories and gender. Sexist words were hurled at book and author alike: *gossip, amateur, emotional, shrill, soft, full of innuendo, high-pitched, hysterically over-emphatic.* "Written," one critic claimed, "in glowing scarlet." What could be expected, these white men of science asked, from an emotional woman working in a man's discipline? Many in the political and academic establishment, meanwhile, appeared baffled by Carson's full-throated attack on chemical pesticides. Ezra Taft Benson, President Dwight Eisenhower's secretary of agriculture, asked the president "why a spinster with no children was so concerned about genetics." The Department of Agriculture compared *Spring's* message to the caliber of science fiction produced on *The Twilight Zone.* William Darby, head of chemistry at the Vanderbilt School of Medicine, cried from his ivory tower that if Americans accepted the arguments laid out in Carson's book they would face "the end of all human progress, reversion to a passive social state devoid of technology, scientific medicine, agriculture, sanitation." Wait, he continued: "It means disease, epidemics, starvation, misery and suffering."

To dislodge her message from American hearts and minds, chemical companies undertook a massive public relations campaign against both Carson and *Silent Spring.* Robert White-Stevens, a biochemist with pesticide manufacturer American Cyanamid, wrote in the trade journal *Agricultural Chemicals* in October 1962 that "the welfare and livelihood of millions of people" have been jeopardized in recent years by "the deliberate misrepresentation of facts." Carson's theories were absurd, he assured his readers; yet astoundingly, a majority of Americans believed her. To remedy this obvious error in collective judgment, White-Stevens set off on a public speaking tour, delivering 28 speeches across America on the efficacy of chemical spraying to eliminate pests and the need for humanity to use every tool available to drag itself from the Stone Age. Yet while talking up the civilizing effects of their products, chemical giants hedged

their bets. They were safe, companies cooed, but if DDT and other chemicals *were* found to cause ecological damage, over-zealous sprayers were to blame — not the chemicals.

Americans didn't prove as gullible as chemical companies and their allies in academia and government hoped. *Silent Spring* sold more than 100,000 copies in less than eight weeks, peaking at number one on the *New York Times* bestseller list in October 1962, a coveted position it retained for 31 weeks. The Book of the Month Club offered it as their October 1962 selection. Within 12 months, *Spring* was translated into German, French, Swedish, Danish, Finnish and Italian, and Spanish, Portuguese and Japanese translations came within two years. In April 1963, CBS produced *The Silent Spring of Rachel Carson*, a documentary film that broadcast the impacts of pesticides into the living rooms of millions of Americans. Passages were quoted into the Congressional Record. President John F. Kennedy was peppered with media questions, forcing him to assure reporters that his administration was investigating the book's damning ecological claims. Months later, JFK's Science Advisory Council announced that the elimination of persistent toxic pesticides should be an overarching goal of the United States.

Ecology as a scientific discipline was budding, but Carson didn't live to see it bloom. Weakened by breast cancer, she died in April 1964. Yet the maelstrom of change she set in motion lived on, restructuring the American political and environmental landscape.

• • •

As our meeting concluded, Mike Freeze handed me a water-stained Bankers Box overflowing with musty fish reports, files and photos dating to the 1960s. That night, I dissected the documents, flicking away the exoskeletons of long dead beetles trapped between Arkansas Game and Fish Commission reports. Suddenly it occurred to me why talk of Rachel Carson stuck in my throat.

Freeze wasn't the first to invoke *Silent Spring* — Drew Mitchell told me much the same.

I reviewed my interview notes:

> *[Mitchell]: Throughout the '40s and '50s there was tremendous chemical usage, DDT being the poster child . . . And then there became many scares in the public and people became very concerned about it biologically. A book arose from this that's really a trendsetter, a wonderfully written book by Rachel Carson. She suggests the use of biological control to get away from chemical controls, even the importation of biological controls. Whatever we can do to lower chemical usage. This was a huge trend. Her book came out in 1962, and in 1963 grass carp was first brought in by U.S. Fish and Wildlife Service.*
>
> *[Me]: Was this actually a driving force behind their decision?*
>
> *[Mitchell]: Absolutely. Because some people say "Well, U.S. Fish and Wildlife Service was really screwed up." But no. They were following what they thought was good, appropriate, sound advice . . . Concern over chemicals so far outweighed it they didn't worry about it. [Fish and Wildlife] were dealing with "How do we lower chemical use?" These grass carp — they gave them something.*

The impact of *Silent Spring* in creating a social mindset where importing an exotic fish for biological control of aquatic weeds seemed rational is often overlooked in Asian carp's American odyssey. Despite its current iteration as a harbinger of ecological doom, invasive carp fit snugly into an environmental ethos that evolved throughout the 1960s. Turning a blind eye to the high cost of prolonged chemical use, both economic and environmental,

became increasingly arduous after Carson exposed the chemical-industrial complex's dark underbelly. Using grass carp was a compelling new course of action. As Mitchell told me: *These grass carp — they gave them something.*

While the public fixated on chemical reduction as the lasting message of *Silent Spring*, a small contingent of fisheries researchers glommed onto the idea of turning to nature for solutions to pests. "Biological control has achieved some of its most spectacular successes in the area of curbing unwanted vegetation," Carson had written. "Nature herself has met many of the problems that now beset us, and she has usually solved them in her own successful way."

Inspired, curious wildlife officials went searching for biological solutions. Grass carp presented just such an option for biologists seeking effective and inexpensive alternatives to herbicides. So too, perhaps, did silver and bighead carp. Growing catfish has always been big business in America, especially in Arkansas, Mississippi, Alabama and Louisiana, home to 94 percent of the nation's farm-raised catfish. By 1985, just 20 years after catfish cultivation began, 6,000-plus people were employed farming catfish worth $8.4 billion. Yet the high-protein feed catfish consume often led to algal blooms that suffocated the fish. Silver and bighead carp, many believed, could be cultured alongside catfish to eat excess nutrients and reduce unwanted blooms. Better, anyway, then dousing ponds with hazardous chemicals. And if the new fish tasted good, they too could be sold for human consumption.

The idea took off. Concluding in 1977, staff members at the Joe Hogan State Fish Hatchery in Lonoke, Arkansas, had raised "Chinese carps," as they were sometimes called, alongside channel catfish. Yet while "Chinese carps" reduced oxygen depletion in aquaculture ponds, catfish farmers soon abandoned the once-promising plan. A hoped-for market for bigheaded carp never materialized, and the economics of buying and raising the fish quickly tilted towards unprofitability. What's more, separating

catfish from Asian carp at harvest was a workplace hazard: silver and bigheads grew larger than catfish and, flailing wildly, often crushed the catfish and imperiled those collecting them. Neither trait endeared the species to farmers, making it plain that bigheaded carp's future in America wouldn't lie in catfish farms.

• • •

A new purpose for Asian carp came from an unlikely source. The Federal Water Pollution Control Act, better known as the Clean Water Act, was passed in 1972 by the Environmental Protection Agency with the expressed purpose of improving water quality guidelines first approved by Congress in 1948. A quarter century later, the act, in many ways, facilitated the spread of North America's most voracious nuisance species.

Improved water quality legislation was badly needed. Bacteria levels in the Hudson River in New York State, to take one example from numerous possibilities, were 170 times the safe limit in 1969. PCBs from industry and waste dumped from agriculture and sewage plants were identified as the primary culprits. The Hudson's desecration caused an uproar. Folk singer Pete Seeger, a river resident in upstate New York, rallied to the Hudson's defense in 1966. "My Dirty Stream (The Hudson River Song)" featured on Seeger's *God Bless the Grass*, sang out a central question facing society: Who should pay for the sewage plants needed to save our rivers?

The river's contamination levels were off the charts. An estimated 41 million fish were killed as a result of municipal and industrial pollution: by 1967, one-third of New York State's drinking water samples exceeded safe contamination levels.

Just three years removed from *Apollo 11* astronauts safely landing on the moon, Washington lacked the authority to set wastewater standards for cities and corporations, having failed to give itself the power to do so. The Clean Water Act finally corrected this with

its simple aim: to regulate pollutants discharged into America's waterways. "You couldn't just dump raw sewage in the rivers anymore," was how Mike Freeze put it to me. "For years that's what was done." After 1972, filtering out solids from human waste and dumping the remainder in local waterways was no longer adequate. Wastewater treatment plants now had to recycle or remove the nutrients found in human feces from the discharge in order to limit waterborne illnesses and curtail algal blooms.

Lower-tier governments were forced into paying to improve water quality. "Cities are saying, 'How we going to pay for this?' and struggling to try and upgrade," Freeze recalled. There were few options. As long as anyone could remember, sewage lagoons with mechanical filtration to remove solids were the typical method for handling human waste. Cheap too. Few rural towns had a substantial enough tax base to finance the sophisticated sewage treatment systems suddenly needed to obtain National Pollution Discharge Elimination System permits. Jim Malone's son remembered the panic well. "EPA calls up and says, 'Your discharge is too high. You've got 30 days to submit a plan, or we're going to start fining.' The fine was $25,000 a day. You get small municipalities quickly saying, 'We've got to come up with a plan.'"

There was another way. In December 1976, economists from Central State University in Oklahoma drafted a "first attempt" report that examined whether it made fiscal sense for rural communities to use fish to clean their soon-to-be-illegal sewage lagoons. It did. "At this stage of our knowledge," the authors wrote, "aquaculture wastewater treatment systems are economically viable alternatives." Besides, as the planet grows more crowded, they suggested, the production of animal protein from waste products that don't require large tracts of land will only become more attractive from an economic standpoint.

Reflecting the innovative spirit of the age, the Environmental Protection Agency built on the 1976 report with a series of four

studies from 1980 to 1983 linking aquaculture with effective waste-water treatment. Cash-strapped counties, it was suggested, should consider stocking their sewage lagoons with phytoplankton-eating silver carp in particular. Anita Kelly, the aquaculture specialist from the University of Arkansas at Pine Bluff, tells me many folks were incredulous when her research with Drew Mitchell revealed the deep interest the EPA took in Asian carp. "People were saying they couldn't believe that. But we actually found the grant," she said, pages of material outlining how counties could obtain discharge permits by utilizing Asian carp as a way around paying for costly infrastructure upgrades, all while ensuring any water leaving their sewage plants was safe. Freeze remembered it this way: "There were actually cities that were forced to stock silver carp in their sewage lagoons." Suddenly, the elder Malone began receiving telephone calls from city governments desperate to buy bigheaded carp to avoid devastating EPA fines. Malone agreed to sell the fish provided counties erected barriers to prevent escapes. "I remember Jim went to stock someplace, and people hadn't put the barrier up and he refused to stock them," Freeze continued. "He didn't want to be accused of furthering the escapement of these fish into the environment."

Encouraged by the Environmental Protection Agency, county governments wanted to know how effective (and expensive) the carp would be for cleaning lagoons. Taking silver and bighead carp mainstream fell to rookie fisheries biologist Scott Henderson with the Arkansas Game and Fish Commission. He believed Asian carp had found their perfect role. Resource agencies nationwide were already exploring biological controls like water hyacinth and shellfish for treating sewage, Henderson told me from his home in Arkansas. "There was quite a bit of [experimentation] going on at the time," he said. Testing the efficacy of Asian carp to clean sewage was worth a shot. "It was a time nobody was rigid," Henderson said. "Everybody was scrambling."

Henderson, a zoology and chemistry graduate from Arkansas

State University, was hired by the commission as an entry-level fish culturist in 1972. (He would later head the agency from 2005 to 2012.) Henderson soon found himself working at the Joe Hogan hatchery in Lonoke, near Malone's fish farm. Malone himself was a frequent visitor to the hatchery that was, at the time, holding the silver and bighead carp he imported in 1972. Despite years of research at the Hogan hatchery, the fish's capabilities were still largely unknown. "We didn't know a whole lot about them," Henderson said. Were they able to clean sewage systems? Could they survive?

The commission's lack of knowledge became untenable once county governments began desperately seeking silvers and bigheads for lagoon cleaning. Henderson was eager to explore their potential. In 1974, he began asking federal agencies for money to determine if raising algae eaters alongside scavenger fish and bottom-feeders in lagoons could be a cheap and effective solution. Most lagoon treatment of sewage at the time relied on aerobic bacteria to transform the organic carbon found in human feces into carbon dioxide. Through photosynthesis, the carbon dioxide is converted into algal cell material that would need to be cleared to avoid blooms. Enter silver and bighead carp. An 18-month pilot project got underway at a state hospital in Benton that relied on six lagoons to break down waste generated by 2,000 employees and patients. Twenty-eight thousand fish, the vast majority silver carp, were placed in Benton's lagoons. As stocking got underway, Henderson broadened the experiment with a further $90,000 in EPA funding. He also had another angle. Believing people could be persuaded to eat fish reared in human excrement, Henderson received another $17,500 from the National Marine Fisheries Service to study whether silver carp reared in sewage ponds were fit for human consumption. He merged the projects and set a completion date of March 1980. The experiment was on.

Early results looked promising. Silver and bighead carp were indeed enhancing water quality at the Benton site, Henderson

wrote in a 1977 preliminary report. Moreover, his work rearing big-headed carp on poop showed tremendous potential for low-cost fish production for human consumption. Extensive monitoring measured biochemical oxygen demand — BOD_5, often used to measure pollution levels — as well as fecal coliform, carbon dioxide and plankton levels. Water quality improved more than Henderson ever imagined it would. Fecal coliform levels dropped 2.6-fold and phosphorous and nitrates by 90 percent; total suspended solids decreased by 78 percent, while BOD_5 dropped by 96 percent. Overall, he discovered, silver and bighead carp made treating human waste approximately 30 percent more efficient. On the fish production front, 1,540 pounds per acre of silver carp became 41,485 pounds per acre in 24 months; bighead poundage leapt from 212 to 8,205 pounds per acre. If county governments could sell the resulting Asian carp for fishmeal, Henderson wrote, they could stand to make $1,100 per acre in profit annually, more if "human health considerations could be mollified and the product sold for human consumption."

Yet Henderson's dream never came to pass. The public's lack of interest in eating fish reared in sewage pools was the first sign the project would never gain widespread acceptance. Counties needed a buyer for their lagoon-raised fish, and none existed at the requisite scale. Without a market, the Asian carp plan was too expensive. Decades later, Henderson still sounded wistful that no use for the Benton fish had been secured. If only the Food and Drug Administration had allowed the lagoon fish to be eaten by people or pets, Henderson believed, then using silver carp for wastewater treatment would have taken off. "All of the fish flesh I had analyzed met every FDA food requirement there was," he said, unfazed by the ick factor of eating fish raised on human shit. Henderson isn't blind to the negative perceptions. "The fact that it came out of a sewage lagoon meant it was dead in the water," he told me.

Ultimately, politics proved to be the final nail in Asian carp's

coffin. The election of California Republican Ronald Reagan to the White House in November 1980 derailed the Environmental Protection Agency and marked the end of Henderson's scheme. Anne Gorsuch, Reagan's appointment to lead the EPA and mother of future Supreme Court justice Neil Gorsuch, set to work gutting the agency. Gorsuch zealously attacked the Clean Water Act, boasting of shrinking the book of Clean Water Act regulations from half-a-foot to half-an-inch. Reagan cut agency staff by 11 percent and the EPA budget by 22 percent, cuts that deepened to 50 percent by mid-decade. Enforcement of agency regulations tanked as violations reported to EPA offices plummeted by 80 percent. Reagan's contempt for the EPA scuttled all experiments with biological control of sewage, including tests with Asian carp. Grant money vanished. Scott Henderson sent his final report on the suitability of silver and bighead carp for sewage treatment to EPA officials in November 1981. He heard nothing back. "It just sort of faded away."

Henderson was forced to tear down the Benton site. Thousands of pounds of Asian carp were destroyed, and those that didn't become fish meal were buried, he told me. None were released into waterways surrounding the hospital. Spawning of silver and bigheads soon ceased at the Hogan hatchery. "It was the end of the silver and the bighead," Henderson said. "There was never another purpose or use for them that I'm aware of."

• • •

No one can say with certainty when, or indeed where or how, silver and bighead carp first escaped state and private fish hatcheries to swim freely in America's open waters. The fish Jim Malone turned over to the Arkansas Game and Fish Commission in 1974 were studied at the Joe Hogan hatchery, but numerous specimens were shipped out of state for research at other institutions. Auburn University studied the polyculture of silver and bighead carp they

purchased from the Hogan hatchery in 1974, the same year the AGFC sold fertile bigheaded carp to Homer Buck at the Illinois Natural History Survey in Kinmundy. Buck, as we'll learn in the next chapter, used the fish as part of an experiment to produce sterile grass carp.

The lax biological security protocols that Drew Mitchell revealed to me were hardly unique to the Stuttgart station. Buck's operation in Kinmundy deployed the same flawed saran mesh screens that first allowed grass carp to escape from Stuttgart. While we can only speculate as to their point of escape, we know that by 1975 silver carp were caught swimming freely in Arkansas's White River. By 1982, the commission had stocked silver and big-head carp in at least four sites in Pulaski and Lonoke counties in artificial lakes and sewage ponds. Mallard Lake, in the northeast corner of the state, was stocked with both bighead and silver carp. When both fish species failed to control the artificial lake's algae problem, the AGFC simply drained the lake into the St. Francis River, an unimpeded tributary of the Mississippi.

• • •

Deep in the Bankers Box of papers Mike Freeze lent me was a letter addressed to Jim Malone. Dated February 9, 1990, it was signed by Barry Beavers, then manager of the Joe Hogan hatchery. Three paragraphs long, Beavers's letter outlined that effective January 31, 1990, the Arkansas Game and Fish Commission had ended its partnership with Malone; it would no longer hold his stock of bighead and silver carp for experimentation. The three-year agreement had lasted, unofficially, for 16 years. There was a finality to Beavers's letter, its words conveying resignation and loss. *We did our best*, it seemed to say. The AGFC returned 80 three-year-old silver carp to Malone's care they "had no immediate use for." While Beavers vowed to keep some on hand for "special work" in the future, should any arise, "these fish you received will be the last

of the Chinese carp species that we will have as surplus." Among the papers, I found no reply from Malone.

• • •

Should resource officials like Freeze and Mitchell have known the cure that was Asian carp would be worse than the disease? With hindsight the answer is clear, but take this vision away and any response will be cloudier, if for no other reason than applying current ecological thinking to the past is a mug's game. What's certain is that resource managers, politicians and academic and government researchers from the United States and around the world endorsed the use of grass, silver and bighead carp for various forms of biological control throughout the 1960s and well into the 1970s. And the experimentation ended not because of any innate failure of bigheaded carps to do what was asked of them, but rather the twin problems of politics and picky taste buds. Neither, ultimately, could be overcome.

Rachel Carson, meanwhile, foresaw a world of natural alternatives to pesticides, one in which predators, parasites, sterile insects, microbial diseases and pheromonal controls (which we'll explore in chapter 5) would allow scientists to work *with* nature to control bothersome species, a radical break from chemical spraying that had carried the day. All species of Asian carp, in unique ways, fit the mold of the ecological helper. And the Game and Fish Commission never conceived of "Asian carp" in our catch-all current sense. "Some people wanted to lump them all together and we kept saying, 'No, no, no,'" Mike Freeze told me. Freeze, Scott Henderson and countless resource officials who worked with Asian carp considered each species a separate case. Vegetation-eating grass carp were always intended for a broader use in pond cleaning, while bighead and silver carp were imported strictly to aid the fish-farming industry with nutrient control. Remember the catfish ponds? Their use as a biological control agent to help county

governments deal with raw sewage was a backup plan. With time running out, testing their effectiveness at cleaning sewage lagoons was a Hail Mary effort to find them some useful purpose.

But we never could.

As the 1970s became the 1980s, it wasn't clear to Jim Malone that even grass carp — still enjoying pockets of support among irrigation farmers and resource managers — could find a niche in its present fertile state. Sterile grass carp, incapable of breeding without human intervention, remained for Malone an oasis in the desert.

Scott Henderson is less sanguine today about the research he conducted at Benton. The long-term ecological costs his would-be test subjects have since exacted on the aquatic ecosystems of North America are incalculably high. Understanding the rationales for introducing these pesky species does nothing to alter the destruction they've caused. Try as resource officials might to contextualize the past, theirs is a minority view. For many North Americans, Asian carp is Asian carp is Asian carp. The gravity of this isn't lost on Henderson. "If I knew what I knew today, I wouldn't want silvers and bigheads loose anywhere in this country."

Everyone I met in Arkansas was asked whether importing grass carp was worthwhile given the devastation caused by their ravenous cousins. All answered affirmatively, but none with quite as much verve as Drew Mitchell. "Has it been worth it? For the grass carp, yes," he said. "I challenge anybody to go to the literature and find any significant damage that the grass carp has done." Problems associated with grass carp eating too many aquatic plants is actually a problem of overstocking, according to Mitchell — less the fish behaving badly than our failure to use them properly. And who's to say researchers and resource managers are smarter today in how they apply chemicals than they were in Carson's day? "Let's bring into the discussion the problems of the 1950s and '60s," he said, sitting in that North Little Rock diner, of mass animal die-offs related to overspraying of pesticides. Because although many

of these issues are behind us, they could come back. Mitchell believes grass carp are one of the most successfully used biological controls in fisheries today. "They would make Rachel Carson proud, even if she was made aware of all the problems associated with the import of exotic species."

So, did Carson underestimate the difficulty of controlling modern pests using biological options? Given the economics of pesticide production, public anxieties about new critters and the complexity of interactions among plants and animals, Simon Fraser University entomologist Mark L. Winston believes this is just what's happened. Carson's view of biological control was an ecological one, he wrote in 1997's *Nature Wars*, "in which we would cleverly use our understanding of pest ecology and behavior instead of chemicals to manage rather than eradicate pests." But this is not what we have done. Our use of chemicals persists. In fact, in the decade between *Silent Spring*'s publication and DDT's American ban in 1972, use of pesticides rose tenfold to one billion pounds annually. Pesticide persistence and bioaccumulation in soils, plants, birds and mammals remains frighteningly real to this day. While the yearly volume of chemical use may not have increased since 1972, their toxicity has intensified 20 times.

For all the talk of biological control for pesticide reduction, banning DDT was one of the few victories (and a contested one at that) in the struggle against the chemical-industrial complex. Since then, industry and the public have been reluctant to approve biologically based technologies, Winston writes. Who can blame them? For every South American alligator weed flea beetle introduced to Florida in the 1960s that successfully controlled alligator weed there are countless tales of introduced snails and flatworms and birds and mongooses eating species to the brink of extinction. Or worse. Just 10 to 20 percent of biological controls for insects, for example, provide even a small measure of control. Even grass carp as biological control backfired in one respect when it was discovered that carp imported to Arkansas in 1968 were infested with

Asian tapeworm, a parasite the fish passed on to native fishes like the red shiner and woundfin, already under threat from hydroelectric installations and dams. Given the controversy over Asian carp to control aquatic weeds and clean sewage lagoons that has raged since the early 1970s, biological control as conceived by Carson and executed by Mitchell, Buck, Henderson et al. has failed and is unlikely to turn skeptics into believers. In the half-century since the release of *Silent Spring*, chemical interference in our agriculture and landscapes has swung from pariah-status back to standard practice as a means of controlling unwanted pests. Biological control, so in vogue during the halcyon days of the 1960s, is today seen as too ecologically risky.

Not all are convinced banning DDT in America (and the subsequent chill that put on the chemical around the world) was sound policy, or smart science. Oliver Morton, a science journalist with *The Economist* in Britain, argued in 2016's *The Planet Remade* that the fear of Atomic Age environmental catastrophe and its technological fixes that Carson stoked so successfully continues to condition how societies feel about geoengineering and other heavy-handed attempts to save our warming planet. But the day may come, he warns, when Promethean schemes to keep Earth habitable are the only avenues our society will have left to explore.

Recent critics have also painted Carson's hands in blood, suggesting her crusade against DDT was little more than eco-dogma and was the primary culprit in the malaria-induced death of tens of millions of people in the developing world. The affordable and effective chemical agent had nearly wiped malaria off the map, its supporters argue; this is surely worth the death of a few birds. Journalist Tina Rosenberg put it succinctly in the *New York Times* in April 2004 when she wrote that America chose the welfare of birds and beasts over the lives of two million people who perish annually from malaria. "DDT killed bald eagles because of its persistence in the environment," Rosenberg argued. "*Silent Spring* is now killing African children because of its persistence in the public mind."

Yet, as our understanding of the interconnectedness of species and ecosystems grows, there is no longer a simple equation putting human interests above all others. Rosenberg's position, and that of those who share it, is increasingly problematic. Balance is a central concept in permaculture, a system of understanding the dynamic interplays of living systems. It's often associated with creating agricultural practices that are as self-sustaining and sustainable as possible, but it need not be limited to that. Tao Orion is a homesteader, permaculture designer and teacher at Oregon State University. In 2015, she published *Beyond the War on Invasive Species*, in which she argues that permaculture design theory has practical applications for how we think about restoring invaded ecosystems. We can think of restoration not in terms of favoring native organisms, but of integrating our knowledge of how components interact and how they might fit into ecosystem blueprints. Every being interacts with every other being. "Everything gardens," she wrote, describing the interplay between bulldozers, bullfinches and bull thistle to each other and the natural world. "From this whole systems-based perspective," Orion wrote, "the proliferation of a particular invasive species is not simply a quality of the organism itself, but a reflection of the ecosystem where it is found." Too often, she noted, our attempts at restoring ecosystems seemingly compromised by invasive species fail to address any "wider ecological context" that invasive species are only one part of. We cannot have short memories about our ability to radically overhaul ecosystems; we do it to this day.

Carson's is a legacy we struggle to untangle with each passing year. Grass carp, still employed by many public and private agencies in their sterile state, remain an invasive species that state and federal groups spend hundreds of millions of dollars to control. Silvers and bigheads have justifiably been federally blacklisted, subject to international eradication and containment strategies and not, as Mitchell, Malone, Henderson, Freeze and, yes, even Carson may have hoped, the tip of the spear in reducing

our collective chemical dependency. Economics, inertia, public ignorance, government regulation; whatever the culprit, Mark Winston wrote, we're living out Carson's worst nightmare.

CHAPTER 3

Tragedy of the White Amur

LONOKE, AR — I was driving through Lonoke County down arrow-straight rural roads. Mike Freeze had invited me back to Keo Fish Farms to see how grass carp are cultured. Keo, along with Jim Malone's facility and another large-scale producer close by, forms a 15-mile triangle responsible for producing 90 percent of the world's sterile grass carp. Fish leave Lonoke daily on transport trucks bound for the Little Rock airport and some 40-odd states where stocking sterile grass carp is now legal. The cotton fields flowing past me were waterlogged. The air was thick.

I parked beside a cornfield, among trucks and aging mud-spattered vehicles. Empty shotgun casings lay in the gravel. Beyond the parking lot, a chain gang of dairy cows walked the thin lip of a distant levee. I headed towards an aluminum door labeled *Office* in black electrical tape. Leaning heavily into the metal door, I stepped inside. Freeze co-owns Keo with Martha Melkovitz, a gray-haired woman with a kind face and genteel accent. Melkovitz bought the land Keo sits on with her husband Cleo in 1953. She partnered with Freeze in 1986 after Cleo, an agricultural pilot, died when his aircraft crashed into low-lying power lines. Three years earlier, Freeze was struggling to kick-start a fish-rearing enterprise he launched with friends after leaving the

Arkansas Game and Fish Commission. Little more than three guys and a truck, they departed the AGFC with $3,000 among them to start Arkansas Aquatics, renting ponds from farmers to raise their fish. "We starved to death," Freeze told me of those early years. He often contemplated returning to the commission, but an opportunity arose with Cleo's untimely death. Melkovitz urgently needed income to pay down taxes owed on the property. Freeze, meanwhile, was convinced money could still be made raising grass carp and game fish, if only he had a permanent space to do it. Martha agreed, and a partnership was formed.

After he greeted me outside his office, Freeze and I left the unadorned reception area and walked towards a squat metal building beneath a steel canopy. There, concrete baths were laid out in long rows. Known as "raceways" for their resemblance to drag racing strips, these water-filled tubs sat 3 feet deep, 4 feet wide and 25 feet long. Inside the rough-hewn robin's egg blue concrete were hundreds of grass carp, swimming in lazy spirographs. Some remained close to the water input where flow is greatest; others congregated at the far end, conserving energy, sitting low in the tank. "I tested a thousand grass carp this morning for triploidy," Freeze said. It's like a structured self-exam to make sure the fish he is selling are completely sterile. Pass the self-exam and a regulator from the federal government will conduct their own testing, he said; pass that and the fish are off to market.

Genetically, the cells of triploid fish contain three sets of chromosomes. Grass carp have 24 unique chromosomes, meaning triploids have a total of 72. Fertile fish, known as diploids, possess 48 chromosomes in two sets. This disparity means triploid fish cannot produce viable sperm or egg cells, disrupting their ability to breed.

Keo consists of low-lying concrete and aluminum buildings, their sides open to allow in breezes and light. A thrum of activity surrounded the farm. A dozen men — Martha was the only woman I saw at the fish farm — fed and prepped the carp and hybrid striped

bass nearing sale, while others tended to 1,200 acres of ponds. Other workers engaged in the unglamorous work of spawning, stripping eggs and milt from fish and mixing them together with the aim of fabricating a new generation of triploid grass carp. It's a picture of calm and orderly aquaculture.

What's fascinating about Keo Fish Farms isn't their current operation, but the arduous path that Freeze, Jim Malone and others walked to reach today's tranquility. These days, triploid grass carp are a routine tool for aquatic weed control across the United States. Yet the advent of triploid grass carp in the early 1980s was a bona fide game changer, the culmination of years of homegrown scientific inquiry, international intrigue and endless politicking. The elder Malone, he who had dedicated his life to the success of grass carp in America, was at the forefront of developing this new fish.

But his woes didn't end once the recipe for cultivating true triploid grass carp was discovered in the mid-1980s; many years of trial and error awaited before Malone and other producers needed to worry about marketability. First, they needed a reliable product. Creating a scalable, sterile grass carp would consume a decade of Malone's life and tens of thousands of his dollars, sunk into research and equipment, all on the blind faith that Fish and Wildlife managers would embrace triploid grass carp as a means of combating aggressive aquatic weeds.

Malone knew it could be done — he just had to figure out how.

· · ·

A visitor to Keo Fish Farm would find its raceways color-coded, festooned with red, yellow and green tags fastened to metal pipes above each tank. This traffic-light color scheme lets staff know immediately whether fish in that pen are verified triploid and by whom. Red tags mean the fish haven't been checked at all, while yellow shows that Freeze has confirmed their sterility in-house;

green means go, as both Freeze and U.S. Fish and Wildlife have certified their sterility. At this point they're ready for sale.

Freeze and I wandered near the back of his property and through the open doorway of a massive steel structure that looked like an airplane hangar and smelled like a pet shop you wouldn't patronize. A dozen or so 1,500-gallon blue plastic tanks sat at one end of the hangar, filled with water flowing counter clockwise from attached pumps. Two rows of clear cylinders called McDonald hatching jars perched on a chest-high bench near the entrance, each containing minuscule striped bass eggs swishing slowly in a simulated, psychedelic stream not unlike a lava lamp. Opposite the tanks were numerous concrete raceways. There, male and female fish, separated by a saran screen slotted in the tank, would provide the eggs and sperm needed to make thousands of grass carp and hybrid bass.

"Just in time," Freeze said. His colleague Rick Williams was beginning the latest batch of striped bass spawning. Williams had separated a dozen females from a handful of large, pale male fish. Reaching into the tank, Freeze and Williams each grabbed a female striped bass, glistening and squirming in the stale hangar air. Nearby stood a rolling cart with plastic bowls on top. Positioning the fish above a bowl, the men squeezed their lower abdomens, forcing out a sturdy stream containing millions of yellow eggs that flowed from urogenital openings like runny Play-Doh. Careful to wipe each fish clean to keep moisture away from the eggs, since water acts as a trigger that activates spawning, Freeze and Williams repeated the process. When the bowl contained perhaps 50 ounces of fish eggs, Williams wrangled a male, wrapping his thick arm around its slippery neck. Applying the same pressure along its lower abdomen, a steady stream of white milt rushed out, gently arching into the pool of eggs.

Roger Freeze, Mike's brother and a Keo employee, had wandered into the hangar behind us. Emerging unannounced beside the cart, Roger casually stuck his index finger into the

bowl, giving the mixture a vigorous stir. Picking up the bowl, Roger walked the concoction to a small lab table alongside the McDonald jars where he treated the yellow, now-fertilized eggs with iodine to kill any infectious diseases. Iodine also stained the eggs dark pink. Eventually, the fertilized eggs would be transferred to the McDonald cylinders where the hybrid eggs would live for two days before being transferred to the big tanks. There they hatch and, four days later, move to the outdoor ponds. The process is nearly identical for grass carp, the only difference being that carp eggs are placed in a hydrostatic pressure chamber after fertilization to fabricate that critical extra chromosomal set. Once this is complete, the triploid carp eggs head to the 1,500-gallon tanks. They hatch the next day and five days later begin life in the real world.

The process of producing sterile grass carp sounds simple enough. Start by filling a stainless-steel cylinder with a 50/50 blend of water and freshly incubated fish eggs. Next, insert a well-sealed brass piston into the cylinder and slowly apply pressure. In theory, the drastic change in air pressure the eggs undergo should disrupt the cells so thoroughly that an extra chromosomal set is created. This third set of chromosomes throws a fish's genetics so out of whack that producing viable offspring becomes impossible. Yet the process is a Goldilocks conundrum. Adjusting the parameters so they are *just right* is a major challenge: apply too much pressure (or not enough) for too long (or too short) a time and the batch is spoiled. Given the difficulty in perfecting the formula, researchers who manage to get it right guard the recipe jealously. Finicky though it is, this process of creating triploid fish using hydrostatic pressure works remarkably better than many of its alternatives. While more fish eggs die in the pressurized method, of those that survive, approximately 99.7 percent are triploid. But like I said — it just *sounds* simple.

Freeze only smiled when I asked about the spawning process he employed at Keo and offered only the flimsiest of details. "Every

farm has their own technology secrets." Even so, his techniques are so site-specific that if he did reveal his tricks a competitor couldn't use them successfully at a rival farm. Freeze has accounted for numerous variables, including pressure levels, timing of pressure and duration, not to mention fine-tuning for water quality, hardness and acidity. "All that has something to do with the egg and inducing the triploidy," he said. "If you took that [information] and went to another hatchery, it's probably not going to work as well there as it does here."

Freeze glanced at his watch. "Shoot. Come on, it's ten o'clock. Nikki's probably here."

<p align="center">• • •</p>

Auburn University researchers first began investigating the idea of non-reproducing grass carp in 1972, though it was Jon Stanley, a biologist at the U.S. Fish and Wildlife Service's Stuttgart lab, who initiated the first serious studies on how to produce sterile white amur around 1975. Stanley initially meddled with genetic crossings, his early work focusing on artificial gynogenesis, a fussy process meant to produce a group of exclusively female fish. He crossed grass carp milt irradiated by ultraviolet light with eggs from goldfish and Israeli carp, two closely related species. The effort failed. Three years later, armed with funding from the U.S. Army Corps of Engineers, Stanley determined that he could generate a same-sex population of fish by exposing milt to a 30-watt germicidal lamp for 60 minutes. The experimental spawning technique worked . . . though not as Stanley hoped. The yield was "too meager for mass production of monosex fish," he wrote, as only 20 fish per 10,000 eggs, a mere 0.2 percent, were viable. Most fish born of Stanley's monosex experiment *were* exclusively female, though all died within 12 hours.

Same-sex fish were a wash, yet Stanley's early research did set the stage for a breakthrough that came in 1978. Homer Buck, a

thick-mustachioed fish biologist with the Illinois Natural History Survey, had forged a friendship with Malone after obtaining research fish from his stock at the Joe Hogan hatchery. Both were insatiably curious about Asian carp. A constant traveler, Buck was alerted to Hungarian researchers who, in 1974, had impregnated female grass carp using bighead carp sperm. The resulting offspring contained three sets of chromosomes — a hybrid, whose genetic asymmetry, as we've learned, made it functionally sterile. While the Hungarians weren't able to manufacture a scalable hybrid, Buck may have thought the Americans could do better. In a portentous move, he had their research translated into English and mailed to Lonoke County.

Malone obsessed over the Hungarian study that arrived at his door. Believing it held the key to a commercially viable sterile grass carp, he spent days in a makeshift lab at his farm fiddling with hatching techniques. Shocking the eggs with near-freezing and then exceedingly hot water moments after incubation held initial promise. After tweaking the procedure for four weeks, never sleeping more than two hours a night, Malone claimed, the fine-tuning paid off. "I finally got them to the point where they'd live in commercial hatcheries," he told *Aquaculture Magazine* in 1979. With the help of Buck and Scott Henderson from the Arkansas Game and Fish Commission, Malone began rearing his new hybrid carp in captivity.

Yet something was off. According to Malone, despite the "short-lived and false assumption" about the early hybrid's success, "there was no magic in the union between bighead and grass carp to make triploids, as the Hungarians had indicated." Those early hybrid triploids he spawned displayed glaring deformities, with undeveloped jaws, too-short intestinal tracts and crooked tails. Yet tossing aside weeks of hard work, near-sleepless nights and what scant research existed on triploid grass carp was not an option. In May 1981, with the help of a young scientist from the Woods Hole Oceanographic Institute in Massachusetts, Malone

began tweaking the process further. Water temperature, pH levels, exposure duration — through minor adjustments, the percentage of sterile fish gradually increased. Once he was able to replicate sterility in two-tenths of 1 percent of his fish, the same meager success rate Stanley had with monosex fish, Malone saw a starting point that was "good enough." He threw the fish into commercial production. The barren hybrid wasn't a pure triploid grass carp as coveted, but Malone was certain enough that it wouldn't breed in the wild.

Soon high-level Fish and Wildlife Service and Bureau of Reclamation bigwigs met in Denver to hatch a plan to verify the sterility of Malone's hybrid fish, just as California approved a field test of his treasured sterile white amur in irrigation districts. The pilot project was urgent, given that a common canal herbicide, acrolein, was responsible for numerous fish kills in Golden State streams where irrigation water met natural waterways. With all systems go, state resource agencies heralded the hybrid a "break-through" in aquatic weed control. Malone's fish, known as the "F1 hybrid," was shipped to California, Florida and far-flung parts of Arkansas. Between 1979 and 1981, Malone's F1 cleaned irrigation canals, golf course ponds, public boat launches and citrus groves, spurred by state agencies that opened their wallets to springboard production and smooth public anxieties. Florida's Game and Fresh Water Fish Commission spent thousands furthering research on Malone's hybrid. Homer Buck's Illinois Natural History Survey paid $1.3 million to analyze the F1's commercial applications, while the Imperial and Coachella Valley water districts in California coughed up $1.5 million to investigate how effectively the hybrid could declutter clogged irrigation ditches.

The F1's popularity radically changed Malone's farming operation. He had always relished working with researchers yearning to study grass carp, throwing his farm doors open to visitors from around the globe. "They come here to learn how to spawn the white amur to go back to Nigeria and other countries in order to

be beneficial to their protein-poor nations," he told *Aquaculture*. But as the F1 leapt into production, Malone closed his facility to outside traffic to protect his investment. "I can't patent the process," he told reporters. It's "not secret because it's written in the literature, but the technique details are not published."

No one knew it then, but the F1 carried the seed of its own destruction deep within its manufactured genetic makeup. Some compared it to crossing a tiger with a rabbit. Over time, states began complaining that the hybrid fish was a picky eater, ignoring more troublesome weeds in favor of native vegetation that states wanted undisturbed. When Florida biologists discovered the F1 ate a third of what diploid grass carp ate, its deficiencies became impossible to ignore. Adding insult to injury, the hybrid also grew slower and died sooner than fertile grass carp. Despite Malone's best efforts, nagging questions persisted among state officials and conservationists worried whether the F1 was truly sterile. In Arizona, resource officials killed 5,000 hybrid grass carp purchased from private producers in California after analysis revealed many of the fish could be fertile. When a parasitic protozoon was found in a canal occupied by the hybrid carp, the state chose not to risk an outbreak, draining and chlorinating the waterway that spring. As word spread of its shortcomings, states gradually lost interest. Just three years after Malone believed the "breakthrough" F1 had answered his prayers, he and his fisheries confrères abandoned production of the hybrid grass carp entirely.

• • •

Despite its complicated success in turning grass carp milt and eggs into sterile, three-chromosomal fish, hydrostatic pressure had by the early 1980s only been used to produce sterile salmonid fish species. But when the juvenile body of literature on pressure shocking fertilized fish eggs to make any resulting fish functionally sterile landed on Malone's desk, he seized the potential. If it

could successfully induce sterility in grass carp, he believed, this method could put his white amur program back on track after the disappointment of the F1 hybrid.

Malone went back to the lab. He poured over the hydrostatic pressure literature and research on heat shocking of grass carp eggs to induce triploidy, most of which had emerged in 1981 from University of Washington biologist Standish K. Allen. While he refined his spawning techniques and fidgeted with variables like temperature and water pH, Malone purchased a $20,000 hospital-grade blood testing machine to verify chromosome counts. As he had in creating the F1 hybrid, Malone squirreled himself away for weeks. Finally, at a Fish and Wildlife agencies conference in Milwaukee in September 1983, Malone was ready. He announced his creation of the first commercial, non-hybridized triploid grass carp.

The news was like a rock chucked into the shallow pool of American fisheries management. Within months, the *Wall Street Journal* sent a reporter to Lonoke to interview Malone. "The sky's the limit right now," an ebullient Malone said of the fish's potential. And to crush any suggestion that his new triploid carp carried working genitalia, Malone was clear. "There's not a damn bit of doubt in my mind that it's sterile," he said. If states bought in, J.M. Malone & Son could charge a premium: $4 per triploid fish, $3 each for 1,000 or more. Years later Malone bragged of his discovery to the Imperial Valley Press in California, saying, "I did all the work on it. There are other people who have picked up on it so now we have competition." Though perhaps he was right to brag. For $1.5 million, a fraction of the $10.5 million price tag typically affixed to hydrilla control in the Imperial Irrigation District, less than 60,000 grass carp had eliminated nearly every ounce of aquatic weeds clogging their canals.

State agencies, those Malone had to convince of triploid carp's significance, finally took notice. Virginia, South Carolina, Florida and Georgia all approved the triploid fish. Yet two dozen states

that had banned grass carp before the triploid discovery held firm, despite sterile grass carp representing an environmentally friendly, non-reproducing biological control for nuisance aquatic weeds. Why?

Malone had a confidence problem. Producers like himself could insist their fish were sterile, but state fisheries managers had to believe them. Few did. By the early 1980s, silver and bighead carp escapes from state ponds, aquaculture facilities and perhaps sewage lagoons were public knowledge. And despite Malone's protestations, there was mounting evidence suggesting that grass carp had reproduced in the wild. Consequently, the aquaculture community's credibility had tanked, threatening to kill production of the one Asian carp that could still prove useful. Yet triploid carp were only effective as biological weed control if state agencies felt comfortable stocking them. What governments and producers alike needed was a cheap and effective way to consistently prove that Malone's sterile fish were, in fact, triploid, a universal standard to measure all triploid grass carp against.

Enter Bob Wattendorf.

Wattendorf arrived at the Florida Game and Fresh Water Fish Commission in 1979 to research the impact of non-native fishes on aquatic ecosystems, particularly walking catfish and tilapia. Many exotic species had arrived in the state via the aquaculture industry and, as in Arkansas, escapes were common. The public took note. Pop culture sources as varied as the *Tonight Show Starring Johnny Carson* and *National Geographic* were covering the spread of invasive species throughout America, though the dangers many posed to ecosystems remained largely unknown. A graduate of North Carolina State University, Wattendorf possessed a master's degree in fisheries science and a passion for aquaculture. Despite aquaculture's involvement in the spread of exotic fishes, he told me over the phone from Tallahassee, in the mid-'70s it was a "feel good arena. There was a lot of talk about aquaculture being the future of feeding human populations."

The need for certified triploid fish was growing. Just as Wattendorf joined the Florida Commission, the "grass carp wars" had reached their nadir. It became urgent once stiff amendments to the Lacey Act were implemented in 1981. Dating back to the first years of the twentieth century, the Lacey Act was intended to help state resource officials crack down on illegal bird and wildlife hunting by restricting animal transportation between states. It also empowered agricultural agencies to halt the importation of foreign species. But over decades, amendments to the act had eroded its original intent. Seismic shifts in 1969, part of President Richard Nixon's tough-on-crime agenda, created fierce criminal penalties. However, the act did allow judges to consider the mindset of someone accused of violating the law to determine if they had "knowingly" or "willfully" committed a crime. Sentences were routinely commuted if crimes were found to be accidental, like unintentionally including a diploid grass carp in a shipment of triploids.

Not so after 1981, when the idea of considering the accused's mindset was discarded. Fines and penalties for rulebreakers were jacked up. The Reagan administration, vowing to give the Lacey Act "teeth," ensured that anyone could be charged with felony-level criminal offenses for "knowingly" importing or exporting restricted plants or wildlife. Individuals were fined $250,000 ($500,000 for organizations) and faced prison terms of up to five years. The new rules also stated that "each violation shall be a separate offense," meaning dozens of individual specimens in a crime could lead to separate charges being applied to each specimen involved, resulting in hefty jail time. Unsurprisingly, the Lacey Act remains something to be feared. "You're better off trafficking in cocaine than to move any fish — not just Asian carp, but any fish — across state lines illegally," Freeze told me. Not for nothing does he tack up a copy of every state's regulation for grass carp beside his desk. It's a bible. "I don't want to be a federal felon," Freeze said, a real possibility should he move fertile grass carp, knowingly or not, into restricted states.

Not all his colleagues were as dutiful. Bill Whiting, a Sheridan, Arkansas, fish farmer, was ordered to pay $200,000 in the early 1980s with his son-in-law Gary Sisk for illegally transporting diploid grass carp to Louisiana and Wisconsin. Whiting served four months in a federal prison while Sisk got nine months for selling diploids illegally to farmers and golf courses. Whiting had done this knowingly. He was adamant that people needn't worry about diploid grass carp and that state laws banning their use were unjustified. "I was never secretive about the fish because it was imperative that the public be made aware of a safe method of removing algae and weeds," he told reporters when the story hit the press. It was wrong to break the law, he felt, but the end justified the means. Whiting and Sisk were captured in a sting operation by state wildlife agents in Louisiana. Later, they eluded surveillance by shipping grass carp to Minnesota and Illinois for Wisconsin clients to drive across state lines to pick up. "It was a flagrant ignoring of the law," noted Fish and Wildlife agent Richard Dickinson, who worked the case. Whiting and Sisk "displayed more intent to violate the law than in any case I've worked on."

At the Florida Game and Fresh Water Fish Commission, Bob Wattendorf wasn't saving the world from hunger using aquaculture as he once imagined. Yet he would end up contributing to U.S. fisheries research in a remarkable way by pioneering a technological breakthrough that ultimately paved the way for sterile grass carp's use nationwide.

Researching exotic species in Tallahassee, Wattendorf's mind wandered one day to the Coulter counter and its potential application for fisheries research. Developed by Arkansas native Wallace H. Coulter and his brother Joseph to count human blood cells, the Coulter counter electronically counts and sizes particles suspended in fluid. Modern Coulter counters resemble a narrow microwave (or a huge coffee maker) attached to a computer monitor. The front features a small protrusion like the tip of a turkey baster called an aperture that slides into a plastic container called

an accuvette atop a movable platform. This shot glass–sized cup is filled with a clear electrolyte solution. Coulter's method focused on the simple fact that red blood cells are poor conductors of electricity: pull a blood cell through an orifice containing an electric current (precisely what happens when the aperture drops into the accuvette) and the cell will deflect the current rather than conduct it, creating a disturbance in the electric field. Imagine that field as a straight line; pull a cell through it and the line jumps. The bigger the jump, the bigger the cell. Wattendorf held a simple hypothesis: if you pulled triploid cells through a Coulter counter, the resulting jump in the electric field should appear greater than a blip produced from diploid cells, which have a smaller and more traditionally oval-shaped nucleus.

As a student at North Carolina State, Wattendorf had financed his college education by working in sports medicine. It was here he first encountered the machine his colleagues were using to analyze blood samples from runners to determine differences in the size, number and shape of red blood cells between average folks, long distance runners and sprinters. By 1983, aware of the ongoing struggle over the stocking of grass carp in many states, including Florida, Wattendorf recalled his schooltime job and called the Coulter's manufacturer. After explaining his idea for using the counter in fisheries research, the company, headquartered in Miami, sent a representative along with a device. Together, they determined the technology was able to process fish samples quickly and accurately.

Word spread. In 1984, the U.S. Fish and Wildlife Service contacted Wattendorf, asking him to demonstrate how the counter evaluated ploidy. If the analysis worked as he believed it would, and if higher-ups at USFWS approved, Wattendorf would also be asked to train their staff on its use. Hearing this, Malone believed Wattendorf had uncovered a solution to his problem of how to gain widespread state and federal recognition for his triploid fish. He bought a counter and invited Wattendorf to show him the

ropes. While in Arkansas, four other grass carp producers also asked him to train their staff in using the device.

The Coulter counter was a revelation for Malone: a simple, accurate and low-cost system for determining ploidy. He must have been relieved. Not only did using the Coulter to measure triploidy work, but it was efficient. And cheap. Three or four people working for eight hours could analyze the chromosomes of 1,600 fish, Wattendorf reckoned, at a labor and supplies cost of anywhere from eight to 20 cents per fish. While the Coulter counter could set a producer back $18,000 (in 1984 dollars), at $4 per fish, they could hope to recoup their losses selling just 4,500 fish. All of which led Malone to beam in the pages of *Farm Pond Harvest* that "a solution to the grass carp controversy is at hand." With this discovery, "states and the federal government are in position to demand a 100% triploid grass carp program," he wrote, a long-awaited reality realized by "unsung heroes" like Wattendorf and Standish K. Allen, whose initial work on hydrostatic pressure shocking set triploidy in motion.

On December 2, 1985, the U.S. Fish and Wildlife Service's grass carp chairman officially approved the stocking of triploid grass carp. Any unwanted impacts on native aquatic plants would be as short-lived as the fish itself, the chairman, Robert E. Stevens wrote; there was now "no compelling reason" to prohibit certified triploid stocking in open or closed water systems, given that their presence "will result in no adverse impact on the environment." Within a year, Fish and Wildlife had taken steps to become *the* agency to certify all triploid carp made in America, despite early concerns from staffers at Stuttgart that any verification program would be time consuming and costly. In September 1985, Drew Mitchell, still with USFWS, had studied the Coulter method and incorporated it into the service's protocol.

States were eager for certified grass carp. California, North Carolina and Florida signed up for the federal program before it even launched. Grass carp were legal in nine states before triploid

carp were created. Once Fish and Wildlife agreed to authenticate fish sterility, that number more than tripled to 30 states.

Fish farmers would be lucky to get five years out of the certification program before it inevitably imploded, Mitchell believed. Grass carp were so controversial, he told me when we met in North Little Rock, that something was bound to scuttle the whole program. One issue nearly did. Doubts about triploid's true sterility haunted the industry throughout the 1980s. "None of us could get to one hundred percent" triploidy, Wattendorf says. Sam Finney, a Fish and Wildlife Service grass carp inspector in Carterville, Illinois, tells me that a degree of faith has greased the certification program's wheels from day one. When producers like Freeze tell USFWS they've prescreened every fish before inspectors conduct their analysis, the service takes them at their word. In testing just 120 fish of a batch that could contain thousands, Fish and Wildlife Service inspectors are seeing only a statistically representative sample, one they believe speaks for the entire lot. It just isn't feasible for USFWS to test every single fish that leaves a triploid producer's farm.

• • •

Nikki was waiting near the front office when Freeze and I approached. Susan "Nikki" Persons is a grass carp inspector with the U.S. Fish and Wildlife Service, the only USFWS employee devoted full-time to triploid grass carp inspection. A fisheries biologist by training, Persons began her career as Drew Mitchell was concluding his work with the certification program. She now shares office space in Mitchell's alma mater at the Harry K. Dupree complex in Stuttgart, the very place where Asian carp got their start in America. Aside from minor variations, the inspection program Mitchell created remains the same system used by Persons today. From the Dupree station, her seal of approval makes or breaks the salability of Arkansas's grass carp industry.

"It's a horrible feeling to fail," Freeze told me as he and two colleagues prepared their fish for testing. "You'll know if we fail today 'cause you'll hear all sorts of cussin' and hollerin'." Fail five times in a season and you're out of the program.

A short woman with close-cropped brown hair, Persons oversees certification of four Arkansas producers on Mondays, Wednesdays and Fridays. It's a lot of time driving, but she has her routine down. Some farms are two and a half hours apart, time she passes in her compact car listening to Southern gospel, talking on the phone and pit-stopping on Highway 49. Most triploid producers have been in business for decades, she said, so inspections typically run smoothly. Though not everyone is on the ball. One new producer failed their first inspection, Persons told me, based on multiple production problems. "That was the longest inspection I've ever done." She laughed. "Bless their hearts, but they didn't last." Overhearing us, Freeze chimed in. "Makes you worry for the future of the industry," he said. Persons nodded silently. Failing one inspection wasn't always a devastating proposition. These days, a $500 first-time failure fee that escalates quickly to $10,000 hangs over producers, as do the additional huge fines and jail time for violating the Lacey Act. With that, Freeze shouted that he was ready. Persons and I headed into the lab.

"Lab" is a generous term for the small space tucked into a corner of Keo's kitchen. A half-eaten birthday cake sat unloved on the counter. Hundreds of accuvette cups were stacked in boxes atop a small supply fridge beside the staff's food refrigerator. A desk ran the length of one wall, holding the Coulter counter and a small monitor. There was space for two chairs. Freeze pulled up in front of the Coulter while Persons positioned herself in front of the screen, a clipboard stuffed with papers on her lap, pen poised.

To their right, a door led to a crowded room tucked between the lab and the open-air structure containing the color-coded raceways. Here, grass carp awaited final say from Persons, who would determine whether they would move to a forever home

or if a diploid in their midst would waylay their plans. In this narrow space, cluttered with tanks and fish and banged-up rolling carts, Freeze's two assistants assembled a collection of 120 fish, that statistically representative sample of the whole lot, in a temporary holding tank. Above it, a slide ran through the wall that emptied into a yellow-tagged raceway. Atop a rolling cart sat a homemade tray roughly three feet long and 12 inches wide made of white PVC piping. The contraption was partitioned into 10 slots like a starting gate at the horse track. Each slot featured a number from one to 10 printed in black magic marker along the rim; the floor was sealed with a fine white mesh that allowed water to fill almost to the brim. On Freeze's word, his assistants nabbed 10 fish from the tank and dropped one into each numbered slot.

The men worked in tandem. One grabbed a fish and, jabbing a needle under its chin, pricked the juvenile grass carp to collect its blood. The needle was placed into an accuvette containing saline solution and zap-oglobin, a chemical that breaks down a cell membrane's outer wall, making it easier to measure the size of the nucleus. The other handler placed the accuvette on a black plank with 10 holes marked one to 10, samples corresponding to the fish from which the blood came. Once full, the plank was walked into the lab and placed gingerly on the desk where the certification would begin.

With skill and experience, Freeze placed an accuvette on the Coulter counter's sliding platform. He lifted the cup, dipping the aperture into the blood mixture. In a flash, a bar graph appeared onscreen showing red lines of various heights. Together they're little more than a crimson blip, the tallest lines indicating the size of the nucleus being pulled through the counter's electric current. Each cell's nucleus is measured in microns. Diploid nuclei come in at 2.6 microns or smaller, while triploid nuclei measure 3.2 microns or bigger. "Triploid," Freeze said.

Before I register what's happened, Freeze slid the platform

down and placed the now-tested accuvette representing Fish 1 back on the plank. He seized sample two and slotted it in place. Pushing the platform up, the fresh accuvette hit the aperture and a new reading darted across the monitor. "Triploid," he said. Persons checked something off in her notes. It was a fluid motion, an integration of human and machine as his arms moved robotically between the Coulter and his sample cups, forcing blips to appear rapidly on screen, the testing software shouting "Triploid" or "Diploid" in red or green font.

"Triploid." Pause. "Triploid." Pause. "Triploid."

The first 10 samples spotless, Freeze's assistants sent that batch on the water slide, through the wall and into a yellow-coded tank. As Freeze tested this set, his assistants had prepared a second congregation of 10 fish to keep the process moving swiftly. They passed him another flight of fish samples and got to work preparing the next set. The process started again.

No one anticipated finding a diploid — they're extremely rare. Only once that morning did Freeze see a reading that perturbed him; it's wasn't diploid per se, but something about the nucleus size unsettled him. He asked Roger to take another sample from Fish 5. The new accuvette was run. His shoulders eased. The result was what he expected. "Triploid."

• • •

Fears over triploid sterility have some basis in fact. Researchers from the U.S. Geological Survey studied the ploidy of grass carp certified sterile and found the Coulter counter possessed an error rate of 0.25 percent. Put another way, one out of every 400 fish passing through a Coulter may be misidentified. (Mike Freeze, however, contested this figure, telling me he estimated it was closer to one out of every 200,000 fish that may, in fact, be diploid despite a triploid reading from the Coulter.) An earlier study predating the USGS analysis found that very low egg production in

triploid females makes them functionally sterile, yet some triploid males continue producing enough viable sperm that could render sexually capable offspring. To counter any chance of sterile fish slipping past their inspectors, the Fish and Wildlife Service has built in a 5 percent margin of error, well within the 0.25 percent error rate calculated by the Geological Survey. But scale is critical. Between 1985 and 2006 alone, 7.5 million triploid grass carp were certified by USFWS and shipped to 30 states. If one of every 400 fish were misidentified, upwards of 18,750 grass carp that could, at least in theory, reproduce were sold as certified sterile.

This uncertainty doesn't bother many working within the program. Coulter counter pioneers Bob Wattendorf and Standish Allen called the potential for reproduction with triploids "infinitesimally small" in a 1987 journal article before reminding their readers that few alternatives to grass carp are risk free. Herbicides carry their own hazards, they wrote, as Rachel Carson, almost three decades earlier, had chronicled so well. Drew Mitchell was equally blunt. "For some people any chance [of reproduction] is way too much," he told me. "And if you're dealing with that, you might as well put a gun to yourself and shoot." For an errant diploid to mate in this scenario, fish would need to find each other and have access to a suitable stretch of river to reproduce, a rare (but not as rare as we may hope) occurrence we'll examine in chapter 11. The odds are indescribably low. Certification isn't perfect, Mitchell says, but it reduces reproductive fish in the wild while allowing states and private companies who benefit from grass carp to have accountable, legal access. "We have a statistically valid and well vetted program," Sam Finney of the USFWS says, "that gives us a high degree of certainty."

By July 1988, 17 states had signed onto the program, relying almost exclusively on Drew Mitchell to conduct 175-plus inspections every year, certifying 357,000 fish annually. It was too much, both physically for Mitchell and cost-wise for the service. Mike Freeze believes that Fish and Wildlife was also hesitant to fund

any program that put money in the pockets of private companies like his and Malone's. "Our response was 'It's not us you're benefiting, it's all the state fish commissions you're benefiting,'" he told me. Once expenses exceeded $150,000 annually to accommodate the expanding program, the service balked. It was an untenable sum to pull away from other environmental endeavors without new sources of revenue.

Yet as more states climbed aboard, more irrigation canals, public fishing ponds, golf courses, hydroelectric facilities, municipal drinking water intakes and farmers countrywide needed aquatic weed-eating grass carp. Strip states of triploid verification and resource officers would doubtless have no choice but to regress to the herbicide-happy days of postwar pest management. The certification program shut down in February 1994 and reopened, seesawing on its tenuous financial footing until 1995. Producers had long told the federal government they would foot the certification program's bill, but strict congressional rules meant only the U.S. Congress could authorize such payments. Freeze, Malone and others began calling senators, congresspersons and state agencies likely to be impacted, asking them to call up *their* senators and congresspersons. The resulting letters in support of grass carp certification worked. With the passage of joint bills in the House and Senate, Fish and Wildlife were finally authorized to collect "reasonable fees" to cover their expenses.

In a bizarre departure from expectation, carp producers in small-government, don't-tread-on-me states actually *wanted* the greater regulatory oversight and legitimacy afforded by federal certification. It was the only way their industry could survive. Paying Washington $0.36 per fish was a small price to ensure a majority of states felt comfortable purchasing and stocking triploid grass carp. Grass carp industries flourished in producer states like Missouri, Florida, Alabama, Arkansas and Illinois. Forty-one states currently permit triploid grass carp use, so the program must still provide an important management tool.

And it may be poised for growth. In April 2017, a U.S. Court of Appeals ruled in favor of the United States Association of Reptile Keepers in their legal battle with the Interior Department and the U.S. Fish and Wildlife Service over what injurious species listed under the Lacey Act could be transported across state lines. This ruling opened the door to increased breeding and sale of various python and anaconda species and loosened rules regulating the interstate transfer of Lacey Act–listed species. The ruling could apply to triploid carp and allow breeders to ramp up production. "The safest thing was for a farmer to stay small and not expand into interstate commerce," Mike Freeze told *The Fish Site*, an online source for fisheries news, after the court ruling was published. "Since there was no way to know all of the various state laws, you were constantly worried about being punished for some accidental movement of an injurious species." Negotiating the "ever-changing regulatory environment that impacts U.S. aquaculture on a day-to-day basis" is the single largest challenge he faced as a carp producer, Freeze told reporters. With this ruling, fish culturists no longer had to fear federal felony charges if an errant diploid carp ended up in a catfish shipment leaving Arkansas for processing in Mississippi. "This is actually a huge victory for state rights," Freeze said; he might have said the same for fish farmers.

• • •

Louisiana was calling. Southeast of Lonoke under dusty skies, I drove the invasion pathway. Put a marble on these highways and it won't roll, the ground a cheesecloth of level, porous buckshot. I gave up counting bridges over water channels so narrow I couldn't see through thickets of bramble growing along their banks to the stream below. Whizzing past, they appear trivial, but these are the bayous Asian carp first swam to reach the Mississippi River. This was ground zero.

While Malone pressed ahead with manufacturing sterile grass carp, silver and bighead carp languished as in-lab test subjects for sewage lagoon treatment. Though they flourished in the wild. Any hopes of containing the abandoned bigheaded carps were dashed by the time the Fish and Wildlife certification program began. Even as the ill-fated F1 hybrid enjoyed its brief fame, Freeze, then employed by the Arkansas Game and Fish Commission, reported in January 1980 that numerous silver carp had been caught by fishermen at Crooked Creek in northeast Arkansas County. This was suspiciously close to the Stuttgart lab and two private hatcheries (including Malone's) known to possess silver carp. Arkansas had prohibited the release of silvers and bigheads in the mid-1970s, but the ban was too little and too late. In February 1980, fishers contacted the AGFC to inform them that hundreds more silver carp were caught near Crooked Creek and at a lock and dam on the Arkansas River. It revealed a clear distribution pattern: 158 of 166 silver carp reported caught were nabbed directly downriver, Freeze wrote, from "one or more of the three hatcheries located in central Lonoke County." But it was not confined to Lonoke County. By then, bigheaded carps had been found in the Arkansas and White rivers. So too in the Ouachita, Black, Red, Atchafalaya and Mississippi rivers flowing ceaselessly through Louisiana to the Gulf of Mexico, waterways I was soon to explore.

• • •

The elder Jim Malone, the man who understood white amur perhaps better than anyone else ever has, had, midway through his career, come to understand that the bigheaded carp he had imported to Little Rock were a dangerous new addition to the country's waterways. Years later, Malone would reveal his deep reservations about stocking silver and bighead carp, admitting to a Quad Cities, Iowa, fisheries conference in 1983 that both species

feed far enough down the food chain that they would thrive in the wild on the same nutrients relied on by native fishes. Bighead would outcompete bigmouth buffalo for food, he noted, while silvers would reduce shad populations dramatically. By all accounts, even then it was too late to prevent the destruction he predicted.

CHAPTER 4

Research Backwater

THIBODAUX, LA — The dead opossum floated past as we disembarked for lunch. The first paddlers in our hundred-strong posse had seen the decomposed marsupial earlier as they put in on Bayou Lafourche (pronounced la-FOOSH) near Donaldsonville, 40 miles southeast of Baton Rouge. That morning, under TV static skies, Leroy Sullivan Sr., mayor of Donaldsonville, offered our Gore-Tex-coated crew a ceremonial send-off. Piling into canoes and kayaks and onto paddleboards, a bidding of land goodbye.

Weeks earlier, I had been invited by Michael Massimi to paddle Bayou Lafourche with the Barataria-Terrebonne National Estuary Program (BTNEP) on their annual four-day, 52-mile voyage. As the invasive species coordinator for BTNEP, Massimi felt there was no better way for me to witness the effects of invasive species, freshwater diversions and dredging in the estuary than to get out on the water. I agreed and hoped four days paddling the bayou would do me good after days spent navigating Arkansas fish farms by car. Little did I know I'd be seated between Massimi and Andrew Barron, BTNEP's water quality coordinator. I plopped onto the wide canoe bottom, awkwardly folding my legs. The teasing I got from fellow paddlers was as joyfully relentless as it was warranted. *Must be nice! Where do I sign up? No one gets a*

free ride! But I put the unexpected idleness to good use, taking in southern Louisiana in all its humid, down-on-its-luck charm. Wildlife viewing — including silver carp — was a distinct possibility, Massimi told me. Though the bloated opossum likely wasn't what he had in mind.

A thousand years ago Bayou Lafourche was the main channel of the Mississippi River. Despite the Big Muddy's constant meandering, residents settled along its porous banks. By the mid-twentieth century, their descendants were anxious about frequent flooding, and they coerced the Army Corps of Engineers into damming the bayou. Subsequently, water levels in Lafourche are anything but natural, having been regulated by a pump station in Donaldsonville since 1955. Today, one proposed plan for the bayou would boost its flow to 1,000 cubic feet per second. "It's an attempt to get back closer to the historic flows in Lafourche," Barron told me — think of it as a reintroduction, and "not a typical diversion."

Currently, an average of 300 feet of water flows in from the Mississippi each second through 27-inch-wide pipes. Pipes just large enough for Asian carp to pass through.

At first glance, Lafourche looks like little more than an industrialized channel to ferry excess river to the Gulf of Mexico. Its brown, sluggish water chugs beside Highway 1, past hardscrabble shacks, agricultural fields and the back end of homes and auto shops. Abandoned dredging equipment juts out from the surface of the bayou like mechanized icebergs. Snarling dogs bark at paddlers from behind chain-link cages. The dogs aren't the only ones unaccustomed to seeing boaters on the bayou. Curious locals toss us brightly colored Mardi Gras necklaces by way of saying hello despite paddle-waving protestations from Massimi and Barron. They fear turtles and fish will think the errant, shiny plastic beads are food. Others wave at us lazily from gazebos on well-manicured lawns — though most simply ignore us. Plenty around here have docks, though in a state where everyone seems to own a boat, few

locals keep their vessels to navigate the bayou. The days of visiting the neighbors by water have passed.

The bayou's struggle with modernity is, in many ways, emblematic of the challenges facing waterways throughout Louisiana. "It's typical of Louisiana's ecology," Massimi told me as we floated lazily downstream. Yet to paddle Lafourche and see only discarded beer bottles and invasive plants misses what makes it so quintessentially natural by Louisiana standards: it's an ecosystem, degraded and managed by human hands, that is still thriving. Despite its regulated flow, the bayou — and the larger Barataria-Terrebonne estuary — remains home to 100 fish species, a dozen kinds of frogs, 150 local and migratory birds, 20 nonvenomous (and four venomous) snakes and 12 bat species. Bobcats, armadillos, beavers, alligators and the aforementioned opossum make the region home. Dolphins and manatees have been found in the coastal estuary; even panthers are rumored to be coming back.

Greeting these legions of native and nativized species, however, are a host of invasives that have profoundly restructured the estuary's food web and habitat. Alongside Asian carp are plants like water hyacinth, hydrilla, Chinese tallow and Japanese privet, and creatures such as the Asiatic clam, the apple snail and red-bellied duck. I lost count as Massimi rattled off invasive plants and organisms taking over the estuary. We never paddled long before he slowed our canoe to examine a tangle of submerged vegetation. His prognosis was seldom good. Yet Massimi's suspicion that a litany of invasives were radically altering the estuary's ecology is, without studies to confirm his hypothesis, simply conjecture — a kind of worst-case scenario.

There are worrying ecological shifts. Blue crab populations are declining. These crustaceans eat zooplankton — the same microscopic material that silver and bighead carp eat. Later, I asked Louisiana Sea Grant marine biologist Julie Anderson Lively whether zooplankton levels are dropping in the face of competition from invasive carp in brackish waters. "That's been

a large question: 'Isn't someone tracking zooplankton?' Well, not really," she told me. Someone would need to fund that research, and studies needing boats aren't cheap. "In terms of impacts," Anderson Lively said, "we know very little. The research doesn't exist." What data we do have suggests fishers are reporting more Asian carp at commercial landings. And an abundance of big-mouthed adult fish gulping down huge quantities of phyto- and zooplankton is paralleled by the reality of fewer shrimp, crab and fish eggs maturing. But correlation, as we know, is not causation.

Veteran biologist David Schultz from Nicholls State University believes the absence of data on Asian carp's impact on southern waterways has been interpreted to maximize the catastrophe. We think the damage these fish have caused in northern waters like the Illinois or Upper Mississippi River is being replicated in Louisiana, he said when we talked. "But how can we know? We're kind of a research backwater, so I can't tell you there's been certain ecological impacts . . . because that work hasn't been done." Ask Schultz his nonprofessional opinion, however, and he echoes Anderson Lively and Massimi's fears. "Each one of those fish is consuming quite a bit of chlorophyll on a daily basis." Those nutrients Asian carp consume would otherwise be available for native species. How could the presence of fast-breeding, big-appetite fish *not* have meaningful implications for their aquatic neighbors?

No one knows the extent of the damage. The only federal cash trickling down to combat Asian carp are meager grants of around $20,000 spent conducting truncated research, scaled to fit slim funding parameters. Even federal giants like the U.S. Army Corps of Engineers have come, cap in hand, to small players like BTNEP seeking grants of a few thousand dollars to complete invasive species assessments. The Louisiana Sea Grant, meanwhile, part of a national research organization funded one-to-one by states and the National Oceanic and Atmospheric Administration to study marine and freshwater issues across America, has been stymied securing funds. Anderson Lively submitted a project recently to

study regional impacts of Asian carp in estuaries. "We tried getting money, and basically the message we've always gotten down here is, 'You have a problem, but since you've had the problem for so long, it is what it is. It's not as big of a problem as the Upper Midwest has.'"

Michael Kaller, a researcher at Louisiana State University's School of Renewable Natural Resources, agrees. "Herein lies [a] pronounced difference between Louisiana and the Midwest; we simply have less data," he says. "The data poor remain data poor because they do not have the data to justify the need for more data."

•••

I had one last stop before leaving Arkansas. Ninety-two of the White River's 720 miles flow through the White River National Wildlife Refuge, a 160,000-acre boomerang of land eight miles north of where the White River meets the Mississippi. Three hundred oxbow lakes are the dominant geographic feature in the refuge. Here, the Mississippi shows signs of its constant movement: as the river erodes its banks, u-shaped meanders form that grow deeper with time. As the horseshoe becomes more pronounced, the neck of land between bends in the river grows narrower until it finally caves. Cut off from the river, the once-vibrant meanders sit dormant, waiting, like lost children, for the river to come collect them.

Oxbows are best seen from above, taking in the breadth of historic twists lacquered on the earth like gobs of oily paint. It's the river as it once was, the river as it could become again. Oxbows, coupled with seasonal flooding of the Mississippi delta, are the lifeblood of the refuge. Nutrients are cycled into dry areas this way, forming habitat and offering food for juvenile fish. Bigmouth buffalo, alligator gar, paddlefish and channel cats share the river and its on-again, off-again oxbows with an array of freshwater

mussels with names like antique furniture styles: the washboard, the mapleleaf, the ebony shell, the pimpleback.

It's the White River I came to see — or, more accurately, its intersection with the Mississippi. That these waterways meet is a simple act of hydrology, a footnote in the Mississippi basin's larger-than-life story. Yet this basic fact is a chapter in the history of Asian carp in America, a geographic quirk that made the White River integral to their continental spread. Here, if anywhere, a historic benchmark of their interaction with native flora and fauna should be found.

Or so I thought.

I arranged to meet U.S. Fish and Wildlife Service biologist Jay Hitchcock at the refuge to learn more about this invasion pathway for Asian carp. While I waited for Hitchcock to emerge from a meeting, I explored the interpretative center, walking past paper-mâché bald cypress trees and taxidermied brown bears. I looked in vain for references to Asian carp or mention of *any* invasive species.

Hitchcock and I soon grabbed chairs in an empty classroom. Stuffed alligator gar hung cheek by jowl with educational posters showcasing popular Arkansas sport fish. I asked if he knew how Asian carp had modified habitat or food supplies for native organisms in the refuge, assuming historic details here could shed light on what other areas may expect in future. He smiled sheepishly. "We don't know," he told me. Not long ago, Hitchcock had developed a study to examine the impacts invasive carp had on the White River's ecology. Yet neither USFWS — whom he works for — nor the Arkansas Game and Fish Commission agreed to fund the project. He never discovered why.

We were joined by Dale Singleton, a commercial fisher and Fish and Wildlife adjunct who's worked at the refuge for many years. Singleton told me that commercial fishing has been poor in the region for the last decade or more. Gizzard shad numbers were low, he said, which is especially worrying. While not a keystone species, shad feed on the same plankton that silver and bighead

carp eat and are essential as prey for sought-after trophy fish like largemouth bass. This makes their population statistics valuable: low shad numbers point to high-predation or fierce competition for food. Without shad, predatory fish will starve, taking a bite out of the $517 million in retail sales that Arkansas reaps from sportfishing. Sampling found no shad in 2014, a troubling absence Singleton and fishers he knows anecdotally attribute to fierce competition with Asian carp. "We don't know what to do about it," he confessed to me. Singleton knew that carp were present in the refuge. When floodwaters leave oxbows behind, he's witnessed the eerie sight of foot-long silver carp thrashing through the forest, searching for the river that deserted them. It's just a matter of time before Asian carp make the White River as degraded as the Mississippi, Singleton said. "There's no doubt in my mind carp will get worse here. Not a doubt."

I set out for Weber, Arkansas, where La Grue Bayou meets the White River. I drove into this two-lane town past dilapidated motor homes and the rusted hulks of cars and boats until the road dead-ended, crumbling into La Grue a few hundred yards north of the White. Water levels were high, rushing over and past the decaying gray asphalt. Roads nearby were closed due to flooding; this was as close as I could get to that aquatic intersection in my car. Swatting at shrouds of mosquitoes, I stepped aside as two old men backed a weather-beaten boat into the fast green water. I waved at the pair. "Mornin'," I said, dropping my *g* like an asshole. "You guys ever see any Asian carp around here?"

One man stepped closer. "Shit," he said, "Asian carp's all through these waters." As we talked, he confirmed Singleton's opinion — the local gizzard shad fishery had bottomed out.

The old-timer's casual comments certainly weren't empirical evidence. Of course it's anecdotal, but locals know these waters well, having lived beside and fished in them for generations. They are shrewd observers of the ecosystems they frequent, and statements like this are often used by wildlife officers to gauge the

population size and movement of an invasive fish. This old man's lived experience (and that of others like him) remains some of the best information available about the prevalence of Asian carp throughout the South. According to Duane Chapman, a fish biologist with the United States Geological Survey, while the Missouri River is choking on Asian carp, no substantial studies have been completed looking at their impacts on other freshwater fish. "All we know is there are a crap load of Asian carp," he said. Larger trends, those backed by scientific studies, the kind that are robust enough to base policy on, simply don't exist. According to Hitchcock, the Asian carp's impact in the refuge is "a big unknown." They come in, but where do they go?

Many swim south. Grass carp were first reported in Louisiana in 1976 with silvers and bigheads following as Ronald Reagan began his second term. By the mid-1990s, both fish had surpassed grass carp as reported by fishers at commercial landings, totaling tens of thousands of pounds of fish hauled from state rivers and lakes; by the early 2000s their dominance at local landings was near absolute. Far more of the fish are caught than are sold to local buyers. Their spread into the Pelican State was gradual compared to the rapid shift into the Upper Midwest. But once active in Louisiana, Asian carp moved quickly into the Mississippi, Red, Atchafalaya, Ouachita, Sabine, Barataria and Terrebonne watersheds. New Orleans is surrounded. Silver and bighead carp swim in Lake Pontchartrain and the Pearl River north of the city, in Davis Pond to the west and in the Caernarvon Freshwater Diversion to the southeast. In 2014, Louisiana resource officials detected silver and bighead carp larvae in a quarter of the 572 water samples they collected in the state's largest rivers, making them two of Louisiana's most dominant species. It also confirmed their reproductive capabilities. While the sampling provided only a snapshot of state waterways, the image was clear: along the Gulf Coast, Louisiana-born Asian carp swim from Texas to Mississippi. These are no longer just hatchery escapees.

This fate wasn't preordained. Louisiana's flooded backwaters remain inundated well into the summer, causing water temperatures to reach 86°F. This is much higher than the 77°F Asian carp prefer; at 86°F they find it hard to breathe. What's more, Louisiana rivers run low for long stretches of time, creating fish-trapping dry spells that can last for years. Add to this a shortage of contiguous back-waters and side channels in the state, and it's led some researchers to believe that Asian carp could have been contained to rivers with open connections to Arkansas waterways.

But spread they did, fully and completely throughout the state. For answers, we need to look at Louisiana's manufactured river-ine topography, a landscape that, radically altered from its natural state, has become an invasion highway for non-native organisms.

• • •

Louisiana's oil and gas sector, more than any single industry, has driven these monumental landscape alterations. They know it. The state's fossil fuel sector estimates their drilling activity has destroyed 720 of the 2,000 square miles of coastal land lost in the past century — roughly 36 percent. The Department of the Interior, meanwhile, pegs their liability closer to 60 percent.

The state's first commercially viable oil well came online in 1901. Within a decade, producers secured oil and gas conservation legislation from the state, laid the first mile of natural gas pipeline, built one of the largest refineries in North America near Baton Rouge (now owned and operated by Exxon) and discovered how to drill over water on Caddo Lake near Shreveport. Yet the oil and gas exploration most evocative of Louisiana today is that done far offshore, a technological feat which became feasible in 1947. Constructed by former oil giant Kerr-McGee, the state's first off-shore rig was built in the Gulf of Mexico 45 miles south of Morgan City near the mouth of the Atchafalaya River. Rigs soon spread throughout the Gulf like measles and pushed farther below sea

level, eventually reaching depths of 6,000 feet or more. The age of offshore drilling had begun.

The terrain that offered billions in corporate profit and thousands of jobs soon threatened to take it away. Transporting equipment for offshore rig construction was punishing for such swampy coastline. Expensive too. One solution was to cut a vast network of canals — some 10,000 miles in total — to float equipment to the rigs while simultaneously creating a corridor for natural gas pipelines. Often these pathways were sliced through freshwater marshes on private land dotting the coast. No channel was larger than the Gulf Intracoastal Waterway. Completed in 1949, the 1,050-mile waterway allowed ships to freight through fragile marshland at a consistent depth of 12 feet or more. From Carrabelle, Florida, through Alabama, Mississippi and Louisiana to Brownsville, Texas, the Gulf Intracoastal connected fossil fuel companies to deepwater ports and major rivers throughout the Gulf. Huge stretches of Louisiana coastline, meanwhile, were severed from the mainland.

But rigs don't need constant repair; some close down. In July 2010, the Associated Press revealed that more than 27,000 rigs lay abandoned in the Gulf, some dating back to the 1940s. Few, if any, knew who bore responsibility for managing their demise and checking for leaks. As oil companies suspended operations, canals built to construct now-derelict rigs were left intact. Industry walked away from damages they wrought with the complicit acquiescence of the state. These channels remain, permanent reminders of the lengths Louisiana went to accommodate the oil and gas sector, scars tracing a wounded landscape. "Those canals became nice conduits for saltwater," says Nicholls State biologist David Schultz.

The first signs of trouble appeared in the 1970s. Decades after the first canals were cut, freshwater plants in coastal marshes weakened. When they are healthy, coastal marsh plants perform the herculean task of anchoring soil against the onslaught of wind

and waves. Without them, southern Louisiana's coastal wetlands would cease to exist. That's just what has happened.

Over 7,000 years, mud and soil from the Mississippi's flow had built the bird's-foot delta where river meets coast. The result was an explosion of life, as freshwater marshes possess the greatest plant diversity of any marsh type. Maidencane, alligator weed and wiregrass form the backbone of the coastal Louisiana freshwater marsh system, home to hundreds of migratory and domestic birds, fish and reptiles. Shrimps, crabs, oysters, mussels — the basis of the region's legendary cuisines — flourish there.

Saltwater flooding brought on by the canals cut by oil firms radically undermined this freshwater ecosystem. The aquatic plants rooting the entire structure in place died en masse from high salinity levels their bodies could not tolerate. Once dead, "the plants and debris floated away, and the soil under them was exposed to erosion," Schultz tells me. With nothing to hold it in place, he says, "the land just goes away."

• • •

The mechanization of the Mississippi River ballooned after 1927. That year, after weeks of relentless rain, a devastating flood along the full length of the Mississippi transported some three million cubic feet of water each second (CFS), fathoms more than the 16,800 CFS it typically moves. Roughly 27,000 square miles of land were buried in water 30 feet deep. Author and activist John Barry wrote in *Rising Tide*, his seminal book on the Mississippi flood that changed America, that looking at the raging river before it stormed its banks was like facing "a dark, angry ocean," undisputedly "the most powerful thing in the world."

In response, the United States Army Corps of Engineers was charged by Congress to assume control of the wild river. The longest levee system in the world was the result. Within a decade, 29 locks and dams and a thousand miles of levees

and diversions regulated almost every inch of a Mississippi made faster, straighter and 150 miles shorter. Over time, sediment that once formed delta habitat as it shuffled slowly to the Gulf of Mexico was diverted through substantial modifications or whipped downstream through ruler-straight channels. The Atchafalaya diversion, one of the Mississippi's largest, has consumed 30 percent of the river's flow since 1964.

The Atchafalaya also consumes the old river's sediment.

More than 2.5 tons of particulate matter, capable of fortifying into solid rock over time, is on the go within the Mississippi River each second. This aggregate is like fragments of bone: individually brittle, but, when joined together, it forms the backbone of the delta. Sediment didn't just make the delta. "The Mississippi River, with its sand and silt," wrote journalist John McPhee in a 1987 *New Yorker* article on the Atchafalaya diversion, "has created most of Louisiana."

After Hurricane Katrina, Baton Rouge formed the Coastal Protection and Restoration Authority (CPRA), charged with overseeing all things coastal. One of their main tasks, outlined in master plans updated every five years, was stemming the land loss undermining Louisiana's coastal ecology. The reclamation method most popular in Baton Rouge is river diversion. In theory, diverting Mississippi sediment towards depleted wetlands throughout southern Louisiana should reduce land loss; in time, it may even construct new delta. And equally valuable to the state, diversions act as control valves for the Mississippi River, BTNEP's Michael Massimi told me. When water levels threaten flooding, the Corps can turn on diversions like a faucet to ease the pressure.

Small river diversions once helped combat saltwater intrusion, brackish regions flooding with freshwater from the Mississippi. That changed when the magnitude of the land being lost was realized. "Now, the CPRA are proposing much larger diversions . . . to move sediment out of the river and into the wetlands," Massimi continued. But in order to build wetlands, the state needs to move

huge volumes of river water for those diversions. "And Asian carp are in the river."

Few know this better than David Schultz. Not long ago, Schultz conducted a joint research project for the National Park Service and the Army Corps to analyze species composition and the volume of fish leaving the Mississippi River through land-restoration diversions to enter shallower, warmer backwaters. He hypothesized that the Davis Pond diversion — capable of moving 570 CFS — would substantially alter the ecology of Lake Cataouatche southwest of New Orleans. "And it did. Greatly," Schultz confirmed. "It freshened Lake Cataouatche up and at least initially, clogged it with vegetation — hydrilla and watermilfoil, both of which are invasive species." Schultz identified a bountiful 108 species in 92,000 specimens entrained at Davis Pond, including silver, bighead and grass carp, fertile descendants of the first hatchery escapes. Schultz took Massimi and a local television film crew out onto the water below the Caernarvon diversion south of New Orleans. "They went out and filmed the carp jumping all around us," he said, spooked with 500-second-long electrofishing runs. "In one shocking run we had 50 of them jump in the boat." It's now painfully clear that diversions have become a primary vector of Asian carp's spread throughout Louisiana. "Where there's outfall from the river, that's where we find carp," Massimi added. "Without a doubt."

• • •

Before setting off to paddle Bayou Lafourche, I met Schultz at his lab in Beauregard Hall. We walked past endless rows of specimens neatly preserved in jars brimming with yellow alcohol. Juvenile silver carp were added to the collection in the past decade, he said. Schultz, a tall, quiet man with thinning hair and a thick white and gray beard, led me to his office. Stuffy academic texts lined the bookshelves. His desktop screensaver rotated through images

of family, research trips and, no surprise, fish. I moved a toolbox of sampling gear and sat down. "Because of the diversions," he informed me, "there is plenty of fresh water downstream." This unhelpful twist wrinkles any plans to rebuild freshwater marshes in Louisiana. Diversions bring in much-needed freshwater and sediment to dilute and solidify salty marshes, but sneaking in on that freshwater stream is a harmful array of invasive plants, fish and invertebrates. "Ecologically," Schultz said, "we're a mess here in a lot of ways."

Yet CPRA has called the loss of Louisiana's coastline "nothing less than a national emergency." Their latest plan, approved by the state in June 2017, identified climate change, sea level rise and the "disconnection of the Mississippi River from coastal marshes" as primary culprits in coastal land loss. Almost $18 billion from a total budget of $50 billion was set aside in their 50-year plan to go towards building and maintaining land, with $5 billion earmarked for sediment diversions, less than what Louisiana will spend on relocating and elevating flood-prone houses. Almost $11 billion has arrived via settlement claims from 2010's calamitous BP oil spill. Sediment diversions may never return the coast to what it used to be, noted CPRA chairman Garret Graves, but if the plan of creating 2.5 miles of cypress swamp, marshes and barrier islands each year moves ahead, land loss could cease by 2042 (provided the rise in sea levels slows, which it's unlikely to do).

This latest master plan raises a host of questions. What are constructed freshwater marshes worth if kept half-alive and half-dead by artificial river flows that threaten to introduce nuisance species? Should mechanical marsh creation proceed if the habitat fostered by the state is compromised by Asian carp and other exotics? These are questions the Coastal Protection and Restoration Authority should have considered from the beginning, but didn't. At the Barataria-Terrebonne National Estuary Program invasive species meeting I attended in Thibodeaux, Schultz had told the group the state's decision to increase freshwater diversions

had put the region "between a rock and a hard place. If you're wanting to control non-natives by allowing saltwater intrusion, you're going to be killing off natives in the process. Yet I think it's wrongheaded to say, 'Let's just cut it off and let the salt come in.'"

Floating down the Bayou Lafourche, Massimi got riled up just talking about how Louisiana has failed to consider invasives in the context of coastal erosion and wetland creation. "I've been rattling cages about invasive species for years," he said. In 2010, he and colleague Andrew Barron joined a team charged with guiding the development of the 2012 CPRA Master Plan and was disappointed when it failed to consider invasives. (The 2017 Master Plan mentions "invasive species" once; it makes no reference to Asian carp.) But land loss in Louisiana is worse than problems arising from invasives, Massimi heard. "There are plenty of well-intentioned people who would argue, 'Who cares about invasive species? We'll deal with that problem later. Right now we have a crisis, and we need to build land.'"

Finally recognizing the complexity of constructing land in the Gulf, an independent expert panel was formed to examine and strengthen the Master Plan. The lack of thinking around the potential impacts from nuisance species was highlighted for the first time. "Invasive species are common in the freshwater wetlands of the delta, and diversions are likely to enhance their spread," the panel reported in June 2014. "The potential for invasive species to undermine restoration goals should be addressed."

Given the ecosystem-wide effects Asian carp have had in other waterways, I asked Massimi how concerned he was that silver and bigheads will overhaul the estuary. Intuitively, he knew to be worried, having read the dossier on Asian carp. But as someone who wanted BTNEP policy to be based on sound evidence, he was at a loss. "In Louisiana we haven't started looking at impacts yet," Massimi said. And here, like nowhere else in America, determining how damaging Asian carp are is compounded by southern Louisiana's distinctive geography: the interplay of salt

and freshwater, the cumulative impacts of preceding invasives and the contrived movement of water drowning the delta in life-affirming freshwater that carries, in Asian carp, the seeds of another kind of destruction. "We don't really have any example anywhere else in the country where this is happening," Massimi said of the quasi-marine ecosystem we were exploring. From behind me in the canoe I heard, "It's uncharted territory."

There is no shortage of damages Asian carp may be causing in the Barataria-Terrebonne. Estuaries are tremendously important nursery grounds for species that require salty water to keep their eggs buoyant. Most commercially important fish in Louisiana rely on estuaries at some point in their lives. Shrimp and blue crab, two of the state's biggest commercial seafoods, have life cycles tied to the brackish water Asian carp can tolerate. "If the adult carp, the large ones, are surviving in the estuaries, they are going to be filtering out large quantities of larval shrimp, blue crabs and who knows what other finfish," Massimi said. Filter-feeding silver and bighead carp typically don't eat other fish, but if their take-it-all-in approach to eating results in the consumption of huge volumes of larval fish, shrimps and crabs, they will be a forceful presence in the estuary. Trading off the ecological health of the freshwater marsh for its very existence is a deal with the devil. To date, resource officials and legislators have had little choice but to take Lucifer's offer. A coast without marshes, even weakened ones, is unfathomable. "Land loss is the linchpin of all other environmental problems in Louisiana," Massimi said.

• • •

Louisiana's backwaters and reservoirs may be freshened by diversions, but the bulk of its coastal waters remain salty. The Mississippi River can get so brackish near New Orleans that marine species like bull sharks and stingrays have been found. But could these coastal waters be too brackish for Asian carp? It depends who you ask.

Along with other freshwater river fish, Asian carp are stenohaline species: unlike fish acclimated to life in estuaries and tidal pools, Asian carp are not well suited to a wide range of salinity levels. While American resource officials have studied Asian carp's saltwater tolerance since the 1970s, the findings are broad. In 1999, University of Florida researchers found that juvenile grass carp could tolerate 16.2 parts per thousand salinity for short periods. Yet the deeper the literature review becomes, the more worrying the results. One 1980 study determined that bighead carp could survive in 20 parts per thousand salinity for two weeks. In Russia's Terek region, bighead and silver carp tolerated 12 parts per thousand salinity along the Caspian Sea coast for years, long enough to reach sexual maturity. And by 1990, bighead carp fry were discovered in the Philippines to possess osmoregulatory capability, allowing them to process low salinities without dying or stunting growth. All these saltwater tolerances are well within Louisiana's brackish water range of 0.5 to 30 parts per thousand.

Invasives adapt to new environments. Look at the typical bell curve for any trait, Michael Massimi explained, and there are always groups in a population that tolerate extremes. Think of it this way: if life and death in Louisiana for Asian carp hinges on an ability to tolerate high-salinity water, evolutionary theory suggests that specimens better able to tolerate saltwater will be those who win the gene-selection pool. "If we are introducing millions of Asian carp into higher-salinity estuaries," Massimi posited, "over time they're going to become more comfortable in those areas."

This evolution may already be happening. The salty Lake Pontchartrain north of New Orleans contains Asian carp. Most arrived via the Bonnet Carré Spillway that releases river water into the lake during high water events. It was opened as recently as March 2018 for several weeks to protect New Orleans from a rising Mississippi River. Researchers didn't previously believe Asian carp could use the 630-square-mile lake as a transportation corridor because of its high salinity levels, but with silver and bigheads

now found in the Pearl River on the eastern side of the lake, biologists know something is off. Either their estimates of Asian carp's salinity tolerance are wrong, or the fish are, perhaps, evolving.

Over time, this saltwater tolerance could be a crucial factor in facilitating Asian carp's spread along the coast. "Even in the five years I've been [at Louisiana State University] we have gotten new reports, especially after floods, of Asian carp moving into waterways they never have before," says Louisiana Sea Grant's Julie Anderson Lively. For years, researchers believed that whatever water bodies the fish were already in is where they would remain, she tells me. But if we're not careful, Asian carp will push towards Texas and Florida. "Most of the Louisiana coastline is very low salinity compared to anywhere else. We easily believe they would spread along the coast."

• • •

"I wish I could tell you more about Asian carp, but we just started in the last few years studying their impacts," says Bobby Reed. A senior fisheries biologist with the Louisiana Department of Wildlife and Fisheries, Reed worked his way through the ranks after starting with the department in 1981. Stationed in the state's southwest corner, he first learned about Asian carp from district managers along the Mississippi, Red and Ouachita rivers. Reed's colleagues stumbled on silver carp in a backwater of the Mississippi in 1988. "They penned up a bunch of the carp and the water just exploded," Reed tells me. "They'd never seen anything like that before."

Eyes open to the hazardous presence of a large new fish in Louisiana, resource officials were confused about how to manage them. Were they Louisiana-born or Arkansas imports? Could they handle saltwater? How would they interact with the state's unique estuary ecosystems? From the beginning, experts from U.S. Fish and Wildlife, Auburn University academics and private players

like Jim Malone had claimed that American rivers weren't suitable for carp spawning. And even if they could reproduce, many speculated, their impact on native species would be minimal. Sure, Asian carp were present in Louisiana — but that didn't mean the state needed to take action.

Data collection on Asian carp in Louisiana has been spotty ever since. The earliest experiments on grass carp measured their appetite for nuisance aquatic weeds, not their niche within America's aquatic ecosystems. Most studies were kept within the strict confines of aquaculture research, ultimately for commercial (and not ecological) purposes. "Implications for nature beyond the pond were not discussed" until after they had spread beyond those porous ponds, wrote environmental author Glenn Sandiford in *Invasive Species in a Globalized World*. Beyond their narrow focus, he noted, initial studies were predisposed towards approving the fish for nationwide use. It's unsurprising that Fish and Wildlife staff didn't investigate potential impacts on native species or their reproductive capabilities until it was too late. "State fish and game agencies, Fish and Wildlife — they weren't proactive enough early on," according to Reed.

Consequently, the state has only collected baseline data on Asian carp in the past decade. Most of that work has focused on reproductive potential, studies to find larval fish conducted with small, one-off grants from USFWS. Since Louisiana's Department of Wildlife and Fisheries has data on native fish health going back decades, Reed tells me his department has dedicated funds to determining whether shad, buffalo or paddlefish have lost body weight due to competition with Asian carp. But it's early going. For example, photographs taken in March 2018 of the Army Corps of Engineers opening the Bonnet Carré Spillway reveal gaggles of curious onlookers and an abundance of leaping silver carp. While removing needles that unleashed some 250,000 CFS into Lake Pontchartrain, Army Corps staff caught and tagged 25 Asian carp to determine age, gender and reproductive condition, part of the

federal agency's plan to create a knowledge baseline for the carp, useful in future risk analyses determining their establishment in coastal rivers.

Like the old man I spoke with in Weber, Arkansas, Louisiana wildlife officials also collect anecdotal evidence on fish abundance by documenting what fishing crews report at commercial landings. Even that has proven difficult since the commercial freshwater fishery is a black box. "It's a lot of families that have done it for generations," says Anderson Lively — few new people enter the profession and not much information comes out. Wondering herself how abundant Asian carp are in Louisiana, the Sea Grant biologist asked fishers she worked with to set some aside. Yet they routinely toss the trash fish overboard or let them rot on the shore, she tells me, making it challenging for state agents or academics to gather even rudimentary population estimates. Since there's no market for Asian carp, there's little motivation to keep them.

Louisiana's reputation as a fishing haven further complicates efforts to combat Asian carp. Panfish, largemouth bass, crappie — these are the bread and butter of sportfishing throughout the state's freshwater rivers, backwaters and reservoirs. More than 820,000 anglers spent $1.4 billion on sportfishing in Louisiana in 2011 alone; two-thirds of those retail dollars went to freshwater fishing. Sportfishing also keeps 13,000-plus people employed, a huge job creator in a state largely dependent on the oil and gas sector. Add to this some $93 million in state taxes it generates and preserving sportfishing in Louisiana becomes a top priority.

Perhaps this explains why the lion's share of dollars dedicated to inland fisheries in Louisiana are directed towards protecting the cash cow that is sportfishing. To date that protection has taken the form of killing aquatic weeds that annoy anglers, an action that gobbles up $8 million of inland fisheries' $10 million budget. "We are employed as fisheries biologists," Reed tells me, "but we spend most of our time controlling aquatic invasive plants." Baton Rouge dedicated that money to weed removal, so it cannot be diverted for

other issues, even those like Asian carp that weaken the sportfish industry through predation and resource competition.

The $2 million remaining for inland fisheries is stretched so thinly that there's laughably little left to manage invasives. When money *is* available to fight exotics, Anderson Lively says, Asian carp compete with Rio Grande cichlids and tilapia for attention and dollars. They're all part of a general destabilization of Louisiana's vulnerable ecosystems, making the challenge of managing a state riddled with invasive plants, bugs, fishes and mammals a monumental task. When Louisiana lacks even basic data about invasive species' pervasiveness, location, spawning or impacts on native flora and fauna, these challenges are quickly compounded. Baton Rouge wants to conduct more research on Asian carp — they just don't have the money, leaving many looking to Washington and the wealthier Great Lakes states for financial aid that has not come.

• • •

Mike Weimer understands the funding disparity for Asian carp work in America. But in the current budgetary framework there's little he can do. A fisheries ecologist from upstate New York, Weimer began his career with the U.S. Fish and Wildlife Service in the mid-1990s conducting research on sea lamprey's destruction of the Great Lakes fishery. Because of his extensive field work on aquatic invasives, Weimer was named co-chair of the Asian Carp Regional Coordinating Committee (ACRCC).

The committee, a hodgepodge of state, provincial and federal governments, works alongside established agencies like USFWS and newcomers like Ontario's Invasive Species Centre to share knowledge and help set policy for managing Asian carp. Since 2010, between $14 million and $18 million has snaked its way annually from Congress to the ACRCC before being awarded to agencies and their academic partners. The committee's funding comes from

the Great Lakes Restoration Initiative (GLRI), a $300-million-a-year entity tasked by Congress with restoring the Great Lakes' ecological integrity. The Restoration Initiative, in turn, gets its cash from the Environmental Protection Agency's $8.5 billion annual budget. Yet little of this is guaranteed long-term. Shortly after assuming office, President Donald Trump signaled his intent to radically descale the EPA and eliminate the Great Lakes Restoration Initiative entirely, effectively bringing the committee and most Asian carp research to a standstill.

The ACRCC funds hundreds of projects undertaken by state natural resource departments, the U.S. Geological Survey, Army Corps, Fish and Wildlife Service, U.S. Coast Guard and National Park Service. All promote the organization's core mandate to maintain "a holistic Asian carp prevention and control program to protect the Great Lakes ecosystem." The committee has been "blessed" to receive congressional support, Weimer tells me.

The Great Lakes have always been Washington's top Asian carp priority. Indeed, their only priority, so far as managing spread or mitigating impacts are concerned. The ACRCC, as the agency charged with overseeing tens of millions in taxpayer dollars to manage Asian carp, was formed in the frenzied aftermath of their DNA being discovered in the wrong part of the Chicago River in 2009, something we'll explore further in chapter 9. Saving a Great Lake ecosystem under attack was the founding principle of the committee. Everything about it — its mandate, the executives that run it, where it gets its money — is framed with that lens.

There is a "lack of equity" regarding how money is awarded to address different facets of the Asian carp crisis, Weimer believes. "It's a very real problem." The committee "certainly would like to see more resources available to the other sites south of the Great Lakes," he tells me, but what's currently holding them back is the geographic allocation of funds. Politics, in other words. Money to combat Asian carp directed through the Restoration Initiative and its maze-like funding apparatus means "there are sideboards

on that money. It has to be spent either within the Great Lakes basin or to protect the Great Lakes from the threat of invasives."

This definition has been strictly interpreted — perhaps too strictly. Even when the ACRCC has secured funding for projects outside the basin, the money is a pittance compared to how Great Lakes projects are funded. It's also geographically constrained. After the Water Resources Development Act was passed by Congress in 2014, and after $2 million was obtained for such work beyond the basin in 2015, the committee looked only as far as the Upper Mississippi River and Ohio River regions to contain Asian carp and not downstream to Louisiana. "We're moving the planning to directly attack the bulk of the problem," says John Goss, Asian carp program director for the U.S. Council on Environmental Quality, "which is fish populations in the Mississippi and Ohio rivers."

That logic may be flawed. Bobby Reed from the Louisiana Department of Wildlife and Fisheries tells me this laser-like focus on the Great Lakes ignores one crucial fact: as long as the fish spawn in the lower reaches of the Mississippi basin, Asian carp will continue migrating north as they have for decades. The ACRCC can plow millions into reducing fish populations immediately south of Chicago, but until Washington puts money into reducing carp populations throughout the entirety of the interconnected Mississippi watershed, everything else is moot. "Asian carp are steadily moving north, and there's not a thing they can do about it," he says. "You could eliminate every Asian carp above St. Louis and in two years they'll all be back."

• • •

Prioritizing the Great Lakes has denied Southerners the resources they need to protect freshwater and marine fisheries as valuable to their way of life as a healthy basin is to the residents of Michigan, Illinois, or Ontario. No one I spoke with in Arkansas or Louisiana

begrudge the federal government its spending to protect the Great Lakes, but the exclusivity with which funds are channeled north leaves Southern researchers in a catch-22. There isn't enough money to determine if the South's burgeoning carp populations are an ecological time bomb, yet without enough primary data to show that the fish are having a negative impact on estuary species or habitat, no one will allocate cash to discern the magnitude of the problem, let alone cash to do anything about it.

Washington, the regional coordinating committee and every federal agency working on this issue must begin to view the carp crisis through a broader lens. While they're at it, the government should stop playing favorites in how they dole out cash to tackle these fish and quit their decades-long thinking that the infection is too gangrenous to treat south of St. Louis. The Great Lakes are vital to the economic and ecological health of 40 million-plus Americans and Canadians living in the basin, but it's far from the only ecosystem crying out for assistance. But there's blame enough to go around. Southern states, for their part, must organize and fund the preliminary research needed to understand the extent of Asian carp's spread throughout their rivers, reservoirs, lakes and streams. If they ever hope to lure Washington into paying to help limit the impact of Asian carp in their waterways, this is a prerequisite. Some of this money could come from federal tax dollars, and some must flow from state governments to analyze the interconnections between Asian carp and seafood production, tourism and the creation of coastal wetlands lost to oil-and-gas-industry-induced erosion.

In short, the South must be data poor no more.

Speculating why Washington has left the South behind in the effort against Asian carp leads (perhaps predictably) to conspiracy and political finger-pointing. Some suggest former president Barack Obama being based in Chicago was one reason why the EPA allocated such large sums to Great Lakes protection in the early days. Others think it's a matter of organization. State, fishing

and environmental interests have banded together in the basin with a zeal often lacking among Southern governments and private entities. Northern states have done a better job of marketing Asian carp as a serious ecological concern. Others I spoke with point to a historically entrenched divide between North and South, in which an inherent bias of Southerners as backwoods types has made it impossible for institutions south of the Mason-Dixon Line to secure funding. "I think that [bias] comes into play tremendously when it comes to [awarding] grants that are available," says University of Arkansas zoologist Anita Kelly. "Which is unfortunate, because there are a lot of good researchers in the South."

Any of these theories may contain some kernel of truth. Ultimately it doesn't matter, because the lack of Southern data is best understood, I believe, through the hard calculus of political expediency. "I tell my students this," says Martin O'Connell, a fisheries biologist at the University of New Orleans: "There are more people voting and paying taxes in the Great Lakes region" than in the South. "There are only so many people in Louisiana or Mississippi versus Chicago or Detroit. It's the way things go." O'Connell, with a close-cropped gray beard and salt-and-pepper hair pulled into a ponytail, looks every inch a fish researcher. O'Connell saw this distribution formula at work in Louisiana after Hurricane Katrina destroyed much of the city (including his home). Barriers and pump stations were built to protect New Orleans from future hurricanes, but residents in remote regions of Mississippi cried that the city had simply offloaded their flood fears to upstream residents. The plan went ahead. Why? "Because people have done the math," O'Connell says. "We have protected 10 times more people and 10 times more money in Louisiana versus the fewer voters and the less-structured coast of Mississippi."

Jim Garvey agrees. The Southern Illinois University biologist tells me that guaranteed funding through the EPA and international agreements with Canada has spurred interest in restoration efforts, pollution abatement and invasive species monitoring in the

Great Lakes that is not seen anywhere else along the Mississippi River. Relying on the Army Corps for this research won't work, he says, since the federal agency is too restricted in what it can accomplish by strings attached to its funding and its top-heavy approach to infrastructure projects. Their focus "comes from whatever the executive wants out of them," Garvey says, a modus operandi that has kept the Corps anchored in the Great Lakes basin.

These days, American scientists know more about how the Amazon River functions than we know about how the Mississippi River works, he believes, largely because there's far more money being spent on studying riverine systems in other countries than in our own backyard. "That's a travesty and a crime. But it's just the way funding is right now. It's very hard to get funding to do a long, sustained river research project. That's why we don't know very much about how these systems work."

This despite a flood of funds towards Great Lakes institutions. Throughout the Midwest and the Great Lakes region, state and university researchers began working feverishly on a host of high-tech solutions. Acoustic barriers, carbon dioxide deterrence, pheromones and targeted piscicides. Flush with GLRI cash, academic institutions quickly became some of the largest recipients of government money to test hypotheses on thwarting Asian carp. In 2015 alone, the ACRCC awarded more than $12.4 million to 10 universities for carp research. The University of Minnesota Duluth, the University of Wisconsin, Purdue, South Dakota State and the University of Missouri, in addition to numerous Illinois schools, received federal money to further Asian carp know-how. Professors built labs, expanded aquatic research programs and lured graduate and postdoctoral students to their institutions on the basis of free-flowing federal money to study a de rigueur invasive fish.

It's all fostered a perhaps mistaken belief we'll explore in the next chapter suggesting science will ride to society's rescue. Yet will it? Data alone isn't knowledge, especially when the wicked

problem of Asian carp has no simple solution. We may have lots of information on the fish in the Upper Mississippi and Great Lakes basins, but does it tell us anything useful about halting this ecological crisis if the South's slow-burning degradation continues? It sounds heartless. But look at where Asian carp have caused the biggest stir and been investigated most fully, says Louisiana State's Michael Kaller. These areas, exclusively in the Great Lakes basin, have become sinkholes for federal cash that's at risk of running out. Yet once Washington investigated Asian carp's impacts in northern states, it became hard to convince funding sources with limited money to repeat similar analyses in places like Louisiana. "Even though reproducing results is an incredibly important component of the scientific process," Kaller tells me, it just doesn't happen. The government is always going to protect assets and voters that generate the most bang for their buck. Martin O'Connell adds, "It's hard to fight for your right as a very small Southern state when you get to Washington."

• • •

Day three on Bayou Lafourche and I had graduated to paddling in the bow. Michael Massimi and I saw his colleague Kristy Monier wave frantically at us boaters passing beneath the Raceland Middle School bridge. An air raid siren had sounded on Monier's phone, alerting southern Louisiana to brace for rain. The exit point for the day's paddle was two and a half miles south. Pulling on my rain jacket, I squinted into the wind blowing menacingly dark clouds in our faces. We forged ahead.

The sky opened up. Rain fell with such velocity that I often broke from paddling to bail out the boat. I felt the water pool in my shoes. I tasted rain and salty skin. Other groups pulled off the water into side channels, following orders to exit the bayou or huddle under bridges to avoid lightning. Conversation ceased. Massimi and I focused only on the act of paddling, the repetitive strokes moving

us closer to land, closer to a hot meal, closer to dryness. In place of talking there were the twin monotonous thumps of wood on water and rain on polyethylene, companionable white noise.

As we approached our demarcation point, paddling fast beside the shoreline, a frightening *crack* shook the canoe. It thought we had run aground. "The hell was that?" I shouted back at Massimi. "It was a silver carp," he yelled, straining his voice above the falling rain. The silver had jumped along our port side, crashing into our hull near the bow before disappearing into the turbid water and out of sight.

Massimi paused. "I didn't know they were this far down the bayou."

CHAPTER 5

Scientific Salvation

ST. PAUL, MN The halls of the Minnesota Aquatic Invasive Species Research Center (MAISRC) are decked with the bric-a-brac of scientific academia: desk chairs in stages of disrepair, aging minifridges emitting acute smells, pizza boxes, assorted bicycles, brightly colored conference posters, whiteboards covered with indecipherable numbers, research papers tacked to corkboards, chest freezers with *do not open* scrawled on the side, *bigger* chest freezers shut tight with lock and chain, yellow emergency eyewash stations, a community notice board with a paper tacked to it saying, *6% of scientists are Republican: Scientists have no explanation for why that number is so high.*

There's also a heavy door leading down into a dark, windowless laboratory animated by red lights, whirring small engines and the smell of live fish. Here, in one corner of the lab, squat round tanks topped by wire mesh screens sit side-by-side, fed continuously by slow-running faucets dripping clean water into the nurseries. There, thick sheets of black plastic conceal silver and bighead carp swimming in slow, steady circles in large glass aquaria. Approach any blackout curtain and there's a narrow, eye-level slit allowing investigators to study the fish without their knowing. It's here that MAISRC founder Peter Sorensen, his

colleagues and graduate students are analyzing a smorgasbord of control methods for the state's growing list of aquatic invasive plants, invertebrates and microbes. Asian carp, swimming not far from the North Star State in rivers and streams in Wisconsin and Iowa, are first among equals.

Housed at the University of Minnesota-St. Paul, the research center began in 2012 with $12.5 million from the statehouse, the Environment and Natural Resources Trust Fund and the Clean Water Fund. Asian carp were written into MAISRC's founding document. Using academic research to find real-world solutions to problems posed by aquatic nuisance species in Minnesota is the modus operandi: working with the Minnesota Department of Natural Resources and the local Sea Grant, training graduate students, encouraging short- and long-term collaboration with outside researchers, making analyses publicly accessible — in other words, operating in the real world.

Sorensen has smooth, square features and sandy hair; he's approaching retirement. We met on campus near his office. After passing empty classrooms and laboratories we arrived at his office, a claustrophobic affair rammed with papers and a small window letting in an eerie light. I cleared books from a chair and sat down beside an aquarium, small silver fish looping endlessly in the confined space.

His interest in aquatic invasives has defined more than three decades of Sorensen's scientific career. While much of his current work explores potential mechanisms for controlling common and Asian carp, this interest is relatively new. Previously, sea lamprey and the seductive power of behavioral modification via pheromones consumed his working days. Sitting in his office, we were soon joined by Ratna Ghosal, a research associate who joined the Minnesota team in 2014. Ghosal completed her doctorate at the Indian Institute of Science's Centre for Ecological Sciences in Bengaluru, India. She had investigated whether the progesterone found in Asian elephant dung was being used for chemical

signaling between elephants. The topic fit strangely well with Sorensen's work on lamprey pheromones.

Pheromones are hormones that exist outside the body. In everything from humans and primates to single-celled yeasts, pheromones (from the Greek words *pherein* — to carry, and *hormon* — to excite) act as chemical messengers that allow beings of the same species to communicate, not always consciously. In humans, for instance, pheromonal cues stem from odors released by our saliva, sweat and urine, and they can profoundly shape our short- and long-term behavior. Heterosexual females, for example, were found in a 2007 University of California-Berkeley study to experience dramatic increases in cortisol levels (the hormone associated with stress and alertness) after smelling a compound resembling male sweat. A 2003 study from the University of Pennsylvania, however, found the opposite: females in their test group were *more* relaxed and *less* stressed when exposed to male sweat. It also affected the timing and length of their menstrual cycles. The effect of pheromones on humans remains contested; some researchers claim humans simply don't possess pheromones at all.

In fish, however, pheromones play a key role in how they communicate. Attraction, fear, arousal, repulsion — these chemical compounds and the results of their mixing together form highly specialized signals and subtler cues that give fish within the species (and even subsets within the species) valuable information on everything from the location of spawning tributaries to the presence of predators. This unconscious dependence on chemical signals to direct behavior has presented scientists and resource officials with a potential opportunity: "If we can exploit a fish's weaknesses or modify their behavior," Ghosal tells me, "that will give us a better chance of success."

• • •

The model for pheromone research in North America is anchored in the Great Lakes basin on the decades-long struggle against sea lamprey, the blood-sucking, eel-like fish that nearly destroyed Great Lakes fisheries in the mid-twentieth century.

By 1955, three decades after their arrival in Lake Erie in the 1920s, researchers had begun thinking about using toxicants to control lamprey. Weirs and electric barriers were installed through-out the 1950s and 1960s, and while they killed their fair share of lamprey, it was never enough to be considered an effective long-term control strategy. Lampricide became the preferred choice for its cheapness and flexibility, at least in comparison to building and operating electrified fences or permanent infrastructure in need of maintenance and upgrades. Control larval lamprey's ability to leave its spawning ground, or mature lamprey's access to tributaries, and resource officials figured they stood a fair chance of keeping the fish-killer under control.

From 6,000 chemicals tested at the U.S. Geological Survey's Hammond Bay Biological Station on Lake Huron, 10 were chosen for further analysis. Of those, 3-trifluoromethyl-4-nitrophenol (TFM) was identified as one of the most potent for targeting larval lamprey, a lethality that was compounded greatly when applied alongside the molluscicide Bayer 73. Beginning in tributaries to Lake Superior in 1958 and expanding to the remaining Great Lakes by 1960, Canada and the United States embarked on a two-decade-long experiment testing the effectiveness of TFM and Bayer 73 at larval lamprey control. In Lake Superior alone, the number of lamprey reported caught at electric barriers fell from 50,000-plus in 1961 to less than 2,000 in 1974. Today, lamprey populations have been beaten back by anywhere from 68 percent in Lake Erie to 95 percent in lakes Ontario and Michigan, largely due to the effectiveness of TFM and Bayer 73 that, despite concerns over impacts on rainbow trout and bullfrogs, have had limited effects on non-target species. And, it should be noted, thanks to the $20-million-a-year effort that Canada and the United States

continuously put into keeping lamprey in check with $3 million worth of chemical poisons.

Pheromone manipulation joined the lamprey control conversation several decades after these chemical efforts began. Sorensen has been investigating links between pheromones and aquatic species since his days at the University of Rhode Island in the early 1980s. From odor cues assisting American eel migration to sex pheromones' ability to synchronize the spawning readiness of goldfish, Sorensen has sought new ways of understanding not only how fish rely on chemical compounds to communicate but how that communication can, at least for nuisance species, be used against them.

His work on sea lamprey began in earnest in 1998 when Sorensen reported to the Great Lakes Fisheries Commission on the potential of synthetic pheromones to manage the species. Over the next decade, he wrote a dozen or more papers on how steroidal compounds that mimic odors produced by larval lamprey guide mature specimens to spawning rivers. Sorensen also looked at how that information could help target populations for extermination.

In the midst of developing the lamprey pheromone, Sorensen secured $100,000 from the Minnesota legislature in November 2003 to study whether genetic mimicking could work against common carp. By 2006, Sorensen reported that juveniles showed "very strong" attraction to odors released by their own species with "great potential for use in control."

He continued to explore the potential for pheromones to direct lamprey movement while diving deeper into the world of Asian carp. Ghosal and Sorensen watched as bigheaded carp inched closer to Minnesota, knowing that pheromones and a host of other control methods under investigation at MAISRC could help stem the invasion. In 2016, Ghosal aided Sorensen and U.S. Geological Survey ecologist Nicholas Johnson in another study of how semiochemicals like pheromones could interrupt invasive fish behavior. While the "field is young and the science is very

challenging," they wrote in the *Journal of Chemical Ecology*, the potential use of pheromones for trapping, monitoring and disrupting carp behavior was "considerable," about as close as staid researchers get to sounding excited. Determining the right mix of fish attractants, let alone producing the necessary quantities of synthetic pheromones, is painstaking work, they acknowledged, but worth the effort. Besides, there is "almost a complete lack of tools to control invasive fishes" currently on the market, Sorenson and Johnson wrote. Why not invest heavily in a promising and environmentally benign control method?

But speaking to me from her office on the University of Minnesota campus, Ghosal sounded spent. "There is so much promise to pheromone research." She paused. "But I can't get anything going. It's been a struggle to continue this research. It feels like we've hit a brick wall."

• • •

Pheromone control is just one of many non-physical barrier options for controlling Asian carp. Another robust strategy under development involves increasing carbon dioxide (CO_2) in a water system. Unlike air bubbles that create a curtain of churning effervescence to drive fish away, CO_2 deployment relies on an as-yet-unknown molecular reaction that fish loathe. Much of the work on carbon dioxide deterrence has emerged from the lab of biologist Cory Suski at the University of Illinois at Urbana-Champaign. A native of Ontario, Canada, Suski came back to teach in Illinois, where he had completed his master's. Since 2010, Suski and his team have explored the genetic and behavioral impacts of elevated CO_2 on silver and bighead carp from larvae to mature fish. While the results suggest Suski is onto something, he's not entirely sure why. "We don't really know exactly how fish even sense carbon dioxide in the water." As best they know, fish may contain carbon dioxide sensors in their gills that interpret rising CO_2 as a degraded water condition.

In lab tests, Suski began with larval silver and bighead carp no larger than an eyelash, placing them in tanks containing high levels of CO_2. He witnessed changes in gene expression — specifically, ones indicating an uptick in stress. The experiment was later expanded to a larger tank where fish up to 4 inches long were ping-ponged within the chamber, chased by carbon dioxide. Yet the biggest test of CO_2's potential was conducted in 2013. Suski commandeered a half-acre pond at the U.S. Geological Survey's Upper Midwest Environmental Sciences Center in La Crosse, Wisconsin. There, 15-inch-long bighead and silver carp were released alongside bigmouth buffalo, channel catfish, paddlefish and yellow perch. A small section of the eight-foot-deep pond the size of an ice hockey rink was targeted with the release of carbon dioxide. Just like in the lab, the presence of CO_2 drove silver and bighead carp (and the retinue of native fishes) to scramble away from the targeted zone.

Prolonged exposure to CO_2 can cause the molecule to pass through the blood-brain barrier, damaging equilibrium and inflicting physiological stress. Yet Suski was uncertain if CO_2's impact on Asian carp was that severe. "I don't think it's a problem breathing because they're not in the environment long enough. It's a rapid reaction, and my gut says they're not experiencing negative consequences." He likened it to sniffing a milk carton to see if it's soured. "You know pretty quick if the milk's gone bad," and you pull the carton away, largely unscathed except for the putrid smell in your nostrils. "That's the equivalent of what's going on. The fish don't like it and they just leave."

Unlike pheromones, CO_2 isn't a species-specific tool. Throughout his research, Suski noted that native fishes fled the elevated carbon dioxide zones as far or farther than bighead and silver carp did. Its use in the field may keep bigheaded carps from entering tributaries of the Illinois River to spawn, sure, but it's likely to do the same for channel cats or buffalo. Moreover, the introduction of CO_2 to water forms carbonic acid that can lower pH levels (increasing acidity). It's diluted enough that the carbon dioxide injected into a water body

isn't acting like acid rain, Suski told me, but it's sufficient that the Army Corps has wondered what effect altered acid levels could have on creaky infrastructure like locks and dams. And for shell-forming invertebrates like mussels, high acidity can be deadly. One paper out of Suski's lab in 2016 detected that lowered pH levels increased stress in *Fusconaia flava*, a freshwater mussel known as the Wabash pigtoe. Over time, the pigtoe allocated more resources towards dealing with elevated acidity and less energy into shell growth. "This diversion of limited resources may have long-term consequences for the survival and fitness of mussel populations that are already imperiled," he wrote. In 2018, his lab detected similar reactions to elevated CO_2 in *Lampsilis siliquoidea*, also known as the fatmucket clam, which struggled to respond well to auxillary stressors like higher water temperatures in the presence of high CO_2, a dangerous new deficiency in a warming world.

Still, carbon dioxide screens could be used as a deterrent to keep Asian carp from moving through the Chicago Area Waterway System (CAWS). Unlike infrastructure-heavy solutions like electric barriers, injecting gas into water requires no more than the gas and an air pump. The entire system can be set up and torn down as needed at the mouths of nursery habitats, for example, before the start of spawning season. By deploying it after heavy rains when bigheaded carp tend to spawn, for example, this kind of application could potentially limit any collateral damage to native species, especially those associated with the indiscriminate application of the fish poison rotenone, as we'll see in chapter 9. What's more, Suski's projects have found a way to repurpose waste CO_2 from oil and gas refineries and local soybean processors. "It's not like we're smelting coal on site to generate the CO_2," Suski said, laughing. Carbon dioxide wouldn't replace the electric barriers already in place southwest of Chicago, "but it's nice to have another tool in the toolbox to supplement [them]."

● ● ●

Let's pause a moment. Amidst talk of deploying carbon dioxide barriers or mind control against Asian carp, perhaps it's useful to understand how invasion biology as a scientific discipline got off the ground. It will help us to grasp how invasive species have garnered such near-universal condemnation. Because the very idea of "invasive" species is a shifting thing; adolescent, too, in relation to other biological disciplines. The concept draws an inherent distinction between introduced species and those we think of as "native," those species that, by happenstance or geography, evolved in a certain time and place while forming relationships with nearby species over millennia. Naming species as "native" or "alien" as a means of geographic cataloging has been around since 1847, though naturalist papers dating back to Francis Bacon in the seventeenth century discuss ballast water as a means of disseminating "foreign herbs, to us in Europe not known." The first use of the term "invasive species," however, likely appeared in the colonial journal *The Indian Forester* in 1891. Whatever its origin, notes Arizona State University biologist Matthew Chew, the idea of permanently affixing certain species to a fixed geographical location is rightly contentious, especially as ecologists tackle notions of ecosystem balance, nostalgia and "fears of irreversible change."

While a host of botanists, clergymen, lawyers and other wealthy notables added to the discussion over time of how and where species were spread across the globe, modern thinking on invasion biology traces its lineage to one man. British zoologist Charles Elton had *The Ecology of Invasions by Animals and Plants* first broadcast as three BBC radio documentaries in 1957. By 1958, the episodes were expanded and compiled into what University of Tennessee invasion biologist Daniel Simberloff called "a bible for practitioners" of the burgeoning new field. While the book didn't register greatly with scientists or the public initially, its stature grew as environmental disasters piled up throughout the 1960s. These days, virtually every article on nuisance species continues to cite *The Ecology of Invasions*. In a foreword to a new edition of the book,

Simberloff (himself something of a guru as the author of *Invasive Species: What Everyone Needs to Know*), argued that Elton was prescient in suggesting global trade, which had expanded in the late nineteenth century and ballooned after 1945, had obliterated floral and faunal distinctions between continents. "The eventual state of the biological world will become not more complex but simpler — and poorer," Elton wrote, proposing that six "continental realms" would slowly morph into one androgynous Gaea. This unintended action, already in motion well before Elton gave it a voice, had proven disastrous for species left to contend with new arrivals they had no evolutionary relationship with.

Just as Charles Darwin had done in articulating his theory of evolution, Simberloff wrote, Elton had employed a "plethora of dramatic examples and vivid metaphors" in creating a framework for the field his work would spawn. Rabbits, Japanese deer, gray squirrels, mongoose, coypu and an host of moths and beetles that ate forests bare and devoured stores of flour, vegetables and nuts — Elton offered them all as thought-provoking examples of the destructive power invasives held by describing them in eye-boggling detail. Yet it was an approach even he knew wasn't good enough; simply writing down a laundry list of culprits, he wrote, "does not quite convey the tumult and pressure" that "escaping" species exact in their new homes.

Invasion biology as a discipline grew rapidly throughout the Cold War, feeding on the highly militarized vocabulary of the struggle against unwanted weeds, bugs and animal pests. The natives-good/invasives-bad approach to species cataloging stuck fast for many decades until fissures in the field grew in the 1980s. As conservationists began debating how to restore local landscapes remade by human-induced impacts like urbanization and pollution, they ran into thorny questions for which there were no easy answers: What ecological baseline should altered landscapes be restored to? What species should be included in the "novel

ecosystems" humans have created? Should introduced species that benefit native birds or insects be allowed to stay?

Mark Davis is the DeWitt Wallace Professor of Biology at Macalester College in Minneapolis. In a paper he wrote on the history of invasion biology since Elton, Davis argued that North American ecologists at this time became obsessed with geographic origin in determining species' risk. (Europeans were less fussed by species origin, he maintained, having decided that millennia of moving plants and animals around made determining their origin impossible.) The end result was the prizing of native species ahead of foreign-born exotics in many conservation plans.

In a 2011 letter penned in *Nature* with 18 other ecologists, Davis argued that "nativeness is not a sign of evolutionary fitness or of a species having positive effects." A "perverse bias against alien species" has infiltrated the public, media and land managers, he wrote, noting there was no understanding of ecology advanced by classifying biota based on cultural standards like "belonging." Rather, resource officials must embrace the novel ecosystems that invasives help foster and focus their efforts on those few introduced species actually harming biodiversity, human health or ecosystem services. "The native/non-native paradigm is losing its value."

He followed the *Nature* article with a piece in *BioScience* arguing that birds native to the United States don't care whether the berries they eat are exotic. Honeysuckle, once spread by the U.S. Department of Agriculture, is now banned in many states as invasive. Yet this berry-producing shrub has evolved to produce its fruit in late summer and early fall when birds begin migrating south, including large clusters of American robins and gray catbirds. Those birds also feed on the berries of native plants rooted nearby, boosting the dispersal of all in a biological trait known (wonderfully) as the *car dealership effect*. Bird populations tripled; honeysuckle and native shrubs flourished. Scientists were increasingly acknowledging that introduced species could provide

valuable ecosystem services and that eradicating select species could weaken some ecosystems overall.

Then there's biodiversity. Invasives have long been lambasted for diluting biodiversity, homogenizing the kinds of species in any one location until the Earth becomes what science journalist David Quammen called a "planet of weeds." This was itself an echo of Elton's prophecy of the world becoming biologically simpler with the advent of transportable species. Davis acknowledged that biodiversity is declining at the local level and that introduced species are changing long-established communities; he does not believe that all introduced species should be embraced. But in a sort of refutation of Quammen's planet-of-weeds scenario, Davis wrote that the "globalization of Earth's biota will not lead to a world composed of zebra mussels, kudzu and starlings," three of the past century's most notorious invasives. Different parts of the world will be more biologically similar in the future, he notes, but they will also be more diverse. "Homogenization," he concluded, "is not synonymous with low diversity."

Outliers like Davis encouraged others to rethink the dominant native/invasive binary. In 2011, as substantial federal dollars began flowing towards research on bighead and silver carp, Oregon-based science journalist Emma Marris wrote publicly what she had only heard whispered in hotel bars at Ecological Society of America conferences — namely, that there was no baseline for measuring whether species are native or invasive. "It was like an unofficial opinion I was hearing from a lot of ecologists," Marris says, though they would often need a drink before admitting it. Attitudes began shifting in the past decade, Marris told me from her home in Klamath Falls, "but I think it's still very common for people who are working in the field to say, 'We have to restore [an ecosystem] to X, obviously,' and there is never any justification." Why? "Because it's always just baked into the assumption that you have to restore it to the first white guy," a values-driven determination that has shockingly little to do with ecology. When

lecturing on the topic, Marris often points to Ebenezer Zane, the first white settler to reach Dayton, Ohio. Montgomery County, where Dayton is situated, uses Zane's arrival as the benchmark for determining the "invasiveness" of a species: anything present before Zane's arrival is "native" while anything arriving after is "invasive." Marris says, "He's their Columbus."

Not long ago, criticizing the use of Zane (or Columbus) as a historical baseline for species diversity was *verboten* in most ecology circles. Convinced there was something off about the thinking on non-native species and the outsized efforts to manage them, Marris began researching the book that became *Rambunctious Garden*. Her central theme is akin to what Davis had argued for years: deciding a species was abhorrent based largely on where it came from, rather than on its impacts, didn't make sense. "We move things around, we turn up the temperature, we chop up the forest into a million pieces with roads and seismic lines, we change the chemistry of the soil and we throw acid rain on everything and add more carbon dioxide and nature still does fine," Marris says. "It comes up with a solution. It's ecology in action."

• • •

It's a precision blade in place of a chainsaw, a gentle suggestion that a fish does what it's biologically predisposed to do by following its nose. When so many options for controlling aquatic invasives rely on expensive and generic options like pesticides, the promise of pheromones is simple for Ratna Ghosal: "It's species specific." Electrofishing is the most common way of measuring fish abundance, but when you zap the water it stuns anything in the current's path. Gill and trammel nets provide the same shotgun blast approach. "Asian carp are smart. They learn fast about nets and learn to avoid them. But with behavioral modification, they don't freak out and avoid the nets later."

Pheromones offer a unique promise. Fish like common and

Asian carp can only detect chemical pheromones at the exact ratio their species emits. According to Ghosal, all fish release a host of different compounds — it's the ratio that matters. Common carp release compounds A and B at a ratio of 1:2, while silver carp release those same compounds at a 1:25 ratio. "Common carp is never attracted to AB at a 1:25 ratio because that's a signature for silver carp," she says.

Working with Sorensen and MAISRC graduate students, Ghosal has helped identify potential pheromone agents to target common carp. Beginning in 2015, Ghosal partnered with U.S. Geological Survey and fisheries biologist Jim Garvey at Southern Illinois University to test synthetic compounds they believe may be useful in modifying common carp behavior. It's tedious work. Her team took water assays from stocked research ponds to study what pheromones the fish release and, if possible, isolate those they think could trigger behavioral changes. They then tested the synthetic makeup of those compounds to see how other carp react. "We measure in the lab what they can smell, and those become the candidates for pheromone production," she says. From there, the cocktail is taken to the pond to assess how attracted or repulsed common carp are to a synthetic odor.

A new spectrum of subtle but deadly control options could become available to resource officials if researchers can decipher the recipe of chemicals excreted by Asian carp. "We could create a fake spawning event," Ghosal says, where females are induced through pheromones to behave as though they are ready to spawn. By disrupting the timing between male and female spawning, scientists could wreak havoc on their reproductive abilities. Or, resource agents could entice bigheaded carp towards any location they please, including streams where nets are waiting to capture them. Pheromone traps only work at short range, however, typically no more than six feet. "You won't attract Asian carp from Iowa," Ghosal says, but strategically placed traps during floods or other periods of high activity could net a lot of fish.

This specificity is hugely important, not only between closely related fish like silver and bighead carp, but even within each species. Adult females release different chemical compounds than males; when spawning commences, those same females release entirely new pheromones, indicating there's been a change in their reproductive state, like updating a relationship status on Facebook. Food-based pheromone attractants are even further ahead. One of Sorensen's graduate students received funding from USGS to study what effect releasing spirulina, a biomass of cyanobacteria, could have on dictating Asian carp behavior. Beyond being declared a superfood by Internet nutritionists (Prevents Cancer! Detoxifies!), spirulina has demonstrated in-lab and in the Illinois River that some component (vitamins, perhaps, or fatty acids) is pleasing to Asian carp "Now," Ghosal says, "we're trying to figure out what they like about it."

While her and Sorensen's research on food and sex attractants continued, work was also well underway at the Minnesota Aquatic Invasive Species Research Center on a system that, to me, is no different from the psychological warfare tactic U.S. troops deployed against Manuel Noriega during his 1989 embassy siege. What I've often thought of (to myself) as the "*PA-NA-MA*-Plan" is, more accurately (if less amusingly), a form of sound deterrence.

Researchers have tinkered with sound to control fish since the 1950s. Ultrasound at upwards of 128 kilohertz (kHz) was almost 90 percent effective at keeping alewives from approaching a Lake Ontario hydroelectric dam intake, while frequencies up to 600 kHz have kept Atlantic herring and European sprat from overrunning Great Lake power plant cooling pipes. Unlike electric barriers or other permanent infrastructure like weirs, acoustic deterrents are cheap, portable and environmentally benign. Sound also moves long distances underwater with ease. So it was no surprise when, over the past 20 years, scientists began wondering if Asian carp could be similarly herded via sound.

In this, they were presented a biological gift.

Asian carp belong to the second largest superorder of fish in the world. Members of Ostariophysi exist on nearly every major landmass in the world and include Cyprinidae, the largest family of freshwater fishes and the one to which Asian carp belong. All ostariophysians share an intricate bone apparatus linking their inner ear to their swim bladder, a significant evolutionary achievement that allows carp to hear at frequencies most other fish cannot register. Three kHz, the upper limits of silver carp's auditory range, is extraordinarily higher than that of lake sturgeon or paddlefish, who cannot detect sound beyond 400 hertz.

Building on the assumption that high frequency sound could control silver and bighead carp without impacting native fishes, a slew of research papers emerged, starting in 2006, seeking the Goldilocks range for assaulting carp's ears. While some stuck with sound, others combined sound with strobe lights and/or bubble curtains to maximize the annoyance. Slowly, a consensus formed regarding the frequency range that Asian carp were most susceptible to — from 750 to 2,000 hertz.

Turns out, however, that Asian carp behave much the same way I expect most humans would to a near-ceaseless barrage of sound: eventually they acclimate. How many of us wince at the sound of a fire alarm but aren't bothered to move great lengths from its source? The reason (for both people and Asian carp, I suspect) may lie in the fact that pure tones, however loud, quickly become background noise once the initial shock has passed. Researchers trying to drive silver carp around a test pond at the USGS facility in La Crosse succeeded with pure tones only 5 percent of the time and, at best, on just two consecutive occasions. A follow-up study from 2017 did little better, eliciting a frightened response in just 12 percent of attempts. Yet a complex, broadband sound like an outboard motor was discovered in both studies to consistently drive silver and bighead carp out of their minds. Both fish only habituated to the complex sound after 10 minutes, likely out of fatigue more than anything. After a short break, they were

terrified anew at hearing the 10 kHz motor. While lead author Brooke J. Vetter from the University of Minnesota-Duluth noted that the concrete pond they performed the experiment in was not a perfect stand-in for a river ecosystem because of echoing, the lab results *would* resemble the kind of sound fish experience in a structured canal like the Chicago Area Waterway System.

Back at MAISRC, much of Peter Sorensen's recent non-pheromonal work on Asian and common carp deterrents has focused on geolocating their winter aggregations. In summer, common and Asian carp live in nimble and dispersed shoals, but in winter, the fish are significantly less active and prone to aggregate in large groups. It's a pattern that could make Asian and common carp susceptible to an ingenious tracking method with a proven, somewhat morbid pedigree.

The Judas technique, as it's known, is a shrewd utensil in the animal-management toolbox. Emotionally cruel, especially if you believe animals like fish and goats and wild pigs (all Judas technique test subjects) are inclined towards deep attachment to peers. For fish, it works by inserting pressure-sensitive radio transmitters into a select few sociable specimens known to group together. In time, these chosen fish will point out the whereabouts of other, difficult-to-find fish. Sorensen and colleagues from the universities of Minnesota and Nebraska-Lincoln tested the Judas concept on common carp in three lakes around the Twin Cities beginning in November 2008. Thirteen adult common carp were surgically implanted with radio transmitters and observed over two consecutive winters.

The results were stunning. Sorensen discovered that carp form tight winter clusters in shallow waters near shore, and after deploying seine nets, his crew seized over 4,400 common carp, an estimated 68 percent of the lake's entire carp population. Subsequent captures apprehended between 52 and 94 percent of all carp biomass. What's more, because such huge percentages of localized carp populations aggregate over winter in small areas,

Sorensen believes that entire lake systems may be controlled by targeting focal points at key times each year. The application of Judas theory to Asian carp, another shoaling fish, just makes sense.

Yet for every solution, there's often a glaring caveat. Like every other control mechanism we've looked at there are limitations to the Judas-n'-Catch premise. Specifically, carp breed like bunnies, and can double their biomass in less than three years. Populations will quickly rebound even after substantial numbers are culled. While the 52 to 94 percent removal rates Sorensen experienced sound impressive, even this may not be enough to substantially reduce populations.

• • •

The response from many invasion biologists to the perceived heresy from Mark Davis and Emma Marris was swift and cutting. Led by Daniel Simberloff, 141 scientists from universities around the world drafted a response to *Nature* in July 2011 refuting Davis's assertion that species origin should matter less to conservation officials than the impacts species may cause. Simberloff accused Davis of downplaying severe consequences from nonnatives that manifest decades after introduction. Moreover, species that affect soil or water quality often punch above their weight in transforming entire ecosystems, not just neighboring species. "Pronouncing a newly introduced species as harmless can lead to bad decisions about its management," Simberloff wrote. The public must remain vigilant.

Simberloff continued his defense of traditional, hardline thinking on invasives in his book, *Invasive Species*. Any shift in thinking from origin to impacts gives biologists too much credit in knowing which invasives could be dangerous in new environs, Simberloff wrote. Invasion effects are subtle, and we often don't know if an introduced species will become threatening, or when. Given our shortcomings and the known dangers that many introduced

species have caused in North America, Simberloff believes that it is better to be wary and sock resources into halting their spread. His recommendations parallel the precautionary principle where in the absence of adequate evidence, one should assume that a human activity *will* harm the environment and should be curtailed.

Others joined the debate, if partially to insist there *was* no debate — and that, like climate change, the science on invasive species was settled. Alarmed by the rise in books and newspaper articles suggesting the impacts from non-natives are overblown, Anthony Ricciardi, an invasion ecologist at McGill University in Montreal, took to the pages of *Biological Invasions* in 2017 and 2018 to call out what he's labeled "invasive species denialism." Studies from the 1980s detailing the risks from introduced species have risen exponentially, he said when I spoke with him, and the vast majority all reaffirm that species introductions are a form of "ecological roulette" in which we gamble on what species could blow up in our faces. "You would think then that contrarianism, if it was honest, would decline in the face of this burgeoning evidence," he said. "It hasn't, because it's denialism."

Ever the rigorous scientist, Ricciardi felt it necessary in his published papers name the practitioners of "invasive species denialism," authors that included Emma Marris. Such public naming was "a very tricky thing to do," he said. "It wasn't about the people writing them, but about the article itself."

Marris has found herself the target of hate mail. Many devotees of traditional ecological thinking questioned everything from her ecological bona fides to whether she had ever truly experienced pristine nature. (She now snaps photographs of herself hiking in wilderness areas and national parks, proof, as it were, of her nature credentials.) She's even borne the wrath of eminent American biologist E.O. Wilson, who she tussled with at the Aspen Environmental Forum. Marris's heretical views were denounced as surrendering to invasives without a fight. "Where do you plant the white flag that you're carrying?" Wilson asked, visibly irritated.

She shrugged it off. Many of Wilson's disciples may be surprised to learn that Marris's rationale for embracing novel ecosystems stems from an abiding respect for nature and its awesome power to adapt to whatever destructive thing humans do to it next. The time may come, if it hasn't already, when the best thing for people to do is . . . nothing. "All ecosystems are novel at this point," Marris says. "All of them have some level of change that flows from what we have done to the planet. It's just a matter of degree." Problems arise when ecosystems are seen as "wild" even when they're not, sparking conservationists to keep spaces "pristine" at the expense of benign (or even useful) flora and fauna. In this mindset, anything vaguely "foreign" is devious.

Perhaps the true power of invasive species stems from how we talk about them. "Stories are incredibly powerful. They're the way we understand the world," Marris tells me. "People are totally ruled by anecdotes," and they like ones with pizzazz. Habitat loss, one of the largest single culprits of species loss worldwide, is visually kind of boring. Bulldozers arrive and men cut down trees with powerful machines before others build a farm on churned-up soil. If invasive species is a summer blockbuster, habitat loss is an art house flick.

Beginning in the 1980s, a rash of papers emerged as invasion biology found its voice, elevating invasives to the level of climate change or habitat loss as a threat to global biodiversity. Some disagree with this new statute. The brown tree snake in Guam arriving in airplane wheel wells, appearing in toilets and killing a dozen forest birds species "like a ravenous demon," Marris says, "that's just an incredibly powerful story." Highly visible invasive species like Asian carp offer such compelling and relatable narratives that it's difficult to see silver carp leaping or a house covered in kudzu vines or pythons eating deer in the Everglades and *not* think they're the worst thing ever, even when most introduced are (so far as we know) relatively benign. In talking up the threats nonindigenous species pose, Marris says, "I think people got carried away."

Yet regardless of how we speak about invasive species, or even the relative dangers they pose to ecosystems or human health, the fact remains that we're in the midst of something our planet has never experienced before. Sure, there have been moments of mass species exchange, Ricciardi said, pointing to the collision of subcontinents in epochs gone by. "But not like this. If all the continents climbed together at once, you still wouldn't approach this," he said. "Species are moving faster, farther, and in greater numbers than ever before, and there is nothing that approximates this in the fossil record. This is a completely unique form of global change," not unlike the transformations caused by climate change, he argued. "Call this for what it is. It is global change."

• • •

I spent hours with Peter Sorensen and Ratna Ghosal on and off campus, meeting graduate students, touring labs and research vessels and sitting in on meetings with vendors and the Minnesota Department of Natural Resources. Even though I had more questions about the status of pheromone traps and *PA-NA-MA* deterrence, something hung heavily over our conversations that I couldn't steer either scientist away from.

Money. Specifically, the lack of it.

Sorensen has witnessed the public reticence to pay for scientific solutions to protect the state from invasives. Combining sound cannons with pheromones and changes in water flow, Sorensen's research group has identified an effective way to prevent Asian carp from moving through locks and dams along the Mississippi and Illinois rivers. "We can stop 95 to 99 percent of Asian carps from moving through the chambers in-lab," he told me. "It just has to be moved out to the field to be tested." Yet even after Minnesota DNR signaled its excitement for the project by allocating $880,000 in April 2016, public interest in spending perhaps $2 million total to field-test these solutions remains slim.

"It's a hard sell," Sorensen told me. And ultimately, it may be out of his hands. "There are two parts to this — what science is capable of and the reality of what people will fund. I really view it [as] more of a social issue than a scientific issue." Politicians are another kettle of fish. "Once you start talking about going to the field, [pheromones or sound cannons] are high-risk. You are politically very visible. It's expensive, and there's a risk of failure. Public officials are very conservative these days. No one wants to fail."

Yet not every laboratory concept needs to succeed in the field to be worthy of sustained funding. New thinking about genetics and behavioral modification techniques as a tool for invasion biologists will inevitably be "serendipitous by-products of research in other fields," such as endocrinology and molecular genetics. "The very nature of creativity is that we cannot easily predict what a breakthrough idea will look like," Daniel Simberloff wrote in the journal *Biological Invasions*, "but we can assert that such ideas occasionally arise." It's in searching that we find solutions, some from unexpected places.

Traditional science will play a defining role in solving the Asian carp crisis, though we neuter it by depriving scientific reasoning of real-world applications. Because when charting a course against wicked problems like invasive species, the customary approach of science and its processes for inquiry, failure and validation won't be good enough when the overlapping needs and fears of biologists, fishers, politicians and the public, to say nothing of nature itself, can't be easily reconciled. The resulting crisis of faith in science from the broader public is precisely what's happened, evidenced anecdotally by the resistance Sorensen has encountered convincing local leaders to take a chance on acoustic or pheromone controls.

It's all pointing to the need for a dramatic rethink of what the public can expect from its taxpayer-funded researchers and what supports scientists can reasonably expect from the public and its elected officials. At the turn of the millennium, former National

Oceanic and Atmospheric Administration head Jane Lubchenco argued in *Science* that the timing was right for a new social contract between science and society. We live on a human-dominated planet, she wrote, in which we transform the land and sea and alter the Earth's major biogeochemical cycles, all while destroying and moving species in unprecedented ways. "The resulting changes are relatively well documented but not generally appreciated in their totality [or] magnitude," changes with implications for everything from national security and the economy to human health and social justice.

Asian carp present far too broad a conundrum for biologists or bureaucrats or fishers to solve on their own, as we'll see in the next chapter. The scope of this challenge reinforces the need for different agencies and levels of government (and sometimes governments from different countries) to collaborate in forging new paths to tackle problems that science, despite its best intentions, has often exacerbated. "The whole system of science, society, and nature," Lubchenco wrote, "is evolving in fundamental ways that cause us to rethink the way science is deployed to help people cope with a changing world."

North America's collaborative approach to managing Asian carp is an example of this new scientific social contract in action, an opportunity to expand and redefine the role that science can play in solving real-world problems. But it's a conversation that shifts only if we want to steer it in new directions. When we find unexpected scientific solutions, as Simberloff suggested we may, we owe it to ourselves, to science (in an abstract sense) and to the taxpayers that funded the work to explore them to the fullest. That doesn't mean behaving recklessly, but it does mean taking calculated risks.

Science, however, remains in some unfortunate respects a product of its time. Avant-garde research, no matter how feted in-lab, often finds a cold reception among policy makers and resource officials who rightly worry what impacts carbon dioxide barriers

or pheromones could have on other species or entire ecosystems. Because it wasn't that long ago that Arkansas fisheries managers heeded their own questionable assumptions about Asian carp's biological impact on the country's waterways, assumptions we now know were breathtakingly, spectacularly wrong. Because running the risk of utterly devastating the aquatic health of the Illinois River with poorly placed barriers or rising acidity isn't worth it to stop one invasive fish, many believe, no matter how unwelcome.

• • •

Here's a thought: If field tests of carbon dioxide barriers ever occur, it will have taken a decade or longer to materialize. "We have done enough stuff in the lab and everyone buys into the concept," Cory Suski, the University of Illinois at Urbana-Champaign biologist, has told me, "so the only real unknown at this point is: Can you actually make this work in a real-world setting?" Part of the struggle with field-testing CO_2, even small-scale trials, is the breadth of those involved. Too many cooks in the kitchen is an understatement. On CO_2 alone, academia needs to find common ground with behemoths like the Army Corps of Engineers, the U.S. Geological Survey, the U.S. Fish and Wildlife Service and the Environmental Protection Agency, which once funded much of the work. "It's such a big boat to steer," Suski said. "To get everybody coordinated and to get everybody to agree and then find the money and then hire people." He laughed. "There is just that much inertia in the system before you can really see a change."

It's the same in Minnesota. Even the less worrisome food-attractant pheromone work has hit roadblocks. Releasing spirulina into a waterbody is expensive and runs the risk of causing algal blooms. According to Ghosal, the USGS is interested in the outcomes, but more studies are needed. And, of course, more money.

It's not just the public that can be tiring to sell on new technologies. "It's difficult to make other scientists understand pheromones,

even those who are doing hardcore ecology research," Ghosal said. People stay in their lane. "Policymakers think about pheromone research from a purely academic perspective, but they fail to understand that it has important real-world applications." The technique can help take pressure off electric barriers in the Chicago waterway system or improve capture rates among commercial fishers in the Upper Illinois River.

Peter Sorensen knew convincing the public to act on combating zebra mussels would be difficult, but he never anticipated that getting the public on board with making the behavioral changes necessary to keep Asian carp out of the state would be so taxing. "Around here, people love to go waterskiing and boating and fishing, and it's really hard to say 'No, you can't take your boat between lakes.' I thought with Asian carp it would be a little bit easier because it seemed like a pretty obvious threat." Apparently not. This lack of urgency may be because Asian carp have never been found in large numbers in Minnesota, though that too may be changing. In March 2017, a commercial angler working with Minnesota DNR caught a 33-inch silver carp the weight of a bowling ball on the St. Croix River some 30 miles southeast of Sorensen's office. "This news is disappointing," DNR official Nick Frohnauer told the *Minneapolis Star Tribune*, "but not unexpected."

Sorensen sighed. "I actually have done what I think I can reasonably do with my skill set" to convince the public to pay for keeping silver and bighead carp out of Minnesota. And it likely won't be enough. Ghosal agreed. "I don't know how far we can take pheromone research." When Ghosal talks with Minnesota DNR and the Geological Survey, her sales pitch centers on how effective pheromone treatment is compared with netting or electrofishing. They're always interested in hearing me out, she said, but want to know how long it will take to develop chemical compounds for Asian carp. "That takes time. And they gave us money to study common carp, *not Asian carp*," which would respond to an entirely different pheromone ratio. When her existing grants run

out, it doesn't seem likely she will pursue pheromonal controls for Asian carp much further.

Keeping sheer exasperation from eroding their work ethic is a near-constant challenge. Scientists can test their hypotheses to find answers to public questions — but like the proverbial horse at a trough, they can't make the public pay to implement their findings beyond the lab. Suski confesses, "I bounce back and forth between some of the frustrations from inertia and realizing that this is just what it takes" to get anything accomplished. Tackling Asian carp with CO_2 throughout the Mississippi watershed "is a big-scale operation on a really high-profile problem in a real-world setting where the public is involved. You need to do it right, and you gotta plan it right. Because the reality is you might not get a second chance." Yet CO_2 trials may also replace old problems with new ones. That's why small-scale field tests are so critical.

Funding shortages are part of a worrying trend. For years, Sorensen found local politicians antiscience and the public risk-averse. It's left the veteran researcher with few options for advancing his small corner of public science. At community meetings, he's discovered that asking for cash to bankroll the outcomes of taxpayer-funded research is excruciating. People ask: "Will this work one hundred percent?" and then look grim when he replies that nothing can be guaranteed with one hundred percent certainty. "I'm staking my reputation on it," he says, yet conducting trials is the only way to know for sure.

"Peter started many novel things in the lab," Ghosal says, pushing the potential of new approaches to old problems. But it makes no sense to assume that the old ways of approaching carp control will one day, miraculously, become effective. "Why keep on doing the same thing that the Department of Natural Resources is doing, which hasn't done much? We have to control Asian carp. Why not try new ways?"

CHAPTER 6

Trouble with Fishing

OTTAWA, IL — Layers of scales glistened on Jim Dickau's weathered skin, mixing with blood and slime to form a permeable casing. He was covered in them, an endless wave of scales like delicate ginkgo biloba leaves, concealing his deeply tanned skin, his waterproof coveralls, his sunglasses, his hat and face. He looked half-fish.

Fishers like Dickau are as rare now as Asian carp are abundant in Illinois, that exotic breed of man (and they're almost exclusively men) who make a living catching fish near the center of the continent. Trim and agile at 48, Dickau has fished the Mississippi and Illinois rivers since his teenage years, following in his father's footsteps. He's worked other jobs when things were tough, but "it's a lot nicer being your own boss — at times." Dickau met me at the Allen Park boat launch in Ottawa, Illinois, early one summer morning. He was clad in a camouflage long-sleeved T-shirt, grungy Chevy cap and an oversized rubber suit the color of an English race car. West, across the sluggish brown river, the Illinois meets the Fox River. This is where Dickau and his 16-year-old apprentice, Damian Seiderman, a lanky, quiet kid with a thick mop of brown hair tucked under an orange cap, would cast their nets today to fish out Asian carp.

Dickau and Seiderman were contracted by the state of Illinois

as part of the Barrier Defense Asian Carp Removal Project. Beginning in 2010, Springfield started allocating money to commercial fishers to remove as much poundage of the fish as possible downstream of Starved Rock Lock and Dam. The goal was to reduce the pressure Asian carp could put on the electric barriers in the Chicago Area Waterway System by harvesting downriver. To collect information about the composition of Asian carp and other species in the Illinois, each fishing crew is accompanied by a biologist from the Illinois Department of Natural Resources.

Dave Wyffels, affable and solid in his mid-30s, with a closely shaved head of light brown hair, oversees the Barrier Defense project for IDNR. A graduate of the Western Illinois University fisheries management program, Wyffels could have played linebacker in high school, though the plug of tobacco kept under his lower lip, tilting his smile to the right, gave him the look of a boxer who'd taken a few knocks. Wyffels and Dickau would be my guides to the river and Barrier Defense. The program even has its own T-shirt: a logo saying, "Asian Carp Removal: Illinois River" on the front while, on the back, a cartoon river and the half-sarcastic idea that the man wearing the shirt was "Living the Dream."

Up to 3.2 million pounds of silver, bighead and grass carp were fished out of the Upper Illinois River in the program's first four years. Contracts last from March to December, and, twice a month, more than a dozen fishers working in two-man teams coordinate with Wyffels on where to hit the river hard for four straight days. They never target the same stretch in back-to-back weeks since the fish need a chance to rebound. They're smart, Wyffels says, and avoid parts of the river they suspect are dangerous.

Each week, Schafer Fisheries from Thompson, Illinois, supplies a truck that fishers load with their catch. The state doesn't pay Schafer to remove the carp, though the fish processor makes a profit by rendering them into fertilizer. Each crew is paid a $2,500 per week flat fee. This way, they don't need to worry if an individual haul is thin. The state doesn't always pay on time,

but the money arrives faster than it does from most processors. In lieu of paying more for catching more fish, IDNR has fostered a healthy competition among its crews. On the line are bragging rights, yet even this is enough to motivate fishers to out-catch their rivals. "You gotta have your goals set, and a little rub-in here and there don't hurt nothing," Dickau tells me. "You always want to be the top guy."

Out on Dickau's boat, we set the trammel nets, methodically laid out like spools of spider silk at the mouth of the Fox River. Cautiously guiding the boat through the maze of netting, Dickau kept his eyes fixed on the buoys attached to the fishing lines, looking for tugs and ripples in the water. Our only clue to what lay beneath the surface was a solitary silver carp that leapt into the boat en route to the river mouth, crashing with a thud on the metal floor. "There's one," Dickau said, keeping his eyes on the river ahead. I watch the fish flop for a moment and slowly stop breathing. Seiderman inserted a grimy wooden slab into metal partitions along the boat's side and floor. As it filled up with fish, the partition would expand. In the bow, he began guiding the nets into the boat, his arms straining under the weight of the first net, heavy with fish that cascaded over the edge of the boat and onto the floor.

The men wielded L-shaped metal picks, jabbing them into a fish's eye socket and lifting it to their chest. Holding it by the lower jaw, shoved their picks into the sliver of space between the fish's body and the mesh netting, wrenching downwards. Big fish needed a leaning into with each jerking heave. Having freed the fish, the men tightened their grip on the carp's jaw, since, under its own power, a fish could easily twist free and flop back into the river. Overcome and chucked into the holding pen, these Asian carp were doomed to die.

Experienced anglers like Dickau need 10 seconds or less to free even the squirmiest fish before moving to the next. Wyffels said I didn't have to get dirty if I didn't want to, but maybe just for a day,

I too could live the dream. "Sure," I said, strapping on gloves. "I'll take a pick."

· · ·

Can fishing's dark talent for decimating stocks be put to good ecological use in American rivers overrun with Asian carp? After all, we've done it before. North Atlantic cod is the most glaring example of fisheries collapse, but there are more than we care to admit: blue walleye in the Great Lakes, anchovies off the Peruvian coast, sea cucumbers around the Galapagos Islands and the Red Sea, sole in the English Channel. Tuna and mackerel populations have tanked globally by 74 percent since 1970; Pacific bluefin tuna, with just 4 percent of its historic numbers remaining, may not survive to mid-century.

Yet what may seem an ideal solution to the carp crisis is, beneath the surface, a tangle of question marks. Researchers are slowly unraveling the knot to better understand what role large-scale fishing could play in the fight against Asian carp but as yet don't know whether it's a magic bullet for halting their progress towards the Great Lakes or little more than a local stopgap.

It's a conundrum that begins and ends with money. Start with fishers like Dickau. They require a minimum of 35 cents per pound for silver (preferably 50 cents for bighead) just to survive. Gear needed to furnish processors with Asian carp makes for a daunting check-list. An 18-foot aluminum jon boat costs a few thousand, depending whether it's new or used. Then there's gasoline and a $15,000 heavy-duty motor. Next, there's a $50,000 truck with the necessary towing capacity and a $5,000 trailer to haul the boat around the Midwest. Add in mandatory insurance for the crew and equipment and ice to keep your catch from spoiling and "it all adds up to an ungodly amount," Dickau noted. "If something breaks, that's the worst."

The return on any fisher's investment, especially for those who have sunk tens of thousands of dollars in upfront costs, has to

be substantial. And immediate. Neither happens selling silver and bigheads for an industry average of 25 cents per pound. Like most freelancers, fishers are paid well after delivery. And, like most small business owners, making it through the first year is tough. Asian carp are too active in summer to catch easily, getting hopelessly tangled in the nets. Trap nets run $300 to $500 apiece, depending on size, and fishers typically put up to 15 nets out at any time to make a living. Even if a new fishing crew survives their first fall, winter and spring, the summer can be merciless.

Although stable, America's market for Asian carp is small with meagre growth potential. This sluggish pace has suppressed the number of commercial fishers willing to catch them, Illinois processor Mike Schafer tells me. His company has employed the same dozen fishing crews since 2000 to supply their operation. Tim Fosdick, a veteran salesman at Schafer Fisheries, agrees, telling me he's seen plenty of young fishers try to start a business catching and supplying Asian carp to Schafer and other processors. He's never seen a start-up succeed.

Dickau hasn't found a way around the high cost of commercial nets, though by crafting his own he saves on labor and ensures they fit his specifications. Each trammel net Dickau puts in the river is 500 feet long and worth $600 if bought preassembled, though his DIY spirit shaves a few dollars off his costs. When he puts all six nets in the water at once, Dickau is watching $7,200 worth of netting slide effortlessly into the river. He has no idea what shape they'll be in when he drags them out.

And Asian carp are rough on the nets. Violently, spectacularly rough. Writhing through openings leads to rips in constant need of repair, a drain on a fisher's time and wallet. Nets are useless after three weeks if they're not constantly mended. Dale Singleton, the commercial fisher I met at the White River National Wildlife Refuge in Arkansas, told me that common natives like crappie and buffalo were getting harder to catch because of the huge holes silvers and bigheads tore in his nets. Through "sheer power,"

silvers and bigheads pulled right through them. "I can show you a net right now in the back of my truck they've ripped a hole clean through." I asked Dickau how long his handcrafted nets last. "Typically, a season," he replied, or, if he keeps them in good repair, two seasons at most. "I haven't encountered a fish that's harder on the nets than silver carp."

"There's not near as many people as there used to be" fishing the river, according to Dickau. "It's so expensive to get into. If you don't know the river and know what to do, it's not like you just go throw a net out and there they are. It ain't that easy. You can have the best gear in the business, but if you don't know how to use it or where to find the fish what good is it?" Schafer told me the same months before. "They sell the gear off in just months," he had said of the inexperienced fishers he'd seen come and go. "They think it will be easy, but it's not as simple as all that. There's a steep learning curve."

• • •

It was a productive morning. We had hauled in hundreds of silver carp with a few dozen bighead and grass carp thrown in the mix. Channel catfish also came along with smallmouth buffalo, but Dickau quickly tossed those overboard. State-contracted fishing crews can't keep non-target fish they catch; anything that's not Asian carp goes back, otherwise the state's assistance could be viewed as a subsidy for contracted crews. When not fishing for the government, Dickau would sell those channel cats and buffalo for far more than he could hope to get for Asian carp.

I slowly became more proficient wielding the pick. My first attempts were clumsy, the fish and me stumbling awkwardly in the boat as if locked in mortal combat (well, mortal for one of us). Securing a solid grip on their jaw with my left hand, my right twisted the netting the length of the fish. Silvers would wriggle from my grasp and land in netting pooling around my feet,

flapping in the nylon bedding until I chucked them behind the partition. I gravitated to smaller fish, those easier to handle, and left the 30-pounders to the pros.

The rubber suit I had borrowed from Wyffels suffocated my skin. Sweat mingled with the blood and slime and scales and shit that coated everything in the boat, hanging over us like a sour pall and clinging to the hairs in my nose. Like in a comic book, I could see my own stink lines. I asked Wyffels how he coped. He spit tobacco juice overboard. "I just got shorts on under the waders 'cause it gets so damned hot," he said laughing. "Hell," I replied, "wish I'd thought of that." I had already rolled my sleeves up around my elbows, revealing forearms a bronze color I didn't recognize. I dove my pick into a silver carp's eye, wrenched it and hauled the fish to my chest. I tossed it back with the others. It landed with a wet thud and skipped across the bodies of those already interred, sending a ripple of spasmodic twitchings through the pile like rocks plunked in a creek.

These fish had been pulled from the Starved Rock section of the Illinois River. For navigation and water control purposes, the Illinois was divided into eight "reaches" (also known as "pools") over the first six decades of the twentieth century. From Alton in the south near St. Louis, Missouri, to the O'Brien Lock in Chicago, these eight reaches designate areas of similar geomorphology, each separated by a lock and dam operated by the U.S. Army Corps of Engineers. The Starved Rock pool was 80 miles downriver from Chicago. From there, the Illinois loses 578 feet of elevation before meeting the Mississippi north of St. Louis. Between Starved Rock and O'Brien, the Illinois River is closed to commercial fishers except those officially contracted by the state to remove Asian carp. This still leaves 231 miles of the Lower Illinois open to fishing. Dickau and his 21-year-old son, Nick, split their time between the Illinois River near Peoria and the Mississippi River in Illinois and Iowa, closer to home. Father and son sometimes fish together; today, Nick was working another crew.

The morning's nets hauled in, Dickau got a call from another contracted angler upriver. A dredged harbor jutting out from the river concealed a bonanza of silver carp resting outside the main channel's faster flow. They had dragged in more silvers than they could carry and needed backup. "What do you think?" Wyffels asked. Dickau readied the engine. "Let's get going."

. . .

Illinois has deep fishing roots. In the late nineteenth and early twentieth centuries, Illinois was one of North America's most productive inland fisheries. "More fish were taken out of the river and shipped to New York and Los Angeles on train cars than from any other fishery," Illinois Department of Natural Resources biologist Kevin Irons told me. A hundred fish houses once lined the shores of Grafton, Havana and Pearl, employing 2,500 people at its peak in rural towns stretched out along the Illinois for miles in either direction.

No more than nine feet deep, the Illinois was highly conducive to fishing. Occasionally beset by heavy flooding, temporary lakes and wetlands formed along its 273-mile length that provided ample opportunities for fish to spawn. Volumes caught from the Illinois quadrupled between 1894 and 1908, the height of this fishy gold rush, from six to 24 million pounds. Buffalo, channel catfish, suckers, gizzard shad and common carp were taken from the river, but people weren't picky. "They caught everything," Irons said. Yet times change. "Somewhere in the last one hundred years the U.S. has gotten away from eating fish."

He's partially right. Americans didn't stop eating fish, as Irons suggests, so much as they simply began eating other foods in much greater quantities. Between 1910 and 2010, U.S. consumption of commercial fish flatlined, rising from 11 pounds eaten annually per capita to 15 pounds. During this time, the population of the United States more than tripled from 92 to 310 million people.

While more Americans ate fish, its share of America's overall protein consumption languished. This four-pound rise was paltry compared to poultry. In 1910, U.S. consumers ate the same poundage of chicken per capita each year as fish — but over the next century, poultry consumption jumped to 60 pounds, a twelvefold increase over fish.

Meanwhile, America underwent a strange shift with the fish and seafood it *did* consume. U.S. seafood chronicler Paul Greenberg wrote in 2014's *American Catch* that despite 94,000 miles of coast and 3.5 million miles of rivers in the United States, 91 percent of the seafood Americans eat every year comes from abroad. And American seafood exports (typically wild-caught fish and shellfish) have risen by 1,476 percent, replaced by imports of farmed seafood of typically lower quality. It's a "particularly American contradiction," Greenberg wrote, that the food we should eat most for its abundance and tremendous health benefits is largely absent from our diets.

North America's evolving taste buds and proclivity to import mass quantities of farmed seafood are part of the story. As to the other part, in Illinois, decades of habitat destruction, dam building, industrial pollution and agricultural runoff took as great a toll on fish populations as overfishing in the first decades of the twentieth century. In 1915, Chicago sanitary engineers John W. Alvord and Charles B. Burdick reported a steady drop in fish caught from the Illinois after 1908. The largest culprit was agricultural levees: the diversion and retention of water for agriculture interrupted the cycle of beneficial flooding that made the Illinois a productive fishery. After 1908, levees destroyed 17,000 acres of wetlands and lakes, a 36 percent reduction in the breeding and nursery grounds of native fish.

If commercial fishing were to have any future in Illinois, Alvord and Burdick wrote, "means must be provided to take the place of the breeding grounds formerly furnished by the shallow waters of the lakes and sloughs." No means were found, sacrificing

river health and the fishery to farming. Local industry built to catch and process native species withered as fish declined rapidly from environmental stresses and habitat loss. Processing plants closed. Laborers found new work or moved away. The result was a compromised ecosystem and declining fishery throughout Illinois well before Asian carp populations ballooned in the 1990s.

Irons has managed the state's Aquatic Nuisance Species Program since 2010. His previous two decades were spent conducting field-work with the Illinois Natural History Survey, much of it on Asian carp. He understands the biological struggle against this invasive fish as thoroughly as the policy challenges Asian carp present to Illinois and other states. Beginning in 1991, Irons worked an 80-mile stretch of the Illinois River in the state's northwest to monitor how the river and its biota functioned. He remembers the first time a commercial fisher arrived at his field station like it was yesterday, lugging what was later identified as a bighead carp. "'I've got this strange looking critter,'" Irons tells me from his Springfield office, lacing his voice with a heavy Midwest drawl for effect. "'What the heck is it?'" Routine sampling didn't turn up another bighead until 1995; the first silvers appeared three years later. By the end of the millennium, thousands of silvers were detected in the Illinois. "We knew they were coming," Irons says, "but then they were here in sufficient numbers to reproduce."

These days, more than 1,300 commercial fishers remain licensed in the state, according to Irons, all ready to fish down Asian carp for a steady wage. "We have people who have done this for generations," he says, who are "still available to utilize this resource." Yet here's the rub. The superabundance of silver and bighead carp could theoretically support an industry-led com-mercial fishing strategy, according to state thinking, rather than relying on a state-subsidized fishery should Springfield step in to boost prices paid per pound. Irons knows the current prices paid are too low, but that could change if the public appetite for Asian carp grew. "The fish is valuable and eventually the industry will

develop and support this," he told me. "We don't think paying fishermen to fish them out through some type of subsidy makes a lot of sense."

Some civic leaders agree. Perched on the banks of the Illinois River, Peoria, the commercial hub of central Illinois and the largest metropolitan area in the state outside of Chicago, has flirted with attracting Asian carp–related infrastructure. But enticing such businesses to set up shop in the city is challenging. "Peoria doesn't have a ton of money to offer, just cash to say 'bring your company here,'" Mayor Jim Ardis told me in his city hall office. The private sector will ultimately lead this fight, he believes, since it's better positioned to innovate cost-effective solutions. His city has a few tools to tempt business — rebates on sales taxes for building materials or lowering property taxes on processing facilities. Not huge dollars, but better than nothing. "Sometimes the state can find little pockets of money. Illinois is not in the upper echelon of having any spare cash," Ardis said with a laugh. "But if it's going to drive jobs and import/export business it would definitely be something we could work hard on."

If the state will not (or cannot) play ball, and cities lack the clout to support a fish-processing industry, then the federal government stands alone. Congress controls the purse strings for any regional incentive program, and proponents of paying fishers have few allies in Washington. Former Asian carp czar John Goss told me he sympathized with commercial anglers, admitting they could use the financial assistance. Yet during his tenure, Goss would not commit Barack Obama's White House to paying subsidies. When I suggested the administration finance processing plants instead, Goss paused for what felt like an uncomfortably long time. "I believe it should continue to be evaluated," he answered, adding, "I don't see significant subsidies in the near-term from the U.S. federal government. It's not likely." States are welcome to invest their own funds to pay fishers, Goss went on to say — but Illinois is broke.

Illinois's lack of funding for carp control may be less an altruistic faith in American entrepreneurialism than a consequence of their messy fiscal house. Unfunded pensions are an unexploded ordnance waiting to blow a hole in the state's future unless politicians move money back into public worker pensions. As of 2016, Illinois carried one of the country's largest unfunded pension debts at roughly $220 billion.

This is not unrelated to the difficult task of managing natural resources. These devastating financial obligations trickle down, determining how effectively Springfield can deter aquatic invasive species. Most money earmarked for Asian carp control has been, to date, federal cash to meet federal program standards. Illinois and other financially strapped states obtain funding aligned with Washington's priorities. Sometimes those are simpatico with local concerns — sometimes not. The South craves better data on Asian carp in their waterways, for example, but that's not a primary federal concern, so data poor they remain. This has profound effects on how local knowledge, initiatives and needs are accounted for, as they're often ignored on Capitol Hill. Washington has been narrowly focused on protecting the Great Lakes, good news for Michigan or Ohio, less so for overlooked fishers and Southern states where some Asian carp have swam freely since before the Civil Rights Act was signed.

• • •

Dickau navigated his boat through the narrow channel separating the inlet from the river. The scene felt familiar, like we were trapped in a YouTube video I had already seen. A rusty chain stretched from one end of the channel opening to the other; it sagged low, letting us pass. This inlet near Bulls Island had been intended as a marina. The U-shaped waterway, lined with deciduous trees and scrub, had been dredged. Orange erosion fencing

lined the artificial shore. Once the marina plan fell apart, the abandoned space became a haven for silver carp.

That the harbor yielded a windfall of fish underscores the link between on-the-ground resource management and public science. The social behavior of Asian carp remained poorly understood as late as 2012, when scientists from the Minnesota Aquatic Invasive Species Research Center uncovered how bighead and silver carp group together and the tight social bonds they're prone to forming. Ratna Ghosal found that the species shoaled together to aid in food detection and in warding off predators. While shoals formed by bighead carp tend to be fewer but larger in size, silver carp form many smaller social groups, she wrote, speculating that, because of their ability to leap from the water, silvers don't require the same strength in numbers. Asian carp aren't randomly distributed in a river system either, Ghosal argued. Rather, they form small, tight-knit clusters of single- and multi-species congregations. The call Dickau received stating that the abandoned harbor was a silver carp gold mine wouldn't have surprised Ghosal.

We worked in tandem with another crew. While they set nets to the west, we worked the eastern portion of the marina. Seiderman released the trammel nets in a maze only Dickau could keep straight. It got hairy. Unlike the relative calm of the morning, the silvers here were spooked and, true to form, burst from the water en masse. One hurtled just inches past my chest on its airborne arc and landed in the boat. Seiderman dodged slower-moving 20-pounders with ease while the faster 10 pound silvers were trickier to avoid; they came from everywhere and nowhere. Some threw themselves with missile-like purpose. Others flew lackadaisically, casually flinging themselves from the water as if doing so only because the herd dictated they must. We saw flashes of silver reflect in the sunlight as they crashed against one another below the surface, abutting the nets. Some jumped one net only to swim through the next, thrashing wildly against the strangling

nylon. Seiderman ran out of netting to unfurl. Finally, the inlet was still, the air thick with musty river bottom. The only sound was the writhing of captured fish, the already ill-fated, tossing about. We caught our breath.

Dickau started the motor and began snaking his way through the jumble of netting, revving the engine to shoo silvers from the depths into the nets. Wyffels and I left our perches on the boat's rim to kneel low. The symphony of splatter began again as the fish leapfrogged to escape the deafening motor's roar. The white mesh of the nets, barely visible above the waterline, was dragged deeper into the river as more fish became entangled. Wyffels inserted another plug between his jaw and lower lip. After 15 minutes piloting the boat through the slender inlet, Dickau cut the engine. The fish were trapped.

Our arms soon ached from the strain of picking and prying the fish free. Like loosening a belt after a big meal, Dickau moved the wooden door to a larger slat, expanding the boat's holding capacity. The fish piled two feet thick. Once a recent arrival twitched its still-working muscles the pile heaved, sending a corresponding ripple through the flesh of dying fish. With a reasonable number of fish in the nets and a fast crew behind him, Seiderman could stick to hauling in the nets. But we couldn't keep pace. No sooner had he tugged in 10 feet of netting and the backlog forced him to start prying the fish from the net with the rest of us. Tossing one more fish aside, I kneeled on the soft netting to stretch my legs. Seven hours on the boat and no one had moved more than eight feet, and much of that was knee-deep through dead fish: one doesn't walk through such a mass so much as glide over it. I set down the pick, hoping no one would notice. Dickau looked up and smiled while he chucked a fish past me into the bin. "What, you takin' a break?" he asked. "Get to it." He grabbed another silver; I did too.

The days commercial fishers spend on the river as part of Barrier Defense start before sunrise and end in the early afternoon.

Wyffels estimated our boat alone dragged in roughly 7,000 pounds of carp, fish no longer capable of pressuring the electric barriers, reproducing or competing with native fauna. Other boats pulled in similar hauls. After we dragged in the remainder of Dickau's nets, we met two other crews in the shallow inlet. The high volume of silvers had set them back, and Dickau volunteered our crew to work their nets. It was a rare show of cooperation among colleagues who don't typically lend one another a hand. "Fishermen would send each other out of state if they thought it would give them a competitive advantage." Wyffels laughed as we got back to work. "'I hear there's some great fishing in Iowa. Get the hell out of here!'"

• • •

The success of Barrier Defense in thinning carp populations south of the Great Lakes is undeniable. But assuming this alone could induce Asian carp populations to collapse is not the logical outcome of the state's commercial fishing program, as many suppose it is.

Michigan State University researcher Iyob Tsehaye studied the prospects for a fishery-forced collapse of Asian carp in the Illinois River in October 2013. He found the concept to be no panacea. Tsehaye argued in the journal *Fisheries* that more than 70 percent of all silver, bighead and grass carp in the Illinois River had to be removed for the fishery to collapse. That's an exploitation rate of 0.7, meaning that, if one million silver and bighead carp inhabit the river, fishers must remove a minimum of 700,000 to reach the 0.7 exploitation rate. At that level, silver carp in the Illinois could be reduced by an average of 60 percent and bigheads by 68 percent. This sounds impressive, but its effects are negligible in the long-term.

Why? Because of an ecological phenomenon called overcompensation. Also known as the hydra effect, overcompensation

occurs when overall species abundance rises despite large numbers of individual members of the group being eliminated. This explosion of life from heightened mortality has been observed among plants, fish, insects — humans too. Surviving targeted fish would find more food available and less competition for it. They would grow larger and breed quickly, allowing the population to rebound. In the Illinois River, collapse is further complicated by the fact that substantially more silver carp live there than bigheads. A 0.7 exploitation rate, while potentially devastating for bigheads, would leave enough silver carp for the population to rebuild, perhaps to an even greater extent than currently seen.

But overcompensation can be overcome, and Tsehaye's paper highlights ways to tip the scales in favor of native fish where Asian carp are a nuisance. Fishers need to stop targeting bigheads for their greater economic value — 25 cents per pound for bigheads compared to 10 cents per pound for silvers — to avoid the hydra effect taking over. Removing more bigheads than silvers all but ensures more silver carp in future, a short-term economic gain that undermines any chance of collapsing the overall Asian carp population. Tsehaye argued that resource managers must increase the exploitation rate for silvers and expand commercial fishing efforts overall. Otherwise current fishing practices are doomed to fail.

We are still faced with the nagging question of what to *do* with hundreds of thousands of pounds of edible fish caught each year from the Illinois River. The past five years has seen tremendous growth in *talking* about eating Asian carp, far outpacing growth in actual consumption or processing capacity.

One state is looking to the private sector. In July 2017, the Commonwealth of Kentucky issued a request for information (RFI) to identify market-based solutions to their burgeoning Asian carp problem in and around Land Between the Lakes National Recreation Area. Recently, silver and bighead carp have undermined Kentucky's ability to protect their fish and wildlife, not to

mention in-state recreational fishing and boating tourism worth over a billion dollars each year. Local fishers already catch two million pounds of Asian carp in-state annually, fish often sold locally under the name "Kentucky blue snapper." Gregory Johnson, commissioner of the Kentucky Department of Fish and Wildlife, believes a demand exists for upwards of 30 million pounds of silver and bighead carp every year. But to test the water, state resource officials have asked the public to weigh in on how just five million pounds of bigheaded carp can be caught in ways that support a reemerging commercial fishery.

Someone needed to try a new approach. Since 2010, many state resource officials have been too overwhelmed to manage Asian carp on their own and too broke to afford subsidies often necessary to enlist private-sector help. The Kentucky P3 model is a new effort whose merits haven't been fully analyzed: until they are, most state-private collaborations will likely be effective but Lilliputian efforts like Barrier Defense — useful in a localized way, but too poorly funded to be scaled up. This has to change. Governments need to acknowledge the vital role they can play in building both fishing and processing capacity for Asian carp, a critical component of any future plan to limit carp populations. To date, states and the federal government have signaled their unwillingness to assist fishers and processors via large or long-term subsidies, since many believe a sustainable market is possible without cash injections. That may be, but without start-up capital to support these infant industries, it's unclear whether that market will ever develop.

States' reticence to put skin in the game may be changing, part of a wider recognition that, on a broad range of environmental topics, states and cities may have to go it alone. In response to President Donald Trump's announcement that the United States would pull out of the Paris Climate Agreement, a coalition of 364 mayors, representing the interests of 60 million Americans, vowed in July 2017 to "adopt, honor and uphold" their nation's climate

commitments. "The world cannot wait," they wrote, "and neither will we."

Even Kentucky acknowledged in their RFI that the state "intends to contribute" towards building whatever industry eventually emerges. It could take many forms: the state could hire commercial anglers as Illinois has done; assure fishers that a fair price would be paid for any Asian carp they caught; enter into sales agreements with processors; rent low-cost equipment to rookie anglers or match start-up capital with forgivable loans. It's one of the most progressive responses I've seen to overcoming the stalemate between governments, industry and the free market. We should all watch closely how Kentucky's P3 experiment unfolds.

• • •

The next morning, I met Dickau and several other crews in a parking lot behind a Quality Inn in Morris, Illinois. A faint orange glow rose above the industrial mall to our east. This was the last day of contracted fishing they would do for two weeks. I followed the convoy of pickups towing grimy metal boats across Interstate 80 and through Morris towards the river. Morris is a small town like so many others I've driven through, torn between its history and its future, the family-owned restaurant on Main Street and the Arby's by the interstate. The highway was winning.

We put in at William G. Stratton State Park on the north shore of the Illinois where N Division Street widens into a four-lane bridge. Crews were heading east to retrieve trammel nets so successfully employed near Ottawa; others would scour a nearby quarry. Bucking the trend, our boat headed west to check hoop nets that Dickau and Seiderman had set days before. Sometimes hoops haul in 10,000 pounds at a time, Seiderman told me — sometimes they're empty.

We chugged past the half-submerged hulls of rusted cargo ships and towering grain silos, built to spit their crop into waiting

barges. Past farmers' fields and worn-out trailer homes dotting the north shore, we came upon Sugar Island, the slug-shaped islet where the crew had set their nets. Hoops function by creating a channel roughly five feet in circumference that fish can swim into but not out of. Fishers collect their catch by hauling the metal hoops up and into the boat one link at a time. The last link is the toughest since fish caught in the net fight desperately to remain in the water. Eight hoops were laid around Sugar Island, each a few feet from shore beneath thick tangles of brush jutting over the river.

Dickau and Seiderman grabbed opposite sides of the first hoop we approached. Bracing themselves with one foot on the floor and another on the gunwale, they heaved, their muscles tensing under green rubber suits. One ring, then another and another — but no fish. "They're in there," Dickau says. "They just don't want to come out." Finally, as the last rung was plucked from the river, a torrent of fish flooded the boat. The catch was remarkably different from the previous day's haul of mostly silver carp. Channel cats and bigmouth buffalo came up, some weighing 20 pounds or more, all released back into the river. To my surprise we had netted relatively few Asian carp. Still, the composition of carp we did catch was strikingly divergent. Bigheads made up maybe five percent of our total catch near Ottawa, but at Sugar Island, 30 miles upriver, bigheads were running. And were they ever *big*. Wyffels bent at the knees to grasp a four-foot bighead slithering on the deck, smacking into channel cats an eighth its size. "Those are the size we used to find in the Mississippi River."

Not anymore. The largest bigheads have crept upstream with the invasion's leading edge. This was the hydra effect in action: with fewer Asian carp this far upstream, there's less competition for resources. And these days, large fish like the one Wyffels held are only found upriver, near Chicago. "What do you think it weighs?" I asked. "See for yourself," he responded, thrusting it at me. Using two hands I grabbed the bighead by the jaw, lifting it

like a kettlebell. "Oof," I groaned. "Maybe 40 pounds?" Wyffels nodded. With some difficulty I hoisted the jostling fish over the wooden slat and watched as it sent smaller fish reeling.

The hoop nets hadn't been as effective this time around. But because of the larger size of the fish we had caught, Wyffels estimated we had still landed 2,000 pounds of bighead, silver and grass carp. The crew called it a day before noon. "You ended up a lot cleaner today than yesterday," Seiderman said to me as we cruised back to the launch. It was true. The day before, I had been in the thick of it, picking silvers out of the netting. But hoops are a different beast. With Dickau, Wyffels and Seiderman hauling in rings, there wasn't space to help without becoming hopelessly intrusive. Truth be told, hoop netting is also much dirtier work — fishers spend plenty of time hunched over writhing fish kicking up blood, slime and dirt. More than once that morning, I witnessed Seiderman gag, spitting out whatever fish fluid had ended up in his mouth. I wasn't eager to tag him out.

• • •

Silvia Secchi wanted to understand whether commercial harvesting was worth the expense. In 2012, the Southern Illinois University–Carbondale resource economist collaborated on a research project that measured fishing's impact in one relatively modest stretch of river during one season. Keenly aware of the limitations of her research, Secchi acknowledges it's too small a sample size on which to build an Asian carp management strategy. Yet it makes for interesting reading.

They found that without knowing the total abundance of Asian carp in the Illinois River, never mind its population size in adjacent river systems, the long-term impacts of commercial harvest are a teeter-totter of knowns and unknowns. Would the three million pounds taken between Chicago and Starved Rock be enough to change the river's biodiversity in favor of native

organisms? Secchi doesn't know. Her SIU colleague Jim Garvey tells me there are probably fewer bigheaded carp in the Illinois River than people think. Over seven years of hydroacoustic surveys of fish populations, Asian carp abundance hasn't gone up appreciably. "They are obviously at some point where they've hit the maximum amount in the river," he says. But in terms of true density or biomass, he suspects the Illinois fishery could bring in between 10 and 30 million pounds of silver and bighead carp. "Whether that will collapse the fishery or whether it will sustain it," he says, "no one really knows."

Kevin Irons from Illinois DNR agrees, though he suspects the river has more Asian carp in it than Garvey estimates. The Illinois must lose between 30 and 50 million pounds of Asian carp each year to drag their biomass down to 20 percent of all living matter in the river from its current 60 percent, he tells me. Only then, in his opinion, would biologists see a noticeable improvement for native biota. This removal target is well above the 10 million pounds of Asian carp removed from the river south of Starved Rock State Park by commercial fishers, all of whom operate, unlike Dickau and Seiderman, without a contract from the state.

The reduction in fish close to the electric barrier shows state-contracted fishing is successfully reducing carp numbers in the Upper Illinois. The repeated efforts of Dickau and his colleagues have made a dent in the silvers and bigheads remaining in the river's upper reaches, evidenced by the opportunistic arrival of the huge bigheads from further south we caught near Morris. Perhaps even more than a dent. In July 2017, Irons told a local news outlet that carp populations in the Illinois River are 25 to 50 percent of what they once were.

Yet recent research shows even heavy-duty fishing in the Dresden, Marseille and Starved Rock pools may not bring about long-term benefits. Led by Jim Garvey, research at SIU in 2015 found that carp densities in backwater lakes and inlets, like those I fished with Wyffels and Dickau, typically rebound or exceed

preharvest populations in as little as two weeks. Since the program began, researchers noted, commercial fishers have hauled out increasingly large volumes of Asian carp from the Upper Illinois without affecting fish density. "Harvest alone is clearly not the only factor regulating population dynamics in the river," Garvey wrote.

So, where are they coming from? Natural reproduction in this stretch of the Upper Illinois is negligible, the researchers concluded, suggesting that fish born outside the state must be arriving via immigration through the Starved Rock Lock and Dam. It's a frightening possibility. So long as Asian carp spawn in the Lower Mississippi River, whose tributary rivers and streams reach tentacle-like throughout the United States, a never-ending supply of Asian carp will continue migrating towards the Illinois River and the Great Lakes beyond, just as Bobby Reed from the Louisiana Department of Wildlife and Fisheries predicted.

Yet IDNR soldiers on, increasing the volume of commercial fishing between the electric barriers and Starved Rock by more than 100 percent in 2016. A further 1.2 million pounds of primarily bighead and silver carp were hauled from the Upper Illinois that year, bringing the initiative's total harvest to six million pounds. There are other reasons to be hopeful. Garvey tells me that hydroacoustic research coming out of his lab has confirmed that commercial fishing south of the Chicago Area Waterway System has suppressed the number of fish making it upriver. Barrier Defense is "buying time to keep the carp population from building up below the CAWS," he says, "which is exactly what we want to hear." Asian carp may be here to stay but managing them the old-fashioned way by fishing them down remains the best and cheapest option, he feels. "Maybe I'm biased, but fishermen have been fishing these things for thousands of years, so why not fish them out? If we spent all that money contracting fishermen maybe we could have a lower [carp] population, at least near Chicago."

But Garvey doesn't believe fishers can build the industry

needed to fish substantial numbers of Asian carp from the Illinois and Mississippi rivers without support. "You've got to create some sort of financial incentive," he tells me. There's a golden opportunity here for academia, government and the public to work together to dramatically reduce carp populations. If the government kickstarts commercial fishing, Garvey thinks that could have a strong impact. "But those fishermen have to realize that once the fish drop out that they are going to have to move to another resource, which might be anything from aquaculture to sustainable fishing of sturgeon and paddlefish for caviar."

Whether the resource managers and fishers who participate and run the Barrier Defense project feel their fish-culling program is working isn't as clear. Researchers at the University of Minnesota surveyed state resource agents engaged in the fight against Asian carp, many of whom warned that "political need" often trumped "biological reality" in determining how the nuisance species were managed. The result was often some quick fixes aligned with election and funding cycles. "Legislators want sure things," postdoctoral fellow Adam Kokotovich heard from one of 16 interviewees he spoke with. "They want . . . fish killed." Another resource official confided anonymously about commercial fishing efforts that "it's nice to be able to see that there's fish on the deck, and the public likes to see that, but does it actually have an impact on the population? It may not at all. Because [if] you're not having an impact on the population you're . . . spending a lot of money to do nothing."

Perhaps the question isn't whether governments should pay fishers to remove Asian carp, Silvia Secchi says to me. Perhaps the real question is: Who gets the money? This will influence whether low-cost options like fishing down carp are prioritized to deal with the crisis, or whether high-cost projects like electric barriers and engineering fixes intent on controlling nature rule the day.

There's no doubt the government expanding its offer to commercial anglers in a wider geographic area, as many propose, will

be cheaper than paying the Army Corps to modify the subcontinental divide. The structural solutions proposed by the Corps are exorbitantly expensive, featuring unknown ecological and economic consequences. "Even if it takes a couple of years for the fishermen to fish the carp because the market needs to be developed," Secchi says, "this is a lower-cost option than changing the hydrology of a river." But it's no use assuming practicality will win out — America has always loved its megaprojects.

• • •

Back on land, with the boat fastened to the truck, Dickau and Seiderman transferred their haul to Mike Schafer's trailer parked beneath the bridge. Before they left on the two-hour drive back to Thomson, I asked Dickau what he thought of the Barrier Defense Program. Could commercial angling play a leading role in keeping Asian carp from the Great Lakes? He downplayed such grandiose visions. "We're just taking the population down to ease the pressure on the barrier," he answered.

And yet. Since the program began in 2010, it's been near impossible to catch Asian carp upriver in the Dresden reach, he went on to say. "You catch two or three a day now and you're doing a pretty good job." The same holds true for lower reaches like Starved Rock where we fished this week. Years earlier, one or two trammel nets was all you needed to fill a boat. Now, "You're lucky to catch a boatload unless you stumble on them." It's progress. Barrier Defense has been good to the commercial anglers who have won state contracts. "I make decent money off them," Dickau said of Asian carp. He admitted it's rare to find a fishing contract that pays a guaranteed weekly income regardless of performance. The uncertainty, however, may not be appealing to a younger generation. I asked Seiderman if he plans on toughing it out as a commercial fisher. He pulled out his earbuds. I repeated the question. "Nah," he said. "I'm looking into welding."

The money, unlike the fish, likely won't last forever. But regardless of its lasting impacts, commercial fishing in the Upper Illinois has helped keep the Asian carp population in check. And as government officials debate long-term strategies for keeping the fish from reaching the Great Lakes, the pressure being placed on commercial fishing to manage silver and bighead carp has grown significantly, as has the pressure to find enough people willing to eat Asian carp to justify the construction and operation of fish-processing plants like the one I visited in Thomson, Illinois. Yet Dickau had faith. "Draw your line in the sand and keep after them constantly and they won't make it past Chicago."

CHAPTER 7

"Eat 'em to Beat 'em?"

THOMSON, IL — Blood-red water pooled around my boots, mixing with clumps of flesh and the brown ice needed to keep 1,200 pounds of carp cold. I stood next to a sewer grate guzzling foul-smelling water as a young guy in hip waders and industrial rubber gloves cleaned up. Sheepishly, I stepped aside as he mopped around me. A truckload of silver, bighead and common carp had just been unloaded, fish tossed in high arcs from a metal holding bin into dirty plastic tubs. The fish were separated by species and weight, piled together in overlapping patterns. A fish head protruded from the slimy mass, its body obscured, yet its eyes were wide and immobile like craft-store googly-eyes that no longer shook.

The silvers were 20-pounders, not unlike those that had assailed Jim Dickau's boat in the abandoned marina near Ottawa, Illinois. The bigheads were noticeably larger. A fine layer of translucent goo mixed with bursts of copper-red blood coated everything in the tubs bound for processing. The fate of these Asian carp lay on the other side of a grimy curtain separating the receiving dock from the knives, descaling machines and meat grinders of Schafer Fisheries, the buyer of Dickau's catch. The afternoon shift had begun.

That morning I had driven the 150-plus miles west from

Chicago through shrouds of mist and corn rows arranged like tombstones. Finding an exit for the Grand River Road running parallel to the Mississippi River, I turned off and screeched north towards Thomson.

After the maximum-security prison, Schafer Fisheries is likely one of the largest employers in town. The functional, nondescript brown warehouse at the end of Main Street serves as their headquarters. After parking my rental car in the gravel lot between imposing pickups, I wandered cautiously through the open doors to the receiving dock. There was no sign to welcome guests or let anyone know what occurs inside. But the stench of fish in stages of deconstruction made it clear I had found the right place.

But not the right time. I had corresponded with the head of SF Organics, Brian Kruse, who wouldn't be in for hours, I was told. I sauntered back to my rental car and leaned heavily on the bumper, watching the birds take flight from the warehouse roof. Men from the morning shift filtered out to their cars, racing off for lunch in a haze of dirt and Spanish words and cigarette smoke. I settled in to wait.

After half an hour spent kicking pebbles in the parking lot, a man in grimy jeans and a black T-shirt began walking towards me. "What are you doing here?" he called out. "You a spy?" I laughed. "Shit, I'd be the worst spy," I said, and explained that I was waiting to interview his boss. Tim Fosdick, a solid, squirrelly man with rough features wearing a gray hoodie and camouflage cap, was called out of the office to keep me occupied. We sat down at a picnic table beside an industrial propane tank. The sun was moving above the nearby treeline, evaporating puddles that had formed in the packed dirt. Fosdick periodically squinted his eyes, tugging down the brim of his hat.

For all the hype about exporting Asian carp to China, Fosdick told me, it's a small portion of Schafer's business. The prices paid by many Chinese companies are too low to make it worthwhile. Despite sales to 16 countries, California wholesalers buy 70 percent

of Schafer's carp. Fosdick's voice was low and gravelly. He stared at the sandpaper skin of his hands as we spoke, glancing furtively between me and the ground. Four trucks leave Thomson every Friday for the Gold Coast, he said, while fresh fillets head east, bound for Chicago and New York City's Jewish communities. There, they'll be blessed and eaten as gefilte fish. Foreign exports are gaining in popularity, Fosdick said, but they don't compete with domestic sales.

Soon after, Mike Schafer arrived from lunch in a retro-chic '80s blue camper van, relieving Fosdick as company representative as we waited for Kruse. Schafer settled in across the picnic table from me. Tall and fair-haired, in his early sixties with a worried face and restless eyes, Schafer didn't know anything about our interview, but he agreed to talk anyway.

His father christened the business in 1954, the year before he was born. He and his wife took charge of the company in 1976 and have groomed their son James to one day take over in his turn. Schafer Fisheries processed buffalo, common carp, catfish and suckers long before Asian carp arrived. In the late 1980s, a brief interest in eating bigheads presented an opportunity to buy Mississippi-caught specimens to feed Chicago's Asian communities. Some of the first bigheads caught were too small to sell, and many Illinois fishers didn't even recognize Asian carp at first. Nor were they much interested in catching them.

But that early indifference changed in the mid-1990s. By this time, silvers and bigheads were firmly established in the Illinois River and Schafer made the decision then to begin processing Asian carp. He hasn't looked back. Concentrations of these fish are higher in the Illinois than anywhere else in the world, and for an able fisher or processor, this is a readily available and protein-rich food, feed and fertilizer source. (And if the Illinois Department of Natural Resources was simply going to landfill millions of pounds of silver, bighead and grass carp every year caught through the Barrier Defense program, it made sense for

Schafer to provide Dave Wyffels and his commercial fishing crews with a truck to take those valuable fish off their hands.) Since pivoting to Asian carp, Schafer has dramatically increased his exports in both domestic and foreign markets. Of the 30 million pounds of fish the plant processes annually, 80 percent is silver, bighead and common carp procured from large commercial crafts capable of hauling 15,000 pounds. These days, almost all the carp they process comes from a 45-mile stretch of the Illinois River between Peoria and Havana. The largest silvers and bighead aren't found in the Mississippi anymore — they've moved upstream.

The high cost of shipping frozen fish abroad leads to razor-thin margins, dangerous given the cyclical boom-and-bust of natural resource extraction. Unwilling to rely on the poor prices paid to ship Asian carp overseas, Schafer diversified. In addition to frozen and fresh fillets, Schafer Fisheries began experimenting with other uses for the fish, including dried dog treats. They can also grind Asian carp for use in anything from spaghetti Bolognese to sloppy joes. The flesh takes well to flavoring, Schafer tells me. "It will never be a boneless fillet" because of the difficulty in deboning it, but there are enough customers outside America who don't mind bony fish and enough U.S.-friendly recipes to use the ground fish. "Processing Asian carp has always been a positive for Schafer Fisheries," he says. "There's no negative aspect to Asian carp in our eyes."

• • •

Brian Kruse arrived dressed in jeans and a gray sweatshirt with three pairs of glasses on his body: the ones he was using, the pair tucked into the collar of his shirt and the set resting on his head. Greeting me with a big outstretched hand, Kruse invited me into the plant as Schafer headed back to work. Past eight tubs brimming with dead carp, Kruse brushed aside a cloudy plastic curtain and ushered me onto the factory floor.

The large warehouse was cluttered with well-worn gray machinery, discarded fish parts and sticky-looking men moving hurriedly between tasks. Everything in the factory felt wet. Spanish hip-hop blared from a stereo above a constant thrum from the equipment, the boom-bap keeping pace with the robotic rhythm of machines. With a fresh delivery waiting in the receiving dock, a 30-foot conveyor belt in the center of the factory was a hive. A dozen men in their twenties and thirties stood on either side of a production line overflowing with dead fish, each man in oversized hip waders, neon rubber gloves and toques keeping errant fish from their hair. Each worker relied on an 18-inch blade to wrench the flesh apart, sharpened on steels that hung from their belts.

Two forklifts whizzed between the loading dock and the warehouse, the beeping whine of backing up a constant reminder to stay alert. They shifted heavy boxes and ushered fish to the next processing stage. Kruse and I watched two Hispanic men jab at a dysfunctional descaling machine next to the disassembly line, a maze of greased gears and flashy rotating blades. It belched descaled fish into plastic tubs. Kruse called a young guy off the line to explain to me how the meat grinder works. Basically, it pulverizes the deboned carp, I was told. He paused. "Is that it?" he asked Kruse, looking puzzled that it needed explaining.

Around 2005, Schafer began producing fertilizer to find secondary uses for unwanted fish parts and reduce their waste stream. After experimenting with composting, the plant tried making hog feed with their fish guts before turning to organic fertilizer, a move Kruse believes has real growth potential in traditional agriculture and hydroponic farming alike.

The fertilizer operation is housed in a separate warehouse from the processing facility. Leaving the factory floor, Kruse and I walked outside towards a beige aluminum hangar that greeted us with a malodorous wall of stink. "Hold your breath," Kruse said, walking through the open doorway. After years surrounded by the smell, it no longer affected him. But this opaque curtain of rotting

fish entrails churned the breakfast in my stomach. I heard him say something about combining fish with phosphorous to cook the mixture into organic fertilizer. I saw Kruse point to barrels and repeat statistics about Midwest distribution. I was half-listening, trying desperately to limit my breathing; I didn't want to vomit during an interview. As a matter of self-preservation (for my dignity, perhaps, more than my health), I backed slowly out of the building, hoping to draw Kruse with me to continue our interview in the fresh air outside.

A 5,000-gallon tank was currently cooking, while 275-gallon drums, stacked atop one another, stood waiting for pickup by local farmers. A tanker truck sat idle in the parking lot, capable of transporting 5,000 gallons of SF Organics fertilizer anywhere in America. They currently sell half a million gallons annually. Legal marijuana may be the next frontier. Kruse hoped to double his fertilizer volume in the next five years as more states legalize hydroponic cannabis, since convincing legal pot growers to nurture baby bud with a protein-rich by-product of an invasive species could mean good money. Their fertilizer is now used from the Midwest to eastern agricultural operations, but western markets are crucial. "I would love to see tankers heading to Texas and Colorado."

Kruse joked with the men on the line as we wandered back through the main plant, at one point hopping on an industrial scale to prove he didn't weigh 280 pounds as one guy suggested. "See," Kruse laughed. "Two-thirty-eight. Told ya!" We passed a crate of bighead fillets ready to be boxed, filled with ice and shipped. "If all goes well, those should be in Chicago markets by midnight."

Back in the rental, I wondered about those Chicago-bound bigheads. Who, exactly, would eat them?

• • •

Joe Roman was catching European green crabs when the idea struck him. As part of his doctorate in evolutionary biology at

Harvard in the late 1990s, Roman sought genetic evidence of how this invasive crustacean arrived on North America's Eastern Seaboard. The crab, indigenous to Europe and North Africa, is now found on every continent but Antarctica. It's also listed as the eighteenth most harmful nuisance species in the world, according to the Global Invasive Species Database.

At the time, the crab's range stretched from Cape Cod north to Cape Breton, Nova Scotia. So Roman set off north to collect specimens, stopping every 30 miles when the tide was right to dig under rocks in the intertidal zone. He would seize military fatigue–green crabs no bigger than his palm and *plop*— drop them into a bucket. Occasionally Roman collected a crab the size of his fist. People don't often think to eat them, he told me, because their bijou stature means that much work goes into finding and preparing them for little payoff meat-wise. Yet softshell blue crabs are a delicacy in New England, worth the effort to catch and cook, he knew. Could softshell green crabs be eaten the same way?

The more Roman began exploring the idea, the more people he found in Nova Scotia, Maine and Massachusetts eating nuisance species like European periwinkle that, like the green crab, inhabit the Atlantic's intertidal region. He even found Nova Scotian foragers collecting periwinkles to sell at Italian and Chinese markets and restaurants. North Americans, he discovered, were already eating invasives.

Roman is a conservation biologist and fellow at the Gund Institute for Ecological Economics at the University of Vermont. He told me that fisheries biologists are hardwired to discourage people from harvesting species. Foragers often want to eat those species in greatest need of protection — that may be why they need protecting. Yet "here was a case where we actually want people to go out and harvest them as hard as they can." While studying green crabs, Roman absorbed Euell Gibbons's 1962 book, *Stalking the Wild Asparagus*, a celebration of wild food. As an homage and update to Gibbons's text, Roman pitched an article to *Audubon*

Magazine in 2004 titled "Eat the Invaders!" Positioning it as *Iron Chef* meets *Wild Asparagus*, he asked chefs to submit recipes for cooking invasives. The result was a four-course meal meandering from dandelion soup to a common carp with wild mushroom entree and kudzu sorbet for dessert. The idea spawned a website of the same name that Roman runs with poet Debora Gregor. "I'm a conservation biologist, but I love good food. This is a way to unite those two and not feel so guilty about what I'm eating."

Eating invasive species gained momentum alongside the urban foraging movement. Despite its growth, the field remains a boutique, somewhat twee affair. While numerous nuisance species can be foraged for food, few but the most ardent foodies and hardcore back-to-the-landers are interested. But tastes change over time, Roman says, and ideas like eating Asian carp could eventually take root with mainstream Americans. "There is resistance as people hear the words 'invasive species' and ask: 'Is it disgusting?' No! Not at all," Roman says. "When prepared well, they can be fresh and delicious." Silver and bighead carp may never become household staples, but that doesn't mean people won't eat them. They just need help getting acquainted with American tastebuds.

Enter Jackson Landers. While Roman preached the gospel of eating invasives as a kind of grassroots management strategy, Landers, a charismatic hunter and writer from Virginia, turned his sights on them too. Growing up vegetarian, Landers didn't eat meat until his teens. In his mid-twenties he inherited rifles belonging to his great-grandfather and began restoring them. Landers had reached a crossroads with the *idea* of meat — if he couldn't kill an animal himself, he reckoned, perhaps he shouldn't be eating them. After bagging his first deer, Landers was surprised how quickly he took to hunting. He found others who were also curious about hunting for food but lacked expertise as he once had, prompting him to share his know-how. Landers's first book was a how-to guide for killing and butchering deer, an effort that earned him profiles in the *New York Times* and *TIME* magazine.

Once the hype passed, Landers cast about for a new idea. Anxious to avoid being pigeonholed as "that deer guy," he sought a subject where his unique skills as a hunter and writer could be useful.

Nuisance species were a perfect fit. While he worries about climate change and habitat loss, Landers admits he's no authority on those issues. But invasives? They too were harming ecosystems, and removing them could support native species reintroductions. "I thought: 'This is something I can do. I can hunt and eat them and write about it, and maybe in some cases I can harness people's self-interest towards harvesting these things.'" If Roman was moved by *Wild Asparagus*, Landers found inspiration in *Last Chance to See* by Douglas Adams of *Hitchhikers Guide to the Galaxy* fame. In the late 1990s, Adams conducted a world tour for the British Broadcasting Corporation to showcase animals and plants on the verge of extinction. Landers was smitten with *Last Chance* when he read it as a teenager, and conceived of his next book, *Eating Aliens*, as *Last Chance* in reverse. He would search the country for troublesome exotic species to hunt, kill and eat.

The intention was to foster a cultural shift in how Americans think about invasive species, particularly invasives-as-food. *Eating Aliens* follows his escapades from Texas to Maine to Florida in search of black spiny-tailed iguanas, armadillos, nutria, Canada geese and, you guessed it, Asian carp. (His assessment? "It was pretty much okay," he said to me. "It's just a whitefish.") The idea that Landers and Roman were popularizing would later become known as the *invasivore* movement, a push to forage and eat invasive plants and animals. Both wanted to prove that this was not only possible, but that it could be tasty.

• • •

In the fall of 2010, a dozen researchers from Southern Illinois University began measuring Asian carp's nutritional value and discovered that both bighead and silver carp would be fair additions

to American diets. Silver carp were found to be 18 percent fat and 56 percent protein; bighead, a leaner fish despite their larger size, contain 10 percent fat and 61 percent protein. The fats they contain are good fats too: up to 25 percent are polyunsaturated fatty acids, including omega-3 and omega-6, fatty acids our bodies cannot make on their own.

Asian carp are also low in contaminants, researchers discovered, surprising given the highly polluted rivers they inhabit. A handful of specimens contained heavy metals and mercury above 10 percent (the threshold at which children and pregnant women should order the chicken), but most contained only trace amounts. Concentrations of PCBs and pesticides barely registered.

One enterprising group had already begun catching and eating American-born Asian carp precisely because of their hard-to-come-by nutritional value. Beginning in 1994, Illinois Sportsmen Against Hunger gave hunters an opportunity to donate their butchered venison to state food banks. In 2011, their rivers overrun with Asian carp, the Sportsmen, alongside the Illinois Department of Natural Resources, expanded the program to include these exotic fish. The idea was simple: Illinois had more protein-rich invasive carp than they knew what to do with, and 1.9 million people, one out of every six people living in the state, relied on food banks for some or all of their nutritional needs. "Protein is one of the hardest food sources to come by at food banks and for those who are food insecure," says IDNR's Chris McCloud. "This is a huge problem, not just in Illinois but across the United States." Target Hunger Now, as the program is known, distributed more than 4,000 Asian carp meals to food banks across Illinois in 2012 alone with the help of fishers and Louisiana chef Philippe Parola, a longtime advocate of eating invasive species.

With Parola's help cooking the donated silvers and bigheads, IDNR took their show on the road, holding seven events throughout the state to drum up interest in eating Asian carp. Seven hundred carp burgers were handed out at Taste of Chicago in 2011, creating

a lineup stretching throughout the fairground. The burgers quickly became the talk of the festival. With the state fair looming in 2012, McCloud's sophomore offering needed the same dynamism as his freshman burgers. He turned to Springfield restaurateurs and asked them to have fun with it. Asian carp spaghetti and sliders anchored the resulting cornucopia of carp-related fare, along with barbecued and pulled carp mains and sides. McCloud's sliders sold out within an hour, almost 1,000 sandwiches gone in 60 minutes. Vose's Korndogs, a Springfield institution, handed out Asian carp corn dogs at a Target Hunger Now event in 2013.

The state doesn't host many stand-alone events to promote eating Asian carp anymore, McCloud said. They cannot afford it. But the program wasn't meant to run indefinitely, since no one would mistake Natural Resource officers for chefs or food bank directors. It was an awareness campaign to eliminate the stigma that still clings to even the idea of eating Asian carp.

• • •

Chef Parola is something of a figurehead in America's invasivore movement. The gregarious, shaved-bald cook first encountered the fish in 2009 as a guest on the Food Network show *Extreme Cuisine*. Jeff Corwin invited Parola to wrestle up and cook a silver carp near Houma, Louisiana, and, as Parola tells it, he was not 10 minutes on the boat when two massive silvers leapt in. So began his obsession.

In the past five years, Parola has turned up anywhere people put Asian carp on the menu, an ambassador for the culinary potential of an adaptable, if somewhat bland, whitefish. Parola bundled Asian carp samples off to Washington in 2012 to light a fire of congressional support for commercial fishers and processors. When Landers found himself in Louisiana hunting nutria for *Eating Aliens*, Parola cameoed, offering to prepare whatever specimens the Virginia hunter rustled up. He appeared at Southern Illinois

University to dish out Asian carp for natural resource economist Silvia Secchi while her team conducted market research on the fish. And, to better acquaint himself with Louisiana's natural resource officers, Parola served silver carp croquettes at the Barataria-Terrebonne National Estuary Program's invasive species meeting I attended in Thibodaux. The deep-fried fish cake he placed before me was delicious, but I wondered: Was it the fish I enjoyed, or the batter and garlic sauce? (I also found a bone, a possibility Parola had all but assured wouldn't happen.)

There's got to be a way to eat Asian carp, Parola told me in his thick Parisian-Creole accent. "There is no such thing as a bad fish, and there are no red flags with Asian carp but the bones and the name." It sounds like a challenge; for Parola, it was. Using proprietary technology he developed to simplify deboning — all he'll tell me is that it's a 50/50 mixture of machine-based and human labor — he processed 10,000 pounds of Asian carp between 2009 and 2011 to sample with test audiences. Mindful of Kentucky State University's remarkably strange effort to rebrand Asian carp as "Kentucky Tuna" in 2010, Parola determined to do things differently. He spent two years paying out of pocket to earn the trademark for Silverfin™, a move he believes will make the fish more desirable.

Kentucky Tuna, the idea of aquaculture economics professor Sid Dasgupta from Kentucky State, was a spectacular failure. He was warned by the Better Seafood Board that "calling a fish that is not classified as tuna by the U.S. Food and Drug Administration . . . is misleading to consumers and violates the Federal Food, Drug and Cosmetic Act." The illicit renaming also violated numerous state food laws.

To be clear, it's not that American's don't enjoy eating fish. The country spends upwards of $85 billion on seafood annually, one-third of that caught illegally. Author Paul Greenberg argued in 2014's *American Catch* that 91 percent of the seafood Americans consume comes from abroad, yet the United States ships 33 percent

of the seafood it catches overseas. "We are low-grading our sea-food supply," Greenberg told *Fresh Air* host Terry Gross in 2014. "In effect, what we're doing is we're sending the really great wild stuff that we harvest here on our shores abroad. And in exchange, we're importing farmed stuff that, frankly, is of an increasingly dubious nature."

Asian carp can help correct both these troubling statistics, Parola believed, by boosting the percentage of locally caught seafood Americans eat and increasing the amount of carp in its seafood exports to China, Korea and Japan. Harvesting Asian carp can also create jobs that reduce demand for unsustainable or ille-gally caught fish. Better branding and larger processing output are critical to making this happen. Parola knows it's a tall order. But even domestically, he believes the largest markets for Asian carp remain untapped: institutional food services, casinos, hospitals, schools, prisons and military bases, not to mention cruise ships. "It's a huge market."

• • •

Roy Orbison crooned. I figured the soul of rock was being streamed online before I heard the familiar scratch of needle-on-vinyl and spotted a turntable located behind the bar. In Chicago's trendy Wicker Park at a popular Mexican joint called Big Star, I met local fishmonger Carl Galvan, a man whose Twitter profile claims he sells "sick fish to Baller Chefs." In person, he speaks in short, rough bursts, liberally peppered with expletives; he wears a loud silver watch. Galvan grew up in Chicago. He was an executive chef by 24, but by 26, he had tired of the hectic lifestyle. Galvan fell in with Supreme Lobster, a Chicago-based seafood company that imports two million pounds each month; it's one of America's largest fish dis-tributors. Galvan now handles their boutique buys for the high-end restaurant market, inputting the company's orders to the European fish markets before going to bed and waking at 2:30 every morning

to fill the day's ledger from auctions in Maine, Massachusetts and other east coast locales. He's in the office before sunrise.

Galvan was perched on a stool near the corner of the bar, conducting business on his open laptop while holding court with passing chefs and waitstaff. Having spent so long in the industry, it feels like there are few he doesn't know in Chicago's restaurant scene.

Asian carp first crossed his path in 2010 when Chicago's Shedd Aquarium asked Galvan to secure processed silvers and bighead for an eat-the-invaders event. He had never tried it before. "It could suck, but it could be good," he remembers thinking. Galvan bought 100 pounds of Asian carp that he distributed to chefs around the city. These people have the most progressive palates in the country, he told me as we ordered tiny Miller High Lifes. If they can't find appropriate flavors to pair with the fish, nobody can. One of those chefs was Chicago culinary heavyweight Phillip Foss, who, at the time of Galvan's experiment for the Shedd, ran the kitchen at the Palmer House Hilton. Foss agreed to be filmed by the *Chicago Reader*'s restaurant critic Mike Sula as he prepared the bighead and silver. The result was "Phillip Foss vs the Asian carp," an online video featuring Foss needing three rounds and half a dozen instruments to finally hack flesh from the bone. At one point Foss got on the phone and called Galvan. "What the hell did you send me, man? I look like a fool on TV cutting this thing up," Foss said. Galvan corroborated the phone call with a laugh. "Yeah, some of the chefs I sent it to were pissed."

I had arranged to meet Foss at his establishment EL Ideas on Chicago's west side. The bus ride revealed a neighborhood awash with military academies, strip malls and gas stations, the accoutrements of a car culture W 14th Street and Western Avenue were designed around. Community safety volunteers in yellow vests kept watch every few blocks. The bus spit me out south of the train tracks into a neighborhood that's bottoming out. A Union Pacific train engine idled beyond the bridge across Western Avenue, connected to an ancient rail yard. The sidewalk was in tatters, broken

into concrete chunks that merged with weeds and grass flowing into the curbless street. Galvan had been right — Foss *did* have balls to open a high-end restaurant here.

I found the thick metal door to EL Ideas and knocked, hearing hurried voices and hip-hop inside. Slipping in after a UPS delivery man holding a pressure cooker, I faced three 20-something male chefs slitting open sides of meat. They stared at me with identical smirks. Despite the neighborhood, EL Ideas is beautiful in a Spartan way. The small dining area with its white-cloth-capped tables looks into a large open kitchen. It's quality over quantity, and based on what Galvan told me about Foss's cooking prowess, he's one of the best. I told the trio of young cooks I was here to interview their boss. Foss appeared from the back office moments later, a tall man with sharp features and dark, wire-frame glasses. He was wrapping a large white apron around his midsection. "You gotta interview me while I prep dinner," he said. I got out my recorder.

"We did a whole bunch of different preparations with it," Foss told me. The recipe he had prepared in Sula's video was a crisp paupiette of Asian carp in Barolo sauce. He blanketed hunks of the silver's flesh in thinly sliced potato, fried it to brown the outside and baked the fish at 400°F. "The flavor of it was not that bad once you took the bloodline off it," he said, pulling mixing bowls from the shelf. At Palmer House they called it "Shanghai Bass" and sold it for two months. People liked it, or at least no one ever sent it back. But after Asian carp's limited engagement at Palmer, Foss quickly moved past the novelty of cooking an invasive. "There was just too much talk about me cooking Asian carp and there wasn't focus on anything else we were doing at the restaurant." Foss, in his mid-thirties, wanted to avoid being typecast early in his career as the purveyor of a kitschy invasive fish that's okay-tasting and a pain to prepare.

Few other haute-cuisine chefs in Chicago cook it regularly these days. It's not worth the time, effort or stigma. Or the cost. Despite buying Asian carp for pennies per pound, the time needed to make it into something people actually want to eat is too much

to spend in a fast-paced, modern kitchen. Given the hassle of wrestling meat from the bones, more than 90 percent of each fish is tossed in the trash. "We charge $145 a person at EL Ideas," Foss said of their fixe prix menu. "Why would we use a cheap ingredient like that? After all was said and done, Asian carp was probably more expensive than the halibut."

Galvan agreed. While the lack of interest from high-end chefs has nothing to do with taste — "It's not bad. It's clean like most lake fish" — time and cost factor in. People say we should triple the price paid per pound to fishermen, Galvan went on to tell me, but tripling the price only triples the cost paid by consumers. This would put a labor-intensive bighead carp fillet in the $60 range, comparable to quality fish. But they're "cheap as shit. No one wants to pay $60 for Asian carp."

But getting the public on board with eating bigheaded carp requires the support of haute cuisine if there's any hope of it catching on, Galvan believes. Like runway-inspired clothing going mainstream, Asian carp will catch on once top chefs use it regularly. Problem is, he doesn't see that happening.

Galvan's opinion seems diametrically opposed to Parola's belief that a market exists for these fish in institutional cooking. I'm not sure Galvan's correct that Asian carp will need to trickle down from fine dining to gain a beachhead in North American diets. It's hard to believe that mess halls and hospital cafeterias will care about high-end restaurant acceptability, especially when a cheap and plentiful source of protein that can be made to taste like anything is available. But like everywhere else I've turned, there are as many opposing views as players.

• • •

Here's the million-dollar question: Do Americans even *want* to eat Asian carp? Are they willing to try it, let alone pay for it? To begin tackling these questions, a motley crew met at the Lewis

and Clark Community College in Grafton, Illinois, in September 2011 to dissect the market for Asian carp. Organized by the Illinois-Indiana Sea Grant, the Asian Carp Marketing Summit brought together U.S. state and federal natural resource officers, commercial fishers, processors, marketers and academics to talk carp. Specifically, what kinds of opportunities the fish offered the state and what barriers existed to making Asian carp a finger-licking kind of story.

First the interest groups had to figure out how to get along, no small feat given what a disparate lot they were. The results of the two-day meeting made it clear that "potential conflicting motivations and goals" were a significant obstacle to building consensus on introducing Asian carp to a skeptical public. But making the fish a high-volume, low-priced export for human consumption abroad and a high-volume, higher-priced U.S. market commodity was ultimately agreed to; so was the need to use its by-products for fertilizer, fish oil, pet treats and food. Everything else was up for debate.

Commercial fishers maintained that a solid market was needed to showcase their product if there was any hope of increasing the price paid per fish. It was classic free enterprise with a twist, since fishers wanted state restrictions on fishing methods eliminated, in addition to liberalizing rules over the kinds of nets they could use, where they could fish and when. However, fishers also wanted assurance that money to buy their fish would be forthcoming, either from the free market or government subsidies. Processors, meanwhile, thought long-term: How long will the supply of Asian carp in America last? How many fish could be harvested sustainably each year? They proposed that governments begin to restore native fisheries so processing plants built with taxpayer money could keep humming.

Whoa whoa whoa, came the reply from natural resource managers. Let private enterprise take the lead, they insisted. Asian carp are an economic opportunity after all. They can help put

underemployed fishers to work and kick-start processing indus-
tries where jobs are desperately needed. Government doesn't
have to get involved: set the guidelines, educate the public and let
business do business. Ecologically, state biologists worried what
impact fishing down silvers and bigheads would have on already
stressed native species like paddlefish. Catching non-target spe-
cies, known as "bycatch," hasn't been an issue so far.

(That may change. According to Duane Chapman, one of
America's leading Asian carp experts with the U.S. Geological
Survey, if commercial fishers have stronger incentives to aggressively
go after Asian carp, their nets will almost certainly snare paddlefish.
The species, so-called because of the paddle-shaped rostrum stick-
ing out from its nose, would take a massive hit. Paddlefish numbers
have already declined in recent decades because of pollution, over-
fishing and habitat destruction. "If you start catching bighead and
silver really hard, you're going to kill a lot of paddlefish," he told me
in a later conversation.)

Marketers offered a more nuanced reply. People are inherently
conservative in their food choices and will lean towards saying "no"
to the unfamiliar, they said. Consequently, a comprehensive business
plan was required, one that focused on selling them where it makes
sense — ethnic urban food markets, for example, or as an export to
Africa or China. Stay focused on attainable goals, they argued, since
no one has enough data to know what solution will be effective.

The cheapest option, the conference heard, may be for the
state to pay fishers to fish as they were in Illinois. Do the math:
say governments pay 25 cents a pound for 100 million pounds. The
$25 million to remove such a huge volume of Asian carp from
below Chicago's electric barriers would be infinitely cheaper than
investing in numerous processing plants made obsolete if popula-
tions crash.

Yet a business case for fishing down Asian carp for human con-
sumption wasn't clear in 2011, and it's no clearer today. Fishers aren't
paid enough, transportation costs are too high and export prices

are too low. The known unknowns, market dynamics included, have made planning a successful strategy for eating Asian carp excruciating.

Two researchers from Southern Illinois University–Carbondale aimed to correct this. Tapping her graduate student's marketing background, Silvia Secchi's quest to gauge America's interest in eating Asian carp began at her local grocery store. Setting up a table in front of the Neighborhood Grocery Co-op, Secchi and Sarah Varble asked customers to complete a small survey about fish consumption, knowledge of Asian carp, willingness to pay for it and willingness to try it. The results were honed into a 40-question survey they conducted through a third-party market research firm. Secchi and Varble polled 23,376 people, whittling the results down to those 15,810 people who ate fish at least once a week at home. This is true of 58 percent of Americans; 88 percent eat fish on a monthly basis.

"What we are talking about here is essentially creating an overall new product," Secchi told me after the study's release. Their survey had found that the market potential for Asian carp was "considerable." A majority of respondents were willing to try Asian carp and pay for some preparation of it. Sixty-eight percent said they would buy a ten-ounce package of frozen Asian carp fillets crusted with panko crumbs while 66 percent reported they would buy silver or bighead fish sticks. A further 64 percent said they would order an Asian carp steak at a restaurant; 59 percent would order Asian carp fish cakes while out to dinner. Overall, "creating demand for the human consumption of Asian carp in the U.S. could be a market-based, cost-effective solution" to the Asian carp problem, the authors wrote. Coupled with creating markets for dog treats or fertilizer, eating them could be a winning strategy when integrated with a larger invasive management plan.

For all the positive indicators that Americans are willing to eat Asian carp, the overwhelming majority still don't. The reasons defy easy explanation. The market for Asian carp lags far behind

those for tilapia or catfish or farmed salmon because people retain a positive perception of these fish. Consumers are willing to pay retailers (who, down the supply chain, pay processors and fishers) more for these fish than for Asian carp, whose reputation has taken a hit after being categorized as a nuisance, low-value trash fish. Consequently, the market for Asian carp is caught in a vicious cycle in which few can buy it at the grocery store or a fast food chain because there's not enough money in it to pay fishers or processors to make these products. Yet there's no money to make these consumer goods because they're *not* for sale at grocery stores or fast food outlets, which would drum up demand. Few can break the deadlock. Banks are loathe to finance an industry with so little public support and no clear concept of the resource's depth or sustainability; and states, as we've seen, cannot afford to connect the jumper cables to boost the market.

While taste tests and market research show the American people would buy panko-crusted Asian carp cakes at Walmart, no one knows just how to get this product to consumers. Fishers lament their low wages and irregular work; and processors seek stable prices at home or abroad; governments sit on their hands over fears of building a market around a species they're actively trying to cull.

<center>• • •</center>

Talking with people about eating Asian carp revealed a clear divide, especially when it came to bones. Carl Galvan told me it was the worst bone structure he had ever dealt with, while Silvia Secchi laughed as she recounted her experience fumbling through gutting and filleting before Chef Parola arrived. "It was not fun." Even Chef Foss, a professional, in his first round prepping a bighead, resorted to wielding an eight-inch meat cleaver to hack it apart. The technique was far from textbook, he cautioned, though it was effective.

But let's be clear: ordering an Asian carp slider won't save the

Illinois River, or the Great Lakes for that matter. I think most would agree on that. Yet there are those who believe our endless fascination with eating invasive species as a means of helping our degraded waterways is doing more harm than good. An article appeared in the environmental journal *Ensia* in September 2014 titled "Why Eating Invasives Is a Bad Idea." The accompanying image pictured a lionfish, another nuisance fish destroying reef habitat along America's east coast, leaping from a plate, as exasperated diners try to pin it down with forks and knives. For someone used to reading articles in the "Eat 'em to Beat 'em" canon, this was markedly different. "Almost all reports trivialize the complex issue of invasions of non-native species," the piece stated. "By promoting an untested solution in the complete absence of evidence for its effectiveness, and promising economic benefits with no consideration of potential cost, they lead the public to believe that a quick fix will exist for any invader."

This was a far-out idea in 2014. Mainstream media reports typically supported eating invasive species without question, portraying it as a novel tactic for Asian carp control (as well as for many other invasives). Jackson Landers may have been the only person eating aliens in 2009, but newspapers, TV stations, national broadcasters and online outlets have published encouraging "Eat 'em to Beat 'em" stories ever since, creating what I and others believe is a false hope that we can feast our way out of the mess we've made. And yet here was a radical article in a credible online journal from respected academics stating an opinion radical only for how *obvious* it was. Of course gastronomy was no panacea, and we were wrong to ever think it was anything more than one interlocking cog in the complex machine that is Asian carp management. Our conversation about eating Asian carp has to mature and jettison this "quick-fix" mentality for the silver bullet thinking it is. And quickly. Because for those wishing to halt Asian carp's ceaseless spread, success lies only in thinking holistically about how human-made and ecological systems interact. There are no simple

solutions to this colossal problem; whether it's carbon dioxide, as we've already seen, eating them, as we explored in this chapter, or creating a new subcontinental divide, as we'll discover in the next chapter, any narrow approach to carp control that assumes the supremacy of any one tactic is doomed to fail.

Yet despite the grand illusions still so common about the unfettered benefits of eating Asian carp, entrepreneurial chefs are picking up where Phillip Foss left off and choosing, independent of kitschy publicity or social pressure, to incorporate bigheaded carp on their menus. The reasons are both altruistic and practical. Sara Bradley from Paducah, Kentucky, worked shifts in New York and Chicago in Michelin-starred kitchens. But rather than find her way in the Big Apple or Windy City, Bradley took her skills back home and sought her parents' help in remodeling a used vegetable depot she purchased with some of her savings.

Freight House, the 140-seat farm-to-table restaurant she opened in 2015, has made a point of showcasing the region's natural bounty on its plates. Staying true to regional cuisine and lingua franca, Bradley has included silver and bighead carp on her menu, though she calls it "Kentucky blue snapper." The fish is cooked with succotash and plated beside charred okra, drizzled with a smoked chili vinaigrette for $20. Chefs have a moral imperative to feed people responsibly, Bradley told the *Chicago Tribune* in September 2017. "We have an obligation to use this thing that's destroying our waterways and killing our native species," she said, "and educate people about how healthy and delicious it is."

I'm sure Jackson Landers would agree. The hunter/angler/writer told me he found nothing in the bone structure of Asian carp that couldn't be overcome; people just need to learn new ways of preparing the fish. After all, there's an entire continent of people who eat Asian carp all the time. "They just cut the fish up differently than we do," he said, "and don't freak out about it." One way or another, Asian carp are ready to find a home on America's plates. We could do far worse than reduce our catching

of haddock and pollock by filling our fish sticks and Filet-O-Fish with bigheaded carp. "Go to the frozen food aisle at the grocery store and look at the frozen fish fillets," Landers said. "What kind of fish is it? Who knows? People don't care. It's battered and they're going to put tartar sauce on it. Right now, with carp, you could put that on people's plates."

・・・

It was dark when I arrived back in Chicago from Schafer Fisheries. The drive from Thomson was mercifully uneventful compared with the traffic-choked, GPS-less nightmare I had endured that morning. The Lincoln Park Zoo had been calling to my wife, Courtney, but I had left her with a favor to undertake for me — to explore the Broadway Supermarket, a massive Chinese grocery store in Uptown, Chicago, to see if she could track down a silver or bighead carp fillet. Carl Galvan had tipped me off that if anywhere in the city would sell Asian carp over the counter, this would be it. In case her search turned up empty, I bought a $4 hunk of smoked silver carp at the Schafer retail store south of Thomson. Courtney had no luck at Broadway, or rather, she thought she'd had no luck. In fact, she hadn't known how good her luck was. All she found was a frozen fillet labeled *white amur*, a throwback to the name Arkansas's Jim Malone had championed for grass carp, but she hadn't recognized the moniker. No one has called grass carp white amur in four decades, so I hadn't thought to suggest she look for it.

Recalling Landers's suggestion to not freak out, I placed the smoked carp wrapped in brown butcher paper onto a cutting board in our Airbnb, peeling back waxy layers. Not sure what I would discover bone-wise, I grabbed a large carving knife and a fork. Along one side of the fish was a massive ridge running the length of its body, containing a surprisingly thin layer of reddish flesh. I jabbed at it with my fork and sliced off flakes of meat, placing it on the cutting board. Seeing lots of soft, white flesh below

the darker ridge of bone, I peeled back a layer of skin and froze. At every third of an inch sat translucent bones intersecting the top of the fish like a lattice. There was no meat more than half-an-inch from bone. I stood back and glared at the garbled mess of flesh and skin and bone and sinew.

Scraping white flesh out from between the bones, I popped the fish in my mouth. The smoke overpowered any other flavor I could identify, but in time recognizable tastes emerged. It wasn't bad, exactly, but if I wasn't writing a book about Asian carp I wouldn't write home about it either. "Well?" Courtney asked. "How is it?" I paused for a moment, chewing the remaining fish. I picked up the deep red flesh and threw that in my mouth too. This was stiffer, with an even stronger, more solidified taste. I swallowed and waited a second as a fishy aftertaste coated my tongue. "Tastes like smoke and whitefish," I say. I didn't know what more to add. I passed Courtney a piece and watched as she popped it in her mouth. "It's okay," she said. Did she want to try the redder meat, I asked. Pass. I took a swig of High Life. Courtney opened a bag of chips. The hunk of carp sat on the kitchen counter the rest of the evening. Untouched.

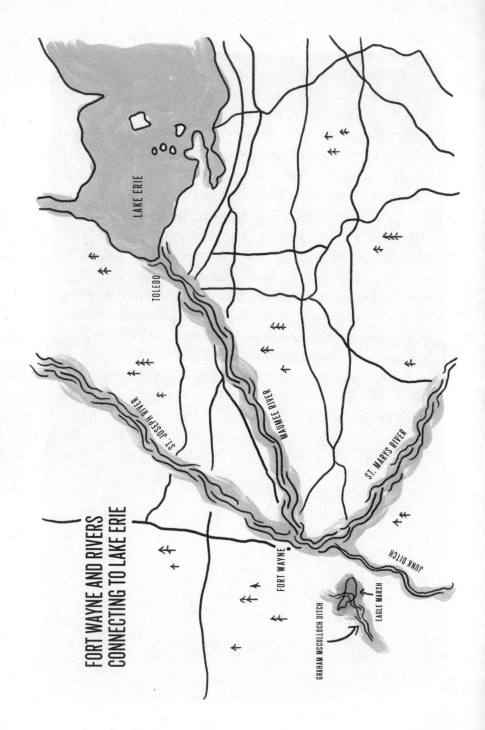

FORT WAYNE AND RIVERS
CONNECTING TO LAKE ERIE

LAKE ERIE

TOLEDO

ST. JOSEPH RIVER

MAUMEE RIVER

ST. MARYS RIVER

FORT WAYNE

GRAHAM MCCULLOCH DITCH

EAGLE MARSH

JUNK DITCH

CHAPTER 8

The Glorious Gate

FORT WAYNE, IN — *Two inches of snow settled on the hardening ground overnight, and I'm six months pregnant. I'm not giving this speech,* thought Betsy Yankowiak. *A perilous two-hour drive to Albion from Fort Wayne, Indiana? Forget it.*

Yankowiak, the nature preserves director with the Little River Wetlands Project (LRWP), had been asked in December 2009 to brag about the wetland restoration work her small not-for-profit had accomplished in Indiana's northeast corner. A who's who of conservation officers were convening in Albion for a meeting of the Indiana Department of Environmental Management to discuss ways of working with landowners on wetland construction. Eagle Marsh, the 716-acre crown jewel of the Little River Wetlands Project, was a rarity worth celebrating: carved from reclaimed agricultural land four years earlier, it was one of the largest non-coastal wetland restoration projects in America. Yankowiak's group had collaborated with private, state and federal players to make it happen — strange bedfellows that, together, were restoring an historically significant wetland to something more closely approximating its natural form. On that cold December day, unable to convince a colleague to attend in her place, Yankowiak had no choice. She braved the elements and trundled off to Albion.

Arriving tired but in one piece, Yankowiak moved through her presentation on the ongoing conservation efforts underway at Eagle Marsh. Forested wetland acquisition, native shrub plantings, endangered species habitat restoration — Yanowiak had reason to boast about her group's accomplishments. The wetland also holds a unique position as a historic transitway between the Mississippi River and Great Lakes watershed, she told the crowd, a point of pride for Fort Wayne. For centuries, Indigenous peoples, homesteaders, traders and soldiers passed through the Little River valley to wage war, barter goods and settle lands that became the American West. As one of the shortest overland passages between two of the continent's biggest freshwater basins, the route was tremendously popular with voyageurs and other travelers looking to lug their boats across the least amount of land possible. And in times of flooding, Yankowiak said, one drainage basin often relied on the other to absorb its excess water. In Eagle Marsh, the barrier between these colossal watersheds was always porous.

Today, the Little River's past lies buried under miles of farmland. But the historic flooding of this western gateway that molded the valley's past would radically remake its future. This had suddenly became clear to many in Albion. But not Yankowiak. "Uh, Betsy," a colleague from the Indiana Department of Natural Resources asked as her presentation ended. "Could Asian carp go through Eagle Marsh to get to the Great Lakes?" Ears perked up. Yankowiak paused, unsure how to respond, thinking, *What's Asian carp?*

• • •

By April 2010, state officials were on-site assessing whether Eagle Marsh was capable of ferrying Asian carp to the Great Lakes. In June, the Little River Wetlands played host to the Environmental Protection Agency, the Army Corps of Engineers, the U.S. Geological Survey and the Fish and Wildlife Service. Federal surveyors used high water marks from a destructive 1982 flood that

had remained imprinted on a barn in the marsh to visualize how high waters have historically risen in the region. The discolored concrete ringing the barn was an ominous sign.

As federal agents turned the conundrum at Eagle Marsh over in their minds, silver carp were discovered at the mouth of the Little River, 24 miles southwest in Huntington, butting heads with the Roush Dam on the nearby Wabash River. If tributaries of the Mississippi like the Wabash and Little rivers flooded north, they could carry bigheaded carp into Eagle Marsh. And if a Great Lake tributary like the Maumee River flooded south into Eagle Marsh, it could, like a lift lock, transport Asian carp from one watershed to another.

Finding invasive carp so close to a previously undetected vector lit a fire under the lumbering federal agencies. Yet news of the action was slow reaching Yankowiak. One morning in September 2010, her mother telephoned from Traverse City, Michigan, asking what she knew about the $300,000 fence that Indiana was erecting through her restoration project. It was in the morning paper, Yankowiak's mother told her, though she hadn't received notice. When state officials telephoned later that morning, Yankowiak feigned ignorance, listening as they detailed a new future for Eagle Marsh.

The scale and speed of the project caught her by surprise. The state's fence measured 1,177 feet long and eight feet high. Dozens of 50-foot rolls of chain-link fence with two-inch openings were erected and buried two feet into the ground to prevent erosion. Four-foot posts, 123 of them, were drilled five feet deep into the sandy earth, kept firmly in place by three-foot concrete casings. To prevent ice floes from bending the fence, 120 concrete Jersey ties, like those dividing highway traffic, were spaced out for additional support, each weighing 2.5 tons. For maintenance and monitoring reasons, vegetation was mowed to an inch off the ground for 20 feet on either side. To measure water levels on both sides of the fence, the U.S. Geological Survey installed solar-powered water gauges spaced less than a foot apart to analyze data from different

watersheds. The coup de grâce — continuous surveillance from a camera installed high above the marsh on a 20-foot pole. "Prisons don't have fences like this," Yankowiak was told. Once complete, the fence was visible on satellite imagery, running north-south like a three-part incision in the marsh's flesh.

Many, Yankowiak included, figured the carp fence was never coming down.

By October, it was over. Within 10 months of her hearing "Asian carp" for the first time, stopping the invasive fish became Yankowiak's first priority. Suddenly her name was in newspapers across the country as America turned its carp-fighting focus on Fort Wayne. But while the fence was a solid stopgap, it was clearly not a viable, long-term option for limiting Asian carp's movement. Its temporary feel, coupled with the haste with which it was erected, led many to ask what kind of permanent solution would be installed at Eagle Marsh.

Six years after that momentous meeting in Albion, I caught up with Yankowiak as the permanent solution was rolling into place. A contagiously friendly woman in her early forties, Yankowiak greeted me at the Little River Wetlands Project office, situated in an industrial park on the marsh's edge. Her long, strawberry blonde hair spilled over a gray fleece pullover with her organization's logo and her name embroidered in white thread over her heart.

A native of Fort Wayne, Yankowiak earned an environmental geology degree from Indiana-Purdue University. She was hired as the Wetlands Project's executive director in 2007 with big plans for the site, beginning with the tedious labor of wetland restoration. Invasive weed removal, planting native grasses, protecting endangered Blanding's turtle eggs, conducting trail maintenance — all in an exhausting day's work. But her ultimate goal was to bring as many properties as possible in the traditionally swampy Little River valley under the project's umbrella. In this way, Yankowiak and the LRWP could better protect existing wetlands from encroaching urban development.

Commanding a small but steadfast crew of volunteers and staff, Yankowiak saw in Eagle Marsh a chance to re-establish a linchpin of the valley's ecology. It wouldn't save the world, but the group's work was vital to the green herons, central mudminnows, northern leopard frogs, twice-stabbed lady beetles and bald eagles that live in Eagle Marsh. Vital, too, to Fort Waynians, who, surrounded by the trappings of drive-through concrete sprawl, lack for greenspace.

Yankowiak led me to a boardroom in the LRWP's modest workspace. She fired up one of many Asian carp-themed presentations she's given since 2009 to state officials, college biology seminars — and the occasional wayward journalist. Before we talk about the carp berm, Yankowiak began, let's take a step back. I wasn't prepared for how far back she intended to go.

• • •

Northeastern Indiana lost its remaining glacial ice somewhere between 25,000 and 13,000 years ago. As the Pleistocene Epoch — a geological period extending from 2.8 million to 11,700 years ago — came to a close, massive ice sheets covered much of North America. Gradually eroding north, they broke apart, wreaking a productive havoc on what became the Great Lakes and Mississippi basins. Much of the glacial activity that shaped the region occurred in a (geologically) brief window of time between 25,000 and 21,000 years ago, in a period known as the late Wisconsin glaciation. Even more than today, Canada was encrusted with an expansive blanket of ice, joining the Midwest, New England and large swaths of Idaho and Montana under frozen water 2.5 miles thick. Sea levels dropped to depths low enough to allow humans and animals to continue their global migrations via the Bering land bridge linking Alaska with Siberia.

The clayey silt and till below the gargantuan ice sheet was carved up as the frozen mass retreated in ways that radically reordered the continent's hydrology. The ice front became

jagged, giving jigsaw puzzle–shaped outcroppings called lobes one final chance to paint the landscape as they desired. These lobes — the Michigan, the Saginaw and the Erie — pounded the terrain between Chicago and Toledo with unimaginable force. The impacts are visible to this day in the dramatically different geologies of the Upper Midwest from southern Indiana, Ohio and Illinois. The Erie lobe cut particularly deep grooves in the soft soil, leaving behind wide glacial lakes. Lake Maumee was one such glacial body, an elongated precursor to modern-day Lake Erie that stretched south to Fort Wayne rather than halting, as it currently does, near Toledo. The "Great Black Swamp," as it's also known to historians, rose 800 feet above sea level at its highest point. Lake Maumee ultimately lasted for less than a thousand years. One day, the lake simply succumbed to pressure built up from great volumes of water. Its banks shattered.

Within days or weeks — who can know for sure? — billions of gallons of water gushed through an opening at the southern tip of the Great Black Swamp. The resulting catastrophic drainage of Lake Maumee devastated the landscape below it. The "Maumee Torrent" rushed south with such force that it tore an outlet two miles wide and 24 miles long, piling 30 feet of sand and silt and rock in the new valley. This southwest flow continued, albeit with much weakened momentum, for hundreds or thousands of years after the torrent began, ending only when the last glacial ice moved off Lake Erie. Slowly, the torrent tamed and evolved into the Maumee River. Taking advantage of a subglacial channel the Great Black Swamp had left behind, the Maumee became the region's dominant waterway, aided by its pirating of the nearby St. Joseph and St. Marys rivers.

The Erie lobe etched vast moraines into Indiana's northeast corner, great formations of glacial rock fanning out from streams and rivers like the rib cage of a fossilized fish. Among the moraines, a 24-mile valley spanning from Fort Wayne to Huntington bore the deepest scars of the late Wisconsin. At its center was an

unassuming waterway that, these days, goes by the name Little River. It was here that, as they moved atop the Earth, the last of the great ice sheets unwittingly created an almost imperceptible hydrologic divide. Water west of Little River would, from that moment, flow circuitously to the Gulf of Mexico some thousand miles away. Water to the east would find its way 140 miles north to Lake Erie. Beyond that, after a journey taking hundreds of years, to the St. Lawrence River on the continent's eastern shore; after that, the Atlantic.

· · ·

At the meeting place of two of the continent's great drainage basins lies a short overland passage — nine miles long at high water and a more grueling 24 miles when nature feels unforgiving. This was the most accessible early location to transport a boat from the Great Lakes to the Mississippi watershed, and it became a staging area for shuttling goods and people and other species between the basins. The Miami Native Americans managed the vital transportation hub until 1795 when control changed hands after the Battle of Fallen Timbers. The Treaty of Greenville, negotiated with Major General Anthony Wayne in the aftermath of Fallen Timbers, ceded control of the land left behind by Lake Maumee to the youthful American government. Stressing the overland route's importance to its new owners as he signed the Greenville Treaty, Chief Michikinikwa of the Miami called the portage "that glorious gate . . . through which all the words of our chiefs had to pass from north to south and from east to west."

The moniker stuck. Yet over the next 200 years, the once "glorious gate" closed under pressure from agriculture and urban development. Over 25,000 acres of wetland in the Little River valley was drained over the course of the twentieth century to make way for crops. Marsh habitat needed by hundreds of birds and endangered species like the Jefferson salamander was drained or

paved over. Water levels dropped to less than 20 percent of their historic heights. The northern ridge of the Little River valley was transformed into suburbia, light industry and malls. In the valley, farmers' fields became the lone occupant of the flood-prone area.

The inescapable fear of flooding left many landowners anxious about losing the life savings they had sunk into their fields. To ease their worried minds, the federal government took a sledgehammer to the perceived problem of seasonal flooding by overhauling the Little River's hydrology, installing ramrod straight ditches to provide relief against rising tides. One, the Graham McCulloch Ditch, was cut the length of Eagle Marsh before meeting the Little River (part of the Mississippi system) to the southwest. The Junk Ditch, dug east of the marsh, runs north before spilling into the Great Lakes–connected St. Marys River. Both ditches were dug in 2005 when local landowner Dennis White realized his property, where Eagle Marsh now sits, wasn't much good as farmland; it simply wanted to be underwater. White enrolled his fields in the U.S. Department of Agriculture's wetland reclamation program for $2,800 per acre, and by 2007, Yankowiak's reclamation of the newly named Eagle Marsh from farmer's field to active wetland was in full bloom. Yet nature didn't wait long to reclaim the glorious gate.

• • •

The Army Corps released a preliminary report detailing how Asian carp could reach the Great Lakes before the protective carp fence went up in October 2010. Eighteen sites from New York to Minnesota straddling the Great Lakes/Mississippi River divide were identified that the Corps believed were permeable enough to allow Asian carp to pass through. After conducting a hydrologic study of each site outside of Chicago, the nation's engineers confidently dismissed 17 of the 18 locations, claiming nature would have to conjure an "epic storm" for these destinations to allow aquatic invasives to pass through. Their investigation left just one site worth watching:

Eagle Marsh. The Corps went so far as to list the Fort Wayne wetland as priority two for halting Asian carp in America, behind only Chicago. Taking the next three years to expand and refine their study, the Army Corps released a follow-up report in May 2013 detailing possible solutions for shoring up the porous marsh.

They were almost too late. Water in the Graham McCulloch Ditch can rise eight feet in four hours. Betsy Yankowiak saw it happen in 2013 — three times. On April 19, floodwater blew a six-foot hole in an existing earthen mound beside the McCulloch Ditch next to the city's wastewater treatment plant. Before the broken berm could be patched, a second flood struck on June 1, more than doubling the gash. Thick brown water gushed from the Mississippi watershed into the Great Lakes system. Recalling how the community came together during the historic 1982 flood, Yankowiak tried to enlist the local high school football team to fill sandbags. They declined, leaving Little River Wetlands to rally battalions of volunteers to plug the gap.

Eight weeks later, the battered berm and its mended hole were tested *again* by the third flood in less than four months. The sandbags held. Yet, distressingly, common carp and catfish, both present in the marsh, had moved through the break in the berm, migrating from the Mississippi River system to the Great Lakes. Yankowiak and the Corps now had all the anecdotal proof they needed that the theory behind Asian carp's interbasin transfer at Eagle March was sound. If silvers and bigheads could make it to the marsh, they could make it to the Great Lakes.

The revamped Army Corps plan offered nine possible control methods. Initially, total basin separation was the primary objective. "Why rip up the marsh and *not* get complete separation?" Yankowiak asks. Some potential solutions created more problems than answers. A $25 million pumping station was deemed too costly and a $14 million plan to install a concrete I-wall was nixed for the unintended catastrophic flooding it could cause to near-marsh communities. While the berm would help alleviate

flooding fears felt by those living close by, the Corps' proposed solutions never considered flood control a primary objective.

By January 2014, Alternative I was approved. It's a compromise plan that protects against once-every-50-year storms but not once-in-a-100-year tempests. A massive berm 80 feet wide at the base and 10 feet high at its flat top would be built on the Great Lakes side of the existing berm beside the Graham McCulloch Ditch. Once the new structure was completed, the old berm would be bulldozed over the new to ensure a protective barrier was always in place. At the southwest end, a chain-link fence would connect the berm with railroad tracks passing through Eagle Marsh. By using a chain-link fence instead of an impermeable concrete retaining wall, water would be able to pass between the basins. It falls short of hydrologic separation, but unless the Corps wanted to buy out homeowners destined to be flooded, the divide had to remain at least partially fluid.

In time, Yankowiak hopes the berm will blend with the existing habitat. Wildlife in the marsh are already familiar with large soil mounds, so the creation of a new, bigger mound will ideally not cause too great a stir. Yet it's already shaken things at the Little River Wetlands Project headquarters. While the $4.4 million project has been spearheaded by the Natural Resources Conservation Service (NRCS), site maintenance on the berm is pegged at $17,000 annually, money Yankowiak's group doesn't routinely have on hand. She's confident they will scrounge the money up somehow, but it won't come easy. "We're a small nonprofit," Yankowiak told me. "Our short-term budgets don't include buffers to cover huge new line items like maintenance on an invasive species barrier."

The project offer for Alternative I hit the market in summer 2014. Within weeks, nature showed its force in the valley by pummeling northeast Indiana with the kind of hard rain that falls just once every thousand years. On August 21, Fort Wayne drowned under 6.4 inches of rain dumped in less than four hours. Roads were closed. Travel warnings took effect. Trapped in their homes

and cars by rising waters, 18 people, accessible only by boat, were rescued by first responders. An additional 2.5 inches fell over two hours the next day, meeting the requirements of a hundred-year storm. The carp fence had come in time, but the long-term stability of a permanent barrier was desperately needed.

As I sat with Yankowiak in her nonprofit's boardroom, she rolled out a four-foot geologic map of Eagle Marsh. Dropping her right index finger on a dotted red line, she slowly traced its angular trajectory as it skirted the historic subcontinental divide. Shifting her hand slightly, Yankowiak brushed her finger along a different line, solid and yellow, running the length of the Graham McCulloch Ditch, bisecting the marsh. "This," she said, "this is the new subcontinental divide we're building" — uttered so casually the feat sounded like little more than landscaping.

"Does it ever strike you how incredible this is," I asked, "helping to direct the construction of a new continental divide?" Yankowiak smiled. "I can put that on my resume," she laughed, before turning solemn. "Look — we're making lemonade. We have to close the divide now because we screwed up both watersheds so badly." She's looking forward to a time when the carp crisis is under control and all the fences and berms can come down, a time when the wetland can be restored to its proper place in the valley and the Blanding's turtle can reclaim nearby Fox Island and the Jefferson salamander won't lose vernal pool habitat to gravel pits. Her laundry list of ecological hopes for the region is extensive. But she stopped, cradling her face in her hands. The magnitude of the work ahead showed in her eyes. "Do you think that day will come?" I asked. She looked up. "Not in my lifetime."

• • •

"That house — it's been flooded at least six times that I know of," said Amy Silva, pointing past me out her Jeep's passenger window at a flood-prone red-brick and beige-siding bungalow. "I know the

guy who owns it. He'll never sell." The house in question sits at the bottom of Little River valley, an area still so prone to annual flooding that local roads between Fort Wayne and Huntington along Highway 24 feature permanent gates to shut down often treacherous routes. From the center of the Little River valley, there's up to a mile and a half on either side, yet just 50 feet separates the valley floor from the surrounding ridge.

Silva, the executive director of the Little River Wetlands Project, grew up three miles from Eagle Marsh. Over her lifetime, she has witnessed flooding, agriculture and urban development slowly eat the valley whole. Armed with a degree in parks management from Texas A&M, Silva served 13 years in the 1980s and 1990s as the Allen County Parks superintendent where Eagle Marsh is located. She feels this place deeply. On a bridge over the Little River, she slowed her suv. "You wouldn't guess it from the way it looks now, but I've seen this area entirely underwater," she said, her eyes scanning across the derelict snow-capped fields where wheat, corn and soybeans grow. "Many times."

With Yankowiak retrieving her kids from school, Silva offered to drive me through the Little River valley so I could better understand its relationship to Eagle Marsh. What's immediately striking is how degraded this once-vital waterway has become. The Little River is a shadow of its geologic self after having suffered the indignities common to natural features that interfere with urban growth. Southeast of Eagle Marsh, Silva showcased its plight, starting her somber tour at the base of a towering gravel mound. Easily one of the tallest features in town, this pyramid of stone and aggregate sits atop the source of the Little River. From there, it dribbles, dirt-brown and ruler-straight, for miles in a manufactured, steep roadside ditch. Past industrial developments and three active landfills, it runs, while eight-inch pipes staggered the length of it spit foul-smelling agricultural and stormwater runoff into the river. The county further added to the Little's ignominy by clear-cutting the riverbank, slashing down trees and shrubs

indiscriminately. To better maintain the waterway, Silva was told; I don't think she believed it. The Little resembles a river only near Huntington where it resumes a natural course, complete with vegetation and intact stream-side trees.

Skating in and out of the valley like a two-mile-wide half-pipe we passed gas stations, gun ranges and a herd of farm-raised buffalo slowly grazing on grass. Many of the farmers whose land we drove past will never enroll their property in the U.S. Department of Agriculture's wetland project, Silva believes. Their attachment to the land runs too deep. Connection to homeland is one thing, I venture, "but they live in a floodplain. That's a pretty big strike against living here." Yet the upside of risking floods to grow food in the valley rests in the soil itself, Silva said. She slowed her Jeep beside a hibernating farmer's field. "When the valley isn't underwater, the yields are tremendous. So, the people remain for the good times and forget the bad." And the Little River Wetlands Project does what it can, by securing and taking out of agricultural production as much valley marshland as possible, on top of protecting land that's already under their care.

The dull winter sun was disappearing. Silva and I were soon stuck at a railway crossing at Ellison Road in rush hour, watching the endless stretch of transport trucks tacked to rail cars. They've come through the marsh on a journey west, chugging beside the Graham McCulloch Ditch that flows beyond our sight and into the wetland. Drive a circle around Eagle Marsh and the urban pressures ceaselessly mount: commercial development, retail, hospitals, quarries, landfills, highways, subdivisions, gas lines, railways, a wastewater treatment plant. Fifty percent of the electricity used by Fort Wayne travels through transmission lines stretching the entirety of Eagle Marsh. Wires are strung high above the earth on towers anchored in concrete 40 feet deep (twice the typical depth required) to prevent the high-voltage metal monsters from shifting in sandy soils. It's a wonder Eagle Marsh exists at all among this modern detritus.

The county around Eagle Marsh isn't all industrial cast-offs. Above the lip of the valley sit stands of oak, maple and hickory that darkened as the day's last light left us, scattered atop the landscape like deciduous oases. A pair of juvenile white-tailed deer wandered out beside Yohne Road, eating knee-high shrubs on the roadside opposite the Hanson Aggregates limestone quarry. They scurried away as we approached. Silva pulled into the Hanson parking lot as I watched the Little River trickle behind barbed-wire fencing, stretching towards the horizon in an uninterrupted line before, turning, the river was gone.

• • •

An intimidating array of federal players suddenly dictated the future of Eagle Marsh. It was all Yankowiak could do during negotiations to remind the Army Corps and others that the Little River Wetlands Project had its own mandate, *thankyouverymuch*, which precluded sacrificing Eagle Marsh to save Lake Erie. Yet she clearly recognized the scale, urgency and necessity of acting to stop silver and bighead carp. "We weren't *not* going to put up the fence and accept the risk of letting Asian carp run amok," Yankowiak said. Still — her hands were tied.

Amy Silva confided to me that she thought the Asian carp ordeal had been hard on Yankowiak. The lands that the LRWP acquired in 2005 had needed substantial work to live again as marshland. Under Yankowiak's eye, one of the largest wetland restoration projects in Indiana's history began. Shallow areas of the marsh were dug out, pumps were removed so the marsh could retain water and drain tiles were broken and scattered to better mimic the valley's natural hydrology. Five hundred acres were seeded with native wildflowers, rushes and grasses: approximately 50,000 native plants and shrubs sewn into the earth. Ten-plus miles of paths were forged to entice the public into exploration, groomed by thousands of volunteer hours poured into Eagle

Marsh. Working under Yankowiak's tutelage, shallow-water wetland, sedge meadow and prairie habitats were constructed for over 225 bird varieties and hundreds of reptiles, fish, amphibians and mammals — many endangered — that call the marsh home.

Yet the pressures posed by Asian carp threatened the foundation and future of the wetland. More people know about Eagle Marsh than would have without the Asian carp crisis, Yankowiak conceded. But what's that notoriety worth? The money and effort to plan contingencies for Asian carp and consult with state and federal officials takes her away from pressing work. Asian carp are more than a temporary distraction like flood cleanup — they've become a permanent black hole in the marsh, gobbling up scarce resources indefinitely.

Sadly, the $4.4 million allotted for the berm included no money to rehabilitate the marsh once construction crews cleared out. Yet even if the funding existed, Yankowiak's group would need years to see how plants living onsite reacted to the hydrological changes accompanying the new subcontinental divide. Odds are it will take five years for native plants to fully root in the wetlands and countless more volunteer hours to redo restoration work completed less than a decade earlier. But Yankowiak's mission is to restore and protect wetlands in the Little River watershed, despite how thankless the task often feels. Controlling Asian carp simply made an already challenging task all the more daunting. "We have to relearn our nature preserve," Yankowiak told me. What else can she do?

• • •

Something remarkable happens past the 15th green of Swinney Park's frisbee-golf course. It's so unassuming, few realize what it is. The spot wasn't located on a park map, so I followed a concrete path for as long as I could before forging a trail through the hard spring snow. It crunched and toppled in broken off-white pieces.

Past the 16th tee, I trundled over an ornamental bridge spanning a small waterway, shoving my hands further into my jacket pockets. Through the trees I spotted the ice-capped river.

It was quiet by the river's edge. Beyond the din of speeding cars nearby, there was little sign of humanity. Tickling the metal of the 15th green cage as I passed, I pushed through bramble and paused where a petite ditch carrying water from Eagle Marsh met the St. Marys River. The banks of the Junk Ditch were seized with chunks of ice, but a recent thaw had sent a small torrent of slushy water tumbling into the river. I didn't know what I was expecting to find, but here it was. This unassuming space marks the passageway that federal officials fear Asian carp will use to reach the Great Lakes. I shivered as I watched the water advance.

Fort Wayne was blanketed in a brilliant, murky sunshine as I drove downtown. Headwaters Park is a former commercial area jutting into the St. Marys like a stubbed toe; here it meets the St. Joseph River moving south, east of the grander Maumee River. This aquatic connection completes the circuit linking Eagle Marsh to the Great Lakes. The city government bought Headwaters Park after the March 1982 flood forced 9,000 residents to flee Fort Wayne. The river subsumed 2,000-plus buildings and caused $56 million in damages. President Ronald Reagan even dropped in during the disaster to toss a sandbag in solidarity, proclaiming Fort Wayne "the city that saved itself."

A riverfront trail under Spy Run Avenue led to the city's gothic-style water filtration plant. Completed in 1933, the imposingly beautiful structure loomed large and low over the north shore of St. Joe's River. Nearby, a silent statue of a man pointed south towards the converging rivers. He wore cloth of the Catholic Church beneath a thick cloak, chiseled in aging copper that ran in long, turquoise stains to the monument's base. A light snow cast the meeting place of the three rivers in an eerie light.

The religiously named rivers around me were given their modern nomenclature by the first Europeans to visit the area. These

Catholic clergy from Quebec were some of the first Europeans to use the Little River valley's glorious gate as a portal to the west. Reverend Joseph Pierre de Bonnecamps, the man depicted in copper, was the first known European to come to the region, arriving at this historic confluence in 1749. A hydrographer, de Bonnecamps trekked to the valley as part of a scientific expedition. He must have marveled at the passageway nature had created where these three rivers met. I cannot imagine what de Bonnecamps would have thought about reengineering the natural divide, draining the wetlands to grow winter wheat.

· · ·

Three years to the day after Yankowiak and the Corps agreed on the earthen berm scenario for Eagle Marsh, it was finished. And nine months after I first peered across the chilly expanse of frozen marshland, Yankowiak and I met again in Fort Wayne to tour the newly constructed berm. The air was crisp as we converged at the edge of the marsh. Where earlier that year a lilting string of orange erosion fencing had bookmarked construction boundaries, now a powerful yet subtle mound of land rose up in Eagle Marsh.

The berm snaked 9,080 feet in front of us, a distance of almost two miles. It contained more than 190,000 cubic yards of dirt — enough to fill an Olympic swimming pool two and a half times over — trucked in from parts of the marsh a mile away. Come spring, a crew of volunteers-cum-landscape-designers would descend on the mound to sow and tend to grasses and trails marked along the berm. The master plan called for a groomed walking trail atop the new edifice to make amends for the berm destroying three existing park trails. Exacting rules for wildlife protection were drawn up, so detailed they're almost funny. Cold-weather tolerant native grass on the new walking trail must be sufficiently tall that snakes feel comfortable crossing the berm, but (*but!*) not so tall they want to linger and bask in the sun, increasing their odds of dying in some

terrible fashion. Five inches of grass should do it, they estimate — no more, no less. But before the green grasses of spring rise from the soil, the berm was a golden-brown ridge of mud, rye seed and straw. More than 16,000 bales — enough to bed almost 100 horses for a year — were tossed on the pile to give workers traction in traversing the mire. As we walked the berm, the sludge pooled around our boots like heavy snowshoes; soon such oddly shaped feet made walking damn-near impossible.

Side to side the berm is 80 feet wide and 15 feet tall at the summit, averaging nine feet in depth. It oozes out from the apex at a 4:1 ratio, dropping four feet out for every one foot down to keep the incline manageably shallow. (Someone's got to mow the lawn safely, after all.) Bolstering where berm meets roadway, concrete blankets weighing 3,000 pounds apiece were rolled out for erosion control. These 16-by-36-foot sheets, permeable enough that the first grass seedlings were sprouting through, needed a skidsteer and a team of workers to unfurl.

As Yankowiak and I walked the stone embankment, we were joined by her partner-in-berm-construction. Duane Riethman, an agricultural engineer with the Natural Resources Conservation Service, oversaw project construction on behalf of the federal government. The NRCS is part of an elaborate confederacy that brought the project to life. While the Army Corps provided the berm's technical specifications, the Indiana Department of Natural Resources was left to handle permitting with the City of Fort Wayne and Allen County. Alongside Yankowiak, Riethman, a 32-year NRCS veteran in Ohio and Indiana, helped oversee day-to-day construction with private contractors, all with input from the U.S. Department of Agriculture, of which NRCS is a part. And because telecommunications, gas, sewer and electricity infrastructure run through the marsh, a host of utilities were consulted. Not to mention the railroad. Because the west end of the berm meets a functioning rail line in Eagle Marsh, Riethman was forced to bring Norfolk Southern Railway into the dog's breakfast of a team. "You

ever worked with a railway company before?" Riethman asked. "They were supportive of the project, but let's just say they run at their own speed."

The gears of construction were slow in turning after my March visit. Any work completed in spring 2015 was stymied when a deluge drenched northeast Indiana and threatened to derail the berm's completion for months. With an end-of-year deadline looming, 18.86 inches of rain fell in 10 weeks from June to August on what one newspaper cartoonist dubbed "Fort Rain." It was the wettest summer since records were kept in 1912. For construction crews, ground conditions in Eagle Marsh weren't great to begin with. Silt and clay soil combined are ideal berm-building materials, Riethman says, but the marsh is pure silt, a fine sand that would be supreme for building land in Louisiana but lacks the strength needed to support 190,000 cubic yards of weighty dirt. And with the water table high after the summer's historic rainfall, Eagle Marsh was soon a morass. Heavy equipment, churning up the squishy earth, frequently became trapped in the quagmire. Riethman used to ask the construction foreman how many vehicles he'd lost to the mud. "It's a number I don't want to keep track of," came the reply.

The intense heat of a Midwest summer eventually dried the land. Work began anew, but crews faced another challenge in meeting the exacting standards of Yankowiak and her no-nonsense construction manager, Judith Bucolo. "The last thing I want is to have all this work done to keep out one invader only to have it replaced by another like phragmites," Yankowiak said. To protect against the introduction of invasive plants hitching a ride to the marsh in construction soil, crews were required to use only earth from the marsh. It wasn't just foreign soil that posed a threat, but the equipment itself that ferried the material onsite. Thinking shrewdly, Yankowiak wrote into crew contracts that all of the 41 heavy machinery types used during construction must be spotless. No dirty machines — or no marsh access. Crews learned fast

that Yankowiak and Bucolo weren't kidding; two machines were inspected and rejected because of potentially contaminated soil clinging to the metal. Eventually, Bucolo told me, workers got the message and brought in only clean machines. They couldn't afford to bring in dirty equipment since the contractor headquarters was 30 minutes away. Losing hours to mud wasn't an option.

The majority of work that should have proceeded at a leisurely pace all summer was delayed until Labor Day. By then, with crews scrambling to make up lost time, two dozen workers arrived on site, many working double-time to complete construction before year's end.

On November 10, 2015, it was finished.

• • •

Faced with restoring Eagle Marsh once again, Yankowiak turned to Aldo Leopold for inspiration. The famed American conservationist was well-versed in Dane and Sauk counties' prairie ecosystems — landscapes that once dominated the territory near his Madison, Wisconsin, home. Rolling hills filled with grasses growing taller than a horse's eye were habitat for thousands of plant, bird, mammal, insect and invertebrate species. Yet as he wrote his influential *A Sand County Almanac*, published in 1949, jaunts into prairie grasslands became somber, highlighting the extent of all the Earth had lost and was continuing to lose.

He set out to buck that trend. Working with botanists from the University of Wisconsin in 1935, Leopold & Co. gathered coneflowers, bluestem, pasque flowers and other plants from the sporadic pockets of prairie remaining around Madison to fill the university's new arboretum so that what specimens remained could live on. But Leopold's greatest work took place outside the confines of academia once he turned his attention to protecting the wild prairie itself. Ecosystem restoration and recreation wasn't new to Leopold; he was aware of woodland restoration projects happening across

America and had contributed to many. After moving to Wisconsin in 1924, Leopold was pivotal in initiating some of Wisconsin's earliest wetland and wildlife restoration efforts.

Focusing on tallgrass prairie was unique. At the time, much conservation work prioritized beguiling locales like Yosemite National Park. Prairies, in contrast, were a flat landscape largely devoid of charismatic mammals or stunning vistas, characteristics typically needed to mark a place as worthy of preservation. Leopold tied his love for the prairies to a larger discussion then underway with Americans about wilderness and nature that began with nineteenth-century environmental heavyweights like Henry David Thoreau and John Muir and continued into the twentieth with nature-preserving swashbucklers like Teddy Roosevelt. "Who cares a hang about preserving prairie flora," Leopold asked, "except those who see the value of wilderness?"

Yankowiak saw that value. As Leopold lamented the loss of prairie systems before devising a means of rescue, so too did Yankowiak agonize over restoring again a long-abused prairie ecosystem that Asian carp threatened to bury under two and a half Olympic swimming pools of dirt. Or if saving this prairie outpost was even possible. Years of work had already been invested in seeding the terrain with grasses to encourage native restoration of the marsh and the return of evicted birds, reptiles and mammals. Now Yankowiak faced the prospect of losing to Asian carp what gains she had made.

Saving the soil from the mechanical digger's maw led Yankowiak to contemplate questions not previously considered. Could they slice the land into chunks and transfer it, piecemeal, like a birthday cake? Would moving the soil give invasive grasses long buried in the dirt a new lease on life? The more she investigated, the more Yankowiak realized that few had considered moving such large volumes of earth in such a delicate manner with an aim towards keeping it intact. Her search for precedents set Yankowiak on a path that led straight back to Leopold.

Tallgrass prairie ecosystems in North America pack an over-sized ecological punch. They're also nearly extinct, a detail that helps explain the lengths Yankowiak went to save a mere quarter-acre from civilization's tread.

Once upon a time, tallgrass prairie stretched from Texas north into the Canadian provinces of Saskatchewan and Manitoba. From Pennsylvania in the east, these grasslands wrapped their green arms around the southern Great Lakes and stretched out, plains-ward, to embrace America as far west as Montana. Less than 300 years ago, more than 354,000 square miles of American heartland was the "Prairie Peninsula." Formed by a drying climate, bison grazing and fires set by lightning and, later, people, the tallgrass ecosystem was typified by prairie grasses like big bluestem, Indian grass and wild rye that often grew seven feet tall. Jackrabbits, coy-otes, Texas horned lizards and greater prairie chickens — among hundreds of other species — called the tallgrasses home.

Migrating west from cities on the east coast, waves of settlers began encountering and treating the prairie as an overgrown garden in need of tending. They saw a land pliable enough to be cut down, fenced in, burned out and planted with agricultural crops, wrote American historian William Cronon. Fires, long central to rejuvenating grasslands by injecting nutrients into the soil to assist plant growth, were outlawed. "Once the farmers had finished their work," Cronon noted, "the tallgrass prairie was doomed to a cornered-up existence in fugitive spots where conditions allowed a few of its species to survive." (These days, what corners of grassland remain on private land are often sold to energy companies, eager for access to oil and natural gas locked in the earth below.)

Something elemental to the big-sky prairie way of life was for-ever lost. In *Recovering the Prairie*, Curt Meine, a senior fellow at Chicago's Center for Humans & Nature, wrote that much is at stake when valuable prairie habitats are systematically destroyed. "When we lose populations, species, floras, faunas, communities and landscapes, we lose our bearings and our reference points.

We lose, too, the ability to ask certain questions, to formulate responses, to envision worlds."

Today, more than 99 percent of this North American tallgrass prairie world has been cultivated for agriculture and housing development, crisscrossed with roads, rail lines and fossil fuel infrastructure. It's all but vanished from Canada. More than 3,700 square miles of former grassland in southern Manitoba alone has shrunk to isolated seams representing just 1 percent of its historic range. America has fared no better. All that remains are pockets of protected prairie like the Joseph H. Williams Tallgrass Prairie Preserve in Oklahoma. Managed by the Nature Conservancy, 39,000 acres contain 2,500 bison ranging in what is now, sadly, the largest intact tallgrass prairie ecosystem left on the planet. In Canada, almost 198,000 acres of grassland across the country are under the Nature Conservancy's protection, most of it in scattered clusters of conserved land. The 13,000-acre Old Man on His Back Prairie and Heritage Conservation Area in southern Saskatchewan remains a flagship project for the conservancy. "A beacon of hope for protecting our remaining intact native grasslands" is how they phrase it.

Leopold's painstaking work with prairie restoration gave Yankowiak hope. Unlike Leopold, Yankowiak controlled a fleet of modern machinery that, channeled properly, could make saving Eagle Marsh's prairie ecosystem manageable.

Just days before the first construction crews appeared onsite in October 2014, Yankowiak finalized a plan to save the Little River valley's most productive soil from becoming infill for the carp berm. Digging 12 inches down into cool brown earth, crews carefully transported slabs of soil one foot deep from a quarter-acre of land. It was spread, six inches thick, over a half-acre of previously unproductive space.

As Riethman, Yankowiak and I approached the new grassland more than a year after the soil resettlement, the space was vibrant with plantlife. Saw-toothed sunflowers, rye, goldenrod, coneflowers and black-eyed Susans replaced the Canadian thistle

that once dominated the poor soil. Bulldozer tracks that cut an ample gash through the prairie (necessary to relocate the ground) were on their way to full reclamation by native grasses thriving in the new-old soil. Leopold would have been pleased. "Anyone not familiar with the project would think the pathway cut by the bulldozer was intended and the new prairie land entirely natural," Yankowiak told me among the goldenrods, swaying flaxen in the breeze. "Which is exactly the point."

• • •

From Towpath Trail, the new subcontinental divide slices south beside Graham McCulloch Ditch. After the violent scarring of the marsh from the berm construction, it's difficult to imagine restoring the landscape to the wetland state that Yankowiak envisioned when her organization assumed control. The place feels like a housing subdivision after construction crews have pulled out but before people have moved in, when the roads are unassumed and front yards are mud piles chockablock with old pipes and broken bricks. It's as if the land here awaits birds and plants and animals to assume ownership.

And it's happening. We spotted holes in the squishy soil where burrowing animals were denning among the slowly growing grasses. Deer scat lined the berm-top trail, confirming my suspicion that animals hold a special affinity for defecating on the pathways we carve from nature. Marsh birds used puddles that coalesced into temporary lagoons to rest and search for food. A muskrat, upon hearing our approach, scrambled along the bank and dove into the safety of the Graham McCulloch. Beside the berm, the ditch took a hard right-angle turn that's markedly out of step with the natural topography. The steep slopes are reinforced with imported stone to prevent erosion or the ditch spilling its banks. "I don't like it, but it's needed," Riethman says of the sharp turn. "Rivers don't take ninety-degree turns naturally."

The initial Asian carp barrier, the chain-link eyesore built in the aftermath of Yankowiak's trip to Albion in December 2009, was gone. The fence that rivaled those installed at state penitentiaries had stood for five years, a symbol of the compromise Yankowiak made in sacrificing Eagle Marsh to protect the Great Lakes. With the permanent berm in place, it was no longer needed. Yet the fence remains, in a sense, despite having made way for a new generation of carp control. Buried deep beneath the berm, it reinforces the new structure, cementing its place on the landscape — and preventing muskrats from tunneling.

Approaching the trail's end, the berm gave way to a smaller structure abutting the railway embankment. This mini-berm protects the Great Lakes from 50-year storms, while a chain-link fence anchored above it can deter Asian carp during once-a-century monsoons. It provides flexibility should a Noah-style, 500-year storm inundate the region by offering an emergency-only outlet for floodwaters. But if such a catastrophe occurs, all bets are off as to whether the berm could stop aquatic life from moving between watersheds.

The Army Corps needed to leave this spillway partially open to protect suburbanites living near the wetlands. The berm ain't about flood control, Riethman pointed out. It may mitigate the impact of future floods in the region, but it can't guarantee the security of Fort Wayne should the heavens open up. The key difference between the berm and other flood protection levees is what the structures are asked to do. Post–Hurricane Katrina, levees carry sweeping requirements for the Army Corps to regulate water flows and safeguard against rising tides. The berm, meanwhile, is an ecological project concerned solely with preventing fish transfer.

The novelty of its work on invasive species gave the Corps an out. Having never constructed a species-control barrier before, there were no standards to uphold; they were free to create and modify regulations on the fly. After all — when you make the rules,

you can rewrite the rules. Ultimately, building for a one-hundred-year flood was agreed to by everyone involved who concurred that the berm wasn't about halting high water — it was about stopping Asian carp. If we ever had to choose between halting these fish and safeguarding property and human life, people would win out.

• • •

Amidst the onslaught of government agents, official plans and construction crews, Yankowiak's sole hope was to remain a voice for Eagle Marsh in a conversation that could have easily drowned her out. Despite all the changes to the wetlands instigated by Asian carp, the marsh remains an intact and, in many ways, thriving ecosystem. "I'm tickled by the progress we've made," Yankowiak told me as we neared the trail's end, not far from where a ceremony held in May 2016 celebrated the berm's completion. U.S. Asian carp director John Goss later told the crowd, "We're declaring victory."

Yankowiak and I bade Riethman goodbye before we trekked to a barn at the edge of the property. She was running late. Two dozen teenagers from her old elementary school were waiting to hear Yankowiak speak about the Little River's ecological history. The students had volunteered to help anchor the berm by spreading rye seeds along the trail. But the bigger aim was to introduce locals to one of the largest wetland reclamation projects in the country happening in their backyard. Integrating the berm into the fabric of the park was as critical for Yankowiak as ingratiating Eagle Marsh to the community-at-large. The Graham McCulloch Ditch, long hidden behind a steep berm and covered with thick brush, was never a focal point in the marsh. Post-berm, the ditch is more natural waterway than spillway, a shallow but babbling brook that, against all odds, is welcoming of hikers, dog-walkers, martens and mallards. It makes the berm feel less obtrusive.

As we left the barn, eager groups of teens grabbed sacks of rye and paired off to tackle the trail. Yankowiak looked up. Past the

tall grasses gearing down for the approaching winter, she saw a white pickup truck tugging a muddy skidsteer. "Look," she says, pointing into the middle distance. "That's it. That's the last piece of machinery at the marsh." We had seen a small crew unearthing erosion fencing as we hiked the berm. Their work was done. Pulling off a gravel driveway and onto Engle Road, the truck kicked up a cloud of dirt and road salt before, growing smaller, it vanished into a grey horizon.

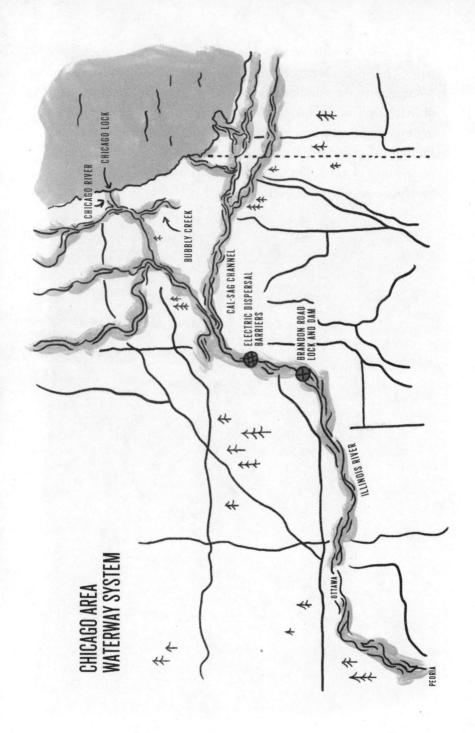

CHICAGO AREA
WATERWAY SYSTEM

CHICAGO LOCK

CHICAGO RIVER

BUBBLY CREEK

CAL-SAG CHANNEL

ELECTRIC DISPERSAL
BARRIERS

BRANDON ROAD
LOCK AND DAM

ILLINOIS RIVER

OTTAWA

PEORIA

CHAPTER 9

eDNA Rising

SOUTH BEND, IN — "None of you have been fishing in the last few days, have you? You haven't been handling fish or amphibians?" David Lodge asked us. It's not a dumb question. The professor emeritus in conservation biology at the University of Notre Dame in South Bend, Indiana, looked out across his crowded laboratory at a pack of unwashed, bleary-eyed journalists: leaning on lab counters, rummaging in dirty backpacks, poking at equipment, shedding hairs and dead skin — walking, talking microbiomes hellbent on contaminating a laboratory space where cleanliness (and the lack of it) has consequences.

Someone murmured from the back of the room. "You ate perch last night?" Lodge repeated. "That's probably okay. You've washed your hands since then? Or taken a shower? I don't want to inquire too much more about your hygiene." We laughed, us journalists from throughout the Great Lakes and Midwest. We had convened in South Bend for an Institute for Journalism and Natural Resources–sponsored workshop on science communication, and Lodge's lab was one of our first stops. But whether that perch-eater actually *had* washed their hands before entering the lab matters a great deal to those researchers charged with analyzing fussy genetic material. In case those hands weren't clean,

measures are taken to prevent contamination. "We bleach the floors and all surfaces on a regular basis," Lodge said. "That's the reason for the lab coats and other precautions." Like booties — don't forget the booties.

Three long, white-topped work benches lined the room, each covered in binders, plastic jars with protruding tubes and brightly capped containers of pipettes. Pipes with neon handles flew over a refrigerator with a specialized locking mechanism standing sentry near the door. Lab coats hung from pegs beneath glass cabinets stuffed with black-and-gold-bound theses from long-ago students. As Lodge spoke, Lindsay Chadderton slipped quietly into the crowded laboratory no bigger than a New York City apartment. Content to let Lodge enjoy the spotlight, Chadderton, a biologist from the nearby Nature Conservancy, stood, arms crossed, near the exit. In many ways, he was the reason why we science journos were squeezed between glass vials and microscopes to learn how trace amounts of discarded deoxyribonucleic acid (better known as DNA) have become invaluable for this century's most highly touted Asian carp detection method — environmental DNA (eDNA). Chadderton, a soft-spoken New Zealander with a *Flight of the Conchords*-esque accent to prove it, might downplay the role he played in the rise of eDNA; yet without the spark his thinking provided, the crisis response to Asian carp as we know it may never have come to pass.

While the Lodge lab at Notre Dame looked like any laboratory I'd visited, this nondescript research space was once a hive for cutting-edge eDNA research. Controversial too. Like seeing the face of Jesus in the clouds, or in the burnt crust of a breakfast taco, the integrity of eDNA was praised, rejected and scrutinized in turn. Soon government agencies and the broader public demanded on-the-ground action in response to a science still finding its voice. In many ways it still is. In the decade that followed eDNA's inception in 2009, the debate has shifted from the method's imperfections to its sky's-the-limit potential. But in that

fateful summer of 2009, before the simmering carp crisis boiled over, Lodge, Chadderton and the team of geneticists and biologists they assembled at Notre Dame had ample reason to suspect the technology they were pioneering would be a flop.

Like many good stories, this one begins over beer.

• • •

Stop me if you've heard this one. Three biologists walk into a bar. They order beer with lunch and chat about the pressing issues of the day. In the spring of 2009, that included the relentless push of silver and bighead carp up the Illinois River. They seemed unstoppable, and the tools then in place to curtail them weren't working. The conversation soon shifts to species surveillance. Andy Mahon, the molecular biologist in the group, is probed by his lunchmates — Chadderton and Notre Dame biologist Chris Jerde — who ask the affable Mahon: "Can we use genetics to do any of this stuff?" He's skeptical. They press Mahon to explain why, but he can't think of any reason why it *shouldn't* work. At least in theory. They leave the pub with a promise to investigate the idea further. Inglorious, sure, but this back-of-the-coaster thinking is how environmental DNA to detect Asian carp was first hammered out. No joke.

Mahon and Chadderton mapped out how to scrutinize their theory and decided to amass some water samples for exploratory testing. The first samples collected for eDNA testing of Asian carp came from the Illinois River near Morris in March 2009. Asian carp are a known entity near Morris — it's where commercial fisher Jim Dickau took me to catch silvers and bigheads with the Illinois Department of Natural Resources. I've seen them there myself. So if genetic detection didn't find Asian carp here, the thinking went, the technology wasn't ready for primetime. "We thought there was no way this was going to work," Mahon confessed from his office at Central Michigan University. The size of the river, the ability

to adequately filter the sample — all these factors and more were thought to conspire against them. "It was just one of those far-fetched ideas." But later that week, back in the lab, Mahon analyzed the samples. "And everything worked. We were pretty shocked." When the team successfully replicated the results, they knew they were onto something.

Later that summer, David Lodge and Chris Jerde traveled to Chicago to present their preliminary eDNA results to the Dispersal Barrier Advisory Panel. The panel had first met in 1997 in response to the threat posed by another non-native fish, Eurasian ruffe, that had been threatening to leap from Lake Michigan into the Chicago Canal. Once ruffe made that jump, the panel, an ad hoc cluster of regional resource bigwigs from government, industry and academia, began investigating ways of stopping other aquatic invasives, Asian carp chief among them.

Heading the group was Phil Moy from the Wisconsin Sea Grant. A fisheries biologist by training, Moy had worked previously with the Illinois Natural History Survey on zebra mussels in the Illinois River before a stint with the U.S. Army Corps of Engineers managing Great Lakes' invasives. After Lodge and Jerde presented their eDNA findings, Moy recalled, the group was excited. They weren't the only ones. "At the time the Corps was looking for a better way to determine if there were Asian carp in the canal." Agencies had netted the river to catch Asian carp since 2004, and while they weren't catching any, few believed the river was carp-free, especially since early tracking efforts suggested the leading bighead and silver carp should have reached the electric barriers by 2008. For Moy, "This technique that David Lodge came and talked about could really provide that proof, we felt, that something was or was not there." After the meeting ended, Lodge sat down with Colonel Vincent Quarles, head of the Army Corps' Chicago district, to discuss the technique and how to get Notre Dame working on Asian carp detection in the Chicago Area Waterway System.

The tentative deal reached at the Chicago meeting became a larger cooperative agreement between the Lodge lab and the Army Corps later that summer after Major General John W. Peabody, commanding general of the U.S. Army Corps of Engineers, Great Lakes and Ohio River Division, met with Lodge's team at a southwest Chicago restaurant and gave it the go-ahead. The Corps was less concerned with how *many* fish were abutting the electric barriers than with how close silver and bighead carp were to the Chicago River. Gaps in their knowledge were, at the time, unsettlingly substantial. "Our lack of information was so great," Peabody later told journalist Dan Egan, "I felt we had to take whatever information we could and apply it as quickly as possible to try and get more information."

The plan was to take the first 18 months to collect samples from above and below the electric barriers throughout the canal, analyze the findings and report them to the Corps. At Romeoville, Illinois, 25 miles south of Lake Michigan in the Chicago Canal, the Army Corps had built an underwater electric barrier to deter the passage of any non-native fish between the Great Lakes and Mississippi River. The $1.5 million Barrier I came online in April 2002, operating at one volt per inch of electric cable. All that juice to run Barrier I costs roughly $1,850 each month. Barrier IIA, the second aquatic electric fence in the canal, came into full-time operation in 2009. Located 1,150 feet downstream from the first barrier, Barrier IIA packs a punch of 2.3 volts per inch. (A third electric fence, Barrier IIB, wouldn't come online until 2011.) In collecting samples from throughout the canal, the Nature Conservancy's Lindsay Chadderton had anticipated the carp might be close to the barriers. "But our expectation was that above the electric barrier we shouldn't be detecting anything."

Chadderton was wrong.

Samples from above the electric barriers soon showed positive hits for bighead and silver carp, some within eight miles of Lake Michigan. The team was floored. What's more, the discovery

presented the Lodge crew with a unique problem. Scientists don't report their findings until their data has been analyzed, retested, peer reviewed and published, typically in a respected academic journal. But the findings unearthed by Lodge's team were shocking and urgently needed by the Corps, the public and numerous government bodies. Asian carp posed a substantial threat to the Great Lakes, and Mahon's early results suggested that the putative invasion front was 50 miles closer to Lake Michigan than the public was being told. What obligation did his team have to the public to act quickly on their findings? What obligation did the team have to the Army Corps who were funding the study? What obligation to scientific process?

Fatefully, the group decided to communicate their results on an ongoing basis rather than follow standard scientific practice. "We felt it was our responsibility to notify the Corps as those results came in," said Chadderton. "This is not the way you would normally want to do your science [as it] meant going through a very public process." But the alternative seemed almost unthinkable. "We could have sat on our results for two years and then released [the data]. But we had an agreement with the Corps, and we were detecting carp DNA in places we knew they and the broader community were interested in."

The narrative soon escaped their control. On Friday, November 20, the Army Corps was forced to acknowledge the results of Lodge's sampling after Egan and the *Milwaukee Journal Sentinel* broke the story. The Corps wouldn't speculate on how the DNA got north of the electric barriers, but others would. Most assumed they weren't operating at a high enough voltage to deter fish; or that lightning, which struck the barrier in 2005, had weakened the field without anyone knowing; or that juvenile Asian carp had slipped through near the hulls of barges; or that flooding between the nearby Des Plaines River and the CAWS in September 2008 had allowed their overland movement. People panicked. "This is like anthrax combined with swine flu when it comes to threats,"

proclaimed *Treehugger*. Everywhere the idea persisted that Asian carp had swum right under our noses to the gates of the Great Lakes — and the Corps had done nothing.

"It was a fight right off the bat," Mahon remembered. "We were attacked in a number of cases" by the media. Though some reporters supported the work, the team faced press criticism calling their work a "glorified science fair project." Others pilloried the Corps. Dan Thomas, head of the Great Lakes Sport Fishing Council, told the *Sentinel*, "It's a disaster. Heads should roll for this." The *Grand Rapids Press* in Michigan took up the theme of negligence, wagging their finger in the Corps' face. "Given that these carp have the potential to do some serious damage," they wrote, "the Army Corps of Engineers better get their backsides in gear."

The timing could not have been worse. Operation Silver Screen about to take effect. Days from then, the Corps was scheduled to conduct routine maintenance on Barrier IIA, a move that would shut down the barrier's electric charge for days. To stop all fish transfer through the CAWS while the barriers were worked on, large-scale application of the fish poison rotenone was proposed for vast stretches of the canal. "There was a great deal of alarm" over the barrier coming offline, according to Phil Moy. Others I spoke with from the Illinois Natural History Survey remembered an all-hands-on-deck approach as state and provincial agencies dispatched electrofishing boat crews to Chicago to ply the CAWS for carp before the poison took hold. Friends of the Chicago River head Margaret Frisbie remembered it this way: "They were all in a tizzy, everyone was freaking out, so they were going to poison the river." The U.S. Coast Guard even shut down portions of the channel to shipping traffic.

With nearly 500 people participating at a cost of $3 million, Illinois Department of Natural Resources staff, clad in lime-green safety vests and respirators, poured 2,100 gallons of rotenone from 50 boats throughout a 5.7-mile stretch of the Chicago Area

Waterway System. It retains the inglorious distinction of being the single largest application of fish poison in IDNR history. Barrier IIA went down on December 3, 2009, at 9:30 a.m. and remained offline for 36 hours. During that time, various parts of the electric infrastructure were cleaned, lubricated, tightened and inspected. The Corps also exhumed the eroding bodies of four vehicles and a tree trunk.

Of the 200,000 pounds of fish that turned belly-up in the river, one stood out — a single, 22-inch bighead carp. Whether the mass fish sampling effort and death of tens of thousands of shad and common carp (all destined for landfill) was worth the expense for a single bighead is debatable. The hype over eDNA had suggested they would find more Asian carp than a single bighead carp, but Mahon reminded me that it's crucial to remember that their study provided a yes/no answer to the question: Are Asian carp above the electric barriers in Chicago? However few in number, finding one bighead upheld that.

Others agreed. "We've now confirmed with a body what the DNA evidence has suggested," John Rogner, assistant director of the Illinois Department of Natural Resources, told NPR. And that lone bighead carp likely wasn't so lonely. Something not often remarked on at the time is that poisoned bighead and silver carp wouldn't have floated to the surface of the river — they would have sunk. Officials onsite knew this and deployed nets and boats to stir up sinking fish to little effect. Divers in the Chicago River confirmed the presence of dead fish on the canal bottom but were unable to identify them. Eleven days later, eight barrels of dead fish were filled from the trash grate of a nearby power station; none were Asian carp.

• • •

Back in his lab, Lodge had addressed the central suspicion of eDNA detection: false positives. From the beginning, critics had

suggested the positive hits detected by his team had originated from alternative sources: the livewells of fishing boats, for example, or birds who ate Asian carp south of the electric barriers and defecated north of them, depositing carp DNA in the process. Another possibility was that a jumping silver carp died on the floor of a passing barge south of Chicago, only to be kicked into the river north of the barriers by a crew member swabbing the deck. "Definitely that has happened," Lodge said. "But it's highly unlikely that that's going to result in a positive detection."

Like the shitting bird theory or the dumping of fish from a careless boater, the odds are stacked against any researcher coming upon a localized area with unfathomably high concentrations of carp DNA. It would have to be a huge amount of genetic material, Lodge told the assembled journalists. Besides the lab results that kicked off the Great Chicago Panic in the winter of 2009 weren't one-offs; they were based on repeated positive Asian carp hits, duplicated in-lab three times more than most eDNA samples typically are, to confirm their authenticity.

The team had expected controversy. As the first results rolled in, it became clear that Asian carp (in some capacity) were above the electric barriers in places the Army Corps was assuring the public and politicians were carp-free. Mahon recalled that they weren't pleased with the results. The Corps "really didn't want the answers that we were providing them." But welcome or not, Mahon and Chadderton knew the technology was sound. And they could prove it.

Coming in with a team of four, including a global expert on the use of genetic tools for surveillance purposes, the Environmental Protection Agency spent two days conducting blind trials and analyzing everything the Notre Dame team had done, just weeks after collecting their first samples in August 2009. Chadderton soon had a report back confirming their methods were unblemished. Crucially, the EPA also verified that their processes and results were rigorous enough to form the basis of future government

management actions. Those two days were the most stressful of my life, Mahon said, despite knowing we had done everything right from the beginning. "We knew we were producing good data. We wouldn't have published it if it wasn't."

But would the public trust how EDNA worked? And after their findings had threatened to undermine public confidence in the Army Corps as stewards of the canal and protectors of the Great Lakes, would the Corps ever trust EDNA again?

• • •

Many metaphors exist to help rubes like me whose science education ended in grade 11 understand the ins and outs of something as complex as genetic testing. Here's one: EDNA is a smoke detector. This is especially true of early iterations of the technology. Finding Asian carp DNA in the experimental days of EDNA testing in 2009 was never a guarantee that the fish was living in a waterbody, so much as it confirmed its genetic material was present. That remains true today. Where there's smoke, there's often fire, sure, but flames aren't a prerequisite for the alarm to sound. Here's another I've heard: cop shows use a similar form of DNA detection in tracking criminals as the one that's employed against Asian carp. Maybe that's not a metaphor, but the example, corny as it is, is rather sound. Humans shed broken fragments of DNA on laptop keyboards and books all the time, tiny pieces representing a small portion of our vast genome; silver and bighead carp similarly shed their DNA in feces, urine and discarded scales. And like the proverbial killer leaving clues in the lipstick on a cigarette butt, researchers can use collected traces of carp DNA to move from speculation to certainty.

David Lodge soon stood aside in his laboratory, turning the lecture over to postdoc researchers Mark Renshaw and Crysta Gantz. Water samples brought to the lab are messy, Renshaw told the group. "There is a lot of material in there that you don't

want." Humic acids from leaf litter and trees, chemical runoff from agricultural production — these contaminants can cause researchers massive headaches when looking for target DNA. The process begins with buffering the water sample to break down cell membranes, allowing for the DNA to transfer from the water to a particulate filter. From there the sample goes through a centrifuge that spins anything heavier than DNA to the bottom. "There are proteins and humic acids that weigh more," Gantz said, "so hopefully that's down at the bottom and we have our DNA and liquid at the top." What's left is pipetted into a small plastic tube containing a volume of water infinitesimally smaller than what researchers had collected. Having filtered out the proteins, algae and acids getting in the way, the tubes possess one microliter worth of DNA-laden water, ready for deeper analysis.

Before heading into the field, researchers will have created a genetic marker for their target organism, a kind of species-specific fingerprint that helps confirm its presence. In some cases, scientists must sequence the target species DNA themselves; in other cases, the genetic sequence they need is housed on GenBank. Kept online through the National Center for Biotechnology Information in Bethesda, Maryland, GenBank's database contains the genetic details of millions of species from around the world. It's constantly expanding.

Researchers use a technique known as a polymerase chain reaction (PCR) to amplify a minuscule amount of DNA present in a sample to create millions of copies of the target DNA sequence. It helps the researchers visualize a positive hit. The PCR-amplified samples are then tested against the genetic sequence from the species of interest as well as those from a number of other species that could conceivably exist in the water body where the sample was collected. The goal is to see if DNA from the sample matches the genetic marker researchers created in-lab or lifted from GenBank. To do this, the field sample is run through a spongelike agarose gel that separates DNA by size: an electric current is run through

the translucent, teal-colored gel, and because DNA is negatively charged, it moves through the gel towards a positively charged electrode. "The distance it goes depends on how big it is," Lodge interjected. And if DNA from the field sample matches the target species researchers are searching for, the DNA amplified from the sample will line up exactly with the marker, creating a consistent band through the gel. Place it under an ultraviolet light and the band glows fluorescent. From there, the DNA can be extracted from the agarose gel and retested to confirm the finding, while protecting against false positives.

This early method was labor-intensive and costly at roughly $35 a sample. "When we started this for Asian carp," Lodge said as we shuffled through the lab to look at an agarose gel, "this is what someone was looking at. Is there a band at the right place here that would tell us what size the DNA are? If so, then yes, we can be certain we have found the DNA of species X."

• • •

What Mahon and Chadderton could never have anticipated was how ferociously the State of Michigan would react to their findings. The Wolverine State glommed onto the results as definitive proof that not enough was being done in the CAWS to keep Asian carp from the Great Lakes. On December 2, 2009, just days after the eDNA news broke, Michigan attorney general Mike Cox notified Colonel Quarles from the Army Corps and Illinois governor Pat Quinn that all bets were off. He demanded that money be directed towards increased sampling and detection efforts while bureaucrats worked out how Illinois planned to permanently separate the Mississippi watershed from the Great Lakes basin. "Absent assurance that immediate action will be taken," Cox wrote, "I will be forced to consider all available legal remedies to protect the citizens of the State of Michigan and their greatest natural resource."

Less than three weeks later, Cox made good on what turned out to be a double-barreled threat. Michigan filed two actions with the U.S. Supreme Court on December 21, 2009. The first was a petition for a new Supreme Court decree on a 1967 ruling defining how much water Chicago could divert from Lake Michigan. The attorney general intended to argue that the watershed connection between the Great Lakes and Mississippi watershed constituted "a public nuisance" by creating "a threat of irreparable injury to natural resources held in trust by the State of Michigan." Assuming the Supreme Court would weigh in on a half-century-old water rights case because of an invasive fish was gutsy, but Michigan's next move took nerve.

Cox wanted to argue in his motion for a preliminary injunction that the Army Corps of Engineers be forced to "close and cease operating" two locks on the Chicago River while blasting all electric barriers at maximum voltage. Illinois's Great Lakes neighbor recognized in the petition that closing the locks would hurt barge and recreational boat traffic but found a diplomatic way of saying "tough shit." "Any such loss is relatively minor and is finite," they wrote. Whereas, "if the Asian carp enter the Great Lakes system, the damage to the environment and economies of the Great Lakes states and Canadian provinces will be staggering with no practical end in sight."

Michigan's petition got downright poetic. "The urgent need for action cannot be overstated. Partial measures are no longer an option," they wrote. "If the carp make it to Lake Michigan, the environmental and economic disaster to follow may take some time to develop but is virtually certain." Noah Hall, an associate law professor at Wayne State University and founder of the Great Lakes Environmental Law Center, maintained an extensive blog on the Michigan lawsuit throughout the trial. For Hall, the Michigan attorney general presented a "thorough, well-researched, and persuasive legal argument." Cox was right in taking action to protect the Great Lakes, he felt. "While some

politicians are sending letters, pointing fingers, or doing nothing at all," Hall wrote, "Mike Cox should be commended for taking reasoned, decisive legal action." Proactive, instead of reactive. Soon, every Great Lake state but Illinois (for obvious reasons) rallied behind Michigan, along with the province of Ontario.

Not everyone saw the Michigan suit as a reasoned defense of the Great Lakes. Future Supreme Court justice Elena Kagan got involved on behalf of the U.S. government in her role as solicitor general. The state's entire lawsuit rested on the Lodge lab's eDNA findings, Kagan wrote, findings that did not, on their own, prove that the existing electric barriers were insufficient to keep Asian carp from the Great Lakes. Nor did the eDNA results or Michigan's argument show that "a reproducing population of carp is on the verge of establishing itself in the Great Lakes." Besides, Michigan's claim that the Army Corps was willing to rely solely on the electric barriers "to the exclusion of all other measures" to halt the carp was wrongheaded. "The Corps is actively considering a number of alternative ways of deterring the Asian carp from migrating through the locks," Kagan stated in her brief, "including high-tech barriers and modified structural operations." The Metropolitan Water Reclamation District (MWRD), the agency overseeing Chicago's labyrinthine sewer system, called Michigan's claim of inaction "insulting." All-in-all, reopening a five-decade-old lawsuit simply wasn't necessary, the defendants felt. The Supreme Court agreed; they denied the injunction to close the Chicago locks on January 19, 2010.

It was then that the Corps turned on eDNA detection. A technological breakthrough that had provided agency staff with a much-needed early warning for where Asian carp were headed suddenly had its validity questioned by a one-time partner. In the summer of 2010, the Army Corps hired Ohio-based Battelle Memorial Institute, a nonprofit science and technology organization, to conduct an independent external peer review of the eDNA methodology despite the EPA having reviewed it in the fall of 2009.

"For whatever reason I don't understand," Lindsay Chadderton said, "that [EPA] audit was never really accepted by the Corps of Engineers." Four Battelle panel members ultimately met with the Corps and the Lodge team. In submitting their final report in December 2010, they too argued the science was sound.

Lodge's eDNA findings suggested truths that nobody wanted to hear, making it (and its practitioners) as popular as a dead carp at prom. When the Corps first learned of the eDNA research, the Battelle report noted, they "viewed it as an emerging technology still in the research stage. It had never been applied in the field before . . . nor had it undergone independent scientific studies or peer reviews of the type that the Corps would normally require before applying a technology which would inform management decisions." While the Corps decided to use eDNA despite their uncertainties and "results that would leave many questions unanswered," the report stated, the agency wanted to calibrate the technology and understand "the meaning of eDNA results." The Corps, for their part, adopted most of the panel's recommendations on improving eDNA detection, including greater analysis of how eDNA degrades in an ecosystem and a promise to study alternative pathways for carp DNA to have made it above the barriers. Whither the pooping bird theory?

It wasn't just the Army Corps that soured on eDNA. One intervenor in the Michigan lawsuit came out swinging against Lodge personally. Lawyers for Wendella Sightseeing, a company that runs architecture boat tours along the Chicago River, argued in a brief that "in Dr. Lodge's attempt to sell himself as the preeminent eDNA expert, he proved only that he is an advocate for permanent separation of the Chicago Area Waterway System." They called into question Lodge's testing methods and accused him of downplaying fears over false positives; they claimed the detection of Asian carp DNA signaling the presence of live fish was his *belief* and not valid scientific opinion; they accused Lodge of withholding data from the Corps and they scolded the entire Notre Dame team for making their results public before a successful peer review

was completed, suggesting their haste had more to do with a to protect proprietary information than any altruistic responsibility to the public. Wendella concluded that "Dr. Lodge's research has not been peer reviewed, is incomplete and is unreliable."

The data got its validation via peer review and publication in *Conservation Letters* in 2011. By then, the unexpectedly nasty public fight led the Lodge group to shift their focus away from the Chicago Canal and towards halting other non-native species already present in the Great Lakes. Chris Jerde left for work in Nevada while Andy Mahon moved to Michigan. The struggle to have eDNA accepted, the ensuing lawsuits and the tar-and-feathering from the Corps left a mark on Mahon. "I've always found it funny that we were funded to do this by the Army Corps and were then attacked by that same agency, who tried to invalidate the science." At the time, Mahon was a young postdoc looking to keep his head down, publish papers and land a permanent teaching gig. "I never thought in my entire life that we would end up producing testimony for the Supreme Court," he said. The experience was "ulcer-inducing, let's put it that way." Phil Moy from the Dispersal Barrier Advisory Panel recalled the episode as a "terrible affair." Looking back, he said, the Corps "kind of vilified David Lodge."

The Michigan suit was just the first in a yo-yo of lawsuits and rejections between Michigan and various levels of the American judiciary. After news emerged that another positive eDNA hit was detected for silver carp in Lake Calumet, Michigan submitted a renewed request to the Supreme Court to close the Chicago locks in February 2010. This too was denied in March, while in April, the nation's highest court formally denied Michigan's petition to reopen the 1967 water diversion case. As did a U.S. district court in Illinois in December 2010 when Michigan filed a new lawsuit to close the locks after a bighead carp was caught by commercial fishers in Lake Calumet that June. The state filed an appeal to the U.S. Court of Appeals for the Seventh Circuit, a gambit rejected by that court in August 2011.

Michigan wasn't done. They then petitioned the Supreme Court *again* to force the Army Corps to place block nets between Lake Calumet and Lake Michigan while expediting completion of their recently announced Great Lakes and Mississippi River Interbasin Study. The country's highest court backed President Barack Obama's pro-Illinois, pro–Army Corps position by rejecting Michigan's legal challenge in February 2012. Once more unto the breach, Michigan lost again in federal court that December when Judge John J. Tharp rejected another lawsuit, this time calling for the forced hydrologic separation of the Mississippi and Great Lakes watersheds. Despite acknowledging "the potentially devastating ecological, environmental and economic consequences that may result from the establishment of an Asian carp population in the Great Lakes," Judge Tharp ruled that the Corps wasn't acting unlawfully in refusing to separate the basins. They were charged by Congress to maintain navigation between Lake Michigan and the Mississippi, an action that superseded all others.

The onslaught of legal challenges pinning state against state and states against Washington took a toll on the spirit of cooperation needed to resist Asian carp throughout the basin. Meleah Geertsma, senior counsel with the Natural Resources Defense Council (NRDC) in Chicago, wrote shortly after Tharp's ruling that the "suit's passing may not be all bad" given how years of legal strife had polarized the fight against Asian carp. A major source of tension, this "us versus them mentality" wasn't helpful, Geertsma felt. Asian carp have never been a problem confined to Chicago, and rather than point fingers in court over who must do what, all parties needed to work together. "By and large this cooperation has occurred in many venues," she wrote, "but the Michigan lawsuit has been looming on the side, threatening closure of all the locks without any bigger picture collaboration." It was time to move on.

• • •

After our communal meeting with Lodge wrapped up, I made plans to talk with Lindsay Chadderton from the Nature Conservancy at his Innovation Park office. The day was cold and clear. I wandered between windswept Notre Dame buildings, past Touchdown Jesus towering above the Colosseum-esque football stadium. After security let me past a fingerprint scanner, I was escorted to the second floor. Chadderton met me in waterproof Keens and a dark gray pullover. He wore a thin turquoise toque, the color nearly matching his eyes. The office he shared with another researcher was a clutter of filing cabinets and stacked binders. "Nice treadmill desk," I noted. "Oh, thanks," Chadderton responded dryly. "Doesn't work though. Now it's just an awkward standing desk." He grabbed a water bottle, and we headed to the lounge.

If the first generation of eDNA sampling tools were revolutionary in their way, the new iterations that built on the technology Chadderton helped pioneer have altered the field of aquatic species detection in previously unimaginable ways, he told me. Developed by physicists at the University of Notre Dame alongside researchers like David Lodge, laser transmission spectroscopy (LTS) has joined the growing pool of detection tools. LTS can determine the number, size and shape of genetic nanoparticles by forcing targeted DNA in a water sample to cling to polystyrene nanobeads. "You can design them so that only a particular DNA sequence like an Asian carp would stick to them and then use the laser to detect that," Mike Pfrender, director of Notre Dame's Genomics and Bioinformatics Core Facility, later explained. "It's a very clever technology," one that in a few seconds can show researchers species presence/absence with a DNA concentration an "order of magnitude less" than what's needed in traditional PCR analysis, one of the more common methods used in eDNA evaluation. While the technology may be best applied testing the ballast water of oceangoing vessels for unwanted species and pathogens, its greatest potential may be its size. Pfrender noted, "It comes in a little attaché case and you can take that right out into the field."

Once you consider the possibility of rapid onsite species detection, the opportunity to discover whole communities of organisms in any ecosystem is staggering.

Laser transmission spectroscopy may be just the beginning. When I spoke with Andy Mahon at Central Michigan University in spring 2017, he told me that forms of eDNA detection that evolved since 2009 have already become obsolete, so quickly is the technology advancing. "We are way past next generation sequencing because we are already in the next generation of the next generation," he said. High-throughput sequencing, a form of passive surveillance, is currently allowing researchers around the world to conduct metagenomic sequencing of water samples. This process can highlight every species in a water body and could provide clues to the presence of species not yet known. Back in 2009, the Lodge team was confined to searching for one species in one water sample; these days, a similar group can search a dozen samples for *every* species present where the sample was taken and see their entire genome. "We don't need to know what's there beforehand," Mahon said. This makes a huge difference. "All the time we were looking for Asian carp, we were trying to find Asian carp. What happens if the Loch Ness monster was in one of those water samples? We never would have found it."

It's not just our thinking about freshwater ecosystems that will be overhauled with eDNA analysis. Terrestrial ecologists have been using environmental DNA to detect non-native species for years, and now that the practice is alive and well in freshwater, marine ecosystems are the latest frontier. Using $830,000 from the Marine Biodiversity Observation Network, researchers from the Center for Ocean Solutions at Stanford University and the University of Washington partnered with the Monterey Bay Aquarium near San Francisco to study eDNA monitoring of marine species in the aquarium's 1.2-million-gallon Open Sea tank. The majority of Open Sea fish, such as sardines and tuna, were detected in the water samples along with human, cow, pig and chicken DNA, likely

from nearby agricultural runoff entering the tank's water intake pipes. But the relative abundance of EDNA markers for most species reflected the known abundance of those species in the Open Sea tank, a positive sign that marine biodiversity will one day be measured more accurately. While obstacles remain before EDNA becomes a standard ocean life census tool, lead researcher Ryan Kelly from the University of Washington notes that the technology is moving towards EDNA becoming capable of counting marine taxa in otherwise impossible-to-reach communities.

The same goes for threatened and endangered species. In late 2016, a report in *Nature Ecology & Evolution* from the University of Copenhagen argued that DNA extracted from saltwater near a Maersk oil platform off the coast of Qatar helped quantify global whale shark populations. This hard-to-study fish — the largest in the world — is often 62 miles or more out to sea and is difficult to track. But advances in environmental DNA have allowed researchers to estimate that more than 71,000 female whale sharks are available for reproduction. It's estimated that metabarcoding of EDNA from saltwater samples can detect fish diversity better or equal to any of the nine most popular methods currently used in marine surveys.

It takes time for any scientific tool to gain peer acceptance, and the time-lapse to approval often trickles more than it flows. Environmental DNA may be the exception. We're not even a decade into the use of EDNA in-lab for aquatic ecosystems, let alone in the field, notes former University of Minnesota biologist Jessica Eichmiller. "Yet there has been a huge surge in EDNA research in recent years, and scientists are cooperating well to advance the technology as quickly and effectively as possible." Andy Mahon agrees. Cost and speed are crucial factors that shaped EDNA's trajectory. Much like the human genome project needing $3 billion and 13 years to map the first human genome (a process that can now be completed for the price of a flat-screen TV), advances in EDNA detection have occurred at an unprecedented rate. The data Mahon analyzed for his PhD dissertation at Old Dominion

University in the mid-aughts took five years to compute; today, that trove of data could be processed in 48 hours.

The academic literature has caught up too. When Chadderton conceived of eDNA as a detection method for invasive freshwater species, he had just one other peer-reviewed academic article to consult — a paper analyzing eDNA to locate American bullfrogs in European swamps. Since 2009, hundreds of papers on the use of eDNA have been published, inching towards solutions to its limitations and improving the veracity of its results. There are bugs, to be sure, but the broader scientific community has accepted the science and begun the tedious but fundamental work of building on existing generations to better the technology.

· · ·

Research into eDNA, CO_2 barriers or pheromone attractants, as we saw in an earlier chapter, isn't science for science's sake — this is public research, funded by taxpayer dollars to find solutions to public problems. It's a process, one that doesn't end with finding workable solutions in-lab. That's just the beginning.

These options must be carried into the real world with the assistance of even more public dollars because the risk of failure may be worth the reward. A nanopore DNA sequencer is smaller than a cell phone and capable of completing full biodiversity assessments for any waterbody. Border control agents aren't able to test every tropical fish shipment that arrives in America, Mahon suggests, and fish importers often lie or are ignorant about what species they are transporting. But if assisted by state-of-the-art gene sequencing tools, it's possible to know the true nature (and ecological risk) of the countless species entering America every year. It doesn't stop there. Nanopore sequencers have already been deployed to track Ebola outbreaks and could easily be applied to rooting out the Zika virus or malaria parasites. "The potential is pretty much unlimited," Mahon says.

Imagine not having these options because the science behind them remained unfunded. The real challenge in creating species-surveillance programs built around technologies like high-throughput sequencing is waiting for management to catch up with the science. Whether policymakers use this cache of new information effectively remains to be seen.

Yet one thing is clear: the fractious debate over eDNA as an instrument of scientific discovery is over. Rather, eDNA has moved out of the cool, academic fringe and into the embrace of mainstream government agencies like the U.S. Fish and Wildlife Service. The technology has flourished in their hands. There has been a massive investment from government in building the infrastructure, training and capacity to use eDNA in the field, Chadderton says. Within three years of the discovery of Asian carp DNA north of electric barriers in the CAWS, Fish and Wildlife took the method in-house, melding it with their routine monitoring plans and tripling sampling efforts. "We took 3,000 samples over a three-year period," Chadderton says of the Notre Dame research, "but Fish and Wildlife took 8,000" samples in 2014 alone. "Clearly the federal family, or at least the Fish and Wildlife Service, sees value in the tool."

As an instrument for resource managers, eDNA is now widespread, so much so that the private sector is developing new conservation tools using core concepts developed by Chadderton et al. in the Lodge lab. In February 2017, Washington-based aquatic technology company Smith-Root unveiled 11 premade species assays that will render results on water samples and transmit data to the cloud directly from the field. Now, researchers need less than one hour to determine whether DNA from invasives like bigheaded carp or near-threatened species like the eastern hellbender salamander are present in a waterbody. But Smith-Root have taken the extraction of water samples for eDNA testing to another level in developing the ANDe™ Sampling Backpack in March 2018. For just under $6,000, the ANDe contains everything

a researcher needs to collect samples from a lake or river without strapping on hip waders or risking contamination, all contained in an easy-to-carry bag no larger than a camping backpack. "eDNA sampling technology is in the process of transitioning from a nascent phase to professionally engineered research tools," said Smith-Root molecular ecologist Austen Thomas. In a paper on ANDe published in *Methods in Ecology and Evolution*, Thomas wrote, "Such innovations will be essential as eDNA monitoring becomes one of the industry standard methods used for species detection and management."

The rise of eDNA occurred in lockstep with Asian carp's transformation into a household name. The December 2009 panic in Chicago, followed by years of fruitless legal battles, may have failed to halt the carp or force a permanent separation of the basins, but it succeeded in drawing national attention to an ecological crisis that biologists, fishers, environmentalists and politicians had screamed about for years. Suddenly, detected above Barrier IIA and within striking distance of the Great Lakes, Asian carp metamorphosed from a perceived local problem into an international disaster, a biological spill flowing into the largest freshwater body on Earth. Studies were commissioned by governments, academia and environmental NGOs exploring ways to keep the carp at bay. As we'll discover in the next chapter, Chicago, gateway between the basins, became ground zero in the latest phase of Asian carp's American odyssey. eDNA had become an accepted tool for locating Asian carp — but once confirmed in situ, the real controversy began.

CHAPTER 10

Via Chicago

CHICAGO, IL — The McCormick Bridgehouse was farther than it looked. After spending a leisurely morning in the stately Harold Washington Library, by noon I was scrambling up State Street towards the Riverwalk, furiously glancing between the time on my phone and Google Maps' pulsing blue beacon. I was nowhere near where I needed to be.

Mark Hauser was leading a public talk on water chemistry in one of America's most notoriously polluted rivers this side of the Cuyahoga. It was an auspicious location: less than a mile east stood the Chicago Lock, the last manufactured impediment on the river to keep Asian carp from Lake Michigan. It didn't look like much could survive in the river — nor would anything wish to. Approaching the bridgehouse, sweaty and ungraciously eating a granola bar, I heard Hauser, an ecologist with Friends of the Chicago River, ask if anyone in the crowd of enviros and tower workers had any questions. Yeah, I thought — *can you start from the beginning?*

As I queued up to beg for Hauser's CliffsNotes presentation, a woman strode quickly to his side. In her early forties with reddish-brown hair, dressed in a floral sundress and dark sunglasses that concealed much of her face, Diane Hickey-Davis signaled to me that she needed only a moment of Hauser's time.

Eavesdropping, I overheard her mention Chicago's infamous Bubbly Creek, part of the river's South Fork that occasionally still emits gurgling gases from decomposing animal parts dumped in the river by meat processors at the Union Stock Yards in the early twentieth century. Upton Sinclair brought attention to Bubbly Creek when he wrote in *The Jungle* — his 1906 exposé on Chicago's inhuman and inhumane meatpacking industry — that the creek resembled "a bed of lava" with caked-on grease so congealed that chickens walked upon the river with impunity. Today it's almost entirely stagnant.

Naturally, I was desperate to see it.

"I've never been," I told the pair, perhaps too enthusiastically. "Wanna lift?" she asked. "I'm heading there now." I left Hauser a card and wandered off to get in a stranger's car.

Hickey-Davis grew up in Mobile, Alabama. She studied chemical engineering at the University of Florida before moving to Chicago "eight winters ago," to live where her husband works. Yet the South still runs through her, and not just in her dislike for the Windy City's damp winters. Driving through the Loop, Hickey-Davis shouted directions across me to another driver at a traffic light. I must have looked at her funny. "I talk to people way more easily than my husband does," she said as we drove away. "He's from around here, and he wonders why I talk to everybody. Or give strangers rides."

Weeks earlier, Hickey-Davis had led a Friends of the Chicago River cleanup at Bubbly Creek. She's volunteered with the organization for many years and, as part of her stewardship, was returning to the creek to seed bomb its riverbanks with Illinois wildflowers. The aim was to make the combined sewer overflow pipe jutting out of the ground nearby more . . . pleasant.

She parked her SUV on Ashland Avenue, not far from where the creek meets the South Branch. At Canal Origins Park, we walked towards the river, the twin white peaks of Willis Tower floating in the distance. Hickey-Davis sporadically reached into

a small package and tossed a cluster of seeds in either direction, carefully hanging onto her car keys. When the concrete path ended, we struck out down a winding riverside trail, wading through waist-high grasses and sedges. "Your shoes okay to get through this?" she asked, hurling a constellation of seeds. I looked at my Blundstone boots and the sandals on her feet. "Yeah," I said, "I'll survive."

Down by the river, on a path overgrown with scrubby underbrush, we stumbled on an old Hispanic couple sitting on frayed folding chairs. The man held a fishing pole in his weathered brown hands, the line cast into the inky water. Leafy trees canopied above them. Hickey-Davis asked what they were after. The old woman turned to the man, speaking softly in Spanish. *Bagre*, I heard him say: *pez sol.* "Catfish," she said to us, "catfish and bluegill." A grimy white pail between them sat empty. We said goodbye.

Bubbly Creek is part of an unusually complex hydrologic system. The north and south branches of the Chicago River were captured long ago and channelized, forced overland towards the Des Plaines and Illinois rivers to ferry wastewater from Lake Michigan. Far from a historical footnote, this send-it-down-the-river approach remains Chicago's preferred method for handling human waste. Seventy percent of the water flowing from Bubbly Creek through the Chicago Area Waterway System and towards the Illinois River is treated effluent; the remaining 30 percent comes from tributary rivers, stormwater and diversions from Lake Michigan to dilute said sewage. The farther that water (such as it is) moves from Chicago, the more it's manipulated: forced through powerhouses, sealed off in locks, pushed over dams, siphoned by industry, inundated with agricultural runoff — it's a lot for a canal to handle when its flow rarely exceeds 2,000 cubic feet/second, a low velocity for a waterway 160–200 feet wide and 25 feet deep. All these factors "cause shocks or waves to the system," says James Duncker, a 30-year hydrologist with the U.S. Geological Survey.

"It's a very complex and unsteady flow." Indeed the river I step in is not the river I stand in.

A small cut in the creek soon appeared before us, a dozen feet below the street. A black pipe jutted out from the soil, dry now, but not always. When rain intensifies and Chicago's sewer system cannot cope with the deluge, combined sewer overflow pipes like this one ferry rain and sewage into rivers and creeks emptying into Lake Michigan and the Chicago River. Untreated. Hickey-Davis approached the pipe and emptied her remaining seeds onto the shaded mud beneath the outfall. We headed back.

Hickey-Davis drove us into the nearby Bridgeport neighborhood for a nickel tour. "There's a lot of new development going in along the riverfront," she told me. At Racine Avenue and W 35th Street, the Bridgeport Art Center was a great example of what renovating old industrial spaces can do for a community, bringing people, art, events and money into a neglected stretch of riverfront. Yet the art center seemed an anomaly. Most industrial sites along the South Fork turn their backs on the neighborhood, and on Bubbly Creek. Not only do they fail to interact with the blue space, but they cordon it off behind fences and *No Trespassing* signs. We pulled into the driveway of one deserted manufacturer and stared through the windshield at the creek, its canopy overgrown with trees and its banks littered with faded neon trash. It's a shame, I thought. For a waterway that's featured so prominently in the ecological fortunes of North America, few even see the river still running.

• • •

Chicago's Civic Opera Building stands so close to the river it looks ready to slip its foundation at the earth's slightest tremble and topple into the water. The imposingly beige Art Deco structure offers Chicagoans a chance to escape the rain under an ornate awning running along North Upper Wacker Drive, resplendent with bright

orbs, gold finishings and imposing columns. Inside the building's 45-story tower, in a west-facing office on the 27th floor filled with photos, awards and plaques, sat David Ullrich. Tall with sparse white hair and rimless glasses, Ullrich had just returned from a run and had changed into a yellow dress shirt and brown tie.

Ullrich heads the Great Lakes–St. Lawrence Cities Initiative (GLSLCI), a binational coalition of mayors scattered from Duluth, Minnesota, at the western tip of Lake Superior to remote Gaspé, Quebec, where a yawning St. Lawrence River meets the sea. From climate change and ballast water to flooding and shipping, the GLSLCI speaks out on a broad range of anxieties and hopes for the basin as determined by city governments and the millions they represent. I assumed a group driven by so many diverse economies would struggle to coalesce around a single scheme to keep Asian carp from the Great Lakes, let alone agree that one nuisance fish was worth the hassle. According to Ullrich, mayors were immediately on board; his board, however, needed time. "There was a debate among our directors whether we wanted to play a major role. It's a politically charged issue with pretty high stakes [and] not a real high likelihood of success." But if they sat this crisis out, he recalled them saying, who were they as an organization?

The plan ultimately settled on was massive (infrastructurally and psychologically), so grandiose that to get it built, the public would need to embrace it with a groundswell of civic pride.

The catalyst came in late 2009. Soon after Notre Dame researchers discovered the carp eDNA north of Chicago's electric barriers, Ullrich saw the region fracture over how to deter the fish. Along with Tim Eder, head of the Ann Arbor–based Great Lakes Commission, Ullrich felt that Michigan's sue-first-ask-questions-later approach to the crisis wasn't the best path. Consequently, the region needed to unite, they felt, not rehash old grudges in court. The two men brought together representatives from industry, government and the environmental community from around the basin

to explore solutions to keeping Asian carp, so menacing that year, from reaching the Great Lakes.

The idea of creating a permanent barrier between the CAWS and Lake Michigan was, at the time, in the ether. Soon after they began thinking about stopping aquatic nuisance species, Ullrich's group figured that something so physically imposing as a plan to sever the Chicago River from Lake Michigan would not get serious consideration. Yet this aquatic connection was the likeliest vector for Asian carp to spread leading the group to focus on what a physical separation of the Great Lakes and Mississippi watersheds in the CAWS could look like. "Intuitively, if not otherwise, [separation] appeared the most effective means of keeping the carp from getting into Lake Michigan," Ullrich said. Not just Great Lakes–bound species, but stopping almost 190 species of mussels, fish, algae and viruses from accessing the Mississippi was equally vital. "That's never gotten a lot of visibility, and a physical barrier would provide protection in both directions."

It would be a tough sell. Ullrich expected the public to look at separation and think it ludicrous. "It's preposterous," he anticipated hearing — "too big a project." Yet Chicago had already reversed the river's flow a century ago. Why, he thought, with 10 decades' worth of technological advancements, couldn't they accomplish such a daring and imaginative technological feat?

Others took up the mantle of physical separation to explore benefits beyond keeping out unwanted organisms by considering separation as part of a larger blueprint to protect water quality and reduce flooding around Chicago. In September 2010, the Natural Resources Defense Council issued a paper reenvisioning the Chicago River in the age of Asian carp, placing control efforts within a broader agenda of modernizing the city's hydrology. Asian carp, the NRDC argued, could be a catalyst for physical separation that would integrate green infrastructure into the concrete jungle, beautify neighborhoods, reduce sewage outfalls and

rejuvenate how goods moved throughout the Midwest, ushering in a "different future."

Yet as far back as 2007, the U.S. Army Corps of Engineers had been charged by Congress with studying ways of preventing aquatic invasives' spread along the entire 1,500 miles of watershed dividing the Great Lakes and Mississippi. And in researching and writing what became the Great Lakes and Mississippi River Interbasin Study (GLMRIS), the Corps aimed to recommend a course of action for halting invasives' movement by 2015. Yet this elongated timeline for completion, typical for large-scale engineering schemes the Corps handles, was criticized after the discovery of Asian carp EDNA as taking far too long. Bipartisan representatives from Congress and the Senate introduced legislation to speed up the study and, indicating how widely the idea of physical separation had permeated society, to conduct a feasibility report on hydrologic separation.

By the summer of 2012, the Army Corps was given just 18 months to complete their study.

• • •

As the Corps began their under-the-gun work on GLMRIS, the Great Lakes Commisson and Great Lakes–St. Lawrence Cities Initiative released their own account on physical separation on an unseasonably warm January 31, 2012. *Restoring the Natural Divide,* as it was called, presented three alternatives for hydrologic separation, all of which met four basic truths: that Asian carp and other invasives would be kept from moving between basins, that water quality would be improved throughout the CAWS, that flood protection would be strengthened and that navigation wouldn't be harmed.

As anticipated, the scope of the study was staggering. The report identified two dozen potential barrier sites, the best of which were grouped into three options. The Down River Alternative proposed

a single barrier where the Chicago Sanitary and Ship Canal (cssc) meets the Calumet-Saganashkee Channel southwest of the city. The Down River plan would completely disrupt commercial shipping, they found, and require $6 billion in upgrades to wastewater treatment plants to process sewage ending up in Lake Michigan. It would cost $3.9 to $9.5 billion. Also in the $9.5 billion range was the Near Lake Alternative, five barriers in Illinois and Indiana that would cut off access to Lake Michigan close to the source. Most of this alternative's cost covered flood protection and the construction of an 18-terminal port to replace three harbors slated for early retirement if the Near Lake option went ahead.

Then there was the Mid-System Alternative. Compared to other options, with four barriers set back from the lake, it posed the smallest disruptions for shipping, water quality and flood management. It also most closely approximated the original subcontinental divide. "We have not identified a preferred alternative," GLSLCI's David Ullrich told reporters, but "this is the one that seems to be most viable." Capped at $4.27 billion, it was also a relative steal.

There are jobs associated with a public works project of this magnitude, said Tim Eder from the Great Lakes Commission — roughly 7,500 jobs annually over its lifespan, expected to be fully realized within one to two decades. Eder spoke with media of property values rising in lockstep with clean water and reminded reporters covering *Divide*'s release that a tiny portion of each alternative's cost — roughly 3 percent — pays for construction. The remainder covers ancillary benefits like improved flood protection and transportation. If every household from Louisiana to New York ponied up, the cost would be $4 a year; $11 if confined to Great Lake residents. "The value of the Great Lakes far exceeds that," Eder said. Ullrich backed him up. "Infrastructure expenses are not cheap," he told journalists, but this was more than *one* project to halt *one* fish. "This is an opportunity to totally redefine the Chicago [Area] Waterway System and the relationship of that waterway to the Great Lakes and the people of this region. Chicago is a city that's always thought big."

Politicians warmly greeted the report from across the political spectrum. Many, including Chicago mayor Rahm Emanuel, Illinois governor Pat Quinn and U.S. senator Dick Durbin initially offered vague promises to consider its findings. Others were more expressive. Michigan attorney general Bill Schuette praised the recommendation to sever the aquatic link (the very thing his state was suing to implement) but also the speed at which Ullrich and Eder got the report out. "We need to get started separating these two bodies of water as soon as possible," Schuette said in a statement. "The Great Lakes Commission accomplished in months what the Army Corps hasn't been able to do in years." Senators and congresspersons used the report to pressure the Corps into tabling GLMRIS faster. Media coverage was extensive, and mostly favorable. "Given the threat posed by the carp and other invasives," wrote opinion editors at the *Milwaukee Journal Sentinel*, "blocking the canal is cheaper and far more beneficial than dealing with the damage that could result." Environmental groups threw their full-throated support behind *Restoring the Natural Divide*, calling it "unprecedented in its scope and ambition."

"There was a lot of bipartisan political support," according to Molly Flanagan, policy head of the environmental nonprofit Alliance for the Great Lakes. "But there was also immediate pushback." Back in his 27th floor office, I ask Ullrich about that pushback. He paused. "The reaction," he said, "has been pretty negative from the transportation and industrial community."

• • •

It was never much to look at. A narrow stream that shuffled more than it ran, the Chicago River was barely able to fulfill its hydrologic task of draining the surrounding woodlands and prairies. Spring floods replenished it with life, clear waters running turbid with clay and detritus. Yet beyond these annual freshets, early river watchers would be challenged to tell if the water was moving. Its

banks and mouth were choked with soil supporting an array of trees and plants like black spruce and tussock sedges, well adapted to cold Midwest winters. The habitat supported diverse communities of fish, amphibians, shellfish and mammals like woodchucks, wolves, elk and black bears. It's an important ecological transition zone between the eastern forests and western tallgrass prairie, an ecotone thriving on the shores of an otherwise uninspiring brook.

Much of what made the river remarkable had nothing to do with *what* it was so much as *where* it is: at the intersection of two drainage basins. Beginning in the Great Lakes watershed, the Chicago oozed a mere six miles west before meeting an entirely new water system. The ridge of dry land between this and the Mississippi River basin is so minimal (no taller than a yardstick) that the divide is practically invisible. "You will search in vain on a topographic map for a contour line," wrote historian Libby Hill in her 2000 book *The Chicago River*. In dry seasons, boaters traveling west would historically need to lift their boats from the river, dragging them around or through a leech-infested bog at its western tip called Mud Lake to reach the Des Plaines River. Beyond that lies the Illinois; beyond that the Mississippi.

Regardless of wind or topographic features, much like at Eagle Marsh, the watershed divide was shortest here, making the river and the city that grew overnight around it a crucial transportation hub. Construction began on a passageway linking Lake Michigan with the Mississippi before Chicago even received its civic charter in 1837. Eight million and change was secured to build the 100-mile long Illinois & Michigan Canal completed in 1848. More than 250 cubic feet of water was pumped every second from Lake Michigan to keep it flowing.

The Illinois & Michigan Canal, though soon obsolete due to competition from railways, changed Illinois forever. Towns on the route like Lockport, Joliet and Ottawa grew fat, buoyed by money generated from shipping grain and lumber. Chicago was never the same. A town of 5,000 people in 1837 ballooned to a prosperous city

of 30,000 by mid-century, and by 1900 its population had reached 1.7 million. Nor would the river ever support the biodiversity it once did: the prairie was plowed, the spruce trees cut and the wetlands, so valuable for absorbing floodwater, were drained. "Neither the Des Plaines nor the Chicago was ecologically equipped for this amount of stress," Hill wrote. A raindrop falling on the city that once took its time percolating through the soil, she noted, now dashed off sidewalks, rooftops and paved streets so quickly that it "inundated the built-up landscape."

On August 2, 1885, 6.2 inches of rain fell on Chicago in 19 hours, four times the volume needed today to send untreated sewage into the lake. The Des Plaines spilled its shallow banks and released a torrent of water cascading into the South Branch. The resulting wave rolled up and into Lake Michigan. The deluge was dramatic. Locals reported hailstones like hickory nuts that knocked out telegraph wires. Basements flooded. Inexplicably, death rates from cholera and typhoid didn't rise.

Yet for much of the late nineteenth century, the Chicago River was a literal cesspool. "Effluent from the stockyards bubbled downriver to mix with industrial pollution, untreated human waste and whatever the crews of the ships choking the river might throw overboard," noted a local merchant. Sewers arrived in the mid-1850s when typhoid alone killed 50 people per 100,000 and had for decades. Far from spiriting wastewater away from urban populations, sewers made Chicago's health crisis worse by ferrying contaminated waste directly where the city drew its drinking water. Intake pipes were pushed further into Lake Michigan, yet the pollution always caught up.

The flood of 1885 was simply the final straw. A vocal citizen's association yowled at city officials for a permanent solution to the never-ending fear that every drink of Chicago's water could be a citizen's last.

In response, Chicago created a Drainage and Water Supply Commission to draft plans for protecting its water by finding

a way to dispose of its untreated sewage somewhere other than Lake Michigan. "Bold in sheer magnitude," as Hill described it, the commission recommended reversing the Chicago River and digging a new channel to connect it with the Des Plaines River near Joliet, a move that would ferry Chicagoans' waste downriver and out of sight, effectively making it someone else's problem. Soon shipping interests throughout the Midwest and along the Mississippi saw an opportunity to turn the sanitary channel into a Great-Lakes-to-the-Gulf waterway, transforming the project into the Chicago Sanitary *and* Ship Canal.

Shovel Day was announced for September 3, 1892. City dignitaries arrived in formal regalia with silver-handled spades for an event written up in the *Chicago Tribune* as akin to pounding in the Golden Spike that completed the transcontinental railway. The comparison matched the rhetoric. "This mighty channel," proclaimed Frank Wenter, director of the Drainage and Water Supply Commission's board, "will rank with the most stupendous works of modern times." Others likened it to an act of the Old Testament God. And the rhetoric matched the project. Running 28 miles from Robey Street to Lockport, the $31.1 million channel (some $861 million today) ran 24 feet deep, 160 feet wide and dropped 5.7 feet. Almost 30 million cubic yards of rock were unearthed, making the cssc the largest public works excavation then ever completed. Bigger scale created bigger problems that relied on engineering creativity and the ingenuity to invent techniques and machinery for rock-blasting and earthmoving that didn't yet exist. This Chicago School of Earth Moving later helped construct the Panama Canal.

St. Louis, Chicago's new downstream neighbor, knew they would lose out with the channel's construction. In April 1899, St. Louis petitioned the U.S. Supreme Court to prevent Chicago from dumping sewage into the channel. Fearful the nation's highest court would rule against them, Chicago officials moved in the bitterly cold predawn of January 2, 1900, to make any decision by

the Supreme Court moot: they would open the spigot. City big-wigs and newspaper reporters, tipped off at midnight on the first day of a new millennium, gathered unannounced with shovels, mechanical diggers and dynamite to blast through the final eight feet of frozen earth separating the Mississippi from the Great Lakes. Crowds gathered and built fires in abandoned oil drums to watch the spectacle, all wondering if a court injunction would arrive. Finally, the mechanical arm of a digger "dropped behind the ice gorge," wrote the *Chicago Tribune*, "and then with resist-less motion swept the whole of it into the Mississippi Valley. 'It is open! It is open!' went up from scores of throats as the water at last, after two hours of constant endeavor, had been made to start down the toboggan slide into the canal." The water in the Chicago River once again "resembled liquid."

St. Louis's injunction was finally dispatched by January 17, long after the Chicago Sanitary and Ship Canal was formally open. Through 8,000 pages of testimony in the subsequent law-suit, lawyers from Missouri and Illinois fought over how complicit the river reversal was in poor water quality found below Joliet. Justice Oliver Wendell Holmes Jr. delivered a majority opinion in Chicago's favor.

These days, the aquatic challenge for Chicago isn't how much water flows in from Lake Michigan; since 1972, when the city's Tunnel and Reservoir Plan (TARP) got underway, the real struggle has swung back to how wastewater moves *out* of Chicago.

• • •

I was handing over my driver's license to security when Richard Lanyon greeted me in the lobby of the Metropolitan Water Reclamation District headquarters. A quiet man with salt-and-pepper hair and beard, the veteran engineer spent 48 years with MWRD before leading it from 2006 to 2010. He retired in 2011. Dressed in a white shirt and pleated beige pants, Lanyon led me

upstairs into a drab gray cubicle he occupies when back at the office. He opened an aging laptop and loaded a slideshow detailing Chicago's struggles with managing wastewater. This complicates any debate about hydrologic separation, he tells me.

Forty million people in 32 states across 772 cities continue relying on combined sewer overflows, commonly known by their acronym cso. When the sewers can't handle the rain and sewage pouring into the system that would normally be ferried to a wastewater treatment plant, csos kick in and dump whatever the pipes contain into lakes, rivers and streams like Bubbly Creek. Urban sprawl has exacerbated the deficiency of this system. As Chicago paved a growing area with impermeable concrete, rainwater that would have percolated into the ground was forced into sewers. There, it mingled with waste from a budding population, stressing the sewage shipping capacity of Chicago's pipes. When storms grew especially thunderous, the Chicago River even reverted to its pre-industrial flow and poured into Lake Michigan.

By the late 1960s, cso events were routine in Chicago. Some pipes overflowed 100 days a year. After the city formed a flood-control committee to investigate possible solutions, the Tunnel and Reservoir Plan was selected as the most cost effective and least disruptive option. TARP, also known as "Deep Tunnel," was designed to protect Chicago's drinking water supply while improving flood control.

With construction beginning in 1975, planners expected the work to be completed within a decade, a timeline that's been extended sixfold. Over $3.6 billion has been spent on TARP, making it one of America's largest, lengthiest and most expensive public works projects ever. Untreated sewage flowing through csos destined for Lake Michigan is now captured by dropshafts plunging 300 feet into glacial till beneath the city. From there, up to 2.3 million gallons of wastewater pool in 109 miles of tunnels flowing towards one of three reservoirs in Cook County. The McCook, Majewski and Thornton reservoirs will eventually store 18 billion

gallons of untreated waste; subterranean pumps will gradually push stored sewage to wastewater plants for processing.

The Majewski Reservoir came online in 1998; TARP's tunnels weren't open until 2006. Cook County residents across a 352-square-mile service area can expect Deep Tunnel work to conclude by 2029. It's been a multigenerational project. Afterall, the logistics of excavating 20.5 billion gallons of wastewater storage in a heavily populated area are intricate.

Yet TARP is already proving its worth in protecting 3.75 million Chicagoans (and their basements) from flooding. The Water Reclamation District estimates that $150 million in annual flood damages have already been eliminated thanks to TARP. "We went from a hundred outflows from CSOs a year to 20 outflows a year with Deep Tunnel and no reservoirs in place," Lanyon says. "With reservoirs functioning we'll reduce outflows each year to four."

• • •

It's here, in a cramped, ground-floor space across the street from MWRD's offices, that Chicago's entire network of tunnels and locks are managed.

The control room is staffed 24/7, a hive of screens and lustrous colors, each indicating some component of the complex apparatus that is Chicago's wastewater system. From the brightly lit screens surrounding the otherwise dark walls, staff govern the whens, ifs and hows of wastewater movement. In a city bewitched by rainfall and the fear of flooding, it's unsurprising that the largest screens in the control room are occupied by weather monitors.

Lanyon and I stood in silence, our attention locked on a screen hanging above the center console. Superimposed on a map of the Chicagoland area sat a shifting satellite image. It displayed a green blob, indicating a roving cloud with indistinct borders. At the center was a yellow-orange concentration of heavy rain. "Uh-oh," I said, pointing to the blob. A man working the control

panel looked at us. "You guys heading out in that?" "We're heading down to the lock," Lanyon replied. "Get moving and you could miss it," the control man muttered. "But I'd get going."

In an underground parking garage, Lanyon and I squeezed into his compact Honda and set off. Seagulls moved cautiously in the dark sky above the traffic-choked streets, balancing their weight against the furious wind. I asked Lanyon what he thought of hydrologic separation. He paused. "Well, while it's not irresponsible of these organizations to suggest physically separating the basins, it is impractical." The manufactured hydrology of Chicago makes it difficult to shutter the existing locks since that would eliminate Lake Michigan as a Hail Mary outlet for the city's floodwater. The logistics of watershed separation along the Chicago lakefront as outlined in *Restoring the Natural Divide* from the Great Lakes Commission and the Great Lakes–St. Lawrence Cities Initiative, he told me, are far more complex than either David Ullrich or Tim Eder likely realized.

Because of how complicated human interventions have made the Chicago River's hydrology, restoring said natural divide to halt Asian carp and other nuisance species could have far-reaching ecological ramifications. A 2015 report by the Army Corps and U.S. Geological Survey found mid-system and lakefront separation schemes, two of *Restoring the Natural Divide*'s more palatable solutions, resulted in "unacceptable" changes in dissolved oxygen content throughout the CAWS, causing Chicago to violate water quality standards set out by the Illinois EPA. Because of barriers erected to keep Asian carp from progressing through the waterway, pumping stations that traditionally sent the city's treated sewage south through the Sanitary and Ship Canal would be forced to dump their waste into Lake Michigan instead. Thus, the Corps and USGS revealed that "huge loads of pollutants going to Lake Michigan" — nitrogen, phosphorus and fecal coliform bacteria — could be anywhere up to 150 million kilograms higher if mid-system separation occurred as mapped out by the Cities

Initiative and Great Lakes Commission. That's in dry years. In wet years, those nutrients offloaded into the Great Lakes could reach 290 million kilograms or more. "Such loads, year-after-year," the report states, "will have substantial cumulative undesirable effects on Lake Michigan."

Lanyon outlined a short list of questions the MWRD must reckon with before physical separation could occur. How would it fit within existing Supreme Court decrees regarding water diversions? How would proponents ensure stretches of river denied fresh water don't stagnate? How does *Restoring the Natural Divide* ensure necessary flood protection from large and routine storms? "Contingencies would have to be built in," Lanyon said. Later I asked James Duncker from the Geological Survey how watershed separation could impact Deep Tunnel's flood protection plans. "You're changing the plumbing in a major way," he answered, adding that "locally intense rainstorms are still going to overwhelm portions of the sewer." It's a huge and hugely complicated system that patrons of hydrologic separation are trying not just to understand but modify and manage long-term. "Lanyon is correct in that most people, even a lot of people quite involved in the discussion," Duncker said, "don't understand the complexity of the hydraulics."

Lanyon hadn't even mentioned the dog's breakfast of stakeholders complicit in something so staggeringly big. Ullrich and Eder aren't blind to this. Asked by *Associated Press* reporter John Flesher during the report's release who has ultimate jurisdiction over the CAWS, Ullrich responded that it was a "combination of authorities" with no single vote able to get shovels in the ground. Illinois is probably the most critical player, Ullrich said, then the Army Corps of Engineers. And the City of Chicago. And the MWRD. He wasn't finished. "Because such a large area is implicated," Ullrich said, including states in the Mississippi basin, "we will need broad public consensus and bipartisan political support." None of which addresses a crucial question: "Who picks up the check?" Lanyon

asked as we neared the lock. Some say Congress or public-private partnerships, but, truth be told, he quipped, "no one really knows."

. . .

The Madison Room at Chicago's Citigroup Center. Two dozen people crowded around a large conference table. Beside them, glass walls looked out over a metal and glass rotunda; behind them, another 30 people sat on tightly packed chairs. Others stood on the periphery, leaning against the walls. Most wore suits and ties. Game one of the Stanley Cup Finals was happening that night; the room, abuzz with Blackhawks fans, was keen to conclude before puck drop.

This was the Chicago Area Waterway System Advisory Committee, an ad hoc cluster of city agencies, government entities, private industry and environmental groups who met monthly to find some kind of consensus on handling Asian carp. John Goss, then America's Asian carp director, had invited me to attend one of these meetings. No one in government would make any carp control decision without the tacit approval of most organizations represented in this room. "It's a tall order this group has taken on," Goss said, yet "it's exciting to see if they can find common ground and make recommendations to Congress and the Corps."

Hydrologic separation was an early discussion topic, but by the time I sat in (I was told I was not allowed to record or attribute what I heard to individuals or groups), the committee was debating non-structural options like heating canal water to 109–120°F to deter Asian carp.

It was a tense meeting. Low-level, chronic tension, the slow burning kind. Many participants I spoke with told me that disagreements were always civil, but ubiquitous. "I don't think there's anybody sitting at the CAWS Advisory Committee that doesn't want to do something to make sure this fish doesn't get to the

lake," one member said outside the meeting. "It's just a question of where you are in terms of the balance you're willing to strike between the environment and the economy." People feel deeply about the Great Lakes, emotional connections infusing debate between groups that everyone knows, deep down, cannot agree. "It hasn't always been fun on this committee," confessed another member. Yet few could think of a better way to gauge the stances of key players other than locking them in a room together and seeing what shook out.

While everyone's voice was equal in the CAWS forum, in an *Animal Farm*–esque way, some voices were more equal than others. One of those came from Lynn Muench, a senior vice president with American Waterways Operators (AWO), an industry group representing the nation's towboats, tugs and barges. It was no secret Muench opposed hydrologic separation. She had already given Congress and the Army Corps an earful, claiming the CAWS must remain open to maintain thousands of direct and indirect jobs supported by river navigation. Muench didn't mince words when we spoke after the committee. "I think anybody who is dealing with logic and facts would tell you that it's a ridiculous idea," she said of watershed separation. Without the ability to divert excess water into Lake Michigan during heavy rains, "it would flood people in the Chicago region and northwestern Indiana. It would kill jobs. It would increase traffic and air pollution and [road] fatalities. It would do all these bad things and [environmental groups] want us to work with them on that? We can't work with them on that."

After Michigan filed its suit to close the Chicago Lock, Muench launched Unlock Our Jobs, a coalition of towing companies, shipyards and marinas, to lobby against hydrologic separation. "We want to protect the environment and don't want Asian carp in the Great Lakes either," Muench said, "but our economic base needs to be protected." Once GLMRIS had lent the Corps's credibility to the idea of physical separation, Muench distributed a letter to AWO members

urging resistance. "The overwhelming majority of the comments that have been submitted so far [about GLMRIS] are strongly in favor of physical separation," the letter stated. "**It is important that the Corps receives as many comments as possible explaining why physical separation is the wrong choice for our industry, the economy and the environment.**"

Yet arguing over physical separation ignores an inconvenient truth for America's shipping sector: tonnage passing through the Chicago Area Waterway System is in long-term decline. Forgetting a minor upswing preceding the 2008 economic meltdown, the waterway's shipping significance has been eclipsed by rail and truck. From 24.5 million tons in 1994, the CAWS handled just 13.3 million tons in 2009, according to the Army Corps, with the Port of Chicago in particular seeing its processed volume drop from 22.7 million tons in 2008 to 15.4 million in 2013. Coal was once "a mainstay" on the Sanitary and Ship Canal, and the industry's decline nationwide has hastened the river's downfall as a prime mover of goods. Coal shipping will continue to decline in the coming years, according to the Natural Resources Defense Council's Meleah Geertsma. "We're not necessarily sure what's taking its place," she says.

Coal isn't the only bulk commodity in decline. The drop in tonnage is reflected across most materials shipped through the CAWS: coal, petroleum, aggregates, grain, iron and steel, chemicals. "The city's traditional barge-using industrial base is changing," noted a report from the City of Chicago on the waterway's industrial uses. As is the city's entire economic base, away from sectors once dependent on the river system to high-value professional and business services.

As part of its unsuccessful legal suit against Illinois, Michigan hired John Taylor to examine cargo movement in the CAWS. Taylor, an expert in transportation policy and supply chain management at the Mike Ilitch School of Business at Wayne State University, specifically investigated what impact closing the aquatic pathways

between the canal and the Great Lakes would have on shipping. The stakes were high. In a filing included as part of Michigan's Supreme Court suit, Illinois claimed that "even a temporary closure of the locks will devastate the local economy and Illinois's role in the regional, national and global economies, endanger public safety and cause serious environmental harm."

Taylor's analysis assumed the closure of the Chicago and O'Brien locks. While navigation would be affected and jobs lost, he found, the negative impacts associated with hydrologic separation were "greatly overstated." Just seven million of more than one billion tons of cargo moving through Chicago would be negatively affected by watershed separation, Taylor argued — less than 1 percent. This would add 1,000 daily truck trips (of more than 40,000 already chugging along the I-80/I-94 south of Chicago) or the equivalent of two added freight trains in a city where 500 pass through daily. Transportation costs from transferring cargo from barges to rail or trucks would cost $69 million annually, well below the $190 million in fees from closing the O'Brien Lock that the Corps had suggested.

Others were less sanguine. In April 2010, Joseph P. Schwieterman from the School of Public Service at DePaul University argued that spending by commercial shippers and consumers to offset costs from closing the locks would top $1.3 billion annually, rising to $4.7 billion over two decades. The costs stemmed from added transportation expenses, losses for recreation and tour boats, private property impingements and weakened flood protection.

What does it all mean? Not that studies are meaningless, but perhaps the CAWS is one of America's most economically, politically and socially complex waterways. Moreover, humans can look at the same data and draw strikingly different conclusions. Data is malleable; and perhaps, it was suggested to me, people are too. "There was an increase in political opposition [to hydrologic separation] from groups that not only are very active in lobbying

in D.C. but give political donations to candidates," says Alliance for the Great Lakes' Molly Flanagan. "I think that's played a big role" in scuttling separation plans. Of the 16 Republican congresspersons who wrote President Donald Trump in February 2017 requesting the Army Corps keep its latest Asian carp report secret, nine received campaign donations from American Waterways Operators during the 2016 election totaling almost $17,000. Seven of those nine congresspersons come from Illinois, Indiana and Louisiana where debate over the waterway is fiercest.

Perhaps no one's hands are clean. Public dread over Asian carp has been a huge motivator for environmental groups, according to Lynn Muench. "You show jumping fish, and it's a good way to raise money. It makes great video — the sky is falling!" But the CAWS Advisory Committee would be more effective, she felt, "if everybody sitting around the table dealt with facts and not hysteria and emotion." Muench too dabbles in conspiracies, linking Michigan's efforts to destabilize the region over Asian carp with residual anger over water diversion into the sanitary canal more than a century ago. "The drivers of the separation discussion, the Great Lakes Commission, they're based in Michigan," she said.

These arguments played out in the Madison Room: *Spending billions on something that may benefit the Great Lakes is silly because we don't know how effective separation will be. Risk reduction is a good enough reason to build barriers in the CAWS. We've relied on conjecture and opinions for a long time regarding Asian carp. Can we agree the basic premise of aquatic nuisance species control has benefits beyond Chicago? Does Louisiana care whether we stop Asian carp in Illinois?* Issues of national security were raised; *terrorist* was uttered. Someone from Michigan choked up while describing to me Asian carp's devastating potential in Lake Michigan. I looked away as her eyes filled with tears.

• • •

January 2014. Winter in Cleveland and the Army Corps's emotionally charged town hall on the much-anticipated Great Lakes and Mississippi River Interbasin Study (GLMRIS). Two years after the Great Lakes–St. Lawrence Cities Initiative released their report on severing the aquatic link between the Chicago River and Lake Michigan, the Army Corps was ready to discuss their own much-ballyhooed plan for halting bigheaded carp. Shortly before the festivities began, I cornered Dave Wethington. The chemical engineer from the University of Iowa had bounced between Chicago and D.C. within the Corps for a decade before we grabbed chairs near the back of Cleveland Library's auditorium. Lean and in his late thirties, Wethington's shaved head and broad smile had become the face of the Corps' efforts to halt Asian carp since being appointed project lead in January 2008.

The Army Corps was pilloried that night for their perceived failure to tell anxious politicians how to stop Asian carp's seemingly unstoppable spread. Yet keeping recommendations to themselves wasn't always the Corps' plan. With their project timeline shortened by Congress, the idea of making a recommendation, as many suspected, was abandoned. Instead, assistant secretary of the Army for Civil Works Jo-Ellen Darcy told reporters in May 2012 that the scaled-down GLMRIS would *start discussions* among policy makers. "The ultimate decision will be made by the Congress," she said.

The final report identified 16 aquatic invasives that were expected to move between the basins, the overwhelming majority (13) of which were poised to spread into the Mississippi. From viral hemorrhagic septicemia and fishhook waterflea to the tubenose goby, silver and bighead carp were put into a broader biological context. Eight control alternatives were studied for preventing the two-way spread of invasives. From low-key options like chemical controls paired with greater outreach and boat washing, the Corps gradually unfurled bigger and costlier schemes.

But the much-talked-about control option was Alternative 5 — Lakefront Hydrologic Separation. To be fully effective,

physical barriers would be needed at Wilmette, Chicago, Calumet City and Hammond, Indiana. Three treatment plants would be built throughout Chicagoland because of waters made stagnant by the changes. Significant portions of Cook County would flood because the control barriers needed for Alternative 5 would eliminate Lake Michigan as an outlet for storm water. Yet far from deterring them, the Corps proposed constructing two reservoirs and numerous mitigation tunnels. Commercial and recreational navigation would be affected; ecosystems and water quality in the CAWS would be degraded. The Corps would need 25 years to finish hydrologic separation as they envisioned it — and $18.3 billion, time and cost estimates that some researchers believed were markedly low.

The sums Dave Wethington and I discussed so casually were staggering. This may be the world the Corps inhabits, but the $18.3 billion needed for hydrologic separation was too much for many Cleveland attendees to wrap their heads around. Mine included. The quarter-century timeline left me feeling that while the Corps believed separation was technically feasible, it was too politically noxious to ever be approved. "Twenty-five years is a long time," Wethington said, especially when herbicides, electric fences and other non-structural options were performing well enough. "Shouldn't the Corps have just told Congress what to do?" I asked. He brushed the notion aside. The Great Lakes and Mississippi River Interbasin Study was about collecting information from any cottager, barge captain or congressperson with thoughts on stopping the fish and about presenting control options to the public and Congress, he said; it was never about pushing plans cooked up by unelected engineers on the American people. "We did a general assessment. It's largely unknown what a lot of these species may do."

Through the haze of bureaucratese, for a moment, I thought Wethington sounded relieved. Just over a year after we spoke in Cleaveland, Wethington left for Washington to liase between Congress and the Corps.

• • •

Opposition has predictably stunted any progress on watershed separation as a deterrence for Asian carp and other aquatic invasives. "The situation is radically different now than it was when we had good momentum" in 2012, says Alliance for the Great Lakes' Molly Flanagan. "We have not been vocally advocating for hydrologic separation recently because there's been more and more political pushback."

It was always a steep path that separation had to climb. Despite the high-profile support it enjoyed from the environmental community and bipartisan politicians, finding the will and funding to restore the natural divide and hive off the Mississippi watershed from the Great Lakes, all to stop a nonindigenous fish, would have required a herculean act of societal cohesion. Unsurprising, then, that those who questioned the feverish decisions made after the eDNA discovery found their voices amplified as time passed. In just five years since its much-trumpeted unveiling, hydrologic separation has become the stuff of eye-rolling legend, like plans to pipe Arctic glacier water to Las Vegas or urban myths like hyperloop. Returning the river to some modern approximation of a pre-human-intervention Eden was (and remains) a longshot.

The Natural Resources Defense Council has also wound down much of their physical separation advocacy. From a technical standpoint, Meleah Geertsma tells me, the NRDC still believes this option remains the most effective way of halting the two-way spread of aquatic invasives. Politics, however, are another matter. There are "major hurdles" to getting every level of government on board. "I think psychologically it's extraordinarily hard for any decision-maker to make that kind of commitment," she says, given what a consensus-building black hole the idea has become. "We spent many, many years trying to get decision-makers to buy into hydrologic separation, and those years were not successful. We've been told that in many conversations even the word 'separation'

makes people shut down. In our minds, it doesn't make sense to continue banging our heads against a wall."

Considering that the leading edge of the invasion hasn't significantly advanced in recent years, skeptics have all the information needed to convince politicians that a wait-and-see approach is prudent. This way no one accepts responsibility for deciding a future for Chicago that alienates industry and worsens air pollution. Or, quite possibly, a future that spends billions of dollars to recalibrate a major urban area's water system and yet still fails to protect the Great Lakes should a faith in watershed separation be misplaced. While closing the hydrologic connection between the basins may seem the smartest thing to do, says Southern Illinois University biologist Jim Garvey, the reality is that watersheds are porous. "Spending billions to reverse the Chicago River system — it's a good idea, but is that really going to shut off the Mississippi River watershed from the Great Lakes? Probably not."

The result is stalemate.

The Great Lakes environmental community has had to rethink a strategy they've employed for almost a decade. "We've pivoted to focus on more of what we think we can get done here in the near-term," Flanagan says. These days solutions to the carp crisis have taken on a decidedly small-ball feel. In place of hydrologic separation with its sky-high price tag and large-scale hydraulic alterations, Geertsma tells me the shift to cost-effective and deployable controls is a combination of "realism and pragmatism." Many possibilities under investigation include the numerous approaches we have looked at in this book: pheromones, acoustic barriers and accelerated water velocity, carbon dioxide screens, commercial harvest in the Illinois River. And one more, as outlined in GLMRIS: a control lock designed to flush contaminated water back into the CAWS before it can reach Lake Michigan.

"We are much more engaged in the discussion of technology, like treatment locks that could continue to allow barge traffic to move through but have a very high rate of control for aquatic

invasive species," Geertsma says. Without the sticker shock of hydrologic separation, it may prove easier to convince risk-wary politicians to greenlight small-scale plans. It's an approach her one-time critics have gotten behind. We want Illinois to continue paying commercial fishers, American Waterways Operators' Lynn Muench tells me, while making sure researchers investigating non-structural options have money to do so. "Those are the sorts of things we want funded because they're very cost effective — and they're working."

• • •

A razor-wire-topped fence slowly creaked back, revealing a near-empty parking lot beside the Chicago Lock. Past the lights and sounds from nearby Navy Pier wafting over the lakeshore, former Metropolitan Water Reclamation District head Richard Lanyon and I tried valiantly to outrun the rain. In parts, the sky was black as an eclipse, moving ruinously fast across the lake; to the west, the sun was breaking through.

Up the stairs of a squat gray office built like a shipping container, we met Lock Master Bob Ojala. With flowing white hair and a trim beard, Ojala looked like Bob Seger in a crimson golf shirt festooned with the Army Corps logo. He has been with the Corps for six years. Before that, he said somewhat cryptically, his life as a marine architecture consultant had taken him "everywhere."

Ojala escorted Lanyon and me to a new control tower perched at the tip of the jetty, offering a 360-degree view of the lock and a million-dollar view of Chicago. Shaped like a warship and completed by the Army Corps in 2007, the new command center allows a single employee to operate the lock from one computer. Filling the lock takes three minutes, depending on water levels that can differ up to four feet. Chambers open and close 16,000 times each year, an average of 44 times each day. Once water levels are even, the doors inch open, letting commercial, tour and

recreational boats into the calm of the canal or the choppy unpredictability of the open lake.

This lock is too important to the city to seal it forever, Ojala explained as we mounted steps to the lookout. What would happen if there was a fire at Navy Pier? Police and fire crews relied on the lock in emergencies and shutting this down would take fire and police boats out of commission. Relocating them lake-side wouldn't be easy. Since Daniel H. Burnham's 1909 plan for the city, Chicago has prioritized parks that connect people with the water. Are residents willing to give up lakefront greenspace and pay more in taxes to accommodate the infrastructural changes necessary to make hydrologic separation a reality? All for a *fish*? Ojala doubted it. And despite a host of reasons why restoring Chicago's natural divide may be a good idea, perhaps the best idea for keeping Asian carp and hundreds other invasive species from slipping between the Great Lakes and Mississippi River watersheds, as I looked out across the city sheathed in rain and the tour boats scurrying back to shore, I doubted it too.

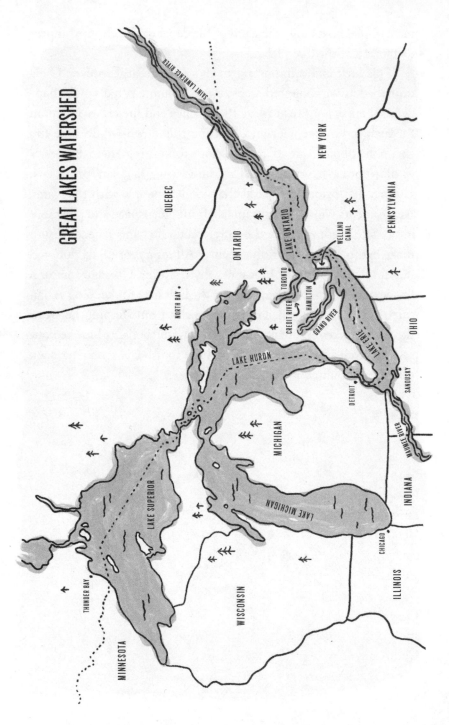

GREAT LAKES WATERSHED

CHAPTER 11

At Home in the Great Lakes

HAMILTON, ONTARIO — Exit the highway at the last possible moment before the Burlington Skyway sweeps you up and over Hamilton Harbour. Practically beneath the bridge, beyond boxy postwar homes with plastic siding, stands the Canada Centre for Inland Waters. Built in an imposing, Stalinist-style concrete brutalism that would make Le Corbusier blush, the squat, eight-story research and administrative office run by the Department of Fisheries and Oceans Canada (DFO) has become the epicenter for Canadian research into Asian carp in North America.

Flocks of late-leaving Canada geese filled up on grass that rimmed the sprawling parking lot on the mid-November day I arrived. Transport trucks hummed on the bridge. Behind the Centre lay the steel mills that birthed modern Hamilton, their smokestacks spewing cloud-white plumes that contrasted sharply with the oily harbor below.

Becky Cudmore is the senior science advisor with Fisheries and Oceans, managing the Canadian government's growing efforts to study and prevent Asian carp's introduction to the Great Lakes. Cudmore, more than any researcher in the country, has become the face of Canada's efforts to halt Asian carp. It's a title she's accepted, albeit reluctantly. Cudmore and former colleague Nicholas Mandrak

from the University of Toronto had recently been guests on the public affairs program *The Agenda* talking carp in Canada; I asked her about the appearance, but she hadn't seen it. "I watched the first five minutes," she said, settling in behind the desk in her second-floor office. "I'm too critical of myself. Like, 'What am I doing with my eyes there?'"

The Great Lakes are in her blood. Cudmore cut her environmental teeth on Lake Huron, where she grew up in a small community called Point Clark, halfway between Sarnia's chemical plants and Tobermory's ancient flowerpots. As a child, she inspected bugs and water samples under a microscope; she absorbed books about pond life; she measured days by the sounds and colors and movement of the steely water outside her door. A treasured science class in eighth grade cemented her purpose, pointing the future biologist to Trent University in central Ontario, where she focused on plankton communities and invasion ecology. Despite studiously avoiding fish research — "Everyone did fish research," she told me, "and fish are boring" — she accepted a fish-focused master's position at the University of Toronto. Her supervisor needed someone to analyze reams of historic data on fish populations in the basin going back two centuries. The project, funded in part by the Great Lakes Fisheries Commission, put Cudmore in constant collaboration with American fisheries researchers. For the Asian carp campaign she waged later in her career, this experience proved invaluable.

Cudmore landed at the Canada Centre for Inland Waters at an opportune time. Zebra mussels, round goby and Eurasian ruffe were making national headlines, projecting the threat from invasive species into living rooms throughout the country. With cash awarded by Ottawa in 2003 to investigate aquatic invasive species in the Great Lakes, Cudmore joined Mandrak, then her boss at DFO, to collaborate on a national risk assessment of Asian carp in Canada. They completed the project in 2004 when the threat posed by Asian carp to the Great Lakes was known to few outside academia and natural resource departments.

The assessment highlighted the tremendous risk each Asian carp species posed to aquatic biodiversity while hinting at the urgent need for Canada to support American agencies already mobilized to halt the carp. Looking back, the early 2000s "was the perfect time to think about how we implemented invasive species management," Cudmore said. Public enthusiasm, money and government interest had finally converged for the first time since the 1960s.

After Mandrak left public service for academia, Cudmore gradually assumed greater control of the department's Asian carp activities. She shifted from fieldwork into management, representing Canada at binational meetings like the Asian Carp Regional Coordinating Committee, where she rubbed shoulders with John Goss, Kevin Irons and a dozen other researchers whose work is chronicled in these pages. She's also gone south to take part in assorted field exercises where she can get her hip waders dirty. These forays into the close-knit and congested world of America's Asian carp experts gave Cudmore (and, by extension, Canadian interests) a seat at a table she may otherwise have been excluded from. But she wasn't a fame-blinded ladder climber — or too squeamish to dissect a fish. Sure, she was in management, but Cudmore knew the carp's biology from years of lab and field work. She could talk to the public in language that conveyed the gravity of Asian carp's risk without slipping into indecipherable jargon, but she *knew* the jargon if needed when talking to fellow biologists or bureaucrats. All this afforded Cudmore a unique authority to be listened to on an issue so clogged with voices that being heard over the din was, in itself, victorious.

Now, Cudmore is running a multimillion-dollar program to protect a Great Lakes fishery worth an estimated $7 billion.

In 2016, she spent three weeks in Ottawa, Canada's capital, outlining to Prime Minister Justin Trudeau's government why the $17.5 million program she oversees needed stable funding. The money, first allocated by Trudeau's predecessor in 2012, was set to expire

in 2017. And while the centrist Trudeau said the right things about environmental protection, nothing had been promised. When I asked what she would do with more funding, Cudmore doesn't miss a beat. "More staff." Her department at the time consisted of just three full-time members and a carousel of casual workers, seasonal employees and a dozen graduate and college students who assisted with monitoring between semesters. Early detection of Asian carp, a cornerstone of Cudmore's plan to focus on prevention, often can't be prioritized with belts so tightly pulled. The department monitors more than two dozen sites in the Great Lakes where Asian carp will most likely be found. But without long-term funding commitments, Cudmore must triage those sites at greatest risk. Few locations get repeat visits in a single field season; some aren't monitored at all.

• • •

The Laurentian Great Lakes were once a biological storm. Aldo Leopold first used that expression to illustrate the flocks of passenger pigeons that once traversed the basin in 140-mile-long swarms containing an impossible 3.6 billion birds. But Leopold could just as easily have been describing the Great Lakes ecosystem as a whole. Such was the value of the birds, fish, mammals, forests, soil and water to First Nations within this productive range.

Much of what the region's first European explorers recorded in their diaries reflected the abundance of wildlife they found all around them. In 1615, French explorer Samuel de Champlain canoed Georgian Bay, a lobe of Lake Huron, and beheld lake trout the length of his paddle. Pike and sturgeon were a plentiful and valuable food source for local First Nations who deployed seine nets in winter to catch fish under the ice. The ingenuity of the nets impressed the French. Traveler Henri Joutel took note of the 1,200-foot-long nets used by the Chippewa at Michilimackinac, crafted with stone weights and cedar floats. René de Bréhant de

Galinee, the first European to overwinter at Lake Erie, witnessed Sault near Manitoulin Island deploy hoop nets from canoes deftly paddled in swift currents on the St. Marys River to catch whitefish thick as tree trunks and so plentiful that the river was unseeable. "The Indians could easily catch enough to feed 10,000 men," de Galinée wrote. Whitefish, yes, but also lake herring, gar and eels, all of which frequented First Nations' plates.

The resource bubble that sprang up around the Great Lakes with the introduction of settlers from the United States and Europe ballooned into the eighteenth century. Though signs of over-exploitation were evident as early as 1800, it was felt the good times would last forever. How could they not? Land appraisers in southern Ontario sold would-be settlers on the natural wealth of the region, highlighting how Indigenous people speared maskanongy, pike and pickerel by the barrel almost year-round. A 1798 edition of the *Gazette of York*, meanwhile, advertised a farm for sale near Yonge Street in present-day downtown Toronto as the perfect site for Atlantic salmon fishing. Farms were often paid off by the revenue generated from catching salmon. East of Toronto, Lynde Creek teemed with salmon that locals speared using pitchforks, balancing atop logs spanning the creek or corralled into flannel petticoats. Six thousand sturgeon, an ancient fish that can survive for one hundred years or more, were caught in a single day in Hamilton Harbour. Years later, guests of Upper Canada governor John Graves Simcoe noted that even their inexperienced fishing party could land five hundred fish, including "a sort of carp."

But the ecological baseline had shifted by 1800. European newcomers, recalling the dearth of fish and wildlife they left behind, still found the Great Lakes basin a place of enormous natural abundance. Not everyone saw it this way. Quinepenon, headman for the Mississauga people, remarked in 1806 that the Credit River fishery was fast becoming destitute. "Waters on this river are so filthy and disturbed by washing with soap and other dirt," he wrote, "that the fish refuse coming into the river as usual for which our families are

in great distress for want of food." Settlers who once found creeks and rivers brimming with fish witnessed waterways choked with sawdust, wood debris and discarded tree trunks. Sawmills sprang up on tributary rivers throughout the Great Lakes, following the crush of immigrants and their urgent need for timber to build the homes and growing cities along the shore. Their proliferation was as profound as their impact on fish communities throughout the Great Lakes. Richard Rorke, an Irish Quaker, wrote in 1834 that the Beaver River near Tecumseh, Ontario, had once provided an "almost inexhaustible magazine of . . . the finest and largest trout, until the milldam at the mouth of the river put an end to trout fishing in that stream forever." By 1850, New York State contained one sawmill for every 700 people; in Ontario that figure was closer to one sawmill for every 600 residents. In more heavily settled counties, that ratio was closer to one in 300. Land appraisers throughout the basin quietly dropped the Great Lakes' natural abundance as a selling point for newcomers.

Yet despite this "civilizing" trend and its harmful effects on native fauna, fish species, by virtue of their underwater isolation, weathered the storm better than their terrestrial counterparts. "Every settler . . . ought to bring out a seine net with him," implored land appraiser Tiger Dunlop in 1832, a recommendation that soon sealed the fishery's fate. Merchants near Lake St. Clair began drawing up sizable contracts for food fish. In the 1830s, a single seine net could catch a thousand whitefish. Successful brokers could fetch one dollar per barrel in Detroit for whitefish pulled from lakes Michigan or Huron, most of it destined for southern cities. But as greater numbers of merchants and land agents grasped the potential windfall to be had from shipping fish to bustling cities, fishing in the basin grew intense. By 1893, more than one thousand miles of gill nets were laid out in Lake Huron and Georgian Bay alone. Whitefish, lake trout and sturgeon needed those waters for breeding, and the impact of 152 registered boats and 15 tugs in Georgian Bay alone had, by 1890, drained the fishery. The advent of fabrics

like nylon to craft more efficient and resilient nets, coupled with new gill nets capable of sinking deeper into the water, only added to the plunder.

Fisheries sank like stones. Atlantic salmon were finished as a commercial species by 1898. Done in by sawmills and their systematic clogging of creeks and rivers, Atlantic salmon were never a dominant species in the lakes again. Sturgeon were all but extirpated by the 1880s; tons of the ancient fish were caught at mid-century as bycatch and left to rot, much like Asian carp are in Louisiana today. And despite holding on until the mid-twentieth century, lake trout died off as a commercial species by 1960, as did blue pike and sauger. Whitefish yields plunged from seven million pounds in 1940 to 368,000 pounds two decades later. Slowly, resource experts awoke to the near annihilation of one of the world's largest freshwater fisheries: 11 native fish were extinct, more than a dozen extirpated and countless others reduced to struggling populations around scattered tributaries.

What happens when you remove most of the dominant fauna "from the richest temperate freshwater landscape in the world in less than two centuries?" John Riley, a senior science advisor with the Nature Conservancy of Canada, tackles this question in *The Once and Future Great Lakes Country*, his weighty look at the basin's ecological history. What he found was a sobering tally of lost fauna. Those shell-shocked organisms that survived were forced to persevere on marginal scraps of land too rocky for agriculture and streams too polluted to sustain aquatic life. Europeans had taken millennia to reduce their wildlife to penury, Riley writes, a feat their descendants in eastern North American needed only a handful of generations to accomplish.

"What we have today," according to Riley, is "a freshwater ecosystem that is totally different and fundamentally vacant in comparison with when we took it over." Polyculture became monoculture in the forests; creeks and streams became infill lots for industrial waste; diverse meadows became pastureland for livestock.

As fisheries collapsed in the late nineteenth and twentieth centuries, no single culprit responsible for the Great Lakes' demise could be pointed to — there were simply too many to count.

•••

In many ways these enormous inland seas have no right to exist. Toronto author Robert Thomas Allen, commissioned to write a book in 1970 on the Great Lakes for the Illustrated Natural History of Canada series, noted that the Great Lakes are fed by no glacier or ice cap, nor are they supplied by a mountain headwater. They are holdings of ancient glacial meltwater, in place since the retreat of the last ice age. Many tributaries like the Don River or Etobicoke Creek near Allen's hometown are shallow, soupy and fatigued. Yet somehow the lakes remain a "sunny jungle of . . . life," he wrote, no small feat in a region possessed by some of the most overdeveloped land in North America. Even in their depleted modern state, the forests, wetlands, prairies, rivers, lakes and dunes of the Great Lakes are still home to more than 3,500 plants, mammals, reptiles, amphibians, fish and birds, hundreds of which rely on the Atlantic and Mississippi flyways bisecting the lakes.

The Great Lakes basin has long been an economic powerhouse. Forty million North Americans live within the watershed, so large at 224,105 square miles that, stretching from New York City to within 100 miles of Hudson Bay in the north, it's bigger than Texas and Tennessee combined. Air pollution control, climate and water regulation, soil retention, flood protection and waste treatment are just some of the natural functions captured under the nebulous banner of "ecosystem services." One report prepared for the Ontario Ministry of the Environment in 2010 argued that putting a dollar figure on tangible services like hunting or fishing or abstract propositions like the intrinsic value of the Great Lakes' very existence is grueling. "The total economic value

of ecosystem services is largely unknown," the report noted, "and is perhaps unknowable."

Still, others have been game to try and affix a price tag to the things nature does — well, *naturally*. The value of wetlands alone, according to Gail Krantzberg, former director of the International Joint Commission's Great Lakes Regional Office in Windsor, Ontario, cannot be separated from the value of biodiversity, she wrote in a 2006 report. Nor can the value be apportioned to specific provinces or states. For their role in everything from regulating water levels and climate to shoreline erosion prevention and providing habitat for fish, fowl, mammals and invertebrates, wetlands offer us $70 billion in services humans would otherwise have to pay for. This despite the Great Lakes region having lost more than 70 percent of the wetlands it once contained to agriculture and urban sprawl.

It's an unfathomably complex web of interconnections. The water we see from shore may end up in our kitchen faucet, cool our heavy machinery or spin the turbines that power our homes; or it may help grow the food we consume or transport our goods to foreign markets. It all adds up to roughly $350 billion in annual economic activity and trade between Canada and the United States. One way or another, the Great Lakes power half of all Canadian manufacturing and a quarter of its total agricultural output.

Yet we pay a hefty price for that economic performance. The Great Lakes are some of the most heavily utilized water bodies on Earth. Fifty million tons of oil, grain, coal, steel, iron and other cargo pass through annually, part of a global trade network expected to grow by six percent annually. Great Lake states and provinces have embraced international trade since 1829 when the Welland Canal linked lakes Ontario and Erie. The St. Lawrence River that connects the Great Lakes to the North Atlantic saw its first lock system constructed in 1847; a channel connecting lakes Superior and Huron followed in 1855. With the latter's completion, ships carrying foreign cargo — and, it so happens, foreign organisms — could now

pass from the Atlantic into the heart of North America. "It would be hard to design a better invasive species delivery system than the Great Lakes overseas freighter," wrote journalist Dan Egan in 2017's *The Death and Life of the Great Lakes*. This uninterrupted passage has subjected the Great Lakes and the Mississippi River basin, via the Chicago Sanitary and Ship Canal, to an onslaught of non-indigenous species. It continues to this day. Asian carp, if they ever become established in the Great Lakes, will join a raucous cast of other invaders, a murderers' row that includes sea lamprey, zebra and quagga mussels, plants like phragmites and a host of algae, fishes, plankton and invertebrates.

• • •

Studying how the Great Lakes were transformed by aquatic hitch-hikers is one of Anthony Ricciardi's specialties. The invasive species biologist at McGill University in Montreal is himself a comprehensive database of nonindigenous invaders that have overtaken the basin since 1840.

He grew up on the St. Lawrence River as a living outdoor laboratory. "I played with it as a kid," he told me at McGill's Faculty Club, "but now I'm doing the same thing I did as a kid, but more rigorously and getting paid for it." He's tied to this place. "I have a bond to it."

But things have been shifting dramatically for most of his adult life. "As long as I've been looking underwater," he said, "this whole river and the Great Lakes it's connected to has been an ecological battlefield. There is war going on there." A war for space, for food, for resources — and today's winners may be undone by tomorrow's invaders. In 2006, Ricciardi reported that at least 182 such invasives were known, 73 of which arrived after 1959. (That number has since gone up to 190 invasives.) Since then, one new invader has been identified in the Great Lakes every 28 weeks, the latest coming in August 2018 with the discovery of two previously undocumented

zooplankton species in Lake Erie, one from Central America and the other from Asia. Ricciardi has helped confirm that ballast water regulations from the late 1980s have failed to halt aquatic hitchhikers. In fact, things have gotten worse: 1.2 new species were found each year after 1993 compared to 1.0 species discovered annually between 1959 and 1988. His figures charting the rise of invasions in the Great Lakes resemble the foothills of a strikingly steep mountain. But it's all part of a troubling long-term trend. Invasion rates since 1840 for fishes and molluscs are one order of magnitude greater than prehistoric invasion rates dating back 11,000 years, Ricciardi noted.

And we don't know what the overwhelming majority of those introduced species are doing. They haven't been studied, Ricciardi told me. So the ecosystem level impacts — how these invasives alter the productivity of a waterbody and their effect on how contaminants and nutrients move through the system — "those impacts, which, arguably, may be the most important to us in terms of ecosystem services," he said, "they have hardly been studied for the vast majority of the 190 species in there." It's entirely possible that many of these non-natives will have negligible impacts on the Great Lakes as a basin. "But altogether, for the total 190, they do add up to something." We just don't know the sum of these additions.

In 2010, Nicholas Mandrak and Becky Cudmore teamed up again to calculate what effect the growing wave of introduced species was having on native Great Lakes fish. The results were shocking. Three of 169 native fish taxa are simply gone: the blue pike, deepwater cisco and the shortnose cisco. A further 18 fish have been extirpated from regions within their traditional range, while 82 species remain endangered in at least one part of the basin where they used to thrive. Invasives aren't the only pressure these native fishes face. Habitat alteration and loss imperil more fish than invasives, but it's the interplay of factors and their cumulative effects that drive species decline and biodiversity loss.

In his research, Ricciardi also hypothesizes that newcomers have altered the Great Lakes ecosystem to favor other invasives,

an apocalyptic scenario known as "invasion meltdown." Just look at *Cordylophora caspia*. This predatory Ponto-Caspian polyp has been found in Lake Michigan eating the larvae and growing in four-inch-thick colonies on the backs of another Ponto-Caspian invader — zebra mussels. Without zebra mussels, *Cordylophora caspia* would lack for food and stable habitat.

Synergies such as this are what keep Ricciardi up at night, especially the effort to predict harmful interactions to come. Just look at the round goby and how it interacted with quagga mussels. In the mid- to late-1980s, both arrived from the Ponto-Caspian region, where they had evolved together at the freshwater margins of the Black Sea. In their native range, quagga mussels can comprise 80 percent or more of the goby's diet. In the Great Lakes, quagga leapfrogged zebra mussels to become the dominant invasive mussel in the basin, a position it has never relinquished.

Once in the Great Lakes, quaggas cleared the water of nutrients and stuffed them into their tissue. And in the absence of nutrients in the water column, benthic algae flourished and died en masse, sucking oxygen from the water as they decomposed. Spores of botulism bacteria present in the sediment waited until there was little oxygen left in the water to spread. "And quagga mussels have provided that opportunity for them," Ricciardi said, setting off an interactive display of bioaccumulation all the way through the food web. Quagga mussels take in the botulism spores and its neurotoxins, transferring those to round gobies who evolved overseas to eat them in big doses. Bass and sea birds eat the gobies, which are one of the most abundant fish in the Great Lakes, and, in turn, take in the botulism bacteria. So do loons, mergansers and gulls. "Since 1999, every year, tens of thousands of fish eating birds wash up on shore in the Great Lakes," Ricciardi told me. "Hundreds of thousands now in the past eighteen years." And as they rot on shore, maggots breed in the carcasses and bring botulism to land animals. And, potentially, humans.

"It's almost impossible to have predicted this," he went on. "How many other crazy synergies like this are occurring as a result

ot combined stressors — including invasions — and we don't know the cost? I suggest to you there are many. There must be. Because we couldn't just be identifying the one that's happened."

Extinctions, extirpations, meltdowns — it all means one thing. The Great Lakes and St. Lawrence River System is the most invaded freshwater system," he said. "Without a doubt."

Back at her office in the Canada Centre for Inland Waters, Cudmore quickly reminded me that not all nonindigenous species in the Great Lakes are problematic. Good science, she said, must determine which invasives are worth targeting, an argument similar to the one made by biologist Mark Davis and science writer Emma Marris in their defense of novel ecosystems and a select few introduced species known to benefit local flora and fauna. (When asked, Cudmore told me she leans more towards the traditional approach to handling invasive species as articulated by Daniel Simberloff in chapter 5.) Ultimately there's no going back on any invasive currently present in the Great Lakes. "Trying to go back doesn't make sense," Cudmore said. "But that doesn't mean we can't mitigate the impacts of our influence. We've made things quite unnatural here."

• • •

The waterfront sky was a jumble of hurried graphite-colored clouds. Small whitecaps broke over the heaving gray water beneath. It looked ominous. I parked at a lot adjacent the Port Credit public boat launch. This wealthy enclave of sprawling Mississauga on Toronto's western edge is where the Credit River, one of DFO's monitoring sites, flows into the lake. The suburb's small harbor was quiet, no boats bobbing on the dark water or moving out to parts unknown. The Starbucks at the corner was crammed with parents and their teenaged kids ready for drop-off at the rowing club upstream.

On the dock, I met aquatic science biologist Dave Marson and the two interns who would join him that summer. Our goal was to

rustle up an Asian carp despite holding a *Catch-22*-ish hope that the fish, like Major Major, wouldn't be in. Cudmore, Marson's boss, had arranged for me to a ride-along with his monitoring team. Marson is one of several researchers who scour the lake's tributaries in search of Asian carp from spring until the cold days of fall. Approaching the boat, I introduced myself and, stepping aboard the 18-foot aluminum craft, tossed my nylon backpack on the floor. "You're going to want to pile that on the waterproof gear or it's going to get soaked," Marson warned. Rookie mistake. Sheepishly, I shifted the bag onto a grimy plastic cooler. The boat reversed out of the dock and spun slowly into the current. We headed upriver.

After completing a master's in marine management at Dalhousie University in Nova Scotia, Marson started working with the Department of Fisheries and Oceans in 2002. Beginning as an intern himself, he later shifted to specialize in species-at-risk. Working outdoors is second nature for someone who grew up hunting and fishing in northern Ontario. The affable 34-year-old graduated just as researchers from Notre Dame and the Nature Conservancy discovered Asian carp eDNA in the Chicago River. When Canada's federal government announced $17.5 million for combating Asian carp in 2012, Marson joined the Aquatic Invasive Species program.

We slowed so that Colin Illes, a young intern from Fleming College, could hop overboard. He began checking fyke and gill nets the crew had set up the day before. He would jump into chest deep, brown water all day, wafting the musty aroma from the depths of the river our way. Soon, foreign fish swam doggedly in circles at the bottom of a five-gallon bucket. One juvenile round goby, was an inch long, though adults can grow six times that size. They're trouble in the Great Lakes because of their propensity to compete with native bottom-dwellers and eat the eggs of sport fishes. And as we saw gobies also play a role spreading botulism among fish and marine birds.

The bucket menagerie was courtesy of a fyke net that yielded an astonishing array of aquatic life. I wondered if anyone living in the

multimillion-dollar homes situated along the river knew the array of species we scooped from a single net in their backyard: a six-inch rock bass, a three-inch golden shiner and an inky northern madtom, a kind of endangered bullhead catfish less than two inches long. The native species were of less concern, though in the interest of obtaining a comprehensive picture of the Credit River's biota, Marson dutifully recorded details of all the fish they caught. Abundance, length and other environmental factors like pH, temperature, catch and habitat information would be uploaded to an online database accessible by researchers from the Royal Ontario Museum, the provincial government and local conservation authorities.

Our initial success soon faded. We traveled two miles upriver. Under the concrete overpass holding up the Queen Elizabeth Way, putted past shoreline anglers squatting on frayed folding chairs. A commuter train rumbled over a rail bridge nearby, shuttling workers into the city. The rowing club launched dozens of canoes, kayaks and anything else that floated onto a river now full of jostling and shouting teens. Dozens of watercraft in the hands of less-than-expert navigators became flotsam that Marson steered around, a ruckus surely startling timid fish below. We had to find a quieter location — and get creative.

• • •

At the opposite end of Lake Erie, some 250 miles as the crow flies from where Marson's crew and I plied the Credit River, the Sandusky River flows slow and brown into Sandusky Bay and the lake beyond. At N 41.426988, W 83.056006 (to be precise), a few miles south of Muddy Creek Bay on the Sandusky River, commercial fishers caught four grass carp on an otherwise routine outing in October 2012. They were small things, the biggest no more than four pounds and 20 inches long. Yet within 24 hours their dismembered bodies were scattered to research stations nationwide. Knowing they had discovered something serious, the commercial

fishers iced the carp and brought them to the Sandusky branch of the Ohio Department of Natural Resources. There the butchering began. The grass carp's eyes were plucked from their heads and sealed in a salt solution stored just above freezing. The eyeballs had an overnight rendezvous with researchers at the U.S. Geological Survey's National Wetlands Research Center in Lafayette, Louisiana, where they were tested to determine the fish's fertility. (Two were found sterile; the others inconclusive due to equipment failure.) Freed from their peepers, the carcasses were frozen. While most of the remainder ended up at the USGS Biological Station on Lake Erie, the anterior portions from the snout to the pelvic fin wound up at the Survey's research center in Columbia, Missouri, where USGS Asian carp expert Duane Chapman made a startling discovery.

Grass and bighead carp had been captured in Lake Erie and tributary rivers of Lake Ontario before, dating back to the mid-1980s. But the finds were all assumed to be one-offs, random fish that somehow escaped from aquaculture or were intentionally released by well-meaning fools into the basin. With the seizure of four grass carp in Sandusky, a part of the Great Lakes where live carp and their eDNA had been previously found, the question for Chapman was not whether the fish had migrated into a new region but whether they had *originated* in the Sandusky. Knowing this would mean the difference between thinking these fish were simply another one-off and the frightening possibility that they were envoys of a broader, perhaps breeding population. Chapman had to know for sure.

Because while it seemed logical that fishes native to northern Asia could spawn and survive in cold Great Lake waters, scientists at the time lacked data to back their hunch. What's more, a contradictory flow of studies in the early twentieth century had complicated matters by asserting contrasting claims regarding the suitability of Great Lake rivers for spawning. In 2012, USGS biologist Peter Kocovsky from the Great Lakes Science Center

had set out to understand whether tributary rivers of Lake Erie were compatible with how grass, bighead and silver carp spawned. It's a delicate business, after all. While female fish lay millions of eggs at once, they're fragile things, requiring the right temperature, river length and water flow characteristics to hatch. Kocovsky's results were conclusive: seven of the eight longest tributaries flowing into Lake Erie possessed the right stuff for all Asian carp species to spawn. Perhaps more worryingly, his study also concluded that, contrary to popular belief, carp eggs could spawn in rivers as short as nine miles long, a sixth of the distance previously thought necessary. This short river discovery had a profound impact on how we think about Asian carp's chances of breeding in the Great Lakes.

Back in Chapman's Missouri lab, he quickly identified a way of figuring out where those four errant grass carp were born. Vertebrates like mammals, reptiles, birds and fish contain three calcium-filled ovals in their inner ear. Known as *otoliths*, these intricate features allow organisms, including humans, to gauge movement and gravity. But for fisheries scientists, otolith analysis also affords a unique opportunity to learn about the environment that a fish lived in and, like human teeth, whether they were alive seven days or 62 million years ago. Fish otoliths are composed of calcium carbonate ($CaCO_2$ — a chemical compound of carbon, oxygen and calcium) that's primarily derived from the water fish swim in. As the lattice structure of the otolith is formed, trace characteristics of the water's composition get encapsulated within the fish.

The basis for Chapman's analysis rests in the periodic table. There, strontium is a close neighbor of calcium. Strontium is a naturally occurring alkaline earth metal that's easily incorporated into fish otoliths. And in a bizarre twist of geographic fate, strontium happens to be found in especially high concentrations in Ohio's carbonate aquifers where the Sandusky River grass carp were caught. The Sandusky's strontium concentration runs to 6 milligrams per liter, densities comparable in America

only to rivers in Texas, Oklahoma and New Mexico. The nearby Maumee River, which also drains into Lake Erie, has a strontium concentration of only 1.5 milligrams per liter, making the find of four grass carp in the Sandusky River a stroke of luck. If the captured fish were born and raised there, Chapman reasoned, the microchemistry of their otoliths, like a birth certificate, would reflect that. He set to work.

Soon, Chapman determined that the juvenile grass carp were 12 months old and, as he suspected, contained a strontium-to-calcium ratio four times higher than grass carp tested from Missouri and Arkansas aquaculture ponds. These fish were Sandusky River born and bred, and the discovery marked the first time Asian carp were proven born within the Great Lakes basin, a finding with implications Chapman called "profound."

While his study made plain that grass carp — and, because of similarities in breeding needs, silver and bighead carp too — could successfully spawn in tributaries of the Great Lakes, researchers have long debated whether the fish could find enough food in the basin's deep, cold waters to support their ceaseless appetites. One 2010 study from Duke University biologists Sandra Cooke and Walter Hill argued that bighead and silver carp's daily caloric intake was simply too large to be satiated in the nutrient desert that is the Great Lakes. Zooplankton concentrations weren't sufficient to support them, and any threat of introduction had to be tempered with the knowledge that a dearth of food could be their undoing.

Cooke and Hill's research became the yardstick against which all discussion of carp's feeding capabilities in the basin was measured, buoyed by a 2002 *Science* article from the University of Notre Dame suggesting silver carp wouldn't become a nuisance in the Great Lakes. However, Cooke and Hill did indicate that more nutrient-rich parts of the Great Lakes like Green Bay, Wisconsin or embayments and wetlands near Sandusky, Ohio, may contain enough plankton for carp to meet their energy requirements.

Sometimes the scientific pendulum never swings too far in

one direction before someone pushes it back. In September 2011, when hydrologically separating the Mississippi River from the Great Lakes was still on the table, a group of senior biologists and resource managers claimed that suggesting food would be scarce for Asian carp in the Great Lakes was "based on misinterpretation of one bioenergetics paper" and an "inadequate knowledge of the physical complexity of the Great Lakes." Don't believe it, they implored — Asian carp will survive in the basin. In 2014, Cooke and Hill's work was questioned again for failing to appraise another food that silvers and bigheads are uniquely suited to eat. Consider the rotifer, a small zooplankton (small even by zooplankton standards) between 0.1 and 0.5 millimeters, the width of thick human hair. Greg Sass, a zoologist with the Wisconsin Department of Natural Resources, analyzed years of never-before-seen data from the Illinois Natural History Survey, where he once worked, on the composition and density of zooplankton communities in the Illinois River. Sass hypothesized that after Asian carp arrived in the Illinois, total zooplankton volumes had declined because of the new predator's filter-feeding physiology. His theory was realized in spirit, but not in the way he anticipated. Rotifer populations in the Illinois River actually *grew* by 50 percent or more in the study years of the late 1990s — while populations of Cladocera and Copepoda, two bigger, more calorically dense forms of zooplankton, absolutely plummeted with the carp's arrival.

Why the drastic difference between rotifers and copepod populations over time? Sass has a theory. Cladocerans and copepods are the preferred meal for many juvenile native fish in the Illinois River, an important source of energy to help fish reach successive developmental stages before they graduate to eating bugs or other fish. While Asian carp *can* feast on rotifer-sized zooplankton, he believes they too prefer a larger meal of cladocerans and copepods. But native fish like gizzard shad and bigmouth buffalo can *only* eat the larger zooplankton forms, while bighead and silver carp can easily survive on a rotifer-heavy diet. By also eating the larger

zooplankton, bigheaded carps are eating someone else's lunch, subtly shifting the nutrient structure of their community and tilting the availability of food in their favor.

"These fish are very good at what they do," Sass told me. "A precautionary approach is warranted because these species may target those cladocerans and copepods, which are at lower abundance in the Great Lakes." Cooke and Hill hadn't tested for rotifer populations in Lake Erie and others, overlooking what could become a favored Lake Erie food for Asian carp. Once larger food sources in the Great Lakes are reduced, as they have been in the Illinois River, Sass believed, bigheads and silvers will simply find smaller rotifers to eat — leaving native fish with nothing.

There is room in this debate for uncertainty and disagreement. Biologist Marion Wittmann argued in the February 2015 issue of *Conservation Biology* that bigheads and silvers might grow larger than Great Lake natives like yellow perch or walleye in Lake Erie. But, Wittmann cautioned, the sheer abundance of food in the ecosystem means this disparity in biomass will likely not hurt native fish communities or their ability to eat and spawn. I'm skeptical — not of the science, but of how policymakers and the public will interpret this. I ultimately worry that conclusions like this may become fodder for those resisting greater action on keeping Asian carp from reaching the Great Lakes. Anecdotal evidence from rivers throughout the United States suggest Asian carp are exceptional invasive species: intelligent, extraordinarily fecund and highly opportunistic feeders that are capable of surviving even the harshest Canadian winters. The idea that there is plenty of food to go around in the inland seas of North America for all fish may be true long-term, yet for aquatic species in the Great Lakes ecosystem, the short-term consequences of an Asian carp invasion are more likely than not to be devastating.

• • •

"Here — give it a try." Kat Doughty, Marson's senior intern on the crew, handed me the gangly tool more out of exhaustion than a sense I should have the full fieldwork experience. Some freshwater fish monitoring can be surprisingly high-tech: environmental DNA analysis, for one, or electrofishing, which allows wildlife technicians to apply a pulsating direct current to a river, afflicting nearby fish with galvanotaxis, a form of uncontrolled muscle convulsions, making them easier to catch. (They return to normal after a few minutes.) Yet the contrivance Doughty offered was far from high-tech, being, as it was, a plunger screwed to the bottom of a six-foot broom handle. No need to dress it up — this was as low-tech as it gets. Yet it's classic American ingenuity. Marson got the idea while palling around with commercial fishers stateside during field tests organized by the Illinois Department of Natural Resources. Facing the problem of wrangling skittish fish, U.S. fishers had jerry-rigged the contraption from cheap hardware store parts. I could see why cost-conscious fishers wanted to save cash, but should the DFO penny-pinch its monitoring efforts? Marson shrugged. "It works."

Illes went over the gunwale in a shady stretch of river to fasten a gill net to the base of a tree. Doughty slowly let 90 feet disappear into the river. With everyone back in the boat and Marson at the helm, the fun began. Doughty and Illes stood port and starboard gripping the elongated plungers, beginning a chorus of smacking and slapping at the water. Marson revved and gunned the engine, zigzagging between the shore and the net and ensuring any fish we terrified would flee into the trap. After several minutes of this, Doughty offered me the plunger. Standing portside, legs astride to keep my balance in the rocking boat, I plunged. And I plunged. There's little acoustic difference between plunging a clogged toilet and plunging at a river in the name of science, regardless of how contextually different the experiences are. I lacked her technique and got myself and the crew wetter than if Doughty had stayed on plunger duty. She jabbed at the boat's hull with the handle of a net, creating a pounding metallic thrum that jolted me, if not the fishes.

Suddenly, bursts of shadow slipped visibly beneath the water. Large plumes of substrate were churned up, clouding the already turbid river. By the end of the second pass, my arm ached, but I saw that Marson and those commercial fishers were right: that plunger worked. Because when the common carp came, they came hard, thrashing and ripping at the gill net. (Just as it had been for commercial fisher Jim Dickau, sewing damaged fishing nets was par for the course for government scientists like Marson.) If it wasn't 25-pound common carp shredding the fibers, it was turtles and muskrats ripping the fykes to nab small fish trapped within. But net mending was a small price to pay to haul in the big ones. And were they ever. The first net had snared seven common carp, massive tan brown fish with deep coloration around the face. Their dorsal, pectoral, ventral and anal fins were interrupted by stark crimson blotches. The smallest common carp we caught was two feet, while the largest needed two interns to lift.

Finding common carp in the river wasn't especially gratifying. Along with the round goby in the morning's bucket and the watermilfoil that choked the river, they were reminders that ecosystems like the Credit River are now more novel than native, a murky blend of foreign and native species whose value ecologists remain unsure of. Forestalling Asian carp was an effort to keep an already altered ecological baseline from slipping further. The buffalo suckers and common carp we caught told Marson that the spots they chose to investigate were sound. Both species seek out the same food and water flow as bighead and silver carp. If we found one, we would, in theory, have found the other.

If and when the introduction of silver and bighead carp to the Great Lakes occurs, it may not take many for a breeding population to entrench itself in the basin. Kim Cuddington, a theoretical ecologist at Ontario's University of Waterloo, believes the competing theories for how many Asian carp would be required to create a sustainable population in the watershed were wildly off-base. Resource managers routinely suggested hundreds of individual

bighead, silver or grass carp would be needed to establish themselves, but Cuddington felt this flew in the face of invasion biology. Hundreds of gypsy moths or European starlings weren't needed in North America for their populations to grow exponentially; why should Asian carp be different?

When the Department of Fisheries and Oceans needed a population model to determine the probability of Asian carp establishment in the Great Lakes, Cuddington led the investigation. The results, eventually published in the April 2014 edition of *Biological Invasions*, surprised Cuddington and her DFO benefactors. Cuddington found a 75 percent probability that only 10 male and 10 female bighead or silver carp were all that was needed for successive generations of Asian carp to spawn in the Great Lakes. Even accounting for scenarios that reduce Asian carp's ability to reproduce rapidly (such as fewer fish and more spawning rivers or individuals beyond peak sexual maturity), the likelihood of these 20 fish establishing a breeding population is between 75 and 100 percent for most tested scenarios. "I thought it might be a hundred [fish needed]," Cuddington told me from her lab in Waterloo. "But when I did the calculation and got down to twenty I just thought — Jesus."

Back on the Credit River, my day with Marson, Doughty and Illes was concluding. Approaching the boat landing, I put a question to the crew that had nagged me all day: What's it like spending a summer looking for an invasive fish they hope not to find? Doughty went silent for a moment. It's reassuring not to find them, she said. "It's like looking for a Yeti . . . but more legit." Yet this question, so theoretical for Doughty and Illes, is different when posed to Marson. As humdrum as these hunts can feel, it has happened that routine detection turned up Asian carp in Canada; Marson was the biologist who caught them.

On August 16, 2013, Marson and his monitoring crew trapped a three-and-a-half-foot grass carp weighing 31 pounds in the Grand River near Dunnville, Ontario. The federal government put out a press release assuring the public that "our continued vigilance"

in seeking out Asian carp will keep the Great Lakes safe. But it was "shocking" for Marson to watch the grass carp writhing on the floor of his boat. No one had wagered on it happening, but it had happened all the same. The fish was sent to the U.S. Fish and Wildlife Service's Whitney Genetics Laboratory in La Crosse, Wisconsin. They confirmed that it, along with another grass carp caught earlier in the year on April 27, 2013, in the same part of southern Ontario, was sterile. Ultimately, Marson was pleased their detection efforts and equipment had worked as planned. His find, and the similar discovery of four grass carp in the Sandusky River in 2014, reinforced his mandate to keep searching.

• • •

Toronto's Asian Carp Public Forum. October 2016. With Becky Cudmore at the helm, the Department of Fisheries and Oceans had assembled a who's who of Asian carp experts from across North America, including the Fish and Wildlife Service, usgs, Environmental Protection Agency and the Army Corps of Engineers. It's a small world, and the guests mingled like friends at a high school reunion. (After several telephone interviews over three years, in fact, it was here that I met usgs carp expert Duane Chapman in person for the first time.) The forum was an opportunity for the public to hear directly from resource officials on the front lines of carp control in America. And, incidentally, the forum gave Cudmore a soapbox from which to tell Canadians and her U.S. colleagues of the scope and importance of the work her group was undertaking. When the time came, I figured, it would help turn that influence and recognition into federal cash.

Cudmore had assured me that Canada had always been treated as an equal member in the fight against Asian carp, even before the government had created the official Asian carp program she leads. Yet the country was on a different invasion timeline than the United States, she told the Toronto crowd. Unlike the Americans who were

managing active populations, Canada was managing potential pathways to invasion. Crucial work, sure, but with all the sex appeal of a budget meeting.

To that end, DFO has invested heavily in public outreach. Drivers along Toronto's Gardiner Expressway passed billboards showing differences between bigheaded and common carp, while the city's transit riders were treated to subway ads telling them who to call if they spotted grass, silver or bigheads. Since 2013, over two hundred reports have been made to the government from anglers worried they'd caught Asian carp. While walking with my daughter in 2016 near the mouth of the Don River even I tweeted a photo of large, carp-like fish to the Toronto and Region Conservation Authority, seeking a second pair of eyes on fish that looked, from the bridge, like grass carp. (They weren't.) A citizen reporting tool pioneered at the University of Georgia in 2005 has also come online in Canada, allowing users to report sightings of invasive species. As of late 2018, EDDMaps has received 3.3 million reports, 41,000 from Ontario. And that funding Cudmore lobbied the Canadian federal government for shortly before we met in her office? It was awarded in January 2018 — $20 million over five years to dramatically expand the program.

It's part of a larger shift in thinking about how invasives in the Great Lakes are managed. Whereas researchers once targeted problem species like sea lamprey in their management efforts, Cudmore tells me, new threats are considered as part of a broader, whole-ecosystem approach by both Canadian and American scientists. All are now keen to avoid the silos that segregated pollution, invasive species, habitat loss, overfishing and other hazards to the Great Lakes for so long. Finally, ecosystem rehabilitation has entered the conversation about how aquatic invasive species can be effectively controlled. This philosophy hadn't taken root earlier because of the intense focus from governments and resource managers on halting specific aquatic invaders one at a time, Cudmore said. It's as if the priority was removing invasives

from an ecosystem and *not* the overall improvement of said ecosystem. But why bother removing nonindigenous species if you're not interested in strengthening the environment it took over?

This acknowledgment that species can't be thought of independently from their environment, and that environments can't be considered apart from how humans influence them, is in itself a profound shift in thinking. Moving from crisis mode to preventative thinking and prediction about invasives-to-come is finally eroding the silos that kept habitat rehabilitation or pollution control from the conversation about controlling unwanted species. And we can no longer assume that eliminating an established invasive will benefit native species in some direct proportion. Round goby, that Ponto-Caspian fish that's spread throughout the Great Lakes and into the Mississippi basin, for example, is now the primary food supply for northern water snakes in Lake Erie. Dam removal is also seen as beneficial for fishes that need longer, unimpeded rivers for spawning. But today, talk of dam removal includes a discussion of what aquatic invaders may benefit from unrestricted rivers. A naturalization project in my hometown is set to remove the concrete L-shaped mouth of the Don River at Lake Ontario. Yet the natural, winding river mouth to come will make it suddenly suitable for Asian carp spawning.

Back at the public forum, Cudmore walked a fine line in dwelling on the dangers of and highlighting the triumphs against Asian carp. She chose to end her presentation on a note of what passes for sober optimism in the conversation about Asian carp in the Great Lakes. There's been no introduction, she told the audience, yet small clusters of grass carp had arrived in lakes Erie and Ontario. And while there was no established population, Cudmore admitted she had seen the warning signs of grass carp recruitment in the basin, a precursor to the establishment so feared. But was it game over for the Great Lakes?

She paused, I assume for dramatic effect.

"Not by a long shot."

CONCLUSION

WHAT DO WE do with all of this? Bigheaded carps still routinely appear as mysterious one-offs north of Chicago's electric barriers, a mere handful of miles from Lake Michigan. But no sooner does one appear than any others nearby vanish, undetectable in the avalanche of monitoring that follows. Congressional funding that underpins the entire symphony of Asian carp research and mitigation has been jeopardized by a White House and Environmental Protection Agency unsympathetic to the very notion of the environment as worthy of protection. Hydrologic separation has become the third rail of Asian carp management. And black carp, the shadowy fourth species of the Asian carp family, are being reported farther north in the Mississippi and Illinois rivers (and east into Kentucky) with increasing frequency, ratcheting up the need for action.

Meanwhile, the U.S. Fish and Wildlife Service reported in 2016 that barges moving downstream in the Chicago Area Waterway System were capable of disrupting its electric fields as they passed through, theoretically allowing juvenile bigheaded carps entrained within a barge to move upstream even with the electric barriers in place. And in September 2017, the Great Lakes Fisheries Commission confirmed that monitoring done that

summer by the U.S. Geological Survey and the Ohio Department of Natural Resources had collected almost 8,000 grass carp eggs in the Sandusky River. Prior to that, the largest number of grass carp eggs ever found in the Sandusky was eight. "The implications," the Commission stated, "are as of yet still unknown."

What about this frightening possibility, first suggested to me by Bobby Reed from the Louisiana Department of Wildlife and Fisheries: if silver and bighead carp continue spawning in the lower reaches of the Mississippi River, will those fish continuously migrate north and supply the Illinois River with fresh recruits? If so, without effectively controlling the species throughout the South, can we ever hope to control Asian carp across all of North America?

• • •

And then there's Donald Trump. Nothing has endangered the future of Asian carp management in North America more than his election to the presidency in November 2016. Called "the Asian carp of politics" by one Canadian observer, Trump rattled politicians, resource agencies and universities throughout the Great Lakes within weeks of taking office by signaling his intention to gut the Environmental Protection Agency's coffers by 97 percent — a $2.6 billion cut. Trump's first budget proposal also called for the Great Lakes Restoration Initiative, the program responsible for funding the bulk of Asian carp work, to operate on a paltry $10 million, down from its annual budget of $300 million. Asian carp would not be alone in thriving under Trump's #MAGA mantra; algal blooms, the scourge of Lake Erie, would blossom without GLRI efforts to curtail their spread, as would polluted Areas of Concern throughout the basin that Restoration Initiative dollars had long helped remediate.

Much of *Overrun* was written in the comparatively halcyon days of government support for science that characterized President Barack Obama's second term, in which unencumbered

access to Army Corps, EPA, Geological Survey, Fish and Wildlife Service and Natural Resources Conservation Service officials was taken for granted. Yet Trump's undermining of science comes at a time when funding for the current management practices underway against Asian carp are often already insufficient, never mind the need to expand efforts throughout the Mississippi basin. We may soon reach a point where science can no longer keep up with the necessities of controlling nuisance carp throughout the United States, Peter Sorensen from the Minnesota Aquatic Invasive Species Research Center says. "Not unless budgets go up at that rate. And they're not — they're static."

Soon after picking a fight with Great Lakes leaders over GLRI funding, Trump stuck his nose into the U.S. Army Corps of Engineers' latest Asian carp management study. After talks on the Great Lakes and Mississippi River Interbasin Study stalled alongside any discussion of hydrologic separation, the Army Corps was directed in April 2015 to begin an $8.2 million study to examine if an existing lock and dam at Brandon Road in Joliet, Illinois, can be used as the site of a new invasive species barrier. Originally scheduled for release on February 28, 2017, Trump balked at the last minute and deferred its release indefinitely, claiming "further coordination" between government and stakeholders was required. Democrats were apoplectic. A letter signed by 11 U.S. Senators from the Great Lakes region claimed that the White House had abandoned any commitment it once maintained to protect the Great Lakes.

Days earlier, Illinois congresspersons and the state's Republican lieutenant governor called on the White House to shelve the report, arguing as the shipping industry had for years that structures impeding barges on the CAWS would hurt industry. Besides — the Brandon Road study was "severely flawed," according to Lynn Muench of the American Waterways Operators. She tells me the report would have vastly understated the economic impacts vis-à-vis construction, maintenance and the added cost of moving freight

through the Midwest that come with adding further impediments to the Chicago Canal. Beyond dollars and cents, Muench told me her organization doesn't believe the Brandon Road study was even congressionally authorized. The proposed lock at Brandon Road was included in four alternatives put forward by the Army Corps in GLMRIS but never assessed as a stand-alone project.

Some view the actions of AWO and their political supporters as little more than opportunistic obstructionism. Molly Flanagan from Alliance for the Great Lakes says it's not just hydrologic separation–style projects that AWO opposes but *anything* altering how the river operates. "It's very short-sighted." And Brandon Road is a draft report, Flanagan tells me, one that Congress would still need to debate and agree to fund. "The [Corps] was potentially looking at options that might cause some delays. But how do you measure a couple of hours' delay against the potential of an invasive species harming a $7 billion sportfishing industry? "That's a difficult equation," she says, "but it seems to me the Great Lakes should come out on top."

The Trump administration is far from infallible. Like other policy failures characteristic of his administration's early days, Trump's opposition to funding the Great Lakes Restoration Initiative and releasing the Brandon Road study on time soon crumbled. In February 2017, 20 Democrat and Republican House representatives from across the Great Lakes region drafted a letter to the president outlining the Restoration Initiative's virtues. More than $2 billion has been directed to the GLRI since 2010, the authors wrote, money that restored 150,000-plus acres of wetland habitat, built awareness for banning plastic microbeads, added conservation measures to a million acres of farmland and cleaned up toxic hotspots blighting aquatic and terrestrial ecosystems. Skeletonizing the EPA and the GLRI they warned would incur dire economic and ecosystem consequences for the entire region.

Trump may not have been swayed by their plea, but the House Interior Appropriations Subcommittee was. In July, the

committee recommended to Congress that the full suite of GLRI funding be included in the FY2018 budget. "I hope we can keep building on this progress," said Ohio congresswoman and long-time Great Lakes advocate Marcy Kaptur. But "it is still beyond me why the president, whose political fortune is so tied to the Great Lakes states, would gut funding for such a valuable environmental and economic resource." Not saved, exactly, but the Great Lakes Restoration Initiative lives. And despite Trump's effort to defang the GLRI and the EPA more broadly, $300 million was again safeguarded in March 2018 for 2018–19 to keep work on pollution cleanup and invasive species management going.

And after a needless six-month delay, Trump quietly acquiesced to the Brandon Road study's release. In the report, the Army Corps asked for $275 million (a figure that more than doubled to $778 million in November 2018) to build a complex fish-deterring lock. By using complex noise, water jets and electric barriers, the Corps argued that we can reduce the risk of Asian carp becoming established in the Great Lakes to a 10–17 percent probability, down from a 22–36 percent likelihood if we do nothing. The report's future is deeply uncertain. While environmental groups applauded its release, earmarking $275 million for additional controls in the CAWS over the extensive opposition of local politicians and industry seems entirely unlikely. Waiting, watching and hoping for the best have become too fashionable.

Yet in much the same way progressive mayors throughout America banded together to commit their cities to fighting climate change after Trump agreed to pull the U.S. out of the Paris Climate Agreement, a coalition of states and the Canadian province of Ontario agreed in February 2018 to help offset the cost of completing and maintaining the Brandon Road lock and dam. "There's been too much talk and not enough action," Michigan governor Rick Snyder told reporters in South Haven. Under the new arrangement, Michigan and Ontario would join Ohio and Wisconsin in paying roughly $8 million each year in maintenance

fees once the lock is operational. The Army Corps had asked for "non-federal" partners to pick up part of the tab, and this binational coalition (representing over 90 percent of the Great Lakes' surface area) could provide just the support the Corps needs to overcome industry and Illinois's opposition. And in May 2018, after years of holding out, Illinois governor Bruce Rauner indicated his state would finally be willing to act as the Corps' non-federal sponsor given the project's outsized impact on the state's public waters (and goods that flow therein). Rauner also wrote to Michigan governor Rick Snyder, whose state has long antagonized Illinois over its heel-dragging on infrastructural solutions to halt Asian carp, urging the states meet regularly to draft a blueprint for Brandon Road that suited everyone's needs. Absent federal action, subnational governments, once again, are filling the void.

• • •

There's no shortage of facts to be sullen or anxious about regarding Asian carp in North America. I certainly explored enough of them in writing this book.

But that's not how I want to leave you.

First, acknowledge a simple truth: Asian carp are here to stay. The question, as Southern Illinois University resource economist Silvia Secchi put it to me, is what our society will pay to manage their presence. This, she said, will ultimately determine whether grandiose plans to alter hydrologic systems are prioritized ahead of smaller-scale options like public outreach about the dangers of invasives. While a policy debate appeared imminent between 2011 and 2014 on the merits of watershed separation to halt Asian carp, it never materialized. In the meantime, managing bigheaded carp with fishers and traditional technologies has become the best *and* cheapest option, according to SIU biologist Jim Garvey. Since the Barrier Defense Program began in 2010, more than six million pounds of silver, bighead and grass carp have been removed from

the Illinois River via nets stretching the distance from New York City to Dallas. "That's wicked," Dave Wyffels from the Illinois Department of Natural Resources told me as we set out to catch silvers and bigheads on Jim Dickau's boat — "that's a huge amount of fish." No approach we have taken to reduce Asian carp has been as effective as paying six crews of fishers $2,500 a week, up to three weeks each month, for 10 months a year to catch these fish.

Make no mistake — the debate over long-term options for halting the two-way spread of aquatic invasives between the Mississippi and Great Lakes watersheds must be rekindled. But in the meantime, states and the federal government need to cooperate with researchers to utilize the latest science on gear, spawning cycles and overwinter locations and get this knowledge into the hands of experienced local fishers to cull as many silvers and bigheads as possible.

This evolution is already underway. In reviewing a book chapter on Chinese fishing practices in 2015, U.S. Geological Survey biologist Duane Chapman noted a reference to the "Chinese unified fishing method" and wondered what that was. Chapman, who heads the USGS Invasive Carp Research Team, corralled Kevin Irons from the Illinois Department of Natural Resources into accompanying him to China later that year. The pair met with fishing experts in Wuhan and returned to America with a plan to field-test the methods they learned in March 2016 with the aid of contract fishers and 20 miles of gill, trammel, seine and block nets.

Near Morris, Illinois, crews of IDNR staff, commercial fishers and local Asian carp researchers laid down an alternating series of nets in a back channel of the Illinois River in lattice-like patterns. Over a two-week period, this motley crew drove the fish with pounding engines towards the awaiting nets while laying further gills and trammels behind them to catch any carp attempting to flee. With great patience, the bigheaded carp present in the inlet were pushed into a catch area. In 40-mile-per-hour winds and driving rain, with the help of two dozen local college students, the team pulled

100,000-plus pounds of Asian carp from a single back channel, fish loaded onto a flatbed truck and later pulverized into fertilizer.

"It's quite an undertaking, doing one of these," Chapman told reporters. But "it's hard to not call it a pretty good success," especially when such huge amounts of Asian carp typically take three months to catch using traditional methods. A hydroacoustic study completed after the experiment found IDNR had fished out 80 percent of all Asian carp in the inlet in one swoop. It's early days for the unified method in America, yet few techniques have proven so effective so quickly in displacing big numbers of Asian carp.

This redoubled effort to fish down Asian carp has become the workhorse of our boots-on-the-ground control effort. In future, the program must be funded beyond the Starved Rock Lock and Dam where it currently ends. "Asian carp is not a Chicago issue or even a Great Lakes issue," said AWO's Lynn Muench. "From our perspective it's a national issue." This is partly why her organization wholeheartedly supports federal funding for contract fishers to tackle Asian carp and why she wants to see Barrier Defense scaled up. Muench may be onto something. The impetus for targeting carp populations in the Illinois River was protecting the Great Lakes, yet we've reduced pressure on the electric barriers so thoroughly that the time may have come to shift our focus downriver or expand the program nationwide. Let's take the hard-earned knowledge we've gained and tested on the Illinois since 2010 and put that know-how to good use throughout the country.

• • •

Saving aquatic ecosystems like the Illinois and Mississippi rivers, the CAWS and even the Great Lakes requires us to think hard about our role in Asian carp's spread throughout America. I'm not talking about traditional miscues like importing the fish or our hubris in releasing them, intentionally or otherwise. Rather, I'm referring to the chronic ways our historic behaviors have created a perfect

storm for Asian carp's proliferation. This idea is summed up nicely by SIU biologist Jim Garvey: "Probably the reason why the Illinois River is ground zero for Asian carp is because of crappy land-use planning and nutrient problems."

I want to explore this statement in-depth.

Recall the 1915 report from John W. Alvord and Charles B. Burdick, the Chicago sanitary engineers we read about in chapter six. The pair identified a steady drop in fish caught from the Illinois River after 1908 that came on the heels of decades of habitat destruction, berm building, industrial pollution and agricultural runoff. Levees to retain and divert water for crops had interrupted the cycle of beneficial flooding that made the Illinois a productive fishery. Between 1908 and 1915, they found, levees had destroyed 17,000 acres of wetlands and lakes, eliminating 36 percent of all in-state breeding and nursery grounds for native fish.

We're still feeling the effects of these historic decisions. Almost nine million acres of Illinois wetlands have been drained and paved over in the past two centuries. Meanwhile, a sizable increase in agricultural output surrounding the river has put 22 million acres of corn and soybean into production, 60 percent of Illinois's land. Both factors are funneling nitrogen and phosphorus into local waterways at alarming rates. Between 1997 and 2011, the U.S. Geological Survey estimated that 536 million pounds of nitrogen and 37.5 million pounds of phosphorus entered the Illinois River, part of an avalanche of nutrients from numerous states sweeping down the Mississippi River and creating an infamous dead zone in the Gulf of Mexico. The dead zone measured 8,200 square miles in the summer of 2017, the size of New Jersey. "Our rivers, for better or worse," wrote environmental poet Bernard Quetchenbach, "take us with them."

Add to this the fact that the Midwest is getting wetter. The 2014 National Climate Assessment reported that rainfall has increased throughout the region over the past century by 20 percent in some locations. The rains, meanwhile, are getting harder. These days, a

year's 10 rainiest days can provide upwards of 40 percent of annual rainfall. "This increasing trend in precipitation is no longer imaginary," Garvey said to me. "One of my pet theories is that Asian carp have taken off because of increasing flow that we see in the rivers." Bigheaded carp respond to spikes in velocity, a biological reaction triggering an urgent need to move upstream, spawn and disperse. It's a message both species have received loud and clear for decades, especially during the kind of heavy rains that are likely to increase because of global warming. Garvey is convinced that "the flow environment influences what kind of animals live in the river. And it makes carp happy. If you go to the Youngstown River and look at where carp have evolved, that water is whipping, it's fast, and that's what they like. Really high-flow, high-energy environments. And they've got it."

With more rain falling across the United States, greater levels of nutrients in runoff nutrients are projected to wind up in America's rivers, boosting the risk of life-choking algal blooms forming in reservoirs and slow streams. A study published in *Science* in July 2017 argued that America's increased precipitation could increase nitrogen runoff from farmers' fields by 20 percent this century. Study author Anna Michalak, a professor of global ecology at the Carnegie Institution for Science, told the *New York Times,* "When we think about climate change, we are used to thinking about water quantity — drought, flooding, extreme rainfall and things along those lines. Climate change is just as tightly linked to issues related to water quality."

And the algae bolstered by those nutrients? "Carp are slurping that stuff up," Garvey said.

Like many other Midwest and Great Lake states, Illinois is ramping up efforts to reduce nutrient-dense agricultural runoff from entering waterways where, in the presence of sunlight, massive algal blooms form. Reducing point-source pollution, carving buffer strips around tributary rivers, constructing wetlands in flood-prone areas, building green infrastructure in cities like Chicago — as with

other environmental synergies, the interplay between food production, the concrete-heavy design of our cities and the flourishing of an invasive like Asian carp is often overlooked. But at our peril.

Implementing these solutions is doable, Garvey believes, and they will have tremendous social and environmental benefits beyond hurting Asian carp's chances of long-term survival in North America. But they do require dramatic rethinks of our existing land-use policies, zoning bylaws and agricultural practices. "I don't want to demonize agriculture," he said, "but the middle of Illinois is just one giant soybean and corn field. Every time we put ammonia on the landscape to keep the corn growing, a lot of that is just blowing off into the streams. That's feeding carp." We do not have to sacrifice our rivers for agriculture — yet finding an enduring balance between the value of our waterways relative to our farmland eludes us, as it has for the past century or more.

Largescale changes have also been proposed and completed in urban areas to address how cities interface with their rivers. As the Boston and Shanghai-based Sasaki architecture firm began drafting blueprints for Chicago's Riverwalk, one prominent local architect put her mind to revitalizing the CAWS in the age of Asian carp. Jeanne Gang, MacArthur Genius Fellow and founder of Chicago-based Studio Gang Architects, seized upon the momentum generated by the city's Asian carp panic in 2009 and the broader idea of hydrologic separation as a jumping off point for thinking big about neighborhood building. For Gang, the highly manipulated nature of the waterway was an asset. "As architects and designers," she wrote in 2011's *The Reverse Effect*, her beautifully glossy $200 coffee table book on reimagining the watershed connection, "we therefore felt a greater freedom — indeed an obligation — to imagine what it could become next." In collaboration with the Natural Resources Defense Council and the Joyce Foundation, Gang conceived of any barrier erected to separate the watersheds as a catalyst for rejuvenating large sections of the city that could be transformed from defunct heavy industry into

wetlands, public spaces and green infrastructure in neighborhoods desperately needing natural areas. Such a "radical transformation" of the region's waterway was not unprecedented in Chicago, she wrote, and was, sadly, an appropriate fit with the scale of environmental crisis facing the city.

Reverse Effect proposed many possibilities for what a future Chicago Area Waterway System could look like. Earlier in the year, Gang put the problem of the river's future to her students at the Harvard Graduate School of Design. In response, many pushed for using carp as biofuel for the city's electrical grid; some wanted abandoned ships to become artificial reefs; one proposal recommended turning the barrier into an extensive greenspace-meets-freshwater-laboratory, while others suggested placing art galleries, cafes and shops atop a watershed-separating berm. One thing was clear. "Creating the kind of plan necessitated by the complexity of today's Chicago requires a new approach to urbanism," Gang wrote, "one that considers the city as an interconnected, ecological system, and accordingly supports the well-being of the built environment, land, water and all of their combined inhabitants." Whether a better future for Chicago's waterways along the lines of what her students proposed would ever come to fruition depended on legislation, Gang told *Chicago Magazine* in 2011. "People won't just do it on their own."

As Gang's ideas percolated throughout Chicago, the NRDC became more active in addressing community safety in stretches of river where neighborhoods abut historic industrial zones. Meleah Geertsma, senior attorney with the NRDC's Midwest office, says it was critical to work with local communities to understand their needs while trying to change people's perception of Chicago's waterways before any ecological restoration agenda could be set. Piecemeal approaches wouldn't work. "In this part of the river we're going to do habitat restoration, but a couple of miles further on it's okay to have massive industrial facilities . . . right next to a residential community? There is a disconnect there." People will never

treat our urban waterways as something special if large stretches of riverbank remain "industrial sacrifice zones," she says. This phenomenon, unsurprisingly, is not unique to Chicago. Nor is Chicago alone in thinking differently about how businesses operate along urban rivers, what communities want from those waterways and whether the two are compatible. The advent of Asian carp lurking nearby provided a spark for these conversations in Chicago, yet the debate has outgrown discussions of halting just one invasive species. "Can we make our rivers a vibrant resource on a level that they currently aren't?" Geertsma asked. "Can we make them thought of by the public in the same way Lake Michigan is, as this great recreational, but also working resource, that lots of people connect to?'"

It's an open question, though these kinds of reconnections are happening across the United States. A $53 million project in Oklahoma City to rejuvenate a seven mile stretch of the Oklahoma River has seen local shops, performance spaces and an 11-acre whitewater kayaking facility open in the Boathouse District. In San Antonio, a riverside promenade snaking through downtown along the San Antonio River now reaches 15 miles, a revitalization project recently expanded with a $271 million project to restore native habitats while adding amenities like beaches and picnic shelters. And in Los Angeles, the city and federal governments plan on investing over a billion dollars to reclaim 11-plus miles of the infamous Los Angeles River from Griffith Park to downtown, part of a master plan first approved in 2007. "There's a movement across the United States," said Molly Flanagan from Alliance for the Great Lakes. "There really is more value being given to these rivers that flow through our cities."

• • •

Many of us are guilty of thinking that targeting Asian carp without addressing how urban and farm practices sustain them will somehow be successful. They won't, because nuisance species have

become nuisances at our behest. "It's always us," said *Rambunctious Garden* author Emma Marris of human meddling in the natural world. "We are always the ones who are fucking things up. And we are tired of being the bad guy since we're always the bad guy" in any story of earthly ecological mayhem. "We have changed the soil or water flows or the salinity or the temperature or just carved up the landscape and routes to access it," she said to me. Marris believes that people became fixated on invasives as a problem apart from our own destructive policies and behavior because it's reassuring to think, among the many ecological woes we encounter in this world, that *maybe invasives somehow aren't our fault*. In this, like so much else, we are wrong. "We'll be like — 'Fire ants, they're assholes,'" she said, "but the fire ants are just following the trail of destruction that humans have made every time we disturb the soil."

In an unexpected way, I think there's some similarity on this front between Marris and Anthony Ricciardi, her erstwhile critic. Too often the public hears about invasions "as a series of monster stories isolated from each other," Ricciardi said. "There's a mussel over here, there's goldfish over there, there's a plant over here. But these are connected. They are all moved by people" and "exploit the opportunities we provide them." It's part of a conservation ethic that Jim Garvey feels many of us have lost. These days, he tells me, "Asian carp are just an example of the environment telling us that we have done something dramatically wrong to our ecosystems."

Restoring the riparian habitat lost in an Illinois River system that's become a food court for Asian carp could undo the damages wrought by agriculture and a century of poor urban planning. The river could become the low-nutrient, high-oxygen habitat it was meant to be, wrote Oregon State University permaculture designer Tao Orion in 2015's *Beyond the War on Invasive Species*. Native fish, she noted, could once again find the resources and comfort they need to thrive by curtailing runoff via nutrient-harvesting hedgerows and shelterbelts. Land converted from monocrops into

riverside wetlands and floodplain habitat, meanwhile, would allow seasonal flooding to occur, improving the health of shoreline vegetation and enhancing biodiversity in tributary streams. "Achieving these multifaceted and long-term restoration outcomes would ensure the return of viable populations of native fish," Orion wrote. "But poisoning, shocking and shining strobe lights on Asian carp will not."

We have utterly failed to consider changes of this kind as solutions to the Asian carp crisis that has unfolded since the 1960s. Without abandoning the science-forward solutions we've experimented with to date, the conversation around managing aquatic nuisance species like Asian carp must broaden substantially. To have any success against Asian carp and the next round of aquatic invasives sure to come, new voices, opinions, small-scale options and entirely new ways of thinking about how we build our cities and grow our food must be included in future debates. These alternatives, taken together, can effect real change.

As part of a whole-ecosystem approach to managing these nuisance fish, every federal agency overseeing Asian carp must also work to view the crisis through a broader lens that doesn't play favorites in where and how federal dollars are spent. Asian carp should be tackled with as much tenacity in the southern reaches of the Mississippi basin as they currently are in the Upper Mississippi and Illinois rivers. This would end decades of prioritizing the wealthier and more powerful Great Lake states and the assumption that Asian carp's spread in Louisiana or Arkansas is too extensive to do anything about, or that their takeover of rivers in Minnesota, Kentucky and Tennessee is a foregone conclusion. It's not. The Great Lakes, vital to the economic and ecological health of 40 million Americans and Canadians living in the basin, is not the only aquatic ecosystem in desperate need of assistance.

Let's work backwards and ask: What enabled nuisance species like Asian carp to succeed in their new environments? What niche did they fill? What component of that ecosystem was out of

whack? Conceived this way, invasives can become clues to solving bigger ecological maladies — not the disease itself, but symptoms of an ecosystem ill long before their introduction. Even if I'm wrong and such natural checks and balances on Asian carp fail to dampen their impact or spread, the end result is — what? Cleaner rivers? Sounder agricultural policy related to hazardous pollution? Green infrastructure to reduce flood risks and keep us safe? Vibrant native fish and plant populations? The reintroduction of native species like freshwater mussels and alligator gar nearly extirpated by centuries of errors in judgment about how to steward the land and water?

Can we afford *not* to try these whole-ecosystem approaches to managing our land, cleaning our watersheds and controlling unwanted species? I don't believe so.

When I began writing this book, my primary aim was to fill in the gaps of Asian carp's long, strange American trip. Taking action on such a monumental ecological challenge, I felt, required an engaged public well-versed in the intricacies of Asian carp — how they arrived here, sure, but also why they're dangerous for the continent's freshwater ecosystems and how science and society's triumphs and failures have shaped the crisis so far.

My hypothesis, such as it was, consisted largely of thinking that hydrologic separation of the Great Lakes and Mississippi River watersheds was essential (if not logical or likely) for protecting the lake my toddler daughter gazes calmly at before chucking a rock into it and making a *splash!*

Now I'm not so sure.

Only as the research broadened and I traveled the length of Asian carp's America did I realize how narrow my original perception of the crisis was, not to mention its potential solutions. Knowing its true scale required that I dive deeply into the continent's geologic history before scaling down into the minutiae of bigheaded carp's bone structure and everything between these related poles. All to recognize the simple truth that everything in

this world is more superconnected than we can possibly imagine. And that any control effort, no matter how effective, is effectively useless if it fails to consider the myriad ways in which society unconsciously props up invasives like Asian carp while simultaneously spending hundreds of millions to beat them back. If we silo Asian carp's North American saga and view management efforts solely as a chance to rectify this *one* mistake, we'll be wasting an epic opportunity to rethink not only the subtle ways that we encourage their prosperity, but how we imagine "invasive species" (scare quotes intended) into the twenty-first century.

But in these connections between Asian carp and nature, between Asian carp and the choices we make in how to structure our cities and farm our land, there is benediction.

Ecosystems shift, Jim Garvey tells me, much more quickly than we ever thought possible. If we ratchet back nutrients from agriculture, improve our wastewater treatment, construct wetlands, reintroduce native mussels to filter the river of toxins and alligator gar to prey on juvenile bigheaded carp, Asian carp biomass could plummet. They won't have access to the energy stores they once did. Couple this with low-cost scientific options like acoustic deterrents at locks and effective fishing techniques like the unified Chinese method and we may, in time, turn back the tide.

No one of these solutions is substantial enough individually to affect noticeable change, nor are any as pie-in-the-sky or impossible to implement as they first seem. But taken together? "That [change] can happen in our lifetime if we just make the right decisions," Garvey says, though the support of the public and governments at all levels of power is an absolute necessity. Even then, it will be an uphill battle.

I hope we're up to the task.

POSTSCRIPT

LEGACIES ARE COMPLICATED; Jim Malone's is no exception. His dedication to biological control in place of the dangerous chemicals then in vogue is laudable, work Rachel Carson herself championed. Yet in importing silver and bighead carp to the United States, despite the positive press both fish were receiving from international bodies like the United Nations and federal agencies like the U.S. Fish and Wildlife Service, Malone shares some responsibility for bringing two of the continent's most notorious invasive species to our shores.

Can we reconcile these dueling realities?

That's not for me to decide. But those I spoke with in researching this book described Malone as a man passionate about his accomplishments. He took pride in growing a business based on grass carp that his family still runs on 200 acres of swampy bottomland. Malone never saw how out of control the Asian carp crisis became; in his later years, when the current saga began, his son Jim B. Malone and the rest of his family shielded him from such controversies. His Alzheimer's had advanced, his son told me. "Things that could upset him would just literally break his heart."

When Malone died on April 27, 2014, his obituary recalled him as an amateur magician, piano player and avid storyteller; a

wonderful dancer, kite maker, firework shooter, house boat captain and "a mean Bloody Mary maker." To Jimmy Bryant, whose life intersected with Malone's at the University of Central Arkansas archives, he was curious and intelligent. Malone found praise and success through grass carp in the global aquaculture community, and his relentless work creating a sterile white amur earned him the respect of fisheries peers around the world. U.S. Fish and Wildlife technician Drew Mitchell remembered Malone like this: "If you gave him respect and you knew what you were talking about — and admitted when you didn't — you got along well with him. No bullshit with Jim. You didn't bullshit him."

One night in Arkansas, I sat alone in my hotel room in my underwear and a T-shirt ringed with sweat. A warm beer shed circles of condensation onto the tabletop. Poring over my notes and a box of papers that Keo's Mike Freeze had lent me, I picked up a private letter Malone wrote to a friend in August 2001. Like all his correspondence, it was typewritten on company letterhead. The pages were wrinkled. It smelled like aging pulp. In the letter, Malone constructed his life's narrative, connecting his earthly joy for the complexities of fish genetics with his heavenly search for God. He was an ardent Baptist. The connection Malone attempted was a stretch for an agnostic like me. But in that moment, reclining in a fake-leather hotel chair that stuck to my thighs, alone and miles from home, I sensed his meaning. After all, wasn't I spending years of my life diving deeply into the world of Asian carp as he had? "What I have found is a tapestry of creation in both life and the design in inanimate chemical elements," he wrote. "There can be no other rational explanation than to admit the existence of a Creator."

Malone was amazed by the physical characteristics of our bewitchingly beautiful biological world and attributed this grandeur to the divine. I share his awe at the mystery of a living world I'll never comprehend, overcome as I've been many times in the cathedrals of American nature. Though I lament his decision to

import silver and bighead carp to America and attribute my own reverence to the Earth itself rather than God, Malone and I share an admiration for the unknowably wondrous life on this planet.

"I cannot tell you how a simple drive in the country affects me as I witness the marvels of this world," he wrote.

I cannot agree more.

AUTHOR'S NOTE

I BEGAN GATHERING material for this book in January 2014 and traveled intensively from August 2014 to June 2015 on field trips spanning several months, broken into numerous trips. I was not present for all events described in this book: interviews, published and unpublished letters, journals, reports, minutes of meetings, newspaper and magazine articles, government records, agency files, archival material, maps, photographs and presentations all helped to construct events from the past brought to life in this book.

I place nothing between quotation marks that wasn't said (either to me or in a written record) verbatim. Where a source's comments were too scattered to quote at length, I paraphrased. Where it was impossible to record lengthy quotes because of ill-suited circumstances (like a fish-laden boat on the Illinois River), I recorded detailed voice memos, wrote down facts and figures in my notebook and conducted recorded interviews with subjects soon after to firm up details mentioned at inopportune times. Where a quote is not from an interview I conducted, I have included source material either in the text or in the bibliography at the end of *Overrun*.

A final note. The term "invasive species" is a troubling and imprecise one. It implies intent, as science author Emma Marris

tells me — and malice. "You don't accidentally invade another country, right? You have to go out and intend to invade it," she says, an accusation that cannot be leveled at Asian carp or any other species termed "invasive." I am indebted to Marris for challenging my use of this term throughout this book. While I have reduced my reliance on the expression, for ease of conveyance, readers will still find "invasive species" and "invasive" used throughout this book largely because of their familiarity in the public discourse.

BIBLIOGRAPHY

The following is a chapter-by-chapter bibliography of selected material referenced in *Overrun*. Some sources were referenced in more than one chapter and are listed in the first chapter in which they appear.

INTRODUCTION

Butler, Steven. Interview by the author, Kaskaskia, IL, June 10, 2015.

Canadian Press. "Michigan Crowns Winner in Contest to Prevent Asian Carp Invasion in Great Lakes." *CBC*, March 28, 2018. https://www.cbc.ca/news/canada/windsor/michigan-asian-carp-competition-winner-1.4596430.

Chapman, Duane. Interviews by the author, phone, September 29, 2014, and February 26, 2015.

Colautti, Robert I., Sarah A. Bailey, Colin D. A. van Overdijk, Keri Amundsen and Hugh J. MacIsaac. "Characterised and Projected Costs of Nonindigenous Species in Canada." *Biological Invasions* 8 (2006): 45–59.

Collins, Scott. Interview by the author, Kaskaskia, IL, June 10, 2015.

Egan, Dan. *The Death and Life of the Great Lakes*. New York: W.W. Norton & Company, 2017.

Expositor Staff. "Grass Carp Found in Lake Huron." *The Manitoulin Expositor*, July 27, 2018. https://www.manitoulin.ca/grass-carp-found-in-lake-huron/.

Goss, John. Interview by the author, Cleveland, OH, January 16, 2014.

Irons, Kevin. Interview by the author, phone, September 30, 2014.

Kolar, Cindy S., Duane C. Chapman, Walter R. Courtenay Jr., Christine M. Housel, James D. Williams, Dawn P. Jennings. "Asian Carps of the Genus Hypophthalmichthys (*Pisces, Cyprinidae*) — A Biological Synopsis and Environmental Risk Assessment." Report 94400-3-0128 to U.S. Fish and Wildlife Service, April 12, 2005.

Luciano, Phil. "Asian Carp More Than a Slap in the Face." *Peoria Journal Star*, October 21, 2003. http://www.pjstar.com/x1754593846/Luciano-Asian-carp-more-than-a-slap-in-the-face.

McCormick, Troy. "Flying Silver Carp on Wabash River in Indiana." Filmed 2010. Bootprints TV, 4:24. https://www.youtube.com/watch?v=x3BfoWhvsNk.

Pimentel, David, Rodolfo Zuniga, and Doug Morrison. "Update on the Environmental and Economic Costs Associated with Alien-Invasive Species in the United States." *Ecological Economics* 52 (2005): 273–288.

Schankman, Paul. "Pleasant Hill Man Injured by Flying Asian Carp." *FOX2NOW St. Louis*, August 31, 2015. https://fox2now.com/2015/08/31/pleasant-hill-man-injured-by-flying-asian-carp/.

U.S. Army Corps of Engineers. *Great Lakes and Mississippi River Interbasin Study: Summary of the GLMRIS Report*. U.S. Army Corps of Engineers, Great Lakes and Ohio River Division. 2014.

——. Transcript of Cleveland Public Meeting. January 9, 2014.

CHAPTER 1 — IN THE BEGINNING

Allsopp, Craig. "Case of the Dead White Amur Remains Unsolved in Orlando." *Sarasota Herald-Tribune*, August 23, 1979.

Anonymous. "Nature's Weed Eater." *Pond Boss Magazine*, July-August (1992): 8–9, 14.

Arkansas Game and Fish Commission. *Joe Hogan State Fish Hatchery: Annual Report*. Lonoke, AR: 1974.

——. *Joe Hogan State Fish Hatchery: Annual Report*. Lonoke, AR: 1976.

Avault, James W., Jr. "Preliminary Studies with Grass Carp for Aquatic Weed Control." *Progressive Fish Culturist* 27, no. 4 (1965): 207–209.

Bailey, William M. "Arkansas' Evaluation of the Desirability of Introducing the White Amur (*ctenopharyngodon idella, val.*) for Control of Aquatic Weeds." Presentation at the 102nd Annual

Meeting of the American Fisheries Association and the International Association of Game and Fish Commissioners, Hot Springs, AR, September 10–15, 1972.

———. "A Comparison of Fish Populations Before and After Extensive Grass Carp Stocking." *Transactions of the American Fisheries Society* 107, no. 1 (1978): 181–206.

Bender, Bob. "White Amur Banned in Florida." *St. Petersburg Times*, July 19, 1975.

Brown III, Francis C. "What Attacks Ducks, Bites Water-Skiers? Not the White Amur." *Wall Street Journal*. Date Unknown.

Clugston, J. P., and J. Shireman. "Triploid Grass Carp for Aquatic Plant Control." Fish and Wildlife Leaflet 8, Fish and Wildlife Service, US Department of the Interior, Washington, DC, 1987.

Cross, D.G. "Aquatic Weed Control Using Grass Carp." *Journal of Fish Biology*, no. 1 (1969): 27–30.

Ellis, Mel. "Good Earth Crusade: White Amur, Either Angel or Devil Fish." *Associated Press*, February 22, 1973.

Finley, John. "Superfish or a Scourge?" *Indiana Carrier Journal*, February 15, 1976.

Freeze, Mike, and Scott Henderson. "The Aquaculture Industry of Arkansas in 1979." *Proceedings of the Annual Conference of the Southeast Association of Fish and Wildlife Agencies* 34 (1979): 115–126.

Gibson, Steve. "White Amur: Florida's Imported Pain in the Grass." *Sarasota Journal*, May 4, 1977.

Greenfield, David W. "An Evaluation of the Advisability of the Release of the Grass Carp, *Ctenopharyngodon Idella*, into the Natural Waters of the United States." *Transactions of the Illinois Academy of Science* 66, nos. 1 & 2 (1973): 47–53.

Guillory, Vincent, and Robert D. Gasaway. "Zoogeography of the Grass Carp in the United States." *Transactions of the American Fisheries Society* 107, no. 1 (1978): 105–112.

Hacker, David W. "Superfish!" *The National Observer*. Date Unknown.

Hawker, Jon L. "Whither the Grass Carp?" *Farm Pond Harvest*, Winter (1977): 12–13, 18.

Henderson, Scott. "Grass Carp: The Scientific and Policy Issues." Presentation at the International Grass Carp Conference, Gainesville, FL, January 11, 1978.

J.M. Malone & Son, correspondence with Drew Mitchell, January 25, 2005.

Kelly, Anita M., Carole R. Engle, Michael L. Armstrong, Mike Freeze, and Andrew J. Mitchell. "History of Introductions and Governmental Involvement in Promoting the Use of Grass, Silver, and Bighead Carps." *American Fisheries Society Symposium* 74 (2011): 163–174.

Kohler, Christopher C., and Walter R. Courtenay Jr. "Regulating Introduced Aquatic Species: A Review of Past Initiatives." *Fisheries* 11, no. 2 (April 1986): 34–38.

Lynch, Teresa. "White Amur Experience Leads to Development of Grass Carp Hybrid." *Aquaculture* 6, no. 1 (1979): 33–36.

Malone, Jim B. Interview by the author, Lonoke, AR, April 2, 2015.

Malone, Jim M. Personal letter to Dr. Carl R. Sullivan, September 13, 1976.

———. "Adventures in Panama." *Farm Pond Harvest*, Summer (1978): 12–15, 31.

———. "Credible White Amur Events." *Farm Pond Harvest*, Spring (1982): 15–16.

———. Personal letter to Senator Dale Bumpers, December 7, 1988.

———. Personal fax to Senator Dale Bumpers, February 1, 1995.

———. Personal letter to Justice Jim Johnson, August 22, 2001.

Malone, Jim M., and J.E. Thomerson. "The White Amur Controversy." *Farm Pond Harvest*, Summer (1982): 10–11, 24.

Mitchell, A.J., and A.M. Kelly. "The Public Sector Role in the Establishment of Grass Carp in the United States." *Fisheries* 31 (2006): 113–121.

Mitchell, Drew. Interview by the author, North Little Rock, April 1, 2015.

Pflieger, William L. "Distribution and Status of the Grass Carp (*Ctenopharyngodon Idella*) in Missouri Streams." *Transactions of the American Fisheries Society* 107, no. 1 (1978): 113–118.

Shuen Chee Yao, professional correspondence from Yuan Hu Chang Fishery to Jim Malone, August 22, 1972.

Stanley, Jon. "Reproduction of the Grass Carp (*Ctenopharyngodon Idella*) Outside Its Native Range." *Transactions of the American Fisheries Society* 1, no. 3 (1976): 7–10.

Thomas, Richard B. "Pot of Gold." *Farm Pond Harvest*, Winter (1978): 16–18.

United States Fish and Wildlife Service. "Bighead Carp (*Hypophthalmichthys nobilis*): A Biological Synopsis." *Biological Report* 88(29), September 1988.

Wells, Kathy. "Magazine Critical of Fish Experimentation." *Pine Bluff Commercial*, February 25, 1973.

Armstrong, Mike. "A Message from the Chairman." *River Crossings* 14, no. 4 (July/August 2005): 3.

Beavers, Barry. Personal communication with Jim Malone, February 9, 1990.

Brinkley, Douglas. "Rachel Carson and JFK, an Environmental Tag Team." *Audubon Magazine*, May-June, 2012.

Carson, Rachel. *Silent Spring*. Boston: Houghton Mifflin, 1962.

Dunlop, Thomas R. "Introduction." In *DDT, Silent Spring and the Rise of Environmentalism: Classic Texts*, edited by Thomas R. Dunlop. Seattle: University of Washington Press, 2008.

Environmental Protection Agency. EPA-230/1-76-065f. *Economic Analysis of Interim Final Effluent Guidelines for the Pesticides and Agricultural Chemicals Industry*. Washington, DC: Office of Water Planning and Standards, September 1976.

——. EPA-600/2-76-293. Prepared by U. Henderson and F. Wert. *Economic Assessment of Wastewater Aquaculture Treatment Systems*. Ada, OK: Robert S. Kerr Environmental Research Laboratory, December 1976.

——. EPA-600/S2-83-019. Prepared by S. Henderson. *Project Summary: An Evaluation of Filter Feeding Fishes for Removing Excessive Nutrients and Algae from Wastewater*. Ada, OK: Robert S. Kerr Environmental Research Laboratory, May 1983.

Freeze, Mike. Interviews by the author, Keo, AR, April 2 and April 3, 2015.

Gartner, Carol B. "When Science Writing Become Literary Art." In *And No Birds Sang: Rhetorical Analyses of Rachel Carson's Silent Spring*, edited by Craig Waddell, 103–125. Carbondale and Edwardsville: Southern Illinois University Press, 2000.

Griswold, Eliza. "How 'Silent Spring' Ignited the Environmental Movement." *The New York Times Magazine*, September 21, 2012.

Henderson, Scott. Interview by the author, phone, May 19, 2015.

Holm, L.G., L.W. Weldon and R.D. Blackburn. "Aquatic Weeds," *Science* 166, no. 3906 (November 7, 1969): 699–709.

Kelly, Anita. Interview by the author, Pine Bluff, AR, April 3, 2015.

Kinkela, David. *DDT and the American Century: Global Health, Environmental Politics, and the Pesticide that Changed the World*. Chapel Hill: University of North Carolina Press, 2011.

Lear, Linda. "Afterword." In *And No Birds Sang: Rhetorical Analyses of*

Rachel Carson's Silent Spring, edited by Craig Waddell. Carbondale and Edwardsville: Southern Illinois University Press, 2000.

Lutts, Ralph H. "Chemical Fallout." In *And No Birds Sang: Rhetorical Analyses of Rachel Carson's Silent Spring*, edited by Craig Waddell. Carbondale and Edwardsville: Southern Illinois University Press, 2000.

Lytle, Mark Hamilton. *The Gentle Subversive: Rachel Carson, Silent Spring and the Rise of the Environmental Movement*. New York: Oxford University Press, 2007.

Maguire, Steve. "Contested Icons: Rachel Carson and DDT." In *Rachel Carson: Legacy and Challenge*, edited by Lisa S. Sideris and Kathleen Dean Moore, 194–214. Albany: State University of New York Press, 2008.

Morton, Oliver. *The Planet Remade: How Geoengineering Could Change the World*. Princeton: Princeton University Press, 2016.

Pimentel, David. "After *Silent Spring*: Ecological Effects of Pesticides on Public Health and on Birds and Other Organisms." In *Rachel Carson: Legacy and Challenge*, edited by Lisa S. Sideris and Kathleen Dean Moore, 190–193. Albany: State University of New York Press, 2008.

Rosenberg, Tina. "What the World Needs Now Is DDT." *The New York Times Magazine*, April 11, 2004.

Simmons, Brig-Gen James. "How Magic Is DDT?" In *DDT, Silent Spring and the Rise of Environmentalism: Classic Texts*, edited by Thomas R. Dunlop. Seattle: University of Washington Press, 2008.

Smith, Michael. "'Silence, Miss Carson!' Science, Gender, and the Reception of *Silent Spring*." In *Rachel Carson: Legacy and Challenge*, edited by Lisa S. Sideris and Kathleen Dean Moore. Albany: State University of New York Press, 2008.

Strother, Robert S. "Backfire in the War against Insects." In *DDT, Silent Spring and the Rise of Environmentalism: Classic Texts*, edited by Thomas R. Dunlop. Seattle: University of Washington Press, 2008.

"Troubled Waters." PBS, December 20, 2002. http://www.pbs.org/now/science/cleanwater.html.

White-Stevens, Robert. "Communications Create Understanding." In *DDT, Silent Spring and the Rise of Environmentalism: Classic Texts*, edited by Thomas R. Dunlop. Seattle: University of Washington Press, 2008.

Whorton, James C. *Before Silent Spring: Pesticides and Public Health in Pre-DDT America*. Princeton: Princeton University Press, 1975.

Wilcox, Fred A. *Waiting for an Army to Die: The Tragedy of Agent Orange*. New York: Seven Stories Press, 1989.

Williams, Terry Tempest. "One Patriot." In *Rachel Carson: Legacy and Challenge*, edited by Lisa S. Sideris and Kathleen Dean Moore, 16–29. Albany: State University of New York Press, 2008.

Winston, Mark L. *Nature Wars: People vs. Pets*. Cambridge: Harvard University Press, 1997.

CHAPTER 3 — TRAGEDY OF THE WHITE AMUR

Allen, Standish K., Jr. and Robert J. Wattendorf. "Triploid Grass Carp: Status and Management Implications." *Fisheries* 12, No. 4 (1987): 20–24.

Anonymous. "Hybrid Carp Destroyed." *Sport Fisheries Institute Bulletin* 326, (July 1981): 5.

Associated Press. "Agencies Still Carping Over Use of White Amur." *Daytona Beach Morning Journal*, August 20, 1979.

Brantley, Robert M. Correspondence with USFWS director Frank Dunkle, July 7, 1988.

Cassani, J.R., and W.E. Caton. "Induced Triploidy in Grass Carp, *Ctenopharyngodon idella*." *Aquaculture* 46 (1985): 37–44.

———. "Efficient Production of Triploid Grass Carp (*Ctenopharyngodon idella*) Utilizing Hydrostatic Pressure." *Aquaculture* 55 (1986): 43–50.

Dieterle, C. Jarrett. "The Lacey Act: A Case Study in the Mechanics of Overcriminalization." *Georgetown Law Center* 12 (2014): 1279–1306.

Dupree, Harry K. "Memorandum Concerning Grass Carp." Fish Farming Experimental Station, Stuttgart, April 24, 1984.

Finney, Sam. Interview by the author, phone, March 13, 2015.

Freeze, Mike, and Scott Henderson. "Distribution and Status of the Bighead Carp and Silver Carp in Arkansas." *North American Journal of Fisheries Management* 2 (1982): 197–200.

Hybrid Grass Carp Steering Committee. Meeting Minutes. Coachella Valley Water District, January 25, 1982.

Kelly, Anita M., Carole R. Engle, Michael L. Armstrong, Mike Freeze and Andrew J. Mitchell. "History of Introductions and Governmental Involvement in Promoting the Use of Grass, Silver, and Bighead Carps." *American Fisheries Society Symposium* 74 (2011): 163–174.

Kern, David F. "Sale of weed-eating amur puts 2 behind federal bars." Publication Unknown. Date Unknown.

Lynch, Teresa. "White Amur Experience Leads to Development of Grass Carp Hybrid." *Aquaculture* 6, No. 1 (1979): 33–36.

Malone, Jim M. "100% Triploid Grass Carp." *Farm Pond Harvest*, Summer (1984): 19–20.

———. "Credible White Amur Events." *Farm Pond Harvest*, Spring (1982): 15–16.

———. Speech to the Inland Commercial Fisheries Association Meeting, Quad Cities, Iowa, 1983.

Melkovitz, Martha. Interview by the author, Keo, AR, April 3, 2015.

Papoulias, Diana M., James Candril and Jill A. Jenkins. "Verification of Ploidy and Reproductive Potential in Triploid Black Carp and Grass Carp." *American Fisheries Society Symposium* 74 (2011): 251–266.

Patterson, Ralph. "It's Now the Day of the Sterile White Amur." *Arkansas Gazette*, August 7, 1979.

Persons, Susan "Nikki." Interviews by the author, Keo, AR, April 3, 2015, and phone, August 19, 2015.

Rasmussen, Jerry. "Regulations as a Tool in Asian Carp Management." *American Fisheries Society Symposium* 74 (2011): 175–189.

Stanley, Jon G., J. Mayo Martin and Jack B. Jones. "Gynogenesis as a Possible Method for Producing Monosex Grass Carp." *The Progressive Fish Culturist* 37, no. 1 (1975): 25–27.

Stevens, Robert E. "Biological Opinion: Use of Triploid Grass Carp in Public Waters of South Carolina." United States Fish and Wildlife Service, December 2, 1985.

Sullivan, Carl R. correspondence with USFWS director Frank Dunkle, December 8, 1988.

Wattendorf, Robert. Interview by the author, phone, May 12, 2015.

———. "Rapid Identification of Triploid Grass Carp with a Coulter Counter and Channelyzer." *The Progressive Fish Culturist* 48 (1986): 125–132.

CHAPTER 4 — RESEARCH BACKWATER

Anderson Lively, Julie. Interview by the author, phone, February 18, 2015.

Barry, John M. *Rising Tide: The Great Mississippi Flood of 1927 and How It Changed America.* New York: Touchstone, 1997.

Coastal Protection and Restoration Authority of Louisiana. "Louisiana's

Comprehensive Master Plan for a Sustainable Coast." State of Louisiana, June 2, 2017.

"EPA's Budget and Spending," United States Environmental Protection Agency, accessed April 16, 2016, https://www.epa.gov/planandbudget/budget.

Expert Panel on Diversion Planning and Implementation. "Report #2." Submitted to Coastal Protection and Restoration Authority, June 2014.

Garvey, Jim. Interviews by the author, phone, October 4, 2014, and January 25, 2017.

Goss, John. Interviews by the author, phone, October 1, 2014, and February 18, 2015.

"History of the Industry," Louisiana Mid-Continent Oil and Gas Association, accessed April 14, 2016, http://www.lmoga.com/resources/oil-gas-101/history-of-the-industry/.

Hitchcock, Jay. Interview by the author, St. Charles, AR, April 6, 2015.

Kaller, Michael. Emails to the author, March 11 and March 18, 2015.

Kardish, Chris. "Southern Louisiana Picks a Fight With Big Oil to Save the Wetlands." In *Governing: States and Localities*, August 25, 2015.

Maceina, M.J., and J.V. Shireman. "Grass Carp: Effects of Salinity on Survival, Weight Loss, and Muscle Tissue Water Content." *The Progressive Fish-Culturist*, 41(1979): 69–73.

Marshall, Bob. "The Louisiana Coast: Last Call — How We Got This Way: Canal Dredging." *New Orleans Public Radio*, May 15, 2013.

Massimi, Michael. Interviews by the author, phone, February 20, 2015, and February 27, 2015, and Bayou Lafourche, April 9–11, 2015.

McPhee, John, "The Control of Nature: Atchafalaya," *The New Yorker*, February 23, 1987.

O'Connell, Martin. Interview by the author, New Orleans, LA, April 8, 2015.

O'Connell, Martin T., Ann U. O'Connell and Valerie A. Barko. "Occurrence and Predicted Dispersal of Bighead Carp in the Mississippi River System: Development of a Heuristic Tool." *American Fisheries Society Symposium* 74 (2011): 51–71.

Reed, Bobby. Interview by the author, phone, October 22, 2015.

Rich, Nathaniel, "The Most Ambitious Environmental Lawsuit Ever," *The New York Times Magazine*, October 3, 2014.

Salyers, Brac. Interview by the author, Thibodaux, LA, April 7, 2015.

Sandiford, Glenn. "Fish Tales: Optimism and Other Biases in Rhetoric about Exotic Carps in America." In *Invasive Species in a Globalized*

World: Ecological, Social & Legal Perspectives on Policy, edited by Reuben P. Keller et al., 72–98. Chicago: University of Chicago Press, 2015.

Schleifstein, Mark. "Louisiana Coastal Restoration 50-Year Blueprint Released." *New Orleans Times-Picayune*, January 12, 2012, updated March 16, 2016.

———. "$50 Billion Plan to Save Louisiana Coast Approved by Legislature." *New Orleans Times-Picayune*, June 2, 2017.

———. "Lake Pontchartrain Basin Being Monitored for Spillway Environmental Effects." *New Orleans Times-Picayune*, March 8, 2018.

Schultz, David. Interview by the author, Thibodaux, LA, April 7, 2015.

———. Remarks at Barataria-Terrebonne National Estuary Program Invasive Species Meeting, Thibodaux, LA, April 7, 2015.

Singleton, Dale. Interview by the author, St. Charles, AR, April 6, 2015.

Southwick Associates. *Sportfishing in America: An Economic Force for Conservation*. Produced for the American Sportfishing Association (ASA) under a U.S. Fish and Wildlife Service (USFWS) Sport Fish Restoration grant (F12AP00137, VA M-26-R) awarded by the Association of Fish and Wildlife Agencies (AFWA), 2012.

Thomas, R. Glenn, Jill A. Jenkins and Jody David. "Occurrence and Distribution of Asian Carps in Louisiana." *American Fisheries Society Symposium* 74 (2011): 239–250.

Weimer, Michael. Interview by the author, phone, October 13, 2015.

CHAPTER 5 — SCIENTIFIC SALVATION

Bajer, Przemyslaw G., C.J. Chizinski, and Peter W. Sorensen. "Using the Judas Technique to Locate and Remove Wintertime Aggregations of Invasive Common Carp." *Fisheries Management and Ecology* 18 (2011): 497–505.

Chew, Matthew K. "Invasion Biology: Historical Precedents." In *Encyclopedia of Biological Invasions*, edited by Daniel Simberloff and Marcel Rejmánek, 369–375. Berkeley: University of California Press, 2011.

Davis, Mark A. "Biotic Globalization: Does Competition from Introduced Species Threaten Biodiversity?" *BioScience* 53, no. 5 (2003): 481–489.

———. "Invasion Biology 1958–2005: The Pursuit of Science and Conservation." In *Conceptual Ecology and Invasion Biology: Reciprocal*

Approaches to Nature, edited by M.W. Cadotte, S.M. McMahon and T. Fukami, 35–64. Great Britain: Springer, 2006.

—— et al. "Don't Judge Species on Their Origins." *Nature* 474, (2011): 153–154.

——. "Do Native Birds Care Whether Their Berries Are Native or Exotic? No." *BioScience* 67, no. 7 (2011): 501–502.

——. "Invasive Plants and Animal Species: Threats to Ecosystem Services." In *Climate Vulnerability: Understanding and Addressing Threats to Essential Resources*, edited by Roger A. Pielke Sr., 51–59. Amsterdam: Elsevier, 2013.

Donaldson, Michael R., Jon Amberg, Shivani Adhikari, Aaron Cupp, Nathan Jensen, Jason Romine, Adam Wright et al. "Carbon Dioxide as a Tool to Deter the Movement of Invasive Bigheaded Carps." *Transactions of the American Fisheries Society* 145 (2016): 657-670.

Elton, Charles S. *The Ecology of Invasions by Animals and Plants*. Chicago: University of Chicago Press, 2000.

Ghosal, Ratna. Interviews by the author, St. Paul, MN, June 22, 2015, and phone, March 17, 2017.

International Union for Conservation of Nature. "Guidelines for Applying the Precautionary Principle to Biodiversity Conservation and Natural Resource Management." Approved by the 67th meeting of the IUCN Council, May 14–16, 2007.

Jeffrey, Jennifer D., Kelly D. Hannan, Caleb T. Hasler and Cory D. Suski. "Hot and Bothered: Effects of Elevated pCO2 and Temperature on Juvenile Freshwater Mussels." *American Journal of Physiology-Regulatory, Integrative and Comparative Physiology* 35, no. 1 (2018): 115–127.

——. "Responses to Elevated CO2 Exposure in a Freshwater Mussel, *Fusconaia flava*." *Journal of Comparative Physiology* 187 (2017): 87–101.

Lechelt, Joseph D., and Przemyslaw G. Bajer. "Modeling the Potential for Managing Invasive Common Carp in Temperate Lakes by Targeting Their Winter Aggregations." *Biological Invasions* 18 (2016): 831–839.

Lubchenco, Jane. "Entering the Century of the Environment: A New Social Contract for Science." *Science* 279, no. 5350 (1998): 491–497.

Marris, Emma. *Rambunctious Garden: Saving Nature in a Post-Wild World*. New York: Bloomsbury Press, 2011.

——. Interview by the author, phone, February 1, 2017.

Minnesota Aquatic Invasive Species Research Center. "Strategic Plan 2015–2025: Reducing AIS Risks by Advancing Research-Based

Solutions." University of Minnesota, November 4, 2015.

——. "Minnesota DNR Funds Sorensen Lab $880,000 to Advance Carp Deterrent Research at Lock & Dams." Accessed March 6, 2017. https://www.maisrc.umn.edu/news/lockdam-carp.

Nijhuis, Michelle. "Save the Median Strip! Or, How to Annoy E.O. Wilson." *Grist*, August 23, 2012.

Pearce, Fred. *The New Wild: Why Invasive Species Will Be Nature's Salvation.* Beacon Press: Boston, 2015.

Quammen, David. "Planet of Weeds: Tallying the Losses of Earth's Animals and Plants." *Harpers*, October 1998.

Ricciardi, Anthony and Rachel Ryan. "The Exponential Growth of Invasive Species Denialism." *Biological Invasions* 20 (2018): 549–553.

——. "Invasive Species Denialism Revisited: Response to Sagoff." *Biological Invasions* 20 (2018): 2731–2738.

Ruebush, Blake C., Greg G. Sass, John H. Chick, Joshua D. Stafford. "*In-situ* Tests of Sound-Bubble-Strobe Light Barrier Technologies to Prevent Range Expansions of Asian Carp." *Aquatic Invasions* 7, no. 1 (2012): 37–48.

Shackelford, Nancy, Richard J. Hobbs, Nicole E. Heller, Lauren M. Hallett and Timothy R. Seastedt. "Finding a Middle-Ground: The Native/Non-Native Debate." *Biological Conservation* 158 (2013): 55–62.

Simberloff, Daniel, et al. "Non-Natives: 141 Scientists Object." *Nature* 475 (2011): 36.

——. *Invasive Species: What Everyone Needs to Know.* Oxford: Oxford University Press, 2013.

——. "Biological Invasions: What's Worth Fighting and What Can Be Won?" *Ecological Engineering* 65 (2014): 112–121.

Smith, B.R. and J. J. Tibbles. "Sea Lamprey (*Petromyzozmaritrus*) in Lakes Huron, Michigan, and Superior: History of Invasion and Control, 1936–78." *Canadian Journal of Fisheries and Aquatic Science* 37 (1980): 1780–1808.

Sorensen, Peter W. "Project Completion Report: The Influence of Pheromones on the Distributional Biology of Adult Sea Lamprey." Great Lakes Fisheries Commission, February 1998.

——. "Developing Pheromones for Use in Carp Control: Final Report." State of Minnesota LCMR Final Work Report, July 20, 2006.

—— and Nicholas S. Johnson. "Theory and Application of Semiochemicals in Nuisance Fish Control." *Journal of Chemical Ecology* 42 (2016): 698–715.

——. Interviews by the author, St. Paul, MN, June 22, 2015, and phone, February 16, 2017.

Suski, Cory. Interviews by the author, phone, February 25, 2015, and February 23, 2017.

University of Pennsylvania. "Pheromones in Male Perspiration Reduce Women's Tension, Alter Hormone Response." *ScienceDaily*, March 17, 2003.

Vetter, Brooke J., Aaron R. Cupp, Kim T. Fredricks, Mark P. Gaikowski, Allen F. Mensinger. "Acoustical Deterrence of Silver Carp (*Hypophthalmichthys molitrix*)." *Biological Invasions* 17 (2015): 3383–3392.

——, Kelsie A. Murchy, Aaron R. Cupp, Jon J. Amberg, Mark P. Gaikowski and Allen F. Mensinger. "Acoustic Deterrence of Bighead Carp (*Hypophthalmichthys nobilis*) to a Broadband Sound Stimulus." *Journal of Great Lakes Research* 43, no. 1 (2017): 163–171.

Walsh, Paul. "First Silver Carp, the 'Flying' Invasive Fish, Found in St. Croix River." *Minneapolis Star-Tribune*, March 17, 2017.

Wyart, Claire, Wallace W. Webster, Jonathan H. Chen, Sarah R. Wilson, Andrew McClary, Rehan M. Khan, and Noam Sobel. "Smelling a Single Component of Male Sweat Alters Levels of Cortisol in Women." *Journal of Neuroscience* 7, no. 27 (6) (2007): 1261–1265.

CHAPTER 6 — TROUBLE WITH FISHING

Alvord, John W., and Charles B. Burdick. *Report of the River and Lakes Commission on the Illinois River and Its Bottom Lands.* Chicago, IL, 1915.

Ardis, Jim. Interview by the author, Peoria, IL, June 9, 2015.

Asian Carp Marketing Summit. "Executive Summary." Illinois-Indiana Sea Grant. September 20–21, 2010.

Dickau, Jim. Interviews by the author, Morris and Ottawa, IL, June 10 and June 11, 2015.

Fosdick, Tim. Interview by the author, Thomson, IL, October 16, 2014.

Garvey, James E., G.G. Sass, J. Trushenski, D. Glover, P. M. Charlebois, J. Levengood, and B. Roth et al. "Fishing Down the Bighead and Silver Carps: Reducing the Risk of Invasion to the Great Lakes." Final Report to the U.S. Fish and Wildlife Service and the Illinois Department of Natural Resources, Springfield. November 2012.

———, et al. "Appendix D. Fishing Down the Bighead and Silver Carps: Reducing the Risk of Invasion to the Great Lakes." A Final Report to the Illinois Department of Natural Resources. Southern Illinois University-Carbondale. January 2015.

Ghosal, Ratna, Peter X. Xiong and Peter W. Sorensen. "Invasive Bighead and Silver Carps Form Different Sized Shoals that Readily Intermix." *PLoS One* 11, no. 6 (June 2016).

Greenberg, Paul. *American Catch: The Fight for Our Local Seafood.* New York: Penguin, 2014.

———. "Multi-Jurisdictional Approach to Asian Carp in the Upper Illinois River and Chicago Area Waterway System, Illinois, United States." Presentation to Illinois Water Conference. October 16, 2016.

Kokotovich, Adam E., and David A. Andow. "Exploring Tensions and Conflicts in Invasive Species Management: The Case of Asian Carp." Minnesota Aquatic Invasive Species Research Center, January 2016.

MacNamara, Ruairi, David Glover, James Garvey, Wesley Bouska, Kevin Irons. "Bigheaded Carps (*Hypophthalmichthys* spp.) at the Edge of Their Invaded Range: Using Hydroacoustics to Assess Population Parameters and the Efficacy of Harvest as a Control Strategy in a Large North American River." *Biological Invasions* 18, no. 11 (2016): 3293–3307.

Nuñez, Martin A., Sara Kuebbing, Romina D. Dimarco and Daniel Simberloff. "Invasive Species: To Eat or not To Eat, That Is the Question." *Conservation Letters* 5 (2012): 334–341.

Parola, Philippe. "Silverfin Marketing Group: The Asian Carp Invasion Solution." Baton Rouge, 2010.

Pasko, Susan, and Jason Goldberg. "Review of Harvest Incentives to Control Invasive Species." *Biological Invasions* 5, 3 (2014): 263–277.

Schafer, Mike. Interview by the author, Thomson, IL, October 16, 2014.

Secchi, Silvia. Interview by the author, phone, September 10, 2014.

Seiderman, Damian. Interviews by the author, Morris and Ottawa, IL, June 10 and June 11, 2015.

Tsehaye, Iyob, Matthew Catalano, Greg Sass, David Glover and Brian Roth. "Prospects for Fisheries-Induced Collapse of Invasive Asian Carp in the Illinois River." *Fisheries* 38, no. 10 (October 2013): 445–454.

Varble, Sarah, and Silvia Secchi. "Human Consumption as an Invasive Species Management Strategy. A Preliminary Assessment of the Marketing Potential of Invasive Asian Carp in the U.S." *Appetite* 65 (2013): 58–67.

Wyffels, Dave. Interviews by the author, Morris and Ottawa, IL, June 10 and June 11, 2015.

Zipkin, Elise, Clifford E. Kraft, Evan G. Cooch and Patrick J. Sullivan. "When can efforts to control nuisance and invasive species backfire?" *Ecological Applications* 19, 6 (2009): 1585–1595.

CHAPTER 7 — "EAT 'EM TO BEAT 'EM?"

Foss, Phillip. Interview by the author, Chicago, IL, October 15, 2014.

Galvan, Carl. Interview by the author, Chicago, IL, October 15, 2014.

Kruse, Brian. Interview by the author, Thomson, IL, October 14, 2016.

Kuebbing, Sara. Interview by the author, phone, October 8, 2014.

Landers, Jackson. *Eating Aliens: One Man's Adventures Hunting Invasive Animal Species*. Storey Publishing, North Adams, MA, 2012.

———. Interview by the author, phone, September 23, 2014.

McCloud, Chris. Interview by the author, phone, October 7, 2014.

National Fisheries Institute. "Kentucky Tuna: A Bad Idea That's Against the Law." About Seafood. Accessed May 17, 2016. https://www .aboutseafood.com/news/kentucky-tuna-a-bad-idea-thats-against-the-law/.

Parola, Philippe. Interview by the author, phone, October 4, 2014.

"Phillip Foss vs. the Asian Carp." YouTube, March 24, 2010. https://www .youtube.com/watch?v=ogRLbNBXGoA.

Rackl, Lori. "Former Chicago Chef Sara Bradley 'Boomerangs' Back to Kentucky with Delicious Results." *Chicago Tribune*. Accessed September 7, 2017.

Roman, Joe. "Eat the Invaders!" *Audubon*. October, 2004.

———. Interview by the author, phone, September 26, 2014.

Simberloff, Daniel, Sara Kuebbing, Martin A. Nuñez and Romina D. Dimarco. "Why Eating Invasive Species Is a Bad Idea." *Ensia*, September 9, 2014. https://ensia.com/voices/why-eating-invasive-species-is-a-bad-idea/.

"The Great Fish Swap: How America Is Downgrading Its Seafood Supply." PBS, July 1, 2014. https://www.npr.org/sections/thesalt/2014/07/01/327248504/the-great-fish-swap-how-america-is-downgrading-its-seafood-supply.

Bucolo, Judith. Interview by the author, Fort Wayne, IN, December 2, 2015.

Chliboyko, Jim. "A Prairie Still Standing Tall, Barely." *Canadian Geographic*, June 1, 2010.

Cronon, William. *Nature's Metropolis: Chicago and the Great West*. New York: W.W. Norton & Co., 1991.

Department of Natural Resources, State of Indiana. "Water Resource Availability in the Maumee River Basin, Indiana." Water Resource Assessment 96-5. Indianapolis, IN. 1996.

Francisco, Ben. "Eagle Marsh Berm Works Restarts after Rain Delays." *The Fort Wayne Journal Gazette*. Accessed September 1, 2017. http://www.journalgazette.net/news/local/Eagle-Marshberm-workrestarts-afterrain-delays-8571026.

——. "Team Declares Victory with Asian Carp Berm." *The Fort Wayne Journal Gazette*. Accessed September 1, 2017. http://www.journalgazette.net/news/local/Team-declares-victory-with-Asian-carp-berm-13012779.

Howe, Henry F. "Managing Species Diversity in Tallgrass Prairie: Assumptions and Implications." *Conservation Biology* 8, 3 (1994): 691–704.

Meine, Curt. "Reimagining the Prairie: Aldo Leopold and the Origins of Prairie Restoration." In *Recovering the Prairie*, edited by Robert F. Sayre. Madison: University of Wisconsin Press, 1999.

Riethman, Duane. Interview by the author, Fort Wayne, IN, December 2, 2015.

Ruch, Don. *Results from the 2014 Eagle Marsh Biodiversity Survey. Allen County, Indiana*. Indiana Academy of Science. Fort Wayne, Indiana. 2014.

Silva, Amy. Interview by the author, Fort Wayne, IN, March 5, 2015.

The Nature Conservancy. "Oklahoma: Joseph H. Williams Tallgrass Prairie Preserve." Accessed February 12, 2016. https://www.nature.org/ourinitiatives/regions/northamerica/unitedstates/oklahoma/placesweprotect/tallgrass-prairie-preserve.xml.

U.S. Army Corps of Engineers. *Great Lakes and Mississippi River Interbasin Study: Other Pathways Preliminary Risk Characterization*. U.S. Army Corps of Engineers, Great Lakes and Ohio River Division. 2010.

——, *Great Lakes and Mississippi River Interbasin Study. Focus Area 2: Aquatic Pathway Assessment Report.* Eagle Marsh, Indiana. U.S. Army Corps of Engineers, Great Lakes and Ohio River Division. 2013.

——. *Great Lakes and Mississippi River Interbasin Study: Eagle Marsh Aquatic Nuisance Species Controls Report.* U.S. Army Corps of Engineers, Great Lakes and Ohio River Division. 2013.

Yankowiak, Betsy. Interviews by the author, Fort Wayne, IN, March 5, 2015, and December 2, 2015.

CHAPTER 9 — EDNA RISING

Chadderton, W. Lindsay. Interview by the author, South Bend, IN, March 4, 2015.

Cox, Michael. Michael Cox to Colonel Vincent W. Quarles, Terrence O'Brien and Honorable Pat Quinn, Chicago, IL, December 2, 2009.

Dispersal Barrier Advisory Committee. Meeting Minutes. June 24, 2009.

——. Meeting Minutes. January 10, 2010.

Egan, Dan. "32 DNA Samples for Asian Carp Found Past Barrier." *Milwaukee Journal Sentinel*, November 20, 2009. http://archive. jsonline.com/news/wisconsin/70637997.html.

——. "Asian Carp Found in Chicago Canal during Poisoning." *Milwaukee Journal Sentinel*, December 3, 2009. http://archive.jsonline.com/news/wisconsin/78425727.html.

Eichmiller, Jessica. Interview by the author, St. Paul, MN, June 22, 2015.

——, Przemyslaw G. Bajer, and Peter W. Sorensen. "The Relationship between the Distribution of Common Carp and Their Environmental DNA in a Small Lake." *PLOS One* 9, 11 (2014): e112611.

Frisbie, Margaret. Interview by the author, phone, March 11, 2015.

Gantz, Crysta. Interview by the author, South Bend, IN, March 2, 2015.

Garvey, Jim. Interview by the author, phone, January 25, 2017.

Geertsma, Meleah. "Solving the Carp Crisis: Moving from Courts to Collaboration." *Natural Resources Defence Council Expert Blog*, December 14, 2012. https://www.nrdc.org/experts/meleah-geertsma/ solving-carp-crisis-moving-courts-collaboration.

Hall, Noah. "Michigan Lawmakers to Join Legal Fight over Asian Carp in the Supreme Court." *Great Lakes Law*, December, 2009. http:// www.greatlakeslaw.org/blog/2009/12/michigan-lawmakers-to-join-legal-fight-over-asian-carp-in-the-supreme-court.html.

———. "Federal District Court Dismisses States' Lawsuit Seeking Hydrologic Separation of the Great Lakes and Mississippi River Basin to Stop Invasive Asian Carp; States Appeal." *Great Lakes Law*, December, 2012. http://www.greatlakeslaw.org/blog/2012/12/federal-district-court-dismisses-states-lawsuit-seeking-hydrologic-separation-of-the-great-lakes.html.

Jerde, Christopher L., Andrew R. Mahon, W. Lindsay Chadderton and David M. Lodge. "'Sight-Unseen' Detection of Rare Aquatic Species using Environmental DNA." *Conservation Letters* 4 (2011): 150–157.

———, W. Lindsay Chadderton, Andrew R. Mahon, Mark A. Renshaw, Joel Corush, Michelle L. Budny, Sagar Mysorekar, et al. "Detection of Asian Carp DNA as Part of a Great Lakes Basin-Wide Surveillance Program." *Canadian Journal of Fisheries and Aquatic Science* 70 (2013): 522–526.

Kart, Jeff. "Asian Carp Fever Grips Great Lakes, Monster Invasive Fish May Already Be Here." *Treehugger*, November 20, 2009. https://www.treehugger.com/natural-sciences/asian-carp-fever-grips-great-lakes-monster-invasive-fish-may-already-be-here.html.

Kelly, R.P., J.A. Port, K.M. Yamahara and L.B. Crowder. "Using Environmental DNA to Census Marine Fishes in a Large Mesocosm." *PLOS One* 9, 1 (2014): e86175.

Knutson, Ariel. "22 People Who Found Jesus in Their Food." *Buzzfeed*, March 29, 2013. https://www.buzzfeed.com/arielknutson/people-who-found-jesus-in-their-food?utm_term=.vyNApkg9Y#.fhVPBxol6.

Kornei, Katherine. "DNA Collected from Seawater May Solve Mysteries about World's Largest Fish." *Science Magazine*, November 21, 2016. http://www.sciencemag.org/news/2016/11/dna-collected-seawater-may-solve-mysteries-about-world-s-largest-fish.

Li, Frank, Andrew R. Mahon, Matthew A. Barnes, Jeffrey Feder, David M. Lodge, Ching-Ting Hwang, Robert Schafer et al. "Quantitative and Rapid DNA Detection by Laser Transmission Spectroscopy." *PLOS One* 6, 12 (2011): e29224.

Lodge, David. Interviews by the author, South Bend, IN, March 2, 2015.

Mahon, Andrew R. Interview by the author, phone, February 24, 2017, and February 27, 2017.

———, M.A. Barnes, F. Li, S.P. Egan, C.E. Tanner, S.T. Ruggiero, J.L. Feder et al. "DNA-Based Species Detection Capabilities Using Laser Transmission Spectroscopy." *Journal of the Royal Society Interface* 10(2012).

McKenna, Phil. "Mass Poisoning to Keep Carp Invaders from Great Lakes." *New Scientist*, December 10, 2009. https://www.newscientist .com/article/dn18263-mass-poisoning-to-keep-carp-invaders-from-great-lakes/.

Merkes, Christopher M., S. Grace McCalla, Nathan R. Jensen, Mark P. Gaikowski and Jon J. Amberg. "Persistence of DNA in Carcasses, Slime and Avian Feces May Affect Interpretation of Environmental DNA Data." *PLOS One* 9, 11 (2014): e113346.

Meyerson, Howard. "Bad News: Asian Carp Closing in on Lake Michigan; Fish Dangerous to Anglers, Other Species." *The Grand Rapids Press*. November 20, 2009. http://www.mlive.com/outdoors/index.ssf/2009/11/bad_news_asian_carp_closing_in.html.

Moy, Philip. Interview by the author, phone, November 23, 2016.

Moy, Philip B., Irwin Polls and John M. Dettmers. "The Chicago Sanitary and Ship Canal Aquatic Nuisance Species Dispersal Barrier." *American Fisheries Society Symposium* 74 (2011): 121-138.

Olds, Brett P., Christopher L. Jerde, Mark A. Renshaw, Yiyuan Li, Nathan T. Evans, Cameron R. Turner, Kristy Deiner et al. "Estimating Species Richness Using Environmental DNA." *Ecology and Evolution* 6, 12 (2016): 4214–4226.

Pfrender, Michael. Interview by the author, South Bend, IN, March 2, 2015.

Rees, Helen C., Ben C. Maddison, David J. Middleditch, James R.M. Patmore and Kevin C. Gough. "The Detection of Aquatic Animal Species Using Environmental DNA — a Review of eDNA as a Survey Tool in Ecology." *Journal of Applied Ecology* 51 (2014): 1450–1459.

Renshaw, Mark. Interview by the author, South Bend, IN, March 2, 2015.

Schaper, David. "Chicago Canal Flooded With Toxin To Kill Asian Carp." *NPR*, December 4, 2009. https://www.npr.org/templates/story/story.php?storyId=121104335?storyId=121104335.

State of Michigan v. United States of America, Motion for Preliminary Injunction, U.S. 6 (2009).

State of Michigan v. United States of America, On Motion for Preliminary Injunction, Memorandum for the United States in Opposition, U.S. 1 (2010).

State of Michigan v. United States of America, On Motion for Preliminary Injunction, Metropolitan Water Reclamation District of Greater Chicago's Response and Appendix to Michigan's Renewed Motion for Preliminary Injunction, U.S. 1 (2010).

State of Michigan v. United States of America, On Motion for Preliminary Injunction, Brief for the United States in Opposition, U.S. 2 (2010).

States of Michigan, Wisconsin, Minnesota, Ohio, Commonwealth of Pennsylvania v. United States Army Corps of Engineers and Metropolitan Water Reclamation District of Greater Chicago, No. 10 CV 4457 (2010).

States of Wisconsin, Minnesota, Ohio, and Pennsylvania v. United States of America, U.S. 7a (1978).

Stern, Andrew. "Chicago River Poisoned to Block Feared Asian Carp." *Reuters*, December 3, 2009. https://www.reuters.com/article/us-great-lakes-carp-idUSTRE5B25R220091204.

Thomsen, Philip F., and Eske Willerslev. "Environmental DNA — An Emerging Tool in Conservation for Monitoring Past and Present Biodiversity." *Biological Conservation* 183 (2015): 4–18.

Turner, Cameron R., Derryl J. Miller, Kathryn J. Coyne and Joel Corush. "Improved Methods for Capture, Extraction, and Quantitative Assay of Environmental DNA from Asian Bigheaded Carp (*Hypophthalmichthys* spp.)." *PLOS One* 9, 12 (2014): e114329.

U.S. Army Corps of Engineers. "The Electric Dispersal Barriers." Accessed February 16, 2017. http://www.asiancarp.us/documents/BarrierBrochure.pdf.

———. "Revised Final Independent External Peer Review Report Environmental DNA (eDNA) Science and Methodology." December 7, 2010. https://cdm16021.contentdm.oclc.org/digital/collection/p16021coll3/id/547/rec/1.

———. "Environmental DNA (eDNA) Science and Methodology Final USACE Response to Independent External Peer Review." September 7, 2011. http://cdm16021.contentdm.oclc.org/utils/getfile/collection/p16021coll3/id/548/filename/549.pdf.

CHAPTER 10 — VIA CHICAGO

Alliance for the Great Lakes. "Great Lakes–Mississippi River Separation Is Possible, Practical and Preventive." 2012. http://freshwaterfuture.org/wp-content/uploads/2014/09/GLC-GLSLCI-Final-PR-013112-v2.doc.

American Waterways Operators. "USACE: Address Invasive Species

Spread Responsibly." Accessed November 4, 2016. http://www
.americanwaterways.com/sites/default/files/GLMRIS%20Member
%20Alert.pdf.

Buckner, Kathryn. Interview by the author, phone, May 17, 2017.

Cusick, Daniel. "Can Chicago Handle the Coming Rains?" *Scientific American*, April 4, 2012.

Department of Policy and Planning, City of Chicago. "Industrial Usage of Chicago Area Waterways System." March 31, 2015.

Dizikes, Cynthia. "Big Report on Asian Carp Put Off until after Options Are Released by 2013." *Chicago Tribune*, May 8, 2012.

Duncker, James. Interview by the author, phone, June 2, 2017.

Eder, Tim, and David Ullrich. *Restoring the Natural Divide: Separating the Great Lakes and Mississippi River Basins in the Chicago Area Waterways System*. Ann Arbor: Great Lakes Commission, 2012.

———. Interview with media, Chicago, January 31, 2012.

Editorial Board Opinion. "Block the Asian Carp by Closing the Canal." *Milwaukee Journal Sentinel*, February 1, 2012.

Flanagan, Molly. Interview by the author, phone, May 17, 2017.

Gang, Jeanne. *Reverse Effect: Renewing Chicago's Waterways*. Chicago: Studio Gang Architects, 2011.

Geertsma, Meleah. "Midwest Governors on Separation of Watersheds: A Closer Look at What's at Stake." *NRDC Expert Blog*, June 11, 2013.

———. Interview by the author, phone, February 15, 2017.

Good, Greg. "Down the Drain." *Chicago Sun-Times*, April 14, 2010.

Hickey-Davis, Diane. Interview by the author, Chicago, IL, June 3, 2015.

Hill, Libby. *The Chicago River: A Natural and Unnatural History*. Chicago: Lake Claremont Publishing, 2000.

Lanyon, Richard. Interview by the author, Chicago, IL, June 8, 2015.

Martin Associates. "Economic Impacts of Waterborne Shipping on the Indiana Lakeshore." Report prepared for Ports of Indiana, August, 2010.

Mayer, Harold M. *The Port of Chicago and the St. Lawrence Seaway*. Chicago: University of Chicago Press, 1957.

Melching, Charles, Jin Liang, Lauren Fleer and David Wethington. "Modeling the Water Quality Impacts of the Separation of the Great Lakes and Mississippi River Basins for Invasive Species Control." *Journal of Great Lakes Research* 41 (2014): 87–98.

Metropolitan Water Reclamation District. "Tunnel and Reservoir Plan." Accessed November 1, 2015. https://www.mwrd.org/irj/portal/anonymous/tarp.

Michigan Department of Attorney General. 2012. "Schuette Praises Quickness of Great Lakes Commission Study on Separation of Great Lakes and Mississippi River." https://www.michigan.gov/ag/0,4534,7-359-82916_81983_47203-270427--,00.html.

Muench, Lynn. Interview by the author, phone, May 23, 2017.

——. Lynn Muench to David Wethington, Chicago, IL, January 30, 2015.

Natural Resources Defense Council. "Re-Envisioning the Chicago River: Adopting Comprehensive Regional Solutions to the Invasive Species Crisis." Accessed September 12, 2016. https://www.nrdc.org/resources/re-envisioning-chicago-river.

Ojala, Bob. Interview by the author, Chicago, IL, June 22, 2015.

Rasmussen, Jerry L., Henry A. Reiger, Richard E. Sparks and William W. Taylor. "Dividing the Waters: The Case for Hydrologic Separation of the North American Great Lakes and Mississippi River Basins." *Journal of Great Lakes Research* 37 (2011): 588–592.

Rice, Mary Jane Judson. *Chicago: Port to the World.* Chicago: Follett Publishing Company, 1969.

Schwieterman, Joseph P. "An Analysis of the Economic Effects of Terminating Operations at the Chicago River Controlling Works and O'Brien Locks on the Chicago Area Waterways System." Report prepared by DePaul University, April 7, 2010.

——. "Gaining Insight into GLMRIS: An Investigation of the Benefits & Costs of the Alternatives in the Great Lakes & Mississippi River Interbasin Study." Report prepared for the Illinois Chamber of Commerce, DePaul University, February 6, 2014.

——. "Stopping the Asian Carp and Other Nuisance Species: Cost Projections for Separating the Great Lakes and Mississippi River Basins Using U.S. Army Corps of Engineers Inputs." *Environmental Practice* 17 (2015): 291–301.

Taylor, John C., and James L. Roach. "Chicago Waterway System Ecological Separation: The Logistics and Transportation Related Cost Impact of Waterway Barriers." Report prepared for State of Michigan, Office of Attorney General, February 2, 2010.

Tibbetts, John. "Combined Sewer Systems: Down, Dirty, and Out of Date." *Environmental Health Perspectives* 113, 7 (2005): A464–A467.

U.S. Army Corps of Engineers. Great Lakes and Mississippi River

Interbasin Study: Inventory of Available Controls for Aquatic Nuisance Species of Concern. Chicago Area Waterway System. U.S. Army Corps of Engineers, Great Lakes and Ohio River Division. 2012.

U.S. Geological Survey. "Identify Potential Lock Treatment Options to Prevent Movement of Aquatic Invasive Species through the Chicago Area Waterway System (CAWS)." United States Department of the Interior File Report 2016–1001. 2016.

Ullrich, David. Interview by the author, Chicago, IL, June 4, 2015.

VoteSmart.org. "Letter to Jo-Ellen Darcy, Assistant Secretary of the Army Department of the Army, Civil Works." Accessed September 15, 2016. https://votesmart.org/public-statement/666240/letter-to-jo-ellen-darcy-assistant-secretary-of-the-army-department-of-the-army-civil-works#.WyP46FMvyRt.

Wethington, Dave. Interview by the author, Cleveland, OH, January 16, 2014.

Wittmann, Marion E., Roger M. Cooke, John D. Rothlisberger and David M. Lodge. "Using Structured Expert Judgement to Assess Invasive Species Prevention: Asian Carp and the Mississippi–Great Lakes hydrologic connection." *Environmental Science & Technology* 48 (2014): 2150–2156.

Young, David M. *Chicago Maritime: An Illustrated History.* DeKalb: Northern Illinois University Press, 2001.

CHAPTER II — AT HOME IN THE GREAT LAKES

Allen, Robert Thomas. *The Great Lakes.* Ottawa: Natural Science of Canada, 1976.

Chapman, Duane C., Jeremiah J. Davis, Jill A. Jenkins, Patrick M. Kocovsky, Jeffrey G. Miner, John Farver and P. Ryan Jackson. "First Evidence of Grass Carp Recruitment in the Great Lakes Basin." *Journal of Great Lakes Research* 39 (2013): 547–554.

Cooke, Sandra L., and Walter R. Hill. "Can Filter-Feeding Asian Carp Invade the Laurentian Great Lakes? A Bioenergetic Modelling Exercise." *Freshwater Biology* 55 (2010): 2138–2152.

Cuddington, Kim. Interview by the author, September 8, 2014.

——, W.J.S. Currie and M.A. Koops. "Could an Asian Carp Population Establish in the Great Lakes from a Small Introduction?" *Biological Invasions* 16 (2014): 903–917.

Cudmore, Becky. Interview by the author, Burlington, ON, November 14, 2016.

Doughty, Kat. Interview by the author, Port Credit, ON, July 15, 2014.

Fisheries and Oceans Canada Central & Arctic Region. "Government of Canada Invests $20 Million to Asian Carp Prevention in the Great Lakes." January 23, 2018. https://www.newswire.ca/news-releases/government-of-canada-invests-20-million-to-asian-carp-prevention-in-the-great-lakes-670710993.html.

Herborg, Leif-Matthias, Nicholas E. Mandrak, Becky C. Cudmore, and Hugh J. MacIsaac. "Comparative Distribution and Invasion Risk of Snakehead (Channidae) and Asian Carp (Cyprinidae) Species in North America." *NRC Canada* (2007): 1723–1735.

Illes, Colin. Interview by the author, Port Credit, ON, July 15, 2014.

Keller, Rueben P., and David M. Lodge. "Species Invasions from Commerce in Live Aquatic Organisms: Problems and Possible Solutions." *BioScience* 57, 5 (2007): 428–436.

Kelly, David W., Gary A. Lamberti and Hugh J. MacIsaac. "The Laurentian Great Lakes as a Case Study of Biological Invasion." In *Bioeconomics of Invasive Species: Integrating Ecology, Economics, Policy, and Management*, edited by Rueben P. Keller, David M. Lodge, Mark A. Lewis and Jason F. Shogren, 205–225. New York: Oxford University Press, 2009.

Kocovsky, Patrick M., Duane C. Chapman, and James E. McKenna. "Thermal and Hydrologic Suitability of Lake Erie and Its Major Tributaries for Spawning of Asian Carps." *Journal of Great Lakes Research* 38 (2012): 159–166.

———. Interview by the author, phone, March 9, 2015.

Kolar, Cynthia S., and David M. Lodge. "Ecological Predictions and Risk Assessment for Alien Fishes in North America." *Science* 298 (2002): 1233–1236.

Krantzberg, Gail, and Cheryl de Boer. "A Valuation of Ecological Services in the Great Lakes Basin Ecosystem to Sustain Healthy Communities and a Dynamic Economy." Prepared for the Ontario Ministry of Natural Resources by the Dofasco Centre for Engineering and Public Policy at McMaster University. Hamilton: 2006.

Mandrak, Nicholas E., and Becky C. Cudmore. "The Fall of Native Fishes and the Rise of Non-Native Fishes in the Great Lakes Basin." *Aquatic Ecosystems Health & Management* 13, 3 (2010): 255–268.

Marson, Dave. Interview by the author, Port Credit, ON, July 15, 2014.

Rapai, William. *Lake Invaders: Invasive Species and the Battle for the Future of the Great Lakes*. Detroit: Wayne State University Press, 2016.

Ricciardi, Anthony. "Facilitative Interactions among Aquatic Invaders: Is an 'Invasion Meltdown' Occuring in the Great Lakes?" *Canadian Journal of Fisheries and Aquatic Science* 58 (2001): 2513–2525.

———. "Patterns of invasion in the Laurentian Great Lakes in relation to Changes in Vector Activity." *Diversity and Distributions* 12 (2006): 425–433.

———. Interview by the author, Montreal, QC, September 28, 2018.

Riley, John L. *The Once and Future Great Lakes Country: An Ecological History*. Montreal: McGill-Queen's University Press, 2013.

Sass, Greg, Collin Hinz, Anthony C. Erikson, Nerissa N. McClelland, Michael A. McClelland and John. M. Epifanio. "Invasive Bighead and Silver Carp Effects on Zooplankton Communities in the Illinois River, Illinois, USA." *Journal of Great Lakes Research* 40 (2014): 911–921.

Wittmann, Marion E., Roger M. Cooke, John D. Rothlisberger, Edward S. Rutherford, Hongyan Zhang, Doran M. Mason and David M. Lodge. "Use of Structured Expert Judgement to Forecast Invasions by Bighead and Silver Carp in Lake Erie." *Conservation Biology* 29 (2014): 187–197.

———. Interview by the author, March 10, 2015.

CONCLUSION

Davis, Jeremiah J., and Rebecca N. Neely. "Barge Fish Interaction Study." Prepared for United States Fish and Wildlife Service — Midwest Region Fisheries Program. Carterville, Illinois. 2017.

Gang, Jeanne. *Reverse Effect: Renewing Chicago's Waterways*. Chicago: Studio Gang Architects, 2012.

Illinois Nutrient Loss Reduction Strategy. Prepared for Illinois Environmental Protection Agency. Springfield, August 31, 2015.

Johnson, Geoffrey. "Jeanne Gang: Reversing the River Could Transform Chicago." *Chicago Magazine*, December 6, 2011.

Lubell, Sam. "7 Cities Transforming Their Rivers from Blights to Beauties." *WIRED*, August 4, 2016, https://www.wired.com/2016/08/7-cities-transforming-rivers-blights-beauties/.

Quetchenbach, Bernard. *Accidental Gravity: Residents, Travelers, and the Landscape of Memory*. Corvallis: Oregon State University Press, 2017.

Sabin, Dyani. "Oh, Carp." *Scienceline*, July 18, 2016, http://scienceline.
 org/2016/07/oh-carp/.
Schlossberg, Tatiana. "Fertilizers, a Boon to Agriculture, Pose Growing
 Threat to U.S. Waterways." *New York Times*, July 27, 2017, https://
 www.nytimes.com/2017/07/27/climate/nitrogen-fertilizers-climate-
 change-pollution-waterways-global-warming.html.

SELECTED BOOKS BIBLIOGRAPHY

Barry, John M. *Rising Tide: The Great Mississippi Flood of 1927 and How
 It Changed America*. New York: Touchstone, 1997.
Carson, Rachel. *Silent Spring*. Boston: Houghton Mifflin, 1962.
Dunlop, Thomas R., ed. *DDT, Silent Spring and the Rise of Environment-
 alism: Classic Texts*. Seattle: University of Washington Press, 2008.
Egan, Dan. *The Death and Life of the Great Lakes*. New York: W.W.
 Norton & Company, 2017.
Elton, Charles S. *The Ecology of Invasions by Animals and Plants*. Chicago:
 University of Chicago Press, 2000.
Gang, Jeanne. *Reverse Effect: Renewing Chicago's Waterways*. Chicago:
 Studio Gang Architects, 2011.
Greenberg, Paul. *American Catch: The Fight for Our Local Seafood*.
 Penguin: New York, 2014.
Hill, Libby. *The Chicago River: A Natural and Unnatural History*. Chicago:
 Lake Claremont Publishing, 2000.
Landers, Jackson. *Eating Aliens: One Man's Adventures Hunting Invasive
 Animal Species*. North Adams, MA: Storey Publishing, 2012.
Keller, Reuben P., Marc W. Cadotte and Glenn Sandiford, eds. *Invasive
 Species in a Globalized World: Ecological, Social & Legal Perspectives on
 Policy*. Chicago: University of Chicago Press, 2015.
Kinkela, David. *DDT and the American Century: Global Health,
 Environmental Politics, and the Pesticide that Changed the World*.
 Chapel Hill: University of North Carolina Press, 2011.
Marris, Emma. *Rambunctious Garden: Saving Nature in a Post-Wild
 World*. New York: Bloomsbury Press, 2011.
McPhee, John A. *The Control of Nature*. New York: Farrar, Straus &
 Giroux, 1989.
Morton, Oliver. *The Planet Remade: How Geoengineering Could Change
 the World*. Princeton University Press: Princeton, 2016.

Orion, Tao. *Beyond the War on Invasive Species: A Permaculture Approach to Ecosystem Restoration*. White River Junction: Chelsea Green Publishing, 2015.

Pearce, Fred. *The New Wild: Why Invasive Species Will Be Nature's Salvation*. Beacon Press: Boston, 2015.

Riley, John L. *The Once and Future Great Lakes Country: An Ecological History*. Montreal: McGill-Queen's University Press, 2013.

Sideris, Lisa S., and Kathleen Dean Moore, eds. *Rachel Carson: Legacy and Challenge*. Albany: State University of New York Press, 2008.

Simberloff, Daniel. *Invasive Species: What Everyone Needs to Know*. Oxford: Oxford University Press, 2013.

Winston, Mark L. *Nature Wars: People vs. Pets*. Cambridge: Harvard University Press, 1997.

ACKNOWLEDGMENTS

OVERRUN BEGAN WITH a spent vacation day and a road trip to Cleveland in January, and through the guidance, assistance, encouragement and love of countless people, became the sum of more than four years of research and writing. And in another sense, the book began as a magazine feature for *This*, where an old high school friend, then editor-in-chief, didn't laugh when I pitched an article on invasive fish. And then, years later, she suggested the article could form the backbone of a solid application to the University of King's College for their Master of Fine Arts in Creative Nonfiction. She was right.

While the book was conceived before I drove to Halifax from Toronto to start King's MFA program, it was there in overheated campus tutorial rooms that *Overrun* took shape. Thank you to Harry Thurston and Kim Pittaway, whose mentorship was essential in helping me determine the book's shape, structure and tone. Additional thanks to the King's staff and my fellow students for their feedback in seminars and readings.

I am deeply indebted to the sources who took time out of their jobs and finite existence on this planet to help me learn more about Asian carp. I cannot begin to thank you all enough for paddling with me, driving me around, showing me your laboratories, letting

me tour your businesses and sharing your stories. In particular, I wish to thank Becky Cudmore from the Department of Fisheries and Oceans, Peter Sorensen from the Minnesota Aquatic Invasive Species Research Center, Betsy Yankowiak from the Little River Wetlands Project, Michael Massimi from the Barataria-Terrebonne National Estuary Program, and Jimmy Bryant from the University of Central Arkansas archives. You all went above and beyond.

And, in no particular order, I also want to extend thanks to John Goss, Emma Marris, Jim Garvey, Ratna Ghosal, Kevin Irons, Duane Chapman, Cory Suski, Molly Flanagan, Mike Freeze, Jim B. Malone, Drew Mitchell, Margaret Frisbie, Jim Dickau, Meleah Geertsma, Dave Wethington, Scott Henderson, Bob Wattendorf, Lynn Muench, Dave Wyffels, Richard Lanyon, David Ullrich, Andy Mahon, Silvia Secchi, Lindsay Chadderton and David Schultz — your insights were truly valuable in understanding the complexity of the Asian carp challenge.

I also wish to thank the Institute for Journalism and Natural Resources for connecting me with researchers at the University of Notre Dame working on environmental DNA in early 2015. In addition, thanks to The Banff Centre for allowing me to develop my chapter on Asian carp and the Great Lakes over several weeks as part of the Environmental Reportage residency in 2016. And to the Toronto Public Library for giving me the opportunity to work as a writer-in-residence in 2015, where I developed the chapter on Rachel Carson and biological control.

Special thanks to my agent, Shaun Bradley at Transatlantic Literary Agency, for hearing me out when I said Asian carp were "charismatic" and worthy of a "big ideas" book. To my editor, Susan Renouf, who saw in *Overrun* what I was attempting to accomplish and helped make it happen. And to Jen Albert, who copyedited the book — your master's degree in molecular biology and keen eye for effective and accurate science communication was tremendously valuable for guiding the writing smartly through concepts often tricky to grasp.

To my family and friends who asked after my book and nod-
ded politely while I talked about an invasive fish, thank you for
asking, even though you didn't always know what to do with the
answers I gave. To my daughter, Frances, who often slept nearby
while I edited the book, thanks for keeping me on my toes and
making me laugh. And to my wife, Courtney, who let me leave
a paying journalism gig to go back to school to write a book —
I'm not sure what you were thinking, but this was only possible
because of you. Thank you. xox

INDEX

ANDREW REEVES is an award-winning environmental journalist whose work has appeared in *The Walrus*, *This Magazine*, *Alternatives Journal* and the *Globe and Mail*. He received a master of fine arts in creative nonfiction from the University of King's College in 2016. He lives in Toronto, Ontario, with his wife and daughter.